Volume 6

DIRECTORY OF WORLD CINEMA
ITALY

Edited by Louis Bayman

intellect Bristol, UK / Chicago, USA

First Published in the UK in 2011 by Intellect, The Mill, Parnall Road, Fishponds, Bristol, BS16 3JG, UK

First published in the USA in 2011 by Intellect, The University of Chicago Press, 1427 E. 60th Street, Chicago, IL 60637, USA

Copyright © 2011 Intellect Ltd

All rights reserved. No part of this publication may be reproduced, stored in a retrieval system, or transmitted, in any form or by any means, electronic, mechanical, photocopying, recording, or otherwise, without written permission.

A catalogue record for this book is available from the British Library.

Publisher: May Yao
Publishing Assistant: Melanie Marshall

Cover photo: *I am Love*: First Sun/Mikado Film/The Kobal Collection

Cover Design: Holly Rose
Copy Editor: Heather Owen
Typesetting: Mac Style, Beverley, E. Yorkshire

Directory of World Cinema ISSN 2040-7971
Directory of World Cinema eISSN 2040-798X

Directory of World Cinema: Italy ISBN 978-1-84150-400-1
Directory of World Cinema: Italy eISBN 978-1-84150-535-0

Printed and bound by Cambrian Printers, Aberystwyth, Wales.

DIRECTORY OF WORLD CINEMA
ITALY

Acknowledgements	5
Introduction by the Editor	6
Film of the Year I	9
Io sono l'amore	
Film of the Year II	13
Le quattro volte	
Industry Spotlight	16
Valerio Jalongo Interview	
Cultural Crossover	21
Opera and Cinema	
Directors	24
Federico Fellini	
Nanni Moretti	
Silent Cinema	32
Essay	
Reviews	
Neorealism	54
Essay	
Reviews	
Melodrama	82
Essay	
Reviews	
Comedy	108
Essay	
Reviews	
Giallo	132
Essay	
Reviews	
Gothic Horror	154
Essay	
Reviews	
Peplum	176
Essay	
Reviews	
Spaghetti Western	200
Essay	
Reviews	
Political Cinema	226
Essay	
Reviews	
Contemporary Cinema	254
Essay	
Reviews	
Recommended Reading	280
Online Resources	283
Test Your Knowledge	285
Notes on Contributors	288
Filmography	294

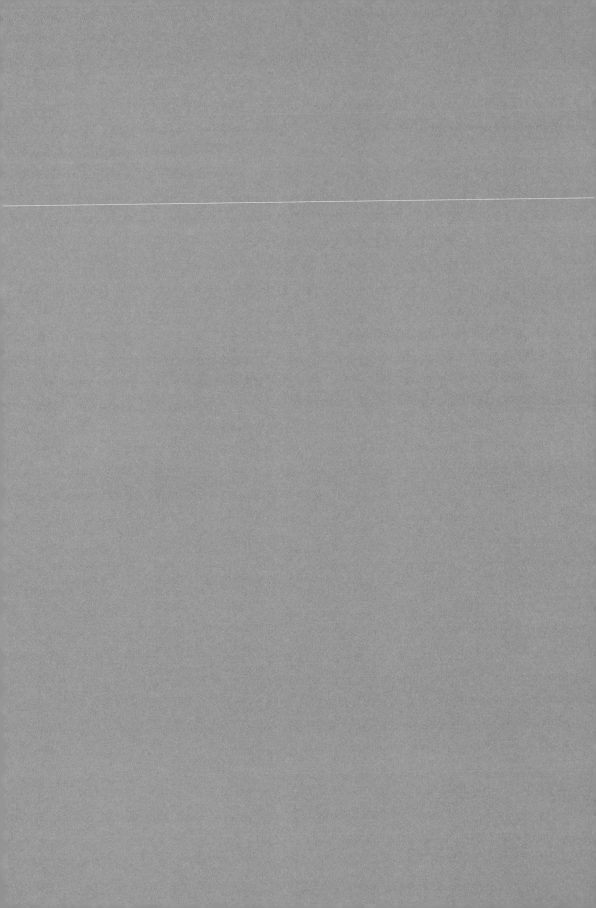

Acknowledgements

I would like to thank all the contributors, many of whom have provided input that goes far beyond simply the credited work here, as well as all the staff at Intellect Press. I would in particular like to thank Hannah, Paul and Peggy Bayman, Jo Bennett, Nick Church, Jonathan Driskell, Laurence Kelvin, Hope Liebersohn, Mariana Liz, Elizabeth Taylor, Russ Hunter and Hesham Yafai for their comments on various aspects of the book. John Berra was of great help; Sergio Rigoletto also deserves thanks for the extra help he gave on matters of translation.

Louis Bayman

INTRODUCTION BY THE EDITOR

'This was my last chance. You know it Melina: for me, theatre is life.' So says theatrical impresario Checco to the woman whose heart he has broken but whose money he needs to stage a show. The actors are Peppino De Filippo and Giulietta Masina, themselves imports to cinema from the popular theatres in which they first became famous. In the film, rehearsals follow, with a crack shot, dancers, and a piano/trumpet duo taking uneasy steps in the construction of a performance. With the clash of a gong, their less-than-successful practice attempts cut to the public success of the grand musical spectacle, which seals the impresario's financial success, repairs his marriage, and ensures the happy continuance of the theatrical troupe.

The film is *Luci del varietà/Variety Lights* (1951). Its sentiment sums up a certain joyous, accessible trait in Italian cinema, and a faith in the show as having almost magical powers of consolation for poverty, or loneliness, or simple disappointment at the rest of life. In the world of the film, strangers are liable to burst into opera arias on the street while any unfamiliar young woman on the train could be an aspiring dancer. The unreality of this image indicates an attitude that the important stuff of life is entertainment, a sentiment echoed even in the directorial duo that made the film, it being a debut from the budding arthouse auteur Federico Fellini in partnership with Alberto Lattuada, the master of popular dramatics.

And yet such a scene may not be what immediately springs to mind as the common image of Italian cinema. After all, Italian cinema was at the forefront of politically-committed realism. Further, it is Italy's arthouse film-makers who, maybe more than any other, contributed to the image of the post-war European auteur and cinema as an artistic endeavour at the upper end of cultural seriousness.

Is the more accurate image one of political commitment and modernist masterworks, or the traditions of comedy and melodrama? Can Italian cinema principally be characterized as a socially-engaged cinema of documentary realism, or by the operatics of excessive theatricality? Is its true heritage the prestige cinema of directorial genius or the popular cinema of genres and *filoni* (strands), the 'cycles' of formulaic, highly popular, low-budget productions whose brief life-spans of intense exploitation each led to total eclipse as fashions changed?

Of course, the problem lies in posing the question this way (even disregarding the question of individual taste), its gross simplification courting stereotypes of national cultural character. To characterize is to select and distil from the full variety of cinematic production. And it is also the task which is set in compiling a fraction of the thousands of films from the richly diverse cultural achievement that constitutes Italian cinematic production.

What is certainly not difficult is to discern a heyday of Italian cinema in the three decades that followed the Second World War. This was the period in which neorealism was credited with creating a new cinematic language, and of a boom in Italian film production of all kinds, leading to the invention of *filoni* such as gothic horror's tales of the macabre or the specifically Italian take on the American frontier known as the spaghetti Western. It was also the period which saw the flowering of the talents of Federico Fellini and Michelangelo Antonioni, Luchino Visconti and Roberto Rossellini, and, later, Pier Paolo Pasolini and Bernardo Bertolucci, only the most famous names from a broad auteur system. Italian film production created in this period a space for exploration and for difference, for creative partnerships and artistic independence, and a vast cultural output allowing dense intertextual reference and direct engagement with social change.

This period did not, however, appear from the blue. It was during Fascism's attempts to revive an industry in crisis that national production was first re-established. A key goal for the cinema under Fascism was to create a popular medium to communicate the regime's favoured images and ideas. Going further back, a desire for realism is found in the historical epics whose reconstructions of ancient epochs were also key in establishing the grandiose possibilities for cinematic spectacle. Central internationally to the creation of the feature film, Italy also granted the world the first cinematic star system in the shape of the divas of the silent screen. And while, as the interview below with Valerio Jalongo makes clear, economic and political forces, as well as the influence of television, have created a sense of crisis since the mid-1970s, Italian cinema remains an important part of popular entertainment and national culture.

The selection of films is not based solely on a personal evaluation of the best of Italian cinema but to balance the range and development of Italian cinema, and its role within national culture and international film history. The merit of a film or film-maker for inclusion involves consideration of commercial and historical importance, the intellectual and academic questions raised, or artistic qualities – each overlapping but not coincident categories. Nevertheless, any reader with a knowledge of Italian cinema will find – amidst the many pleasures the volume also offers – omissions, most obviously of any separate entry on Michelangelo Antonioni, or, for those of different tastes, *Nuovo Cinema Paradiso/Cinema Paradiso* (Giuseppe Tornatore, 1988). Mitigation can be requested solely in pointing to the fact that selection must take place, and we hope to have saved some gems for future volumes.

Despite a weighting towards the post-war decades the reader will find a full historical sweep on offer, from Italy's first fiction film, *La presa di Roma* (1903), to the 'Films of the Year'. With individual *filoni* the historical sweep available is not always all that great – the selection of films for the *peplum* runs from 1958–1962. The meta-genres of melodrama and comedy, on the other hand, dominate across Italian cinema just as they

do in Italian culture more generally, and are present not only in their own chapters but also in the sections on Silent and Contemporary cinema which mark the beginning and end-points of the volume's main section. The chapters balance popular and domestic traditions with more prestige forms, whether in Visconti's lifelong interest in opera realized in the emotionality of cinematic melodrama or a maestro of cinematic violence such as Dario Argento. The weighting is pushed more decisively back to radical and art cinema in the choice of director profiles and in the chapters on neorealism and political cinema, although, even here, who could imagine Fellini without his cartoonist's eye, Lina Wertmüller without her experiments with popular comedy – in short, a cross-fertilization between entertainment and high-minded goals?

To return to the opening problem of the characterization of Italian cinema, it is the productive aesthetic, industrial, cultural, and political tensions between popular and arthouse, realist and spectacular, the renowned and the overlooked that are key to a comprehensive understanding of Italian cinema. It is with this in mind that two 'Films of the Year' have been chosen: *Io sono l'amore/I am Love* (Luca Guadagnino, 2009), a lavish and melodramatic tale of the crisis of a rich Milanese family, and *Le quattro volte/The Four Times* (Frammartino, 2010), a quasi-documentary of Calabrian goatherders. Yet the opposition is set up precisely so as to then be re-thought: as the reviewers make clear, *L'amore* is a sumptuous romance, but simultaneously a dissection and critique of class and an evocation of the details and habits of life. Meanwhile *Le quattro volte* is a highly constructed glimpse into almost mystical realms.

It is precisely in this merging of critical categories that they are emblematic, and not only because they make evident the limits of classificatory systems when applied to artistic creation. For, as a final comment, where Italian cinema excels is precisely in the realization of film's unique capacity to record from reality so as to produce experiences of aesthetic and affective delight. As a final, prefatory attempt at characterization, in Italian cinema, what is repeatedly taken most seriously is showmanship, thereby creating a continuing exploration of the connection of art (in its widest sense) to life.

Directory of World Cinema

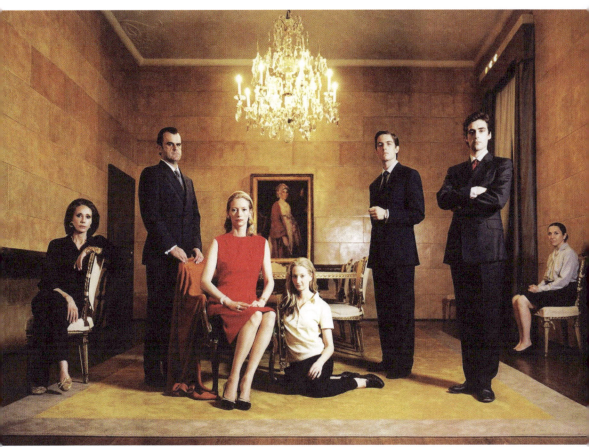

I Am Love/Io sono l'amore, First Sun/Mikado Film/The Kobal Collection.

FILM OF THE YEAR I

Io sono l'amore

I Am Love

Studio:
Mikado Film, First Sun

Director:
Luca Guadagnino

Producers:
Luca Guadagnino
Tilda Swinton
Alessandro Usai
Francesco Melzi d'Eril
Marco Morabito
Massimiliano Violante

Screenwriters:
Barbara Alberti
Ivan Cotroneo
Walter Fasano
Luca Guadagnino

Cinematographer:
Yorick Le Saux

Art Director:
Francesco di Mottola

Editor:
Walter Fasano

Music:
John Adams

Duration:
119 minutes

Genre:
Drama

Cast:
Tilda Swinton
Flavio Parenti
Edoardo Gabbriellini
Alba Rohrwacher
Pippo Delbono

Year:
2009

Synopsis

Milan, winter. At a dinner party at the mansion of the wealthy and powerful Recchi family, patriarch Edoardo announces that he is handing on the reins of the family textile company – to be run jointly by his son Tancredi and grandson Edoardo Jr (Edo). That night, Edo is brought a present of a cake by Antonio, a chef who has beaten him in a rowing race. Edo and Antonio subsequently become firm friends, and Edo helps him set up his own restaurant in the city.

Spring: Tancredi's Russian-born wife Emma learns by chance that her daughter Betta is lesbian. Visiting Antonio's restaurant with her mother-in-law Allegra, Emma falls in love with Antonio's cuisine. Meeting Antonio by chance in San Remo, Emma joins him at his farm in the country, and the two embark on a passionate affair. When the family business is sold to an international corporation, the Recchis hold a dinner, which Antonio caters. As a result, a tragic turn of events affects the fate of the entire family.

Critique:

When premiered in Venice in 2009, Luca Guadagnino's *Io sono l'amore* was the very epitome of a festival discovery: a third fiction feature by a hitherto little-noticed director, programmed in an unobtrusive non-competition slot. Few festival-goers – outside those with a specialist interest in Italian cinema – were expecting revelations, but Guadagnino's film was hailed by the international press as arguably the most significant film of the festival. It was one of those films that not only present a strikingly-talented new director, but also reveal possibilities – of expression, scope, intensity – that had otherwise seemed underexplored in narrative cinema.

Guadagnino had previously made a low-budget meta-thriller, *The Protagonists* (1999), with *Io sono l'amore* star Tilda Swinton, and a commercially-successful softcore youth-sex drama, *Melissa P* (2005), based on an Italian bestseller. But if anything in his filmography gave a clue to the tenor of his breakthrough film, it was probably his 2004 documentary *Cuoco Contadino*, a portrait of chef Paolo Maseiri (a real-life model for Antonio), not to mention his knowingly-glamorous promo shorts for fashion house Fendi, their detached chic underlaid with premonitions of the Lawrentian raptures of *Io sono l'amore*. (The fashion house's leading light Silvia Venturini Fendi is associate producer on *Io sono l'amore*, which features both Fendi and Jil Sander in its wardrobe.)

Io sono l'amore nonetheless had its detractors, and what offended them in no small part was the film's unapologetic opulence – a very unfashionable quality in contemporary European art cinema. The Recchi mansion is a place of regal proportions and gleaming finish, a place where not a single surface does not signify wealth, power and lofty social discretion. But Guadagnino's film also explores an opulence of depth, of the senses, that allows this initially glacial film to burgeon gradually into a radiant extended

swoon. Tilda Swinton dubbed this operatic, highly romantic narrative 'Visconti on acid', but there is much Antonioni in it too: not just the early 1960s period evoked in the overture's snowbound Milan but also the more warmly melodramatic director of the 1950s. The shades of both Italian masters hover over the film, betokened by the casting of Gabriele Ferzetti, from Antonioni's *L'avventura* (1960), and Marisa Berenson, from Visconti's *Morte a Venezia/ Death in Venice* (1971).

Io sono l'amore could loosely be described as a family saga, although it increasingly veers away from the other family members to focus on Emma (whose name unavoidably echoes *Madame Bovary*). Arranged in a series of seasonal acts, the film progresses from its chilly wintry overture to spring, as Emma becomes the story's focus. When Emma samples Antonio's food, she is instantly transformed: a baroque confection of prawns, seen in radiantly succulent close-up, makes her whole being explode in ravishment. Few films have so intensely evoked the combined experience of the taste, smell and sight of food; *Io sono l'amore* achieves a genuine sense of erotic synaesthesia. It is not long before Emma falls into an altogether amorous rapture, joining Antonio in a *Chatterley*-style bucolic coupling amid sunlight, greenery and extreme close-ups of skin surfaces, raspberries and insects on moss.

Some have balked at the euphoric overload of such sequences, but Guadagnino's commitment to a visual language of emotional intensity transcends accusations of kitsch. He aims for the amplified emotional sweep, and the formal stylization, of grand opera. A climactic sequence of revelation and shockingly-abrupt calamity leads to a stark climax as Emma faces Tancredi – whose terse but brutally-conclusive malediction effectively wipes her off the face of the earth: '*Tu non esisti*' (You do not exist). Staged in a vast, echoing chapel, this austere confrontation scene takes the film beyond opera, and into the stark realm of classical tragedy. The film's dramatic power, its sometimes-ceremonial formality, are boosted by the extensive use of music by John Adams, with Guadagnino sampling his score from right across the American composer's repertoire, including the operas *The Death of Klinghoffer* and *Nixon in China*.

One of the most striking aspects of *Io sono l'amore* is Emma's gradual emergence as tragic centre. At first, although the female head of the house, she seems less mistress than administrator, supervising an army of servants as they lay places for the film's opening dinner. Much of the time, she seems an onlooker in her own home: when Edo holds a poolside party, it is shot from the point of view of Emma, observing discreetly from an upstairs room. It is only later that we learn Emma was born in Russia, and remade as a Recchi by her husband Tancredi. Her Russian identity reinforces her credentials as a tragic adulterous heroine, *à la* Anna Karenina, and supplies an essential link between her and Edo. She used to make her son a special Russian fish soup, and it is Antonio's bespoke version of that soup that triggers a fateful realization for Edo at the film's climactic dinner.

This is also a political film about class and exclusion. The family member most akin to Emma is her daughter Betta, who similarly rebels sexually, embracing her lesbianism. But it is Betta, ironically, who displays the callous class instinct for exclusion, snubbing her rejected boyfriend with a brusqueness that is the true mark of the Recchis. And when the final dramatic axe falls, Emma is not the only outcast: it is wordlessly suggested that Edo's fiancée Eva has also been shut out of the family. The drama revolves around reactions to an outsider, Antonio; the clan's collapse begins, in fact, with the news that a Recchi has been beaten in a competition by a commoner. Never mind that Emma is sleeping with Antonio, it is already the discreet beginning of a scandal that she even addresses him at his restaurant with friendly intimacy.

Emma is a personality to be unravelled slowly, revealing a succession of selves in conflict, and Tilda Swinton's performance comes across as a series of modulations, a complex solo part in an orchestral score. The role calls both for hyper-formal decorum as the society matriarch, and for a vivid evocation of Emma's physicality – culminating in a moment of physical and emotional exhaustion as this tragic heroine is entirely consumed, burned up by her destiny. Towards the end, a thunderstruck Emma stands like a floppy mannequin, a body emptied of its self.

Walter Fasano (also credited as co-writer) offers subtle and complex editing: note the superbly tense, altogether Hitchcockian sequence in which Emma trails Antonio through the streets of Sanremo; a wonderfully devious trick scene that convinces us the lovers are about to be discovered in flagrante delicto; and the cleverly developed use of an intermittent MacGuffin, a book on colour in art.

The film's director of photography, Yorick le Saux – a regular collaborator of Olivier Assayas – is acutely, analytically attentive to surfaces, interior and exterior, rural and urban (note the way his lens flattens the Gothic geometry of Milan's Duomo). His camera movements elegantly rhyme with the way that people glide in this world of precision and decorum: in particular, a dizzy piece of circling Steadicam choreography linking kitchen and dining room at the film's climactic meal.

Jonathan Romney

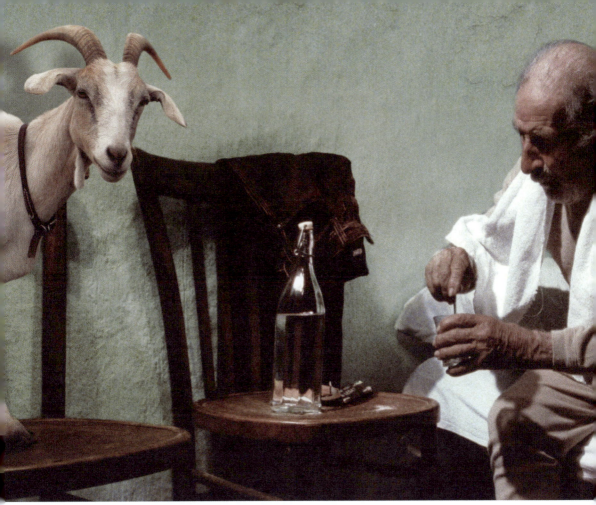
Le quattro volte, Vivo Film.

FILM OF THE YEAR II

Le quattro volte

Studio/Distributor:
Vivo Film

Director:
Michelangelo Frammartino

Producers:
Marta Donzelli
Gregorio Paonessa
Susanne Marian
Philippe Bober
Gabriella Manfrè
Elda Guidinetti
Andres Pfaeffli

Screenwriter:
Michelangelo Frammartino

Cinematographer:
Andrea Locatelli

Art Director:
Matthew Broussard

Editors:
Benni Atria
Maurizio Grillo

Duration:
88 minutes

Genre:
Drama

Cast:
Giuseppe Fuda
Bruno Timpano
Nazareno Timpano

Year:
2010

Synopsis

An elderly goatherd takes his flock out to pasture every day helped by his dog. He has a chronic cough but every night drinks water mixed with dust swept up from the church. One day he drops the packet of dust and that night is unable to wake anyone in the church. He is discovered dead on the day of the village's Calvary procession. Someone else takes over his herd. A kid goat gets left behind and dies. A tree is cut down and used as a maypole, before being converted to carbon, which the villagers use in their homes.

Critique

There is a very long take half-way through *Le quattro volte* that is its turning point, and in more ways than one. It is literally so: it includes two pans, the camera turning on its axis. Like the camera movement, the take points backwards and forwards, to what has gone before and what is to come. In its imagery it encapsulates the film's concerns, in its restraint and deliberation its stance.

The camera is positioned high above the village in which, together with the surrounding countryside, the film takes place. On the lower left, at the outset, is the pen where the old man keeps his goats. A van drives up and two Roman centurions jump out; one shoves a stone under the back wheel of the van to prevent it sliding on the steep slope and both run off into the village, the goatherd's dog barking at them. After some time, a Calvary procession emerges, including the two centurions, and the camera pans right to follow it as it makes its way out of the village; on a hill in the distance, two crucifixes stand out in silhouette; the dog runs after the procession barking, but then runs back to the village, the camera panning back with it. A girl comes running from the village, evidently late for the procession; she is intimidated by the dog's barking but eventually manoeuvres her way round it and runs after the procession, the dog following her, the camera panning with them; in the distance there is now a third crucifix. Again the dog, and the camera, return to the village, and the dog removes the stone from the back of the van in its jaws, causing the van to run back down the slope, crashing into the goats' pen.

This take, even within its own bounds, creates the sense of the mysterious within detachedly-observed everyday life. The bizarrerie of Roman centurions jumping out of a van lingers until it is explained by the emergence of the procession. We had no prior knowledge of this, though it at once explains a strange, earlier moment in the film, shot from the same position, in which a priest and a girl seem to discuss a veil and she practices genuflecting: only now is it evident they were rehearsing for the Calvary procession (and she may well be the girl late for the procession). Earlier, too, we had seen a man dragging a length of wood which we can now see was the spine for a crucifix. In these instances, the take points narratively backwards, but it also points forwards. The two crucifixes in the distance indicate that a third is to come; this appears, disclosed by the camera on its second pan to the right,

but it is not feasible that the procession could have reached the hill and erected the crucifix in the time it is out of view. One might consider this a sleight of hand, but that would not be characteristic of the film and its appearance as much suggests mystery, and the holiness of mystery in Christian tradition.

A different anticipation of what is to come centres on the dog. Why does it remove the stone from the van? (As striking as the action is the logistics of training the dog to remove the stone after barking and running back and forth and before the shot comes to an end: it took 22 takes.) Why indeed is it barking all the time? – it knows the people; the Calvary procession is unlikely to be a novelty. However, by causing the van to crash into the pen, the dog allows the goats to get out. By mysterious instinct, the goats make their way to the goatherd's home. He is dead. Presumably the dog has been trying to tell the village people.

Events in the film are explained and yet they still retain a sense of mystery. There is a luminous shot early on of dust dancing in a beam of light streaming into the church. A cleaning woman sweeps up and then, at the altar, tears a strip from a magazine, puts a small quantity of dust on it, neatly folds the strip around it, mutters some words and gives the package to the goatherd. He gives her a bottle of milk and says thank you. This is, significantly, the only audible dialogue in the film: 'grazie' (thank you) and 'Grazia' (Grace) are virtually the same word. A little later we see the man drinking the dust stirred into water. So far, it seems like observation of a folk Christian superstition. A little later, a packet of dust drops out of the man's back pocket; the strip has by chance been torn so that an image of a pair of eyes fills one side; it lies in the undergrowth while ants work away underneath, making the packet and the eyes move, entirely explicably and yet also mysteriously. That night, without the dust, he dies – because he was not able to ingest the holy infusion?

This is one of four deaths in the film – the four times of the title: him, Christ, a kid goat and the world. The kid is one that gets left behind as the man who has taken over the herd leads them out to pasture; there is no sign of the dog – before, it or the old man would have rescued the kid. This is in miniature the pattern of care for nature that has been broken.

There are those who read the film in terms of the cyclicality of nature and even reincarnation. This is plausible: the film opens and closes with charcoal burning, a kid dies but one is born, Christ rose from the dead. Yet it seems to me there is an altogether bleaker vision at work. The dog disappears, the kid is left behind and the birdsong diminishes as the film proceeds. A beautiful tree is cut down, stripped of its branches and erected as a maypole, with its cut-off tip affixed to the top of the pole, a pathetic last glimpse of its beauty. Then it comes down again and is turned into charcoal. The last ten minutes or so of the film show the process of charcoal-making in (fascinating) detail. The tree is cut and burnt, the charcoal is delivered to the villagers' home; the last shot of the film is smoke rising from the chimneys. Renewal – or the finality of death, the gradual attrition of nature?

Richard Dyer

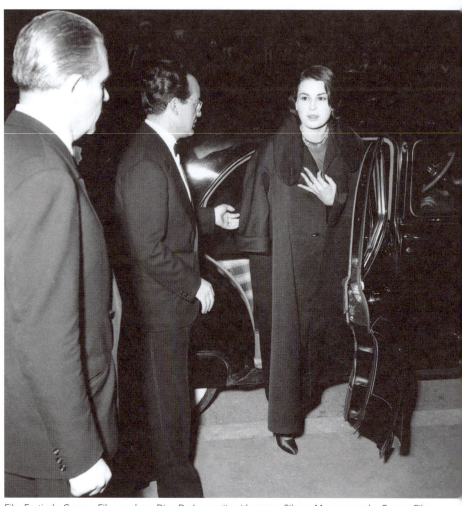

Film Festivals: Cannes. Film producer Dino De Laurentiis with actress Silvana Mangano at the Cannes Film Festival. The Kobal Collection/Bob Hawkins.

INDUSTRY SPOTLIGHT
VALERIO JALONGO INTERVIEW

Valerio Jalongo is one of the founding members of the 'Centoautori' film movement and, in 2009, released the film *Di me cosa ne sai/What Do You Know About Me*, a documentary into the current state of the Italian film industry.

Your film begins with veteran film director Bernardo Bertolucci asking the question 'would [Pasolini's 1975 film] Salò be possible today?' Why this is an important question for the Italian film industry?
When we started working on *Di me cosa ne sai* back in 2005, we were asking ourselves what freedom, what degree of independence does Italian cinema have now compared to the past?

Italian cinema allowed a great degree of diversity, producing films that dared to be original and controversial, films that became part of world cinema while *representing* Italy to the Italians. Film-makers' work ranged from experimental to a variety of genre films, while the auteurs enjoyed great freedom. I am using the past tense because, unfortunately, the answer to Bertolucci's question is that no one today would have the courage to finance a film like *Salò*. What in the mid-1970s was dubbed 'free TV' – that is commercial TV based on a somewhat grotesque version of American television – killed one of the most vital film industries in the world, substituting it with a media system that is less competitive and unable to produce the same quality. I believe our political system and our democracy are gravely affected by the cultural conformism of our TV system, by its lack of freedom, by the simplification in storytelling that it has bestowed on our country.

What industrial factors enabled the three decades of Italian cinema's post-war 'golden age', and how has the situation changed?
I think film historians and cinephiles have always focused their attention mainly on the great Italian *auteurs*, in a sort of idealistic approach: after all, Italy always had great artists! *Di me cosa ne sai* proposes a change of perspective: Rossellini, De Sica, Fellini, Visconti, Pasolini, Bertolucci, Bellocchio and all the other celebrated auteurs were able to accomplish so much thanks also to a great number of producers who were able to work independently in a very dynamic yet well-balanced national market.

It was the Fascist regime that began a strategy of protectionism that allowed the Italian film industry to grow stronger. After the war, the MP Giulio Andreotti and the Christian Democrat governments substantially followed the same politics, counterbalancing the large number of films from Hollywood with a series of laws helping Italian producers and distributors – fixed quotas for domestic films was one of those. After a few years, Italian films grossed 50 per cent, at times up to 60 per cent of the total box office, growing beyond the quotas.

I believe independent producers and distributors had a major role in this successful growth. Theatre owners often teamed together to finance films, and so did the distributors who were doing the same thing on a bigger scale, competing to get the best actors and directors. The key mechanism then was the *minimum guarantee*, that is money advanced to producers by theatre owners and distributors. This mechanism was essential for two reasons: it lessened risks for independent producers and it created a sort of 'open' or 'free-flow' vertical integration: distributors and theatre owners who had advanced their money to produce a film would then be trying their best when launching it, keeping it as long as they could in their theatres. The golden age of Italian cinema didn't rely solely on the talent of its auteurs: it had deep roots in a very good domestic market, that is a system that allowed plurality and diversity. Artistic freedom was also the result of the great number of films produced in those years in Italy (up to 300 per year).

Today in Italy we have two 'majors', Rai and Medusa (owned by Berlusconi's Mediaset group), which are vertically integrated in a rigid way: they produce and distribute films (Medusa also owns a circuit of movie theatres) besides of course acquiring TV rights as a part of their financing mechanism.

Hollywood films account for some 70–80 per cent of Italian box office receipts: block-booking, which I believe is illegal in the US, is instead widely practised in Italy by Hollywood and the Italian majors.

Traditional theatre-owners account now for less than 50 per cent of total box office revenues, the rest being multiplexes, where national or European quality films are usually an unfamiliar, out-of-place presence.

Historically, what relationship is there between popular cinema and art cinema in Italy?
It is a very complex question. I can say here that from the industry point of view there was a very close link. Great producers who were aiming at block-busters, like Dino De Laurentiis, Carlo Ponti, Alberto Grimaldi, were very often able to produce major *auteur* films thanks to the fact that at the same time they kept producing widely commercial, genre movies. Grimaldi, for example, had huge success with Italian westerns and with Sergio Leone's movies, and went on financing films by Bertolucci, Pasolini, Rosi, Fellini.

Intellectuals from journalism and literature have been waging a war against bad commercial television: unfortunately this war has been grounded, more or less consciously, on the superiority of literature, on the pre-eminence of the written word over the language of images. Several progressive newspapers, for example, have taken this defence of traditional culture as a way of defending the centrality of a free press and ultimately their own right to existence. That is why a part of the cultural elite has taken a very active role in the 'down-grading' of the cultural status of Italian cinema.

Last but not least, since the 1980s only a handful of Italian *auteurs* appeared to be willing or able to overcome public detachment and appeal to wider audiences. I believe these circumstances are changing rapidly: a new wave in Italian cinema has already shown its strength, including film-makers such as Garrone and Sorrentino.

In Di me cosa ne sai, *film director Mario Monicelli blames 'the policital classes' for the current state of Italian cinema. What role have politicians played in the Italian industry, from Andreotti to Berlusconi?*
Di me cosa ne sai focuses on a key moment: 1975 is the year Pasolini was killed, commercial TV became legal, the Communist Party reached its electoral peak, while Italian cinema reached the peak of its international stature, being second only to Hollywood.

Then, in a handful of years, Italian governments managed to dismantle an industry that had steadily grown for over 50 years. The 1970s brought an end to the Fascists' and Andreotti's style of support to Italian Cinema, inaugurating *laissez-faire* in the media business that was obviously inspired by US interests. The Hollywood majors and the American TV networks had pressed for years to put an end to the State RAI TV monopoly so they could sell more of their films and telefilms in an open market situation.

At the same time, the US governments saw with growing anxiety the biggest Communist Party in the West getting closer and closer to the majority party, the Christian Democrats. Those were also the years in which Italian films dared to attack more aggressively the political and economic establishment, while many major film-makers were overtly for the Left or the Communist Party. Then terrorism came along, and everything changed.

I believe the massive intervention in the Italian media system and the tremendous impact it has up to these days, were born out of US worries over the future of Italy. In that context, with terrorists killing journalists, judges and politicians, the fate of the Italian film industry must have seemed a trivial problem to Italian lawmakers.

The fact that to this day, 35 years later, no government has been capable of drafting

an organic regulation for the media system spells out how much political power and television have become intertwined in Italy. Berlusconi's unsolved conflict of interests, in this context, is a mere corollary.

What remains today of the experience of the large producers? What financial opportunities are there for film-making?
At this time in Italy there is only one producer who works like the great producers of the past: Aurelio de Laurentiis, Dino's nephew. He finances, produces and distributes his films independently – mostly Italian comedies that fare well in the domestic market.

There are many other excellent producers of course, but they are not *independent*: essentially, they all need either Rai or Medusa to sign a contract before they can begin working on a film.

Thanks to a positive collaboration with the previous government, the Centoautori movement together with ANICA (the industry association) obtained for the first time in Italy *tax credit* and *tax shelter* for theatrical film production and distribution; these incentives are starting to work quite well. In the meantime, though, the Berlusconi government has reduced production funds from the State almost to zero, without producing a serious reform proposal yet.

The Centoautori, now the most important association in Italy for writers and directors of TV and Cinema, is asking for a new *system law* for cinema and television. We think our government should impose precise and effective limits to trusts, while creating incentives for independent producers and distributors. The market of culture is a special, strategic field, it should be open, diverse, pluralistic: the state's intervention is foremost in the interests of the spectators, that is of its citizens. As Ken Loach has said in an interview, we wouldn't accept European museums and galleries showing only American art, why should we accept this for cinema?

What has been the impact of TV on Italian cinema?
State and private television in Italy have the majority of their audience among kids and people over 50. When Rai or Mediaset put money into a project, they have to consider this. Films that are too difficult or too explicit are not easily financed. When you sign a contract with TV you have to assure them in advance that the film is going to be rated 'for a general audience'. There is a strong contradiction here. The primary cinema audience, the one, say, from 15 to 45 years of age, won't watch this kind of TV, and probably would like to find something more daring in movie theatres, both in terms of language and in terms of subject matter.

The new wave of Italian directors has to fight with this state of things: it is not easy to gather the courage to do something very outspoken, very aggressive politically, or even risky for the language or the style you choose. In one word, the system is not dynamic, there are few subjects, few individuals who can decide if a film gets made or not. If you fail commercially, you'll never know when and if you'll be able to work again.

We go back to the question that prompted me to work on *Di me cosa ne sai*: in the golden age of Italian cinema, the Catholic Church and the Christian Democrats exerted some censorship, but its results were really quite minor compared to the cultural conformism we live in today. It is in fact what Pasolini was telling us: fascism, that is, a right wing, obscure, violent attitude to power, isn't really dead in Italy. In this regard Berlusconi's government is a direct child of unsolved cultural and political conflicts from the 1970s.

How come the diffusion of multiplexes has not contributed to widening choice for Italian spectators?
Most multiplexes are built in imitation of their American models. They are actually modelled on the American style of living. They land in the outskirts of big or small cities, very

often killing – commercially speaking – the city centre. Young people go there to feel like they are somewhere else: they drink coca-cola, eat popcorn and normally go to the cinema after an intense shopping session. They are ready for an American movie. Every other film is out of context there. Most quality European or Italian films – with the exception of popular comedies – don't do well in multiplexes. The same quality film would get an audience three or four times larger in a traditional movie theatre.

The media are not neutral. Multiplexes are giant commercial ads to a certain model of consumption. They are born to show Hollywood films, to quote Fernando Solanas' words. That, they do very well.

There is talk of a rebirth of Italian cinema recently with films like Il divo *(Paolo Sorrentino, 2008),* Io sono l'amore/I am Love *(Luca Guadagnino, 2009),* Gomorra/Gomorrah *(Matteo Garrone, 2008),* Vincere *(Marco Bellocchio, 2009), etc. Do you think this is down to a change in the structures around film-making or will the future remain difficult?*
Most of the films you quote came after a small reform in State funding for cinema. There was enough money, selective committees worked according to a *reference system* that assigned quite objectively a percentage of points to each project. Rai Cinema also started working much better after a case of corruption forced out one of the executives. The present government cut State funds but hasn't done much so far. It promises to renew tax credit and tax shelter for the future, but that alone won't be enough. Berlusconi being the Prime Minister, I don't feel this government will be the one that after 35 years will be able to create rules for this crucial market. On the other hand, I am sure that many interesting film-makers are ready to work and will be able to make stronger films as a reaction to the culturally depressed situation, as happened in the UK during the Thatcher years.

A note from Jalongo on the Centoautori: *The Centoautori was born in 2007 as a cultural movement bringing together directors and screenwriters from different generations. The first meetings took place to request the truth over an alleged case of corruption that had involved an executive in Rai Cinema. Since then we have developed a programme to reform the media system in Italy. Our basic tenet is that in an advanced democracy the spectators/citizens have a right to quality storytelling, allowing diversity, freedom, pluralism. I collaborated in writing the programme and acted as a coordinator in the first two years of its existence. Since 2009 Centoautori has become the most important association in Italy for writers and directors of TV and Cinema.*

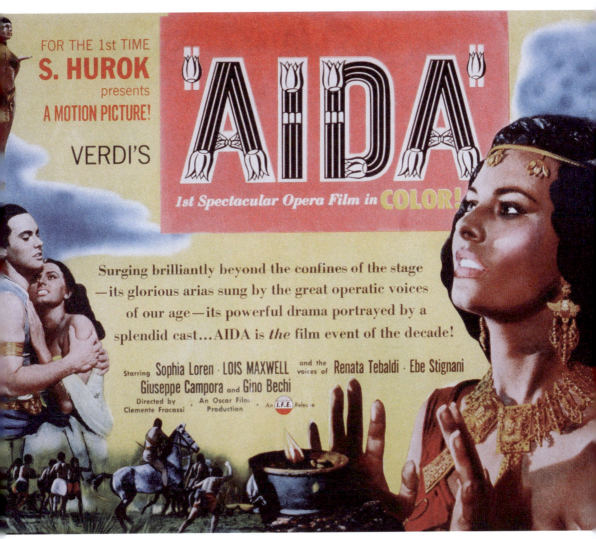

Aida. Scar Film/The Kobal Collection.

CULTURAL CROSSOVER
OPERA AND FILM

To understand the role Italy played in the creation of the feature film it is helpful to consider the preceding centuries of opera in Italy. The setting of dramatic events to music, a grand thematic and emotional sweep, and the placing of a powerful and suffering diva at the centre of the medium's expressive means take their place on a continuum in the traditions of public spectacle from seventeenth-century Venice to the cinema of the early twentieth century.

Such affinities did not go unnoticed by early practitioners of cinema: the diva system of female stardom was itself a model transposed from that of the *prima donna* of the operatic stage, and was responsible for the emotive and gestural style that was to mark acting in silent cinema. 22 Italian films were made of operas in the silent era – indicating the appeal of the melodramatic and romantic storylines that remained when the operatic voice could not be present. Irene Lottini notes in this volume an instance of new music being written for the screening of a film, with the music for *Rapsodia satanica/Satan's Rhapsody* (Nino Oxilia, 1917) composed by Pietro Mascagni, who, from such *verist* productions as *Cavalleria rusticana,* could be assumed to be up to the task – keenly pursued in the early days of the cinema – of conferring artistic legitimacy on the young form in a way that would be especially in tune with a mass popular audience.

The connection of cinema and opera became closer with the coming of sound, and opera was part of a successful strategy to revitalize the flagging film industry by mining Italy's cultural heritage. The tenor Beniamino Gigli made the most frequent appearances in feature films, starring in a series of vehicles in which dramatic narratives about fickle females, male seducers and Gigli's poor luck in love showcase as many performances as possible of classics from the operatic canon (amid newer popular songs by composers such as Nino Bixio). The standard Gigli narrative works to make the arenas of domestic life and musical performance increasingly and unavoidably intertwined, thus posing questions about the separation but interdependence of art and reality which are philosophical, although expressed within the films in only emotional and dramatic terms. Films such as *Non ti scordar di me/Forget Me Not* (Zoltan Korda, 1936) – filmed also in English – and *Mamma/Mother* (Guido Brignone, 1941) present a vulnerable and emotional masculinity in fairly low-budget films, comparable, although with less comedy, to the contemporaneous Austrian operetta film.

While vaunted by the Fascist industry – and Gigli's allegiances were the topic of some controversy after the Liberation – *cineopera* (opera on film) enabled the re-establishment of the post-war Italian film industry as much as the now better-known films of neorealism. Baritone Tito Gobbi became the face of post-war *cineopera* and his films *Davanti a lui tremava tutta Roma/Before Him All Rome Trembled* (Carmine Gallone, 1946) – also starring Anna Magnani and about a production of *Tosca* in a Rome under German occupation – and *'O sole mio* (Giacomo Gentilomo, 1946) – whose spy narrative includes documentary footage of the liberation of Naples – have Resistance themes and even some neorealist traits. However, *cineopera* was also able to offer fantasies of spectacular theatricality in historical or mythological eras, with *Aïda* (Clemente Fracassi, 1953) giving the first major starring role to one Sophia Loren (her voice dubbed by Renata Tebaldi, *cineopera* being more a vehicle for the faces of male than female vocalists, despite the historical importance of the diva). Biographies of composers *Giuseppe Verdi* (Raffaello Matarazzo) and *Puccini* (Carmine Gallone) helped make 1953 an annus mirabilis for *cineopera* on Italian screens, and although there were more films, most famously Franco Zeffirelli's productions of *La Bohème* (1965) and *La traviata* (1982), *cineopera* never regained the position of cultural dominance and amount of film production that it held in the two decades up to the mid-1950s.

This is not, however, the end of opera's reach into Italian cinema. Italian films make continual reference to people visiting the opera, listening to opera, talking about opera, in ways that are significant for theme and character. Anna's determination in *Anna*

(Alberto Lattuada, 1951) is shown the moment she interrupts the chief surgeon who is in the midst of watching a performance; in *La vita è bella/Life Is Beautiful* (Roberto Benigni, 1997), Guido's romance begins through a visit to Jacques Offenbach's *Les contes d'Hoffmann* (repeating the mythology, common also to *cineopera*, of the direct equivalence of operatic and romantic emotion). Federico Fellini imagined the twilight of a whole class and era, as well as the allure of nostalgia and fantasy, through their attachment to opera in *E la nave va/And the Ship Sails On* (1983). Most famous here is the extraordinary opening scene of *Senso* (Luchino Visconti, 1954) in which the repeated call 'to arms!' from a performance of 'Di quella pira' from Giuseppe Verdi's *Il trovatore* leads to an Italian nationalist revolt against the occupying Austrian army; the failure of the main protagonists' subsequent love affair to live up to their own operatic gestures serves to create the film's bitter critique.

These examples, like *cineopera*, inspire consideration of the relationship between art, life, and emotion. It is the very need for art to express, to heighten, and to console for the disappointments of life which also describes a function of another of Italy's long-standing traditions, that of melodrama. It is not simply a coincidence of etymology that opera in Italy was referred to as *melodramma*, indicating the connection of music and drama (melos=music). As the chapter on melodrama in this volume shows, the stark and heightened emotionality, dramatic confrontations, and deliberately theatrical stylization of both opera and melodrama indicate a deep affinity between the two – as well as a sense that operatic and melodramatic expression are necessary to articulate the emotionality of life as, simultaneously, life falls short of the realms of heightened expressivity of those artistic forms.

It was with mention of an affinity, in that instance a historical affinity, between opera and cinema that I began. This affinity seems a chief imputed characteristic in Italian cinema, which is repeatedly referred to as 'operatic'. Genres such as the Spaghetti Western or the Giallo are notable for the prominent musical scores whose timing seems to govern the action of the dramatic situations – often ones of delirious violence overtaking all rational restraint. Yet what of the frequent reference to 'operatic' when no music is even present? What quality is being suggested? In his review of *Io sono l'amore/I Am Love* (Luca Guadagnino, 2009), Jonathan Romney speaks of the opulence and sensuality given to an 'amplified emotional sweep' and formal stylization; Richard Dyer mentions how the archetypal silent spectacular *Cabiria* (Giovanni Pastrone, 1914) was influenced by the grandeur of opera staging, thus placing the influence of opera at the basis of the ambitions and scope of the feature film.

In returning to the opening suggestion of an affinity between opera and cinema, then, is it not that what is considered 'operatic' when performed in an Italian accent is simply that which elsewhere we would term 'cinematic'? Is not an interest in the expressive capabilities of the form, with the aim of increasing dramatic tension, a central property of classical cinema? Certainly, opera is invoked throughout this volume and elsewhere in a manner which can become this encompassing. But let us remember that it is specifically referred to as an expressivity that privileges emotion over logic and theatricality over mimesis. Such definition, whilst remaining broad, aims at capturing opera's overarching influence on dramatic construction. Its specific national inflection is in the self-conscious relish with which Italian films often treat the overwhelming nature of the artistic experience. Applied to Italian film, 'operatic' is thus a central way of describing the application of cinema's affective properties to the heightening of drama.

Louis Bayman

Intervista, Aljosha/RAI TV/Cinecitta.

DIRECTORS
FEDERICO FELLINI

In the Italy of the early 1950s, the neorealist movement was beginning to look a touch moribund, and a fresh and iconoclastic personal cinema began to flourish. The filmmakers who were the standard bearers for this new trend (principally Federico Fellini and Michelangelo Antonioni) manifested an interest in a very individual mode of eroticism, though Antonioni's intellectualized view of sexuality was characterized by protagonists whose encounters are joyless and vitiated.

Not so the many pulchritudinous, hyper-sensuous sirens who inhabit the universe of Federico Fellini. There was a time when Fellini was regarded as the most significant of all Italian directors, and his iconic middle-period works (particularly *La Dolce Vita*, 1960, and *Otto e mezzo/8½*, 1963) were key texts in any examination of serious cinema. But Fellini committed the cardinal sin of over-production, seemingly turning out film after film that replayed earlier tropes, and his later films had people doubting the value of his initial achievements. Had those earlier works really justified all the acclaim? In dispiriting fashion, the director's work began to appear (even to admirers) like a parody of itself; retrospective views of his earlier movies acquired a jaundiced tone. But in the twenty-first century, after the director's death, those masterpieces of the 1960s can now be freshly appreciated as among the most exuberant and imaginative examples of the art of film.

Fellini had close professional and personal relationships with several neorealist filmmakers, but he steered clear of the diktats of the form in his own work, although he finessed the screenplays of several key films in the field (notably and *Roma città aperta/Rome, Open City*, 1945, and *Paisà/Paisan* 1946, both directed by Roberto Rossellini). In his early years, Fellini was concerned with the quotidian lives of ordinary people, with a notable concentration on the wilfulness and immaturity of his male characters, with their own maladroit actions responsible for the predicaments in their lives (rather than social injustice, as in most neorealist films)

His own vision of often dream-like cinema was ultimately to become radically at odds with the disciplines of neorealism, quite unlike his contemporaries (if Visconti was grand opera, Fellini was opera buffa). By the time of such international hits as *La Strada* (1954) and *Le Notte di Cabiria* (1957), Fellini's increasingly phantasmagoric (and sometimes mystical) vision was being married to a celebration of theatrical spectacle and circus-style showmanship – the latter element to prove dismayingly seductive to the director.

Fellini was born in 1920 in Rimini, Italy. His childhood in the provinces (which he was later to draw upon to evocative effect in his films) was unexceptional, and he found a useful outlet for his creative instincts in drawing cartoons – in fact, these wonderfully cruel caricatures were drawn by the director throughout his career and proved useful when he was designing his films; always one of the most visually extravagant of directors, this particular skill was often utilized (as it was by another great director who was a similarly gifted illustrator: Alfred Hitchcock). Fellini's apprenticeship as a cartoonist developed in the 1960s when, undergoing Jungian psychoanalysis, Fellini began chronicling the images from his own dreams, many of these images finding their way into his films.

Feeling stifled during his teenage years, Fellini moved at the age of 19 to the Italian capital, still utilizing his cartooning skills by working for such humorous magazines as *Marc'Aurellio* (the issues containing his work are now considered collectors' items). World War II was to bring ignominy to his country but Fellini was able to continue working, now as a scriptwriter for radio on a programme called *Cico e Pallina*. (He had been developing his ability to write jokes along with his cartooning skill.) His radio work was to become significant in more ways than one when he fell in love with the young actress for whom he was writing, and that actress, Giulietta Masina, was to be important to him in both his personal and professional life. The couple married in 1943, and remained married for half a century, Masina giving some of the most distinctive performances in the director's films. A year after his marriage to Masina, Fellini became acquainted with the director Roberto Rossellini and was hired as one of the cadre of writers working on

one of the key films of the burgeoning neorealist movement, *Roma città aperta* in 1945. Fellini received an Oscar nomination for his contribution to the writing of this important film. It was to be the harbinger of a highly-successful career as a screenwriter, and Fellini was to work with such talents as Alberto Lattuada, Pietro Germi and Luigi Comencini (his most personal work as a writer was principally for his mentor Rossellini). But Fellini was aware that he was now only using one aspect of his talents, and a new career as a director (now calling on his underused visual skills) was, perhaps, an inevitability.

Lo sceicco bianco/The White Sheik (1952) was an early calling card showcasing the director's sardonic and cutting views of contemporary Italian society. While always humorous, the narrative was infused with a cold-eyed cynicism for the characters' cheap and novelettish views of life, identified by Fellini as bad faith. *I vitelloni/The Calves* (1953) largely eschewed plot and looked forward to Fellini's later, impressionistic work. A merciless (but savagely comic) examination of the dullness of provincial existence, the film extrapolates memories of the director's youth, focusing on a group of aimless young men (the 'calves', as they are cuttingly known in Fellini's home town of Rimini).

With *La strada* (1954) the director was obliged to use an imported American star, Anthony Quinn. However, the film is most notable for its casting of the director's wife, the unconventional Giulietta Masina, as the woeful companion of Quinn's unlikeable strongman. Pre-echoes of later work appeared in the larger-than-life, theatrical aspect of the film, with its circus protagonists.

But cinematic history beckoned. The *locus classicus* for any study of Federico Fellini is, of course, *La dolce vita* (1959), in which the under-motivated journo Marcello moves in a somnambulant state through a surrealistically-rendered Rome. Fellini's epic essay on Italian morality is a vast, uneven work, which created a seismic division in critical opinion that persists to this day, although the striking of a new print in 2004 resulted in a slew of unalloyedly enthusiastic reviews. Ironically, the then denounced 'blasphemous' sections would not raise an eyebrow today, and the rather decorous orgies were hardly pornographic even in the 1960s. *La dolce vita* also brings attention to both the spiritual aridity of the period and the emptiness of religion (the shot of a statue of Christ transported above the city by helicopter is a key image of Italian cinema). However, a twenty-first century viewing reveals that the film's most signal achievement is Fellini's wry dissection of pointless celebrity culture, looking even more on the nail now than it did in the 1960s.

With the heavily-autobiographical *Otto e mezzo*, Fellini encountered a critical reception even more keenly divided than that received by its predecessor. The seeds of Fellini's later, less controlled indulgence are beginning to be in evidence in this thinly-veiled autobiographical narrative of a director struggling to conjure up the concept of his next film, prompted by the incessant nagging of those around him. Claudia Cardinale plays a representation of the ideal woman for whom Guido yearns, and is the one figure in the film who appears not to want anything from him. The seamless blend of fantasy, dream and memory into the narrative are key to the success of the film, and the bravura of the circus-themed resolution is particularly to be noted.

A recurrent theme of this era of Italian cinema is the deeply ambiguous attitude to religion in this most Catholic of societies. The figure of the cardinal here offers conventional platitudes, which can give Guido no guidance. To the accompaniment of Nino Rota's distinctive and inimitable score, the film ends with a classically Fellini-esque circus (a motif that was to become overused in his work, but is fresh and pertinent here). While later films such as *Giulietta degli spiriti/Juliet of the Spirits* (1965) may have used colour in a more delirious fashion, this remains Fellini's most phantasmagorical film.

Looked at today, the stylized approach of the film appears to dovetail perfectly with its notions of artistic stasis. Guido Anselmi may be an idealized portrait of the director, but he sports a pitiless self-knowledge of his own artistic dead end.

There was no dead end beckoning – yet – for Fellini himself, as the surrealistic, anti-clerical *Giulietta degli spiriti* forcefully proved, completing a trilogy of brilliantly-realized masterpieces by the director, and representing the undisputed apogee of his career.

Subsequent work, such as *Fellini Satyricon* (1969) and *Roma* (1971) boasted the outrageous production design and imagery that were by now the director's hallmark. These later films also developed the director's customary forensic analysis of the male ego and sexual impulse, along with a more startling grotesquery, anchored in the self-reflexiveness that had always been a crucial element of the director's work. *Satyricon* was one of the few 'art' films to get a major circuit release in 1969, no doubt due in part to its erotic content but also as testament to Fellini's ability to bring an arthouse style and themes to a popular audience. The experience of watching such a surrealistic and visceral film would have been strange indeed for those regular habitués of the Odeon circuit, tempted in by the promise of naked male and female flesh (generously supplied here). The Rome presented in the film is like no Rome that ever existed. In fact, the final effect is of a slightly lascivious science-fiction film with a heaving and energetic tale of concupiscence among some strange alien race which also, however, could be seen as an allegory for the hippie craze of the era. As so often with later Fellini, structure is pretty well jettisoned in favour of a series of strikingly-staged set pieces. But it was becoming clear that the director was losing the keen intellectual focus that distinguished his earlier work. Fellini continued to produce more late-period offerings such as the almost plotless *Roma* and the anarchic *Prova d'orchestra/Orchestral Rehearsal* (1978), but it is undoubtedly true that his 1960s movies remain his greatest legacy.

Barry Forshaw

Nanni Moretti, Faso Film.

DIRECTORS
NANNI MORETTI

What is my ambition? I hope to make the same film over and over gain, but perhaps better. (Giovannini, Magrelli and Sesti 1986:39 [author's translation]).

Nanni Moretti has been part of the Italian film industry since the early 1970s and is certainly one of the most important Italian film-makers of the past 30 years. As a true auteur, he has worked in the capacity of director, actor, writer, producer, distributor and exhibiter. Although not prolific in his film-making, Moretti is important because of his filmic style as creative artist, and his influence on the Italian film industry as mentor and entrepreneur. His films courageously and uniquely raise the consciousness of his compatriots to what is actually happening in contemporary Italian politics and society.

Moretti's early interest in film was encouraged by his father and, as a teenager, he became a member of a film club, where his filmic influences included neorealism, the *nouvelle vague* and the comedy output of Jacques Tati, Jerry Lewis, Buster Keaton and Totò. He combined his interest in cinema with his love of water polo and a burgeoning interest in left-wing politics, which were his other major activities at this time.

Moretti's entry into the world of cinema was by a very direct route, without any specific academic qualifications for film-making. After an unsuccessful bid for the position of assistant director with the Taviani brothers, he started his film-making with a group of friends in 1973, creating three short works: *La sconfitta/The Defeat* (1973), *Pâté de bourgeois* [an untranslatable pun, playing on the phrase 'epater le bourgeois', to shock the bourgeoisie, and 'pate de foie gras', goose liver pate] (1973) and *Come parli, frate?/What's That, Brother?* (1974). Within these very early films, three major trends of his oeuvre were quickly established: politically committed film-making, episodic narrative structure and satirical comedy. Furthermore, by making films about his own experiences, set in his own milieu of middle-class Rome, his work showed an inclination towards an autobiographical style with a focus on the intermingling of public and private life. His first feature-length film, *Io sono un autarchico/I am Self-Sufficient*, was made in 1976.

Moretti has always had a political and moral purpose in his film-making, while employing the concept of entertainment to put his message across to the audience. As a form of *cinéma engagé*, Moretti manages to involve his audience by using a sometimes amusing, sometimes poignant plot, and thus conveying a straightforward message: that he wants people to speak right, think right and act right. The connection between thoughts, spoken words, written words and actions interests Moretti greatly: the act of speaking and its relationship with reality; its possibilities of distorting and concealing things; the fact that language belongs to everyone. Words are important and words can make a difference to people's lives. In *Palombella rossa/Red Lob* (1989) the character Michele insists that people should fight against journalese and clichéd expressions. This film considers the rapid and, some would say, catastrophic changes that were happening in Italy in the late 1980s. Subsequent films, such as *Aprile/April* (1998) and *Il caimano/The Caiman* (2006), have also addressed contemporary political issues in Italy, notably the consequences of several years with Silvio Berlusconi at the helm. Moretti takes a moralistic view of the world, openly criticizing what he feels is wrong with contemporary society in Italy. In this context, Moretti recognizes that he often shares the point of view of his protagonist, who is usually played by Moretti himself.

In all Moretti's films the enmeshed connections between Moretti the author/writer/director (creator of the filmic text), Moretti the narrator (enunciator of the filmic text) and Moretti the actor (character within the filmic text) are complex. This intricate relationship is seen from *Io sono un autarchico* onwards, and of course for certain films, such as *Caro diario/Dear Diary* (1994) and *Aprile*, some aspects of his personal life do become part of the filmic text.

Moretti has frequently admitted that he shares some of the personality attributes that he gives to his characters (interest in politics, cinema, sport) and that he exorcizes his

fears, inhibitions and obsessions in his work, using irony as his most important weapon. However, he points out that there are also many traits which are not held in common between himself and his protagonists (propensity to murder, religious vocation and political public office). Some film critics suggest that the characters that Moretti plays are different stages in an individual's development (Mazierska and Rascaroli 2004: 17), making Moretti a symbol for his age, characterizing the post 1968 generation, whether playing a 1970s student in *Ecce Bombo/Here is Bombo* (1978) a 1980s teacher in *Bianca* (1983) or a 1990s writer in *Caro diario/Dear Diary* (Marcus 2002: 286).

Although at first described as a comic director, as Moretti's career developed it became clear that his films were of a very different type from the other Italian comic film-makers, such as Maurizio Nichetti and Roberto Benigni. Moretti absolutely refused to be identified with the earlier notion of *commedia all'italiana*, and indeed has nothing but criticism for two icons of this genre, Nino Manfredi and Alberto Sordi. The principal difference between Moretti's comedy and the *commedia all'italiana* is that he aims his ironic humour principally at himself and his own social milieu, rather than at others (Giovannini, Magrelli and Sesti 1986:15).

In *Sogni d'oro/Sweet Dreams* (1981) the whole system of Italian cinema is scrutinized, while in *Caro diario* Moretti comments on the dire state of the Italian film industry, especially the paucity of films shown in the summer months in Rome. He criticizes the language of the film journalists, while paying homage to the Italian melodramas of the 1950s (*Anna*, Alberto Lattuada, 1951) and gently lampooning Hollywood films of more recent years (*Flashdance*, Adrian Lyne, 1983). He also movingly pays his respects at the monument to the film-maker Pier Paolo Pasolini. Both *Aprile* and *Il caimano* deal with the problems of being a film-maker: remaining true to your ideals; finding the crucial funding; rising above the difficulties of your personal life; keeping focused on the project in hand.

Family life, and in particular parenthood, is an important feature of many of Moretti's films. The early films deal with the problem of being part of a dysfunctional family and generally depict a rejection of family life. In *Bianca* and *La messa è finita/The Mass is Over* (1984), the perfect family is sought. Moretti presents his real life family in *Aprile*, and in *La stanza del figlio/The Son's Room* (2001) he shows a seemingly ideal family, which is very nearly destroyed following the death of one of the children. However, *Il caimano*, displays the consequences of separation once family life has turned sour.

Stylistically, Moretti's work has developed from a predominantly static camera style, which he termed *montaggio interno* (internal montage), where characters move in and out of the frame, assembling different aspects of the *mise-en-scène*. With *Caro diario* the camera becomes increasingly mobile, giving a sensation of joy which continues in *Aprile*.

Moretti's narrative structure is often fragmented and episodic, forcing the spectator to be actively engaged. In Moretti's work we are frequently thrust *in medias res*, with no obvious equilibrium, to be disrupted and then restored. However, *Bianca*, which is in the guise of a thriller, and *La stanza del figlio*, belong to a more traditional form of film narrative.

Italian history, apart from contemporary issues, is notably absent from his work, and Moretti, unlike other contemporary Italian film-makers, does not concern himself with issues such as poverty, bad housing, child abuse, unemployment and the North/South divide. Despite making films which have as their backdrop education (*Bianca*) and Catholicism (*La messa è finita*), Moretti does not have a great deal to say about formal teaching or about religion. The patrimony of Italy in art, literature and architecture is rarely put on display, except for aspects of the cinema. Any nostalgia that Moretti displays is personal rather than general. The audience does not see a great deal of the Italian countryside and the panorama is treated in a less loving way than are the façades of buildings in Rome. Italian cuisine, apart from cakes and coffee, is scarcely

visible. Apart from the composed soundtrack, the only types of music regularly heard are popular songs and world music, rather than opera. Italian fashion, style and the physical attractiveness of the people are largely overlooked.

As well as fulfilling the authorial criteria for having creative and productive control of his films, Moretti also has a clear visual style and recurrent themes which include family relationships, order and disorder, sickness and health, life and death, his native city of Rome, the cinema, the contemporary state of Italy and the activities of Silvio Berlusconi. Several motifs run throughout his work: love of chocolate and cakes, hectoring volleys of questions, often on the telephone, outbursts of anger and even violence, personal neurosis and narcissism, love of shoes and of the sea. He also possesses a personal philosophy of individual responsibility, which flows beyond the world of his films and into real life, where, in recent years, he has become a political activist.

Eleanor Andrews

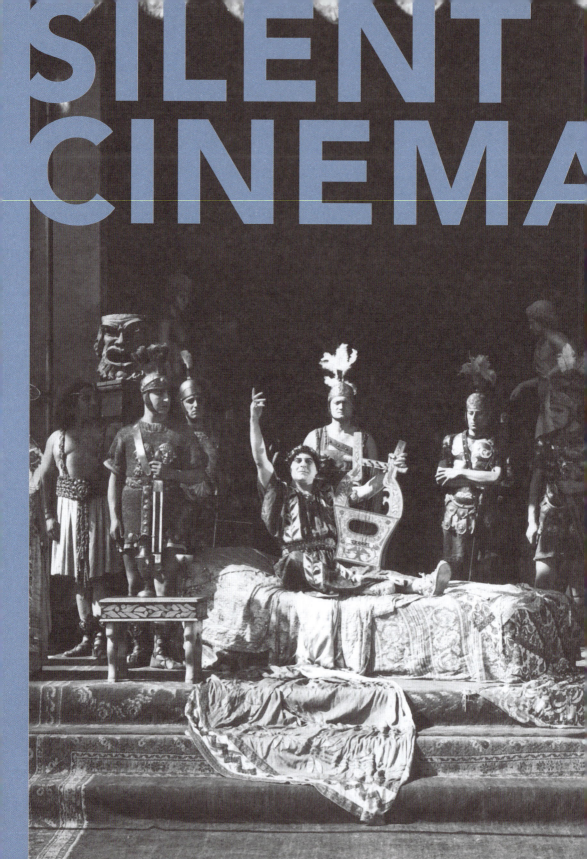
SILENT CINEMA

1905 is generally considered a foundational date in the history of Italian cinema. In that year Filoteo Alberini established the film company Alberini & Santoni and produced the work that is recognized as the first Italian fiction film: La presa di Roma. XX Settembre 1870/The Capture of Rome, a film celebrating the breach of Porta Pia in 1870 and the consequent annexation of Rome to Italy. A year later, Alberini & Santoni became Cines, a major production company that determined the development of the national film industry on a more stable economic basis. Meanwhile, new film companies were founded in Naples, Milan and, above all, Turin, a particularly important center for early twentieth-century Italian cinema.

The films produced by these companies between 1905 and 1909 encompassed different genres. There were 'live' actualities featuring news, athletic events, and folkloric curiosities. There were fantasy films, mainly inspired by George Méliès, and slapstick comedies. And there were emotional dramas with stories of passion and crime and social, religious and nationalistic themes.

By the end of the first decade of the century, then, the aspiration to achieve cultural legitimacy drove film companies to abandon the production of fantasies and féeries (works involving magical elements in a spectacular use of trick techniques), and to invest in the production of historical and literary dramas. An adaptation process began that brought well-known events from national history and the most popular works of classic and contemporary literature to the screen.

This predilection for the transposition of classic literary texts occurred alongside an important innovation in Italian cinema: the first production of full-length feature films. In 1909, when films had reached about 450 metres in length (about 25 minutes), Milano Film company began the project of a new cinematic version of Dante's Inferno (Francesco Bertolini, Adolfo Padovan, and Giuseppe de Liguoro), a film that was longer than 1000 metres (about 55 minutes). This film, released in 1911, was immediately followed by two other ambitious productions by Cines: Enrico Guazzoni's Gerusalemme liberata/Jerusalem Delivered (1911) and Giulio Antamoro's Pinocchio (1911). For its first full-length feature films, the Italian film industry adapted three central texts of national literature which could easily attract a wide audience encompassing both less educated spectators and intellectuals and guaranteeing success for the companies' financial efforts.

Among the films produced during the 1910s, historical dramas constituted the most successful and profitable works. Telling stories set in ancient Greece or Rome, these films were characterized by a precise reconstruction of sets and costumes, a predilection for crowd scenes and an attention to the integration of characters and environment. While the European figurative tradition offered models for set design, the relatively inexpensive cost of labour, the presence of monuments and favorable natural light allowed the reconstruction of spectacular scenes and location shooting. Giovanni Pastrone's La caduta di Troia/The Fall of Troy produced by Itala in 1910 already showed significant attention to scenographic possibilities. Three years later, Enrico Guazzoni's Quo vadis? (Cines), based on the novel

Left: Quo Vadis, Cines Co, Roma.

by Henryck Sienkiewicz, and Eleuterio Rodolfi's *Gli ultimi giorni di Pompei/The Last Days of Pompeii* (Ambrosio), inspired by Bulwer-Lytton's text, offered important examples of the aesthetic exploration of the filmic space. But it is especially Giovanni Pastrone's *Cabiria* (Itala, 1914) that is generally recognized as the masterpiece of the genre. An ambitious project, *Cabiria* required a big financial investment that increased with the amount of money paid to the poet and public figure Gabriele D'Annunzio for the use of his name and for writing the intertitles. The involvement in the production of this most influential cultural personality was a result of the aspiration to artistic consecration dominant in the Italian film industry of the early twentieth century. For similar reasons Ildebrando Pizzetti was commissioned to compose a symphony to be played at the premieres in the main Italian cities. The magniloquence of the intertitles and the music responds to the complexity of a plot that encompasses different spaces and a long temporal arc, and to the grandiosity of the set design.

During World War I colossal films continued to be produced – Antamoro's *Christus* (1916), Guazzoni's *Fabiola* (1917) and *Gerusalemme liberata/Jerusalem Delivered* (1918) – but they could not equal *Cabiria*.

The flowery and symbolist elements characterizing D'Annunzian intertitles to *Cabiria* also featured in contemporary dramas starring the Italian *diva*. So-called *divismo* was a significant phenomenon in 1910s Italian cinema: a national star system arose around a few actresses who were major attractions for the growing cinematic public. Reincarnations of the theatre *prima donna*, Italian divas transposed the image of the late nineteenth-century *femmes fatales* into new cinematic dramas. And if, on one hand, their stories of devastating passions represented an escape from reality for middle class spectators, their attitude and style also significantly influenced these spectators.

Lyda Borelli and Francesca Bertini were the two main personalities of this star system that also included Pina Menichelli, Diana Karenne, Maria Jacobini, Hesperia, and Italia Almirante Manzini. In her move from theatre to cinema, Lyda Borelli began Italian *divismo*, developing an acting style that became a model for contemporary actresses. In her most successful dramas – Mario Caserini's *Ma l'amor mio non muore!/Love Everlasting* (1913), Alberto Degli Abbati's *La memoria dell'altro/Memory of Another* (1913), Carmine Gallone's *La donna nuda/The Naked Truth* (1914), *Fior di male/Flower of Evil* (1915) and *Malombra* (1916), Nino Oxilia's *Rapsodia satanica/Satan's Rhapsody* (1917), Amleto Palermi's *Carnevalesca* (1918) – she communicates her feelings and passions using her whole body in frenetic gestures and stretching her arms in curvilinear poses. A wider heterogeneity characterized Francesca Bertini's long cinematic career: her roles included passionate *femmes fatales* and figures from regional and realist literature. A complex artistic personality, Bertini's acting style is strongly influenced by naturalist and romantic nineteenth-century theatre.

The passage of theatre actresses to the new cinematic art was also made by Eleonora Duse. Her only film, *Cenere/Ashes* (Febo Mari, 1916) based on Grazia Deledda's novel, stands apart from other contemporary diva films due to her unique performance which is characterized by a naturalism that annuls melodramatically emphatic gestures.

As well as these feature-length dramas, comedies were very successful in Italy during the silent period. From 1909–10, film companies released onto the market several series of short films featuring actors identified with a comic character. Itala film began the Cretinetti series starring Andrè Deed, Ambrosio produced the Robinet series starring Marcel Fabre, and Cines released the Tontolini series with Ferdinande Guillaume, who, in 1912, left the Roman company and started a new series as Polidor at Pasquali in Turin. These series present significant differences in terms of content, style, actors' physical appearance and artistic background, but their common element is the main character's disturbance of the institutions, rituals, and locations of contemporary bourgeois society. The comic types aim to destabilize a codified system that encompasses

social institutions, official ceremonies, social events, professional rules, friendships and love relationships, new inventions and technology, sports, means of transport and objects of everyday life. The comic aspects derive from the character's chaotic and catastrophic adventures in common situations determined by well-defined and recognized social codes.

Irene Lottini

Ashes

Cenere

Studio:
Società Anonima Ambrosio

Director:
Febo Mari

Producer:
Arturo Ambrosio

Screenwriters:
Febo Mari
Eleonora Duse

Cinematographer:
Eugenio Bava

Music Director:
Antonio Coppola

Duration:
31 minutes

Genre:
Melodrama/Silent

Cast:
Eleonora Duse
Febo Mari
Nietta Mordeglia
Ettore Casarotti
Ilda Sibiglia
Carmen Casarotti

Year:
1916

Synopsis

Based on the 1904 novel by later winner of the Nobel prize for literature, Grazia Deledda, *Cenere* tells of Rosalia, a young Sardinian woman from the countryside who, through financial hardship, finds she is no longer able to care for her illegitimate son. After giving him an amulet, she takes him and abandons him to his father. Years pass by. The son, Anania, now fully-grown, is about to marry his childhood sweetheart and so goes in search of his mother to invite her to his wedding. Rosalia recognizes him from the amulet he is carrying. Anania is dismayed to discover she is poor, dishevelled and hungry, and resolves to ask his betrothed whether she will welcome his mother into the marital home. Given Rosalia cannot read, she suggests he sends her the amulet wrapped in a white cloth if his betrothed accepts, and in a coloured cloth if she does not. Rosalia waits for the answer in suspense, and when she finally receives the amulet wrapped in a coloured cloth she takes her own life.

Critique

Febo Mari's career as a director of silent film stemmed from his involvement on screen as an actor – during the first ten years of the twentieth century he was one of the best known *divo* actors. *Cenere* was the third film he directed, and was one of many Italian 'diva films' discussed by Angela Dalle Vacche in her book *Diva: Defiance and Passion in Early Italian Cinema* (2008) as 'a specific genre in and of itself' (p. 2), in which the film's subject is the diva, in this case Eleonora Duse (1858–1924). Prolific in her day as a stage actress, this was Duse's one and only appearance on screen after a break from stage-acting of seven years (she returned to playing theatre roles in 1921). In *Cenere* she enacts the role of the quintessential Catholic *mater dolorosa*: having been abandoned by her one and only love (Anania's father), she suffers once more when she realizes she has no choice but to abandon her son to his wealthier parent so that he can be brought up away from poverty. Her suffering is further intensified when she is rejected by her son's betrothed, and it reaches its apotheosis abruptly when she sacrifices her life to allow her son to marry without shame. Suffering is not mapped exclusively onto the female role, however: Anania also suffers when abandoned by his mother in childhood, as well as when he is reunited with her as an adult and discovers she is aged and destitute. In the first part of the film Duse is veiled to hide her maturity, and there are a series of close-up and static shots of mother and son together. The piano musical accompaniment, first performed by Antonio Coppola at the Pordenone Silent Film Festival in 1992 and composed by Bruno Moretti, who based his score on the traces of the original held at the George Eastman House film archive in New York, is suitably slow, funereal, chromatic and composed in a minor key signature to convey her suffering. When Anania is on his way to see his mother for the first time in

adulthood the music switches to a major key, and is lighter and more optimistic to convey Anania's hopeful mood. An operatic heightening of the emotions occurs when Rosalia finally receives news from her son that his betrothed does not accept her and she expresses despair in emphatic, over-reactive gestures – also a feature of Mari's acting style during fraught moments. The reception of the film on its release was, by all accounts, quite negative; this may in part be explained by the audiences' high expectations of Duse's grand acting style on stage, which did not suit the new art of screen acting in the same way as in live performance. Another noticeable anomaly is that Mari opens his mouth to gesture dialogue whereas Duse keeps hers firmly closed throughout. The film comes into its own as a 'diva film' when, at the end, Duse is represented as both human and divine – a combined Christ and Virgin Mary figure – and her weeping son is abandoned by his mother for a second time, this time in her death, which, as was common during the period on the Italian opera stage, purged the society of its ills (in this case a single mother with an illegitimate son), so that the status quo could be firmly re-established.

Katharine Mitchell

Assunta Spina

Studio/Distributor:
Caesar Film (Rome)

Director:
Gustavo Serena
(uncredited) Francesca Bertini

Producer:
Caesar Film (Rome)

Screenwriter:
Gustavo Serena
Francesca Bertini from the play by Salvatore Di Giacomo

Cinematographer:
Alberto Carta

Art Director:
Alfredo Manzi

Duration:
73 minutes

Genre:
Drama

Synopsis

Assunta Spina, a laundress from Naples, is engaged to a butcher named Michele Boccadifuoco but is also intensely courted by Raffaele. One day, during a celebration in Posillipo, Assunta dances with Raffaele. Michele slashes her face and is arrested. During the trial Assunta claims he did not wound her, but the jury does not believe her and Michele is condemned to spend two years in the prison of Avellino. When Federico Funelli, corrupt vice-chancellor of the Court, offers his help to let Michele stay in the nearby prison of Naples, vulnerable Assunta accepts his proposal and becomes Federico's mistress. One night Michele, released early from prison, finds Assunta and Federico together. He kills Federico and leaves. When the police arrive, she takes the blame for the crime in order to save Michele.

Critique

An adaptation of the drama by Salvatore Di Giacomo, *Assunta Spina* represents a unique example of realism in the films starring Italian silent divas. It has a typical Neapolitan story combining strong passions (love, jealousy, desire for revenge) and ritual gestures (the public knifing) in its regional society. Set in a working class neighbourhood in Naples, *Assunta Spina* was shot in real locations. The characters' move around the city, revealing authentic areas and citizens. Assunta walks alone in flooded streets, goes to fish markets, dances on a terrace in Posillipo, works in a laundry, and walks toward the courthouse surrounded by a crowd of local extras.

Cast:
Francesca Bertini
Gustavo Serena
Carlo Benetti

Year:
1915

The opening of the film immediately declares this realistic and regional setting, identifying the diva with the city and its traditions. Francesca Bertini stands in front of the well-known seascape wearing the typical Neapolitan white shawl with long fringe. An authentic piece donated by the producer's wife, this shawl represents a key object in Assunta Spina's story and Bertini's interpretation. Assunta wears it the day of the dinner in Posillipo in a celebration of her engagement, when she moves between Michele and Raffaele. Here the shawl is the traditional Neapolitan object that accompanies a ritual gesture: the knifing that Michele performs on Assunta, a ritual gesture which sets the drama in motion.

This white shawl from the beginning is replaced at the end of the film by a dark, poor, long dress when Assunta faces Michele. The final scene represents the climax of Bertini's performance. In a long, fixed, medium shot, Francesca Bertini expresses her feelings bodily. When Michele enters the room, she looks at the camera,

Assunta Spina, Caesar Film.

revealing her insecurity. Then she starts curving and waving her body, avoiding Michele's eyes until, after his reaction, she falls down and remains on the ground stretching her arm. It is a dramatic departure from the naturalistic acting that otherwise characterizes the film. The common gestures that Bertini uses throughout the film – like in the scene of the lunch with Michele and her father – here become pure corporeal expressivity. The way she sits at the table and stands up incapable of eating, the way she avoids looking at Michele, or the way she puts her hands into the pockets of her long dark dress show her capacity to interact in a realistic setting using the communicative power of her body.

Irene Lottini

Cabiria

Studio/Distributor:
Itala Film

Director:
Giovanni Pastrone

Producer:
Giovanni Pastrone

Screenwriters:
Gabriele D'Annunzio
Titus Livus
Giovanni Pastrone
Emilio Salgari

Cinematographers:
Augusto Battagliotti
Eugenio Bava
Natale Chiusano
Segundo de Chomón
Carlo Franzeri
Giovanni Tomatis

Duration:
148 minutes

Genre:
Epic

Cast:
Lidia Quaranta
Ada Marangoni
Umberto Mozzato
Bartolomeo Pagano

Year:
1914

Synopsis

Three centuries BC. The child Cabiria is rescued by her nurse Croessa from the eruption of Mount Etna but both are captured by pirates who sell them as slaves in Carthage. Cabiria is rescued from sacrifice to the flames of the God Moloch by the spies, Roman patrician Fulvio and his Nubian servant Maciste, but Croessa is sacrificed in her stead. Hannibal is bearing down on Rome. Fulvio has to flee Carthage but Maciste is captured and tortured, though not before he can give Cabiria into the keeping of Sofonisba, Hannibal's sister. Years pass. Syracuse is saved from Roman invasion by the use of Archimedes' mirrors casting sun on their ships and setting them alight. Fulvio, now one of Scipio's men, meets Cabiria's father, who recognizes the ring Croessa had given him; Fulvio promises to go and rescue Cabiria. In Carthage he meets up with Maciste again and they discover that Cabiria is again to be sacrificed to Moloch. Carthage is besieged and Sofonisba frees Cabiria into the hands of Fulvio and Maciste. They make their escape as Scipio conquers Carthage.

Critique

Cabiria was one of the most successful of all Italian films, in Italy and internationally, widely credited with influencing the development of spectacle in Hollywood, not least the Babylon sequences in *Intolerance* (DW Griffith, 1916). It exemplifies the fusion of the principles of epic and spectacle in Italian silent cinema, influenced by opera staging in scale and also in line with contemporary trends in design.

Cabiria is epic in its large-scale rendering of major events in classical history (the eruption of Mount Etna, Hannibal's crossing the Alps with an army of elephants, Scipio's defeat of Carthage, Archimedes' invention of fire weapons) and in the way it shows individual characters caught up and made great by them (the heroes alert the Romans of Hannibal's advance, their rescue of the child Cabiria from sacrifice to Moloch is emblematic of Roman chivalry

and Carthaginian savagery). The presentation of the two heroes, patrician Fulvio and brawny Maciste, deploys statuesque postures and ennobling framing, opening with shots of them picked out as men of destiny on a rocky promontory by the sea.

Yet it was the slave Maciste, played by Genoan docker Bartolomeo Pagano, who was to become the popular hero figure in a series of subsequent films. Here he is identified as a Nubian slave, all brawn, wearing a leopard skin and requiring Fulvio's presence to inspire him; he is also gentle, even feminine, sewing a tear in Cabiria's frock and cuddling her (something Fulvio certainly never deigns to do). In later films (including those of the 1950s/60s peplum cycle), he is no longer black and is wiser and self-motivating, although, as in *Cabiria*, there are the set pieces of muscle action (here knocking down a door with one blow, bending the bars of a cell where he is imprisoned, breaking a chain that attaches him to a millstone) and he wears less clothing as the film proceeds.

Cabiria is, at the same time, spectacular in its sensuously overwhelming visual quality. The massive sets have a solidity staggering in comparison with both stage sets and later back projection, animation and CGI constructions of the ancient world, and the scale is emphasized by canted angles that dwarf the humans in the shot, pans that indicate extensiveness, forward tracking shots that draw the viewer in, and lighting that emphasizes the vastness of the space involved. Design pits the clean lines, open spaces and white and martial clothes of Rome against the Orientalist decadent languor of Carthage, especially in Sofonisba's court, where the screen is crowded with ornate furnishings, sumptuous fabrics and furs, statues and animals, both live ones (panthers, peacocks) and in elephant pillars, horse's head statues and seahorse harps. This fashionable Orientalism was complemented by other aspects that made the film modern. The extensive use of camera movement was innovative for the period, creating a spatial dynamism impossible in the theatre. There was a use of superimposition to convey dream sequences, and modelling and camera tricks to create special effects. The language, too, by the decadentist poet Gabriel D'Annunzio, is flowery, comparable perhaps to opera arias, and the film had music specially composed by Ildebrando Pizzetti, one of the leading contemporary composers of the day. The spectacle of suffering, popular in Symbolist and decadent art of the period, is dwelt on in the whipping of Cabiria's nurse Croessa, Maciste chained to a millstone and, above all, the God Moloch, a vast statue with a giant mouth into whose flames children are tossed.

In short, *Cabiria*, in a blend characteristic of Italian cinema, welds together in equal measure antique ideals, stylish design, sensuous pleasures and sensual energies.

Richard Dyer

The Capture of Rome. 20th September, 1870

La presa di Roma. XX Settembre 1870

Studio/Distributor:
Alberini & Santoni (Rome)

Director:
Filoteo Alberini

Producer:
Filoteo Alberini

Art Director:
Augusto Cicognini

Duration:
4 minutes

Genre:
Drama

Cast:
Ubaldo Maria del Colle
Carlo Rosaspina

Year:
1905

Synopsis

Rome 1870. General Carchidio, emissary of the Savoy army, is blindfolded and escorted from Ponte Milvio to General Ermanno Kanzler of the Papal forces in Piazza della Pilotta. General Kanzler receives General Carchidio in his study but he refuses the ultimatum to surrender issued by Carchidio on behalf of General Cadorna. On 20 September, at the troops' camp on Via Nomentana, the trumpeter sounds the alarm and the soldiers storm the city. The cannon battery opens a breach in the Porta Pia wall until one cannon fires the last shot. The 12^{th} battalion of the Bersaglieri corps charges toward the opening in the wall. Apotheosis: in a tableau a female figure embodying the free and independent Italy presents the palm of victory to Cavour, Vittorio Emanuele II, Garibaldi, and Mazzini.

Critique

La presa di Roma is considered the first film industrially produced in Italy. It is not by chance that for this first important production of his newly established film company Filoteo Alberini chose to celebrate a crucial event of national history. He linked the birth of the Italian film industry to the Risorgimento, the process of the political unification of individual Italian states and the birth of Italy as a nation state.

Produced on the thirty-fifth anniversary of the capture of Rome, *La presa di Roma* was first presented on 20 September 1905 in celebration of this historical event. It was screened outdoors on a big white canvas in the crowded Piazzale di Porta Pia. The symbolic birthplace of the Italian nation became, with this premiere, the symbolic birthplace of Italian cinema.

As the first significant Italian film, *La presa di Roma* was extraordinarily long compared to contemporary productions. According to different sources it measured 250 metres of which, unfortunately, only 75 metres remain. Thanks to the surviving frames and thanks to other documents, it is possible to reconstruct the original structure of the film. The story was organized in seven tableaux, each one preceded by an intertitle: General Carchidio, head of the negotiations, at Ponte Milvio; From General Kanzler – 'No surrender!'; In the Bersaglieri's Camp – 'To Arms!'; The last cannonade; The breach at Porta Pia – 'Attack!'; White flag; Apotheosis. Even in the elementary simplicity of the syntax, this organization of the plot already reveals an aspiration to a magniloquent narration that increases tension and pathos toward the final apotheosis.

In this precise structure, the seven parts alternate interior and external shots. On the one hand, the shot of General Kunzler in his study, in the second tableau, pays particular attention to the reconstruction in the studio set, a result of the work of the well-known theatre set designer Augusto Cicognini. On the other hand, the idea of shooting some scenes outside in the same locations where the historical events took place testifies to the effort Alberini

put into this production. Particularly the image of the fifth tableau, showing the Bersaglieri charging toward the opening in the Porta Pia wall, represents a first important example of exterior shooting requiring the organization of numerous extras. It is a crowd scene – the archetype of such scenes that would become typical of Italian films – that acts as a prelude to the final apotheosis.

This last shot is a *tableau vivant* dedicated to the protagonists of the Risorgimento [the Italian movement for national independence]. Today only eight seconds of this seventh tableau remain: an image that is probably a set picture or a still frame included in the past to replace the already lost original sequence. Thanks to various documents – used as sources for the restoration of the film – it is known that this last scene was in colour, hand-tinted according to a technique that was widespread at the time and certainly practised in Alberini's studios. The iconographic character of this last scene seemed to require particularly vivid coloration emphasizing the image of the female figure who personifies Italy. This tableau confirms the celebrative nature of *La presa di Roma*. It is a celebration of a crucial event, but it is also a celebration of the potential of the newborn Italian film industry. This public re-enactment of the breach of Porta Pia in its thirty-fifth anniversary is an affirmation of an industry able to use its national historical and artistic tradition to create a film that can compete with the best foreign products.

Irene Lottini

Dante's Inferno

Inferno

Studio/Distributor:
Milano Film

Directors:
Francesco Bertolini
Adolfo Padovan
Giuseppe De Liguoro

Producer:
Milano Film

Cinematographer:
Emilio Roncarolo

Duration:
68 minutes

Genre:
Drama

Cast:

Synopsis

Dante, lost in a dark and gloomy wood, attempts to ascend the 'hill of salvation' but is assailed by three wild beasts: a panther symbolizing Avarice, a lion symbolizing Pride, and a wolf symbolizing Lust. Beatrice descends from Paradise and asks the poet Virgil to rescue and guide Dante. Virgil leads Dante to the gate of the Inferno and Charon ferries them over the river Acheron. Dante and Virgil begin their journey through the different circles of the Inferno. Dante meets different figures and sinners: the poets Homer, Horace, Ovid, Lucanus in Limbo; the judge Minos; the carnal sinners Cleopatra, Dido and Helen of Troy; Francesca who tells Dante her story; the three-headed monster Cerberus and the glutton Ciacco; Filippo Argenti among the wrathful; the heretics Farinata degli Uberti and Cavalcante de' Cavalcanti; the suicide Pier delle Vigne who recounts his story; Caiphas among the hypocrites; Ulysses and Diomede among the fraudulent councilors; Muhammad and Betran de Born with the sowers of discord and dissension; the giant Nimrod; Ephialtes and Antaeus; the traitor Count Ugolino, who remembers his sins. At last Dante and Virgil meet Lucifer chewing the bodies of Brutus and Cassius. The two poets climb down Lucifer's fur to leave Inferno.

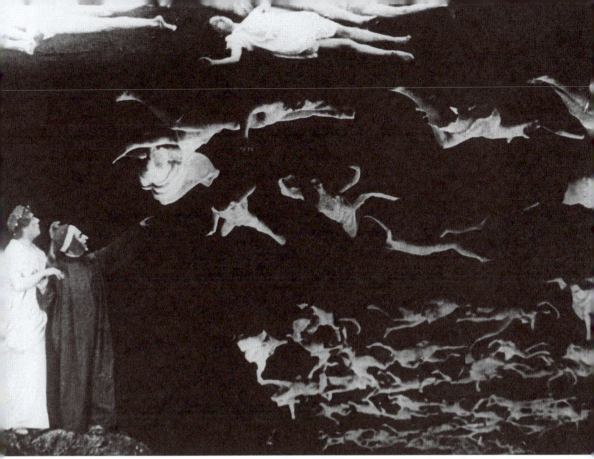

Dante's Inferno/Inferno. Milano Film.

Salvatore Papa
Arturo Pirovano
Giuseppe De Liguoro

Year:
1911

Critique

The film *Inferno* produced by Milano Film represents the climax of the adaptation process that was characteristic of early Italian cinema. In order to gain cultural legitimacy and artistic consecration, the Italian film industry selected Dante's work as subject for the first full-length feature film to be produced in the country. In a combination of business interests and pedagogical-aesthetic ambitions, this project was based on the central position of Dante's *Inferno* in the popular cultural imaginary of Italian society. This derivation process also involved the figurative tradition of the *Divine Comedy*, since the most popular illustrations of the poem – those by Gustave Doré – were used as models for the film images. Significantly, it was on this literary and iconographic tradition that the long promotional campaign focused its attention. And it was to the same tradition that the intellectuals attending the premiere at the Regio Teatro Mercadante in Naples referred in their positive critiques.

The film recuperates the fundamental episodes and figures of Dante's *Inferno* in an elementary illustrative structure in which the intertitles quoting the original verses introduce the subject of the following corresponding tableau. These scenes combine Dante's tales and the iconographic tradition of Doré's illustrations with the new imaginary produced by the cinematic medium. Here, the

typical tricks characterizing the so called 'cinema of attraction' are recuperated in a different context and renovated to emphasize the hallucinatory character of Dante's work. Paolo and Francesca fly in a superimposition that, even though reproducing Doré's image, dramatically accentuates the ethereal nature of the two characters. Thanks to the double exposure of the film, in the ending chapter Lucifer appears horrifically gigantic, while a close-up reveals the macabre image of his mouth holding and chewing the bodies of Brutus and Cassius. Analogously, for the representation of the mutilated bodies of the sowers of discord – especially the poet Bertran de Born's detached head – Méliès' trick of human bodies' disintegrations is used in a dramatically terrifying tone.

In this hallucinatory context, then, the stories told by some sinners find a visual meta-representation. The direct speech of these figures reproduced by the intertitles determines changes in point of view and leads to flashbacks portraying past episodes. The memories of Paolo and Francesca, Pier delle Vigne, or Count Ugolino become inserts in the continuity of Dante's journey, revealing cinema's potential in the visual rendering of a literary work. This first significant encounter between national literature and cinema is a filmic illustration of Dante's text which reproduces a well-known figurative tradition and also offers new iconographic representations of literary passages.

Irene Lottini

The Last Days of Pompeii

Gli ultimi giorni di Pompei

Studio/Distributor:
Ambrosio (Torino)

Director:
Eleuterio Rodolfi (note: Fiaf sources quote Mario Caserini as director of this film)

Producer:
Ambrosio (Torino)

Screenwriter:
Arrigo Frusta (Augusto Ferraris), from the novel (1834) by Edward George Earl Bulwer-Lytton

Cinematographer:
Giuseppe Paolo Vitrotti

Duration:
106 minutes

Synopsis

Pompeii, 79 A.D. Egyptian priest Arbaces wants to conquer Jone, a beautiful Greek girl, but she is in love with the handsome and elegant Glaucus, who returns her affection. In the meanwhile, Glaucus buys the blind slave Nydia in order to save her from her master's abuse and she falls in love with him. Arbaces invites Jone to the temple and tries to seduce her but fortunately she is rescued by Apoecides. She flees to Glaucus' home and Glaucus asks Nydia to assist her. While Glaucus and Jone enjoy their time together, Nydia, jealous, goes to the Temple of Isis and confides her sufferings to Arbaces. He decides to take advantage of her feelings: he promises her a love potion for Glaucus but, instead, he hands her a death potion. Nydia gives the potion to Glaucus and he temporarily goes out of his mind. Apoecides wants to unmask Arbaces' misconduct but Arbaces kills him and then accuses Glaucus of the murder. Glaucus is condemned to fight against lions, but suddenly, on the day of the spectacle in the arena, Mount Vesuvius erupts. Nydia helps Glaucus and Jone to escape and then she kills herself.

Critique

Five years after its first version of the novel by Baron Edward Bulwer-Lytton (*Gli ultimi giorni di Pompei* by Luigi Maggi, 1908), the Turin film company Ambrosio released this new feature-length film inspired by the same text. It was an important project that was the

Genre:
Drama

Cast:
Fernanda Negri-Pouget
Eugenia Tettoni
Ubaldo Stefani

Year:
1913

origin of one of the first conflicts between Italian film companies. When another Turin film Company, Pasquali & Co., quickly produced its *Jone o Gli ultimi giorni di Pompei* and released it promptly, taking advantage of Ambrosio's promotional campaign, Ambrosio started a legal action that, even though unsuccessful, represented a crucial moment in the history of the Italian film industry.

Projected as a grandiose work, Rodolfi's *Gli ultimi giorni di Pompei* focuses on the spectacular elements of the representation. In the first part of the film, the development of the love triangle is told in a series of paratactic scenes introduced by intertitles. A 'pictorial' approach to the organization of the scene reveals the influence of historic paintings such as Alma Tadema's works, showing a predilection for medium shots with human figures framed by architectonical elements. The creation of pathos is, rather, determined by symbolist influences. These are evident in the scene in which Nydia discovers Glaucus and Jone's love. The intertitles emphasize her torn feelings by referring to two metaphorical phrases. The 'roses of gratitude', that introduce the shot of Jone picking roses for Glaucus, are turned into the corresponding 'thorns of jealousy' that precede the shot of Nydia's realization and disappointment. In order to accentuate this symbolism, the editing inserts the metaphoric image of two doves dissolving into the figure of a large owl. Partially inspired by titles from Lytton's novel, this symbolism recuperates a typical trend of early twentieth century Italian culture.

A related esoteric atmosphere is then accentuated by Arbaces's presence and actions. When the Egyptian priest tries to convince Jone of Glaucus's infidelity by using one of his tricks, his magic is spectacularized by a frame that combines Jone and the projected image of Glaucus surrounded by courtesans.

Similarly to Guazzoni's *Quo vadis?*, the predilection for spectacular elements particularly dominates the final part of this film. The scenic reconstruction of the games in the arena is determined by the organization of masses and figures. A sort of crosscutting alternating the images of the arena, Glaucus's movements and Nydia's actions produce a change in the narrative rhythm until the intertitle announcing the eruption opens the dramatic and spectacular climax. In this scene, rapid editing combines documentary images of the fire and images of massed extras. Long, medium shot and close-up are frequently alternated while a red tint emphasizes the pathos of the disaster.

Irene Lottini

Love Everlasting

Ma l'amor mio non muore!

Synopsis

Grand Duchy of Wallenstein. Elsa Holbein is the young beautiful daughter of General Julius, the Chief of the General Staff. After a spy named Moise Sthar steals military documents, Julius is accused of betrayal. He kills himself while Elsa is forced to leave. Homeless, she begins wandering the streets until, on the Riviera, she starts her

Studio/Distributor:
Film Artistica Gloria (Turin)

Director:
Mario Caserini

Producer:
Film Artistica Gloria (Turin)

Screenwriters:
Emiliano Bonetti
Giovanni Monleone

Cinematographer:
Angelo Scalenghe

Duration:
78 minutes

Genre:
Drama

Cast:
Lyda Borelli
Mario Bonnard
Vittorio Rossi Pianelli

Year:
1913

performing career under the pseudonym of Diana Cadouleur and becomes a successful actress and singer. One day, in a small church, she meets an elegant young man and falls in love with him. But during a tour on the Lucarno Lake she runs into Sthar who, rejected by Elena, spreads rumours about Prince Massimiliano's behaviour. When Massimiliano is obliged by his father to return home, Elena, shocked because she did not know her lover's real identity, abandons Massimiliano. The Prince looks for her and finds out that she is playing *La Dame aux Camélias* in a theatre. He rushes to her but Elena has swallowed poison and, performing Marguerite's death scene, dies while Massimiliano assures her of his everlasting love.

Critique

Mario Caserini's *Ma l'amor mio non muore!* stands out as the first diva film. It is the first film featuring Lyda Borelli, who, at that time, was already an appreciated theatre actress about to achieve wider popularity in her new cinematic career.

In her first film drama, Lyda Borelli is the protagonist of a passionate story that involves different themes. The first part of the film is occupied by a familial drama developing around an espionage topic borrowed from the adventure genre. The tragic conclusion of this familial drama, Elsa's father's suicide, offers Lyda Borelli her first opportunity to perform the typical silent gestures that characterize her cinematic acting style. The shot shows General Holbein on the left in the foreground. Elsa enters the room from the back and, after a while, begins to employ minor gestures to communicate that she has discovered her father's body. Her arms, her hands and her torso start a series of waving, curvilinear, slow movements in a dramatic climax to the final loss of her senses.

The second part of the film focuses on Elsa's new performing career. An element appears here that often returns in various diva films with character and actress coinciding in a self-referential superimposition. It is a *mise-en-abyme* that becomes particularly evident in the scenes set in the theatre. Elsa's first appearance on stage immediately links her character to Lyda Borelli's theatrical career. She wears a costume that recalls the one Lyda Borelli wore in Oscar Wilde's *Salomè*. A shot filmed from the wings shows Elsa in a curvilinear pose typical of Borelli while a large audience watches the performance. The inclusion of the spectators in the image is another fundamental element for this meta-textual register. The public is here a reflection of Borelli's public: the public that attended her theatrical performances but, above all, the public that would attend the screening of her future films. In this auto-reflexive representation of stardom, the scene set in Elsa's dressing-room acquires relevance as a consecration of the Diva's private space. Significantly, the mirror on which she poses her arm multiplies her private image in her own *sacrarium*.

Considering this identification of actress and character, then, the final sequence explicitly declares the complete coincidence between life and theatre. While playing Marguerite's death, Elsa collapses from the effect of the poison, and Prince Massimilano,

almost performing Armand's role, holds her agonized body. She dies on stage like a heroine from the romantic theatrical tradition. In a perfect collusion between actor and character, life imitates art.

Irene Lottini

Pinocchio

Studio/Distributor:
Cines (Rome)

Director:
Giulio Antamoro

Producer:
Cines (Rome)

Duration:
42 minutes

Genre:
Comedy

Cast:
Ferdinand Guillaume
Natale Guillaume
Lea Giunchi
Augusto Mastripietri

Year:
1911

Synopsis

Carpenter Geppetto carves a block of wood into a puppet and names him Pinocchio. As soon as his feet have been made, Pinocchio runs out the door and a series of adventures begins. He burns his feet upon a stove; is caught in a trap by a farmer; is hung in a tree and then saved by the Fairy who gives him some gold pieces; he meets the Cat and the Fox who trick him so as to steal his money; and he is sent to prison for his foolishness. Escaping from prison, he swims across the ocean; he has almost reached 'the land of Indians' when he is swallowed by a whale. Inside the whale Pinocchio meets Geppetto. They escape from the whale's belly but are captured by the Indians. Pinocchio saves Geppetto and, during the night, leaves the Indian camp to reach the Canadian soldiers, who kill all the Indians and send Pinocchio back home by shooting him out of a cannon. Later, Pinocchio enters a puppet theatre and is caught by Mangiafuoco. Able to escape again, he follows his friend Candlewick's suggestion and goes to Playland, where he is transformed into a donkey. Saved from the Fairy, Pinocchio starts working hard. As a reward, the Fairy transforms him into a real boy.

Critique

This first cinematic version of Collodi's *Le avventure di Pinocchio* is a very free adaptation of the original text. It renews and modifies the fundamental episodes of the novel in order to undermine the moralistic-pedagogical elements and emphasize the comic-burlesque tone and the picaresque-adventurous dimension.

Collodi's character could appear to be the perfect subject for a comic film in the early years of cinema, when comedies were corporeal and instinctive. Pinocchio's unstoppable dynamism could offer motives for those chases, clashes, and pratfalls recurrent in contemporary films featuring comic characters. In Antamoro's work, an amplification of the burlesque tone is guaranteed by the actor Ferdinand Guillaume in his popular comic character Tontolini. Significantly, the opening of the film confirms Tontolini's role. Employing a practice common in vaudeville, Ferdinand Guillaume appears on a stage as Tontolini and, as Tontolini, he transforms himself into Pinocchio. He changes into the puppet's costume while doing a somersault, which is Tontolini's characteristic move; a move that, combined with the 'stop-substitution' cinematographic technique, produces a spectacular moment.

The search for the spectacular also characterizes the combination of Collodi's original texts with new adventurous and fantastic

episodes. If, on the one hand, the elimination of the talking Cricket undermines the moral-pedagogical elements, on the other hand, Antamoro's adaptation offers extravagant digressions and eccentric additions. Pinocchio fights against Capitan Fracassa on the stage of the puppet theatre and, above all, Pinocchio and Geppetto have an extraordinary adventure in the land of the American Indians. Escaping from the whale's belly they are captured by the Indians, who choose Pinocchio as their new Chief and put Geppetto on a grill. After saving his father, Pinocchio escapes from the Indian camp and reaches the 'Red Coats' – the Canadian troops – who kill all the Indians and send Pinocchio home by shooting him out of a cannon.

This eccentric addition to the original text, completely extraneous to Collodi's novel but accepted by the public and by the press, is the result of a combination of different references. If, on a generic level, the influence of contemporary travel and exotic literature is evident, a more specific reference is the link to the so-called Pinocchiate, books of new stories about Pinocchio or his brothers/cousins/friends and which started to be published in the late nineteenth century. In books such as *Pinocchio in Affrica* by Eugenio Cherubini (1904) or *Viaggi straordanissimi di Pinocchio intorno al mondo* [Pinocchio's extraordinary journeys around the world] by Augusto Piccioni, the travel theme is dominant. Pinocchio meets indigenous tribes in episodes that show an evident Eurocentric and imperialistic point of view. Regarding this, it is no accident that, in Antamoro's film, the 'Giubbe Rosse' who save Pinocchio do not wear Red Coats but the outfit of the Italian colonial troops; the same troops that, in 1911, were engaged in the conquest of Libya.

This recognizable reference concludes the episode. Pinocchio's flight on a cannon ball specifically recalls *The Adventures of Baron Münchhausen* by Rudolf Erich Raspe. A very popular novel in nine-tieth century Italy, this book offered Antamoro a new motif for the picaresque theme; a new fantastic topic that, combined with other references, could be brought into Collodi's original text in order to create a feature-length film able to attract Italian children and confirm the dominant ideology of the time.

Irene Lottini

Quo vadis?

Studio/Distributor:
Cines (Rome)

Director:
Enrico Guazzoni

Producer:
Cines (Rome)

Synopsis

During the reign of Emperor Nero in Rome, patrician Vinitius, the nephew of one of Nero's favorites, falls in love with the Christian Lygia. Thanks to Vinitius's uncle's intercession, Lygia is taken to the Royal Palace by order of Nero. She is accompanied by Ursus, her giant and devoted slave, who rescues her from Vinitius's several harassments. During Vinitius's last attempts to seize Lygia, Ursus is about to kill him when Lygia commands him to be merciful. Saved and recovered under Lygia's care, Vinitius begs for forgive-ness and declares he will accept Christianity to marry Lygia. While

Screenwriter:
Enrico Guazzoni from the novel (1896) by Henryk Sienkiewicz.

Cinematographer:
Alessandro Bona

Art Director:
Camillo Innocenti

Duration:
120 minutes

Genre:
Drama

Cast:
Amleto Novelli
Lea Giunchi
Gustavo Serena

Year:
1913

Apostle Peter blesses their love, Nero burns Rome and, blaming the Christians, orders a general arrest. With other Christian martyrs, Lygia and Ursus are taken to prison and then driven into the arena to be engaged in mortal combats against lions. Thanks to his strength Ursus saves Lygia from the beasts and Vinitius pleads to Nero for Lygia's life. Nero grants her mercy and Lygia is escorted out of the arena by Ursus and Vinitius. Apostle Peter attempts to leave Rome but has a vision of Christ and returns back to save the city, while Nero's reign comes to an end.

Critique

Starting the production of full-length feature films, film company Cines commissioned Guazzoni to direct the first adaptation of Torquato Tasso's *La Gerusalemme liberata/Jerusalem Delivered* in 1911. One year later they decided to invest in another big project: a new cinematic version of *Quo vadis?* by Henryk Sienkiewicz. Cines paid a large amount of money for the copyright of this novel that, first published in Italy in 1897, had become very popular and had already been adapted for the screen in various short films. No expense was spared for this production: the film had to be a unique, colossal, longer and more spectacular than any previous works. The effort was repaid with enormous national and international success that contributed towards imposing the new full-length feature film model as standard.

To this ambitious project, Sienkiewitz's novel could offer a complex and intricate plot. Guazzoni's film covers the main episodes of the story, balancing the narration of historical events (Nero's persecution of the Christians and burning of Rome) with the representation of the characters' personal episodes and romantic relationships, religious topics with spectacular elements, and suffering with ultimate catharsis.

The characters are delineated with particular intensity. Among them, the slave Ursus, played by Bruno Castellani, represents a prototypical figure. He is the gigantic slave able to resolve any problems with his extraordinary strength; he is the archetype of the Herculean male character that would be fully established, one year later, by the figure of Maciste in Giovanni Pastrone's *Cabiria*.

This deeper representation of the characters is the result of a very able direction of the actors. Their acting appears more natural and less theatrical than the style dominant in that period, and Guazzoni uses close-ups to capture the intensity of their expressions. But it is the relationship between individuals and environment that acquires a particular expressive power. The characters have freedom of movement and walk around the space of the frame, occasionally reaching the foreground. Around them, Camillo Innocenti's set design results from meticulous research into the reconstruction of architectonic elements and interiors, and precise attention to realistic details.

This attention to scenography and spatial organization is combined with a predilection for spectacular elements in the two most memorable scenes: the burning of Rome and the games in the

arena. In this last scene, gladiators' combats, chariot races, lions and masses of extras are combined in an aesthetic construction of filmic space. In the organization of the frame, the architectonical elements are used to stage main characters and masses along different lines of depth.

Irene Lottini

Satan's Rhapsody

Rapsodia Satanica

Studio/Distributor:
Cines (Roma)

Director:
Nino Oxilia

Producer:
Cines (Roma)

Screenwriters:
Alfa (Alberto Fassini)
Fausto Maria Martini

Duration:
55 minutes

Genre:
Drama

Cast:
Lyda Borelli
André Habay
Ugo Bazzini
Giovanni Cini

Year:
1917

Synopsis

Old Countess Alba d'Oltrevita, nostalgically envying her past years, makes a Faustian deal with the devil: she gives up love to have her youthful beauty back forever. Young again, Alba opens her Castle of Illusion for dances and parties. One day, during a party, she meets brothers Tristano and Sergio, who fall in love with her. Refusing Sergio's love, she indirectly causes his death. In the meantime, she begins to have feelings for Tristano and immediately a wrinkle appears on her face. She tries to refuse love, but then she accepts it again and falls victim to her own deal. She becomes old and dies lying in her garden on the shore of the lake.

Critique

Rapsodia satanica is the result of an ambitious project. Almost re-elaborating the symbolist/Wagnerian ideal of the *Gesamtkunstwerk*, it was produced with the aim to create a 'complete work' combining different arts or, more specifically, the talents of several important artists: the diva Lyda Borelli, the director Nino Oxilia, the poet Fausto Maria Martini, author of the intertitles and of a poem published in a booklet in occasion of the film premiere, and the composer Pietro Mascagni, composer of a symphony that accompanied the film projection (an important example from the history of Italian cinema of music created especially for a silent film).

As an aspiration to the 'complete artistic work', *Rapsodia satanica* is characterized by symbolist culture, from which originated the idea of a conjunction of the arts. If the title already reveals a symbolist inclination in the combination of a musical term and a demonic image, many other themes, motifs, and figures confirm this influence. In the toponymic and anthroponymic system of the story, the protagonist is named 'Alba d'Oltrevita' and her villa is called the 'Castle of Illusion'. And the main male character's name, Tristano, refers, significantly, to Wagner's *Tristan und Isolde*, a reference also for Fausto Maria Martini's poem and Pietro Mascagni's music. There are, then, two aspects in particular that draw on the canon of symbolist aesthetics: the connection between characters and the natural world and the presentation of reality as a 'forest of symbols'.

Countess Alba's story develops in conjunction with nature. It is marked by the rhythm of the seasons: springtime celebrates her return to youth while autumn arrives after the re-appearance of her

first wrinkle. In this identification with seasonal rhythms, different natural elements often recur as symbolic motifs. In particular, flowers form a dominant presence during Alba's adventure and are objects whose significance diva films take from the late nineteenth-century literary, figurative and operatic tradition. In the first part of the film, the parties at the Castle host an explosion of flowers; the images recall analogous iconographic motifs recurrent in Borelli's films such as *Malombra* directed by Carmine Gallone (1917) or *Carnevalesca* directed by Amleto Palermi (1918). Other flowers reappear to emphasize key moments of the story. They represent the love triangle and the development of Sergio's jealousy when the rose Alba gives to Tristano provokes Sergio's reaction. They accompany the devil when a close-up shows Mephisto's face appearing amidst a bouquet of roses. And, above all, flowers represent Alba's return to love. When she decides to open the door to Tristano, she asks for the best flowers from her garden.

Among the scenographic elements, great emphasis is placed on mirrors. If the satanic deal is signed around a small mirror, other reflective surfaces return to emphasize the breaking of this deal. Necessary for the plot, these reflective surfaces enhance Borelli's performance. In the final sequences, a play of mirrors starts a slow movement of Alba toward Tristano, or better, toward the devil. Lyda Borelli covers her face with a white veil and a series of reclined mirrors multiplies her images. In a complicated image, her upper body appears, disappears, and is doubled. A significant play of light accentuates this effect, recalling the attention to Borelli's veil – an object that takes on a greater role in the following shots. Borelli walks slowly, opens her arms and lets her veil wave in the wind imitating the shape of a butterfly, recalling two butterflies from a close-up inserted in between images of Borelli. Borelli's veil remains present on her final walk, standing out in a silhouette effect typical of Nino Oxilia's films.

Irene Lottini

Tontolini is Sad

Tontolini è triste

Studio/Distributor:
Cines (Rome)

Producer:
Cines (Rome)

Duration:
7 minutes

Synopsis

Disappointed by love, Tontolini sits in his living room unable to shake off his depression when he receives a letter from the doctor prescribing distractions and entertainment as a cure for his sadness. Tontolini decides to accept the doctor's advice and goes to the theatre. But a moving drama is played on the stage and Tontolini, particularly sensitive to such things, begins crying desperately. Once he leaves the theatre, he follows a crowd and goes to a circus but when some spectators, disappointed by the clowns' performances, try to beat them, Tontolini has to leave again. He then enters a movie theatre. On the screen a comic film starring Tontolini himself is playing. The Tontolini spectator progressively begins smiling and laughing until a last irrepressible burst of laughter finally cures his sadness.

Genre:
Comedy

Cast:
Ferdinand Guillaume (Tontolini)

Year:
1910

Critique

Self-referentiality is a dominant element in early Italian comedies. As with other comic characters, Ferdinand Guillaume often settled his adventures in the new world of which he was part. Tontolini and Polidor's comic series propose episodes in which Tontolini/Polidor focuses his destabilizing and parodic action on different aspects of the cinema. Sometimes he attacks the new professional world of the film industry, as in *Tontolini scrittore di soggetti cinematografici/Tontolini Writes for the Cinema* (1911). Sometimes he parodies other successful cinematic characters, as in *Tontolini Nerone/Tontolini as Nero* (1910) which references the film *Nerone* directed by Luigi Maggi (Ambrosio, 1910), or in *Polidor Za la mort* (1917), a sarcastic response to the popular character played by Emilio Ghione. But, above all, this self-referentiality focuses on Tontolini/Polidor himself, proposing gags that refer to the character's typical facial expressions, costumes or moves. In *Polidor si fa la réclame/Polidor Makes Himself Known* (1912), the character's image is multiplied by the promotional flyers Polidor spreads around the city. In *Polidor in pericolo/Polidor in Danger* (1913), Polidor escapes from an insane man and reaches 'his' studios which are covered in his pictures. In *Polidor Apache/Polidor as an Apache* (1912), he is requested to prove his real identity as a popular actor and does so by performing his characteristic move: the somersault.

Tontolini è triste (1911) represents a climax in this auto-reflexive representation of popularity. Here, Tontolini's success is considered from the angle of the relationship between cinema and other media. This film celebrates, first of all, Tontolini's powerful character. When nothing seems to help him, Tontolini is healed by one of his own comedies: a typical comic film in which he performs his gags, breaking all the furniture and doing one somersault after another. But on a second level, this comedy also celebrates cinema – and particularly comic cinema – as a relaxing and collective entertainment. The representations of Tontolini's different spectatorial experiences and the audiences' different reactions confirm cinema as a co-participated phenomenon. Contrary to what happened at the theatre or at the circus, in the movie theatre, Tontolini shares his laughter with the other spectators.

Irene Lottini

Too Beautiful!

Cretinetti che bello!
Aka Troppo bello!;
Cretinetti troppo bello;
Cretinetti vittima della sua bellezza; Cretinetti e le donne; Tutte amano Cretinetti.

Synopsis

After receiving an invitation to a wedding, Cretinetti gets dressed up for the ceremony: he smugly wears an 'elegant' suit, long pointed shoes, an enormous top hat, a walking stick, and gaudy make-up. As soon as he leaves his house, no woman can resist his sex appeal. He is chased by his doorwoman, an ice-cream seller, a nanny who abandons her baby and her current lover, and by two other women who see him walking down the street. When

Studio/Distributor:
Itala Film (Turin)

Director:
André Deed

Duration:
4 minutes

Genre:
Comedy

Cast:
André Deed

Year:
1909

Cretinetti reaches the wedding reception, even the bride and all the other ladies attending the party begin to chase him. He runs, followed by a growing flock of female admirers who, eventually, catch him and dismember his body. But when these women leave horrified, Cretinetti's limbs magically reassemble.

Critique

Among the numerous Cretinetti comedies produced by Itala, *Cretinetti che bello!* offers a good representation of André Deed's variegated character. The comic potency of its simple plot is based on a paradoxical situation that combines different elements of early Italian comedies and especially Cretinetti's comedies. As a topic of early comedies, the comic character disturbs and destabilizes the codes and rituals of contemporary bourgeois Italian society: male/female roles and relationships, the work ethic, the wedding ceremony, the institution of marriage. In this erotic chase which reverses traditional gender roles, a doorwoman leaves the apartment building she is attending, an ice-cream seller destroys her ice-cream cart, a nanny abandons the child she is nursing, and a newlywed bride leaves her wedding reception and her husband.

This chase is also a celebration of the *poursuite* (pursuit) and its consequent destructions, motifs that, following French models, determine the instinctive and corporeal comic aspect of Italian comedies. Chases including clashes, pratfalls, and a constantly-growing number of pursuers often recur in Cretinetti's comedies such as *Cretinetti ha rubato un tappeto/Foolshead has stolen a carpet* (1909), *Cretinetti re dei ladri/Foolshead, King of the Robbers* (1909), *Come Cretinetti paga i debiti/Foolshead Pays his Debts* (1909), *Cretinetti re dei reporters/Foolshead, Chief of the Reporters* (1910), *Cretinetti nella gabbia dei leoni/Foolshead in the Lion's Cage* (1910), *Cretinetti agente di assicurazione/Foolshead, Insurance Agent* (1911).

In *Cretinetti che bello!* the *poursuite* ends in a catastrophic – but not irreparable – final act. Cretinetti's initial confidence and narcissism result in a disintegration/reintegration of his body that recuperates a topic of Méliès' trick films such as *Un home de tête/Four Heads are Better than One* (1898), *Nouvelles luttes extravagantes/The Fat and the Lean Wrestling Match* (1900), *Chirurgie fin de siècle* (1902), *Tom Tight et Dum Dum/Jack Haggs and Dum Dum* (1903). As with other comic masks, Cretinetti elaborates upon his previous work by introducing some elements of the *scène à transformation* of French comedies and evolving the trick of dismemberment performed in Méliès' *La dislocation extraordinaire/An Extraordinary Dislocation* (1901), in which he detaches his limbs and his head and sends them to pick various objects up until the different parts re-attach and recompose the entire body.

Irene Lottini

NEOREALISM

There are two political statements which demarcate the origin and closure of the initial era of neorealism. The first is of Vittorio Mussolini, son of Il duce, storming out of a screening of the poverty-ridden crime-drama of Ossessione (Luchino Visconti, 1943) with the insistence that 'This is not Italy!' The other was made by the Christian Democrat MP Giulio Andreotti in a letter to film-maker Vittorio De Sica. In defending his censorship laws that were killing off the movement's critical edge, Andreotti claimed that De Sica had 'rendered a poor service to his country if people throughout the world start thinking that Italy in the twentieth century is the same as [his 1952 film] Umberto D.'

The former incident occurs during the war and Fascist dictatorship. The latter is a product of the post-war Christian Democrat restabilization of Italy, and after two years of military occupation, the Partisans' anti-Fascist struggle and the liberation of the country, and during the social and economic problems of post-war reconstruction. If perhaps apocryphal, the Mussolini story is at least well invented for, together, the quotes place neorealism as a political challenge to the Italian social system whether dictatorial or democratic. They indicate that at stake was a battle over the role of national culture itself in defining Italy.

Although they had to gain success at international film festivals first, Roma città aperta/Rome, Open City (Roberto Rossellini, 1945), about a Communist and a Catholic who join the Partisan struggle to rid Rome of the Nazis, and Sciuscià/Shoeshine (Vittorio De Sica, 1946), about two shoeshine boys struggling unsuccessfully against poverty and imprisonment, were critical sensations. They heralded a period of film-making that was opposed to the fascist rhetoric of national wellbeing, and different from the studio-bound conventions of classical cinema.

What most made neorealism seem like a revolutionary change in cinema was the seriousness with which it took the aim to record real life. Neorealist films were set on location in the streets and fields where its protagonists lived and worked, and often used non-professional actors speaking in dialect. Neorealism's mimetic realism, seeking to look like the actual world from which its stories were drawn, was developed through prominent moments of long takes, deep focus, and episodic digressions which seemed to record an environment which existed before, and continued beyond, any film-maker's attempt to capture it.

The reason for this urge to document reality can be found in an insistence during the neorealist period that cinema mattered, both artistically and socially. Neorealist film-makers sought to discover the authentic Italy, to be found in the inclusion of real locations and of characters who were weakened and uncertain. Authenticity was guaranteed by a direct relationship to an environment either through the physical labour of the worker, the economic dependence of women, children and the unemployed, or the hand-to-mouth existence of the petty criminal. The image of an authentic, suffering Italy also allowed a reconstruction of the national image into that of a working and peasant population pre-existing and opposing Fascism and its rhetorical bombast. In keeping with its influence

Left: *Bitter Rice/Riso amaro*, Lux/De Laurentiis.

from *verismo*, the turn-of-the-century Italian variant of naturalism, neorealism offered an unsentimentalized look at the locales, habits, rituals, song, and entertainments that characterize popular life. Anticipating the later influence of Marxist literary critic György Lukács in Italian cinema, it offered protagonists on whom historical and political questions centre and form dramatic conflicts.

While techniques such as location shooting and even an interest in the ordinary person from the street were not as new to cinema as mythology surrounding neorealism would have it, freshness lay in the adoption of newspaper values of chronicling and campaigning on matters of immediate public interest. Titles such as *Roma città aperta* or *Roma, ore 11/Rome 11:00* (Giuseppe De Santis, 1952), precisely designating time and place, indicate dramatizations of real events; more common were tales of unemployment and banditry, of poor housing and official neglect, that could make up an item in any hypothetical newspaper. For principal neorealist theorist Cesare Zavattini, scriptwriter for De Sica's principal neorealist films amongst many others, events were sought that might not even be important enough to fill a few lines in a newspaper, but which highlighted the poverty and social relations that could give small events – such as the simple theft of a bicycle in *Ladri di biciclette/Bicycle Thieves* (1948) – vital importance.

Zavattini names this dramatic strategy *pedinamento*, or shadowing, discarding dramatic action to unobtrusively follow small incidents. *Pedinamento* was exemplified in *Umberto D* in a famous scene that lingers on the maid making coffee – the sequence has no dramatic importance, but instead refocuses attention on what is everyday in life.

Neorealism thus mattered not only in debate over Italy's post-war future but also because it enabled opportunities to explore the very relationship of cinema to reality. For French critic André Bazin, what was important was how cinema conveys the experience of reality: marked by ambiguity, continuity and spontaneity, neorealism's breakthrough was its emphasis on the process of revelation. Although a film such as *Stromboli, terra di Dio/Stromboli* (Roberto Rossellini, 1950) is not directly concerned with immediate social issues, it is constituted by a series of revelations made to its protagonist, and therefore the audience: the way of life of Sicilian fishermen, a volcanic and apparently pre-historic landscape, and a spiritual awakening. The revelation of previously unseen aspects of the world is found in the importance in neorealism of an often haphazard and bewildered journey: a soldier returning to Turin from a POW camp to his bombed-out home in *Il bandito/The Bandit* (Alberto Lattuada, 1946); a man and his son in search of a stolen bike through Rome in *Ladri di biciclette*; Sicilian immigrants in search of work northwards through the peninsula in *Il cammino della speranza/Path of Hope* (Pietro Germi, 1950), for example.

In a later development of Bazin's phenomenological interest in the experience of reality that cinema offers, Gilles Deleuze saw neorealism as marked by a new perception of time and movement which was disoriented and uncertain in the wake of the horror of wartime destruction. Such critical theory positions neorealism decisively within European art cinema, which was, however, to develop by questioning the very basis of neorealism: the ability of cinema to capture reality at all. The French New Wave and Italian film-makers like Bernardo Bertolucci and Pier Paolo Pasolini (see *Accattone* [1961] review below) were driven by a politicized will to debunk the claim that artworks objectively present reality; film is not a reflection of the world but a recreation and construction of the illusion of a world.

Historically, debate over neorealism has been structured by the perception of a series of overlapping failures: a failure to succeed in delivering unmediated truth, or to reach a popular audience or, alternatively, a failure of subsequent Italian film culture to live up to the cinematic high-point represented by neorealism. Such pessimism is perhaps already the predominant mood within neorealist films themselves (even the Communist-made *Caccia tragica/Tragic Pursuit* [Giuseppe De Santis, 1947] places its victory for the

collective at the film's end, concentrating for the duration of the narrative on the personal misfortunes of its proletarian protagonists). The focus in neorealism is primarily on suffering and dramatic defeats (also when, as with *Roma città aperta*, the historical referent – the Partisan struggle – was one of eventual victory). Neorealism's focus on suffering can be seen as much as a Catholic lamentation for the ills of the world as a Marxist exhortation to social change.

And so, finally, one can ask whether neorealism, its pitying gaze frequently rejecting popular pleasures, mattered to the masses it aimed to represent. Yet the alleged unpopularity of neorealism is itself a critical construct, with the commercial failures of *La terra trema/The Earth Trembles* (Luchino Visconti, 1948) and *Umberto D* taken as emblematic rather than the popular successes of *Riso amaro/Bitter Rice* (Giuseppe De Santis, 1948) or *Vivere in pace/To Live in Peace* (Luigi Zampa, 1947). Suggestion that such works gained their popularity by an impure or traitorous contamination of neorealism would obscure that popular modes are central to neorealism: whether in Ricci's dramatic failure in front of his son at the end of *Ladri di biciclette*, the comedy that conveys popular anti-Nazi sentiment in *Roma città aperta*, or the fittingly melodramatic death of Pina in the same film. It is precisely through such heightened drama – further examples being found in the glittering stolen necklace in *Riso amaro*'s gangster narrative, the comic attempts to hide two escaped GIs in *Vivere in pace*, the dramatic underworld of vice and prostitution in *Il bandito* – that an opposition to poverty, violence and oppression are expressed.

Neorealism was not a conscious movement, and no convention occurred to determine its constitution except imperfectly and in retrospect. After neorealism, however, classical cinema's studio-bound artifice became immediately archaic. In Italy, location shots of city environments and tales of humble people in difficulty give a 'popular neorealist' feel to star vehicles like *La vita ricomincia/Life Begins Anew* (Mario Mattoli, 1945) and *Catene/Chains* (Raffaello Matarazzo, 1949) or the 'rosy realism' of comedies such as *Pane, amore e fantasia/Bread, Love and Fantasy* (Luigi Comencini, 1953) each reviewed elsewhere in this volume. It gave a language of low-budget film-making to subsequent cinema movements which found their voices during times of revolt and/or decolonization from Brazil to Algeria and beyond. It was the origin and reference point for post-war art cinema, a redefinition of how reality can be documented, and a challenge to filmic style that forever altered the conventions of cinema.

Louis Bayman

Accattone

Production Companies:
Arco Film
Cino del Duca

Distributor:
Brandon Films

Director:
Pier Paolo Pasolini

Producers:
Alfredo Bini
Cino del Duca

Screenwriters:
Pier Paolo Pasolini
Sergio Citti (additional dialogue)

Cinematographer:
Tonino Delli Colli

Editor:
Nino Baragli

Art Director:
Flavio Mogherini

Duration:
115 minutes

Genre:
Drama

Cast:
Franco Citti
Franca Pasut
Silvana Corsini
Paola Guidi

Year:
1961

Synopsis

Vittorio 'Accattone' Cataldi is a low-class pimp living in the inner city slums of Rome. He spends his days killing time in cafes and bars with his friends and attending to his small group of prostitutes, one of whom, Maddalena, he lives with in a small house alongside another woman and her many children. When Maddalena is beaten up by a gang, she finds herself in jail, and Accattone turns his attentions to a new woman he meets named Stella. He tries to make her into a prostitute but, soon after reluctantly agreeing to go on the street, she is picked up by a man with whom she refuses to have sex, and is left in despair. However, Accattone comforts her and allows her to move in with him. He then finds work in manual labour but, after finding the job too intense and physically tiring, he gives up and decides fatefully to return to his previous criminal ways.

Critique

The 1960s was a highly significant, transformational decade in the history of Italian cinema, and it was at this opportune time that the infamous, once-censored poet and novelist Pier Paolo Pasolini moved away from his literary concerns and turned his voracious artistic attention to directing films. In so doing he made a film in *Accattone* that took one of the most decisive steps toward affecting a new mode of cinema for a new era in Italy, one of capitalism and consumerism against which Pasolini so vehemently reacted.

That this mode should be concerned with realism and representation should perhaps come as little surprise less than ten years after *Umberto D* (Vittorio De Sica, 1952) had brought the curtain down on neorealism. But despite ending with a scene in which its desperate, driven protagonist steals a bike and is briefly pursued by a crowd through the streets of Rome, the realist aesthetic of *Accattone* owes little to *Ladri di biciclette/Bicycle Thieves* (Vittorio De Sica, 1948) and its ilk. Indeed, in spite of his forceful statement that he wished to turn his back on literature and language as a means of renouncing his nationality (which he saw as corrupted by the bourgeoisie), Pasolini in fact drew heavily on the dialectical style and idiomatic experimentation contained within his writing (especially his 1959 novel *Una vita violenta/A Violent Life*). That is, *Accattone* is not realistic merely in the sense of phenomenological acuity. Rather, it is about realism and reality, the extent to which it can be shaped and conditioned, created and interrogated, as opposed to existing as a given, an *a priori* fact that is simply captured on film. It is presented rather than represented, and in this capacity defines the horizons of Pasolini's early work in the first half of the decade.

There is thus a thematic as well as a stylistic engagement with reality in *Accattone*. There are overt markers of denotative naturalism, most obviously in the twin, patterned scenes filmed entirely in a single take in which Accattone walks with different women.

However, these shots contrast with the presentational style in evidence elsewhere, especially in the numerous scenes featuring the men with whom Accattone associates. A number of scenes begin with the said group, making of these characters both a social microcosm and something of a theatrical chorus that is used to pass comment on a particular action or character. Accattone's position with regard to this collective is ambiguous, though; they turn on him in an instant when he is seen to defy their inherent code of conduct, and in fact are explicitly juxtaposed with the police in that both demand a straightjacket for the protagonist when his behaviour threatens to become violent.

Accattone the character is thus more complex than simply being representative of a social class, as neorealist protagonists often tend to be. Indeed, he is rarely depicted as a social being at all, certainly beyond an early scene in which he breaks down in floods of tears like a disaffected child. His own situation, his reality, is more openly multivalent than is the case in neorealism, able as he is to shape his small corner of the world. And even if, as with the protagonist of Luis Buñuel's comparable *Los Olvidados* (1950), the outlets for this agency seem ritually circumscribed, then this reinforces the view that it is only within a personal code of conduct that Accattone lives and dies.

Adam Bingham

The Bandit

Il bandito

Studio:
Lux-RDL

Director:
Alberto Lattuada

Producer:
Dino De Laurentiis

Screenwriters:
Alberto Lattuada
Oreste Biancioli
Mino Caudana
Ettore Maria Margadonna
Tullio Pinelli
Piero Tellini

Cinematographer:
Aldo Tonti

Art Director:
Luigi Borzone

Synopsis

Wartime buddies, Ernesto and Carlo, return to Turin from a German POW camp. Widower Carlo heads to his country home to be reunited with his young daughter Rosetta, but Ernesto is less fortunate. Appalled by the inhuman bureaucratic treatment of returning POWs, he becomes increasingly angry as he finds that his mother has died in a bombing, and eventually discovers his sister Maria in a brothel. In the ensuing fight with her pimp, Maria gets caught in the crossfire and dies. Ernest kills her murderer and a *carabiniere*, and goes on the run. Taking up with a criminal gang, which centres on the glamorous and irresistible Lidia, Ernesto lives as an outlaw. However, his values trouble the gang, as he attempts to execute a rough kind of justice that the Italian state appears to lack by defending the poor and pursuing the rich. When an impatient Lidia betrays them, the criminals flee into the mountains, where, to his horror, Ernesto realizes that the car they have hijacked, whose driver they have killed, contains Carlo's daughter Rosetta, still alive. Forcing the gang to leave him behind, he sets out to return Rosetta to Carlo, which he manages to do, risking capture, or worse, at the hands of the police.

Editor:
Mario Bonotti

Duration:
78 minutes

Genre:
Neorealismo nero

Cast:
Amedeo Nazzari
Anna Magnani
Carla Del Poggio

Year:
1946

Critique

Redefinitions of neorealism (Wood 2005) have finally recognized *Il bandito* as one of the finest achievements of that period. The film's recourse to elements of noir and melodrama, firmly rooted in the ruins of postwar Turin, produce a powerful critique of the failure to accommodate militarized masculinity. Ruth Ben-Ghiat has suggested (2005) that the returning POW was to become a scapegoat for the crimes of Fascism, and Lattuada's dramatization of this particular process is unique. As Ernesto (Nazzari) turns out to be his own worst enemy and is transformed from a returning hero into a dangerous bandit, our sympathy never leaves him. Unlike the greater intellectual objectivity towards which Rossellini, Visconti and Zavattini aspired, Lattuada was not afraid to use Hollywood-tested methods to keep his audience on board, restricting the linear narration to Ernesto and leading us to understand all the moral and psychological motivation behind any crime he does commit. The only murders we witness Ernesto undertake, for example, are of pimps, as revenge for his sister's exploitation. As a result, however, Lattuada is able to venture into much more radical and interesting political territory. If Antonio Ricci in *Ladri di biciclette/Bicycle Thieves* (Vittorio De Sica, 1948) looks on awkwardly at the weakness of the Italian police, Ernesto rages against the inhumanity of the bureaucratic machine with the power of a Christ in the face of the moneylenders. Ernesto's antiheroic death could be regarded as a cathartic sacrifice, but it is a tough message that ends the film with the unjust slaughter of the film's most sympathetic and only fully-developed character, played by one of Italy's most popular male stars, who, as box office success might suggest, made his mark.

Another unique aspect of *Il bandito* is the way in which the male character is defined primarily through his relations with women. In contrast to *Ladri*, which notoriously excludes Maria from the action early in the film, here it is the male friendship that is tied up in the opening ten minutes of the film: a homosocial bond of war that the return to normality must repress. Carlo can only remain a fond memory, and the two never meet again. The return to civilian life involves a re-engagement with femininity that is shown to be deeply flawed because it is based upon a monolithic vision of women as sexual objects. Ernesto's greed for 'a woman' is marked from the opening of the film as he talks greedily of 'ragazze', and then lingers over the poster of a bikini-clad showgirl, and the photo of a semi-naked Lidia (Magnani), which he finds in her purse. He becomes hastily embroiled with Lidia, as she oozes sex appeal in her feathery negligee, but she betrays him. Mary Wood has noted that 'it is very significant that Lidia goes unpunished' (Wood 2010), which she attributes to the strength of Magnani's star persona, but the film also underlines the existence of women beyond male imagination. This difference between projection and fact is reinforced when Ernesto follows a prostitute to a brothel, having failed to recognize her as his sister, and then indirectly causes her death. Ernesto is only finally allowed to rescue a woman when he

is forced to stop seeing her as a sexualized apparition. In this, the young girl plays a significant role: in one way, as Carlo's motherless daughter, she becomes a surrogate child joining the two men in their homosocial bond. However, like the other women in this film, Rosetta has a personality of her own, and is suspicious of her rescuer, flatly calling him a 'bandito'. If anyone is to inherit the good in Ernesto that postwar Italian society has otherwise failed to channel, it must be a young girl.

Danielle Hipkins

Bicycle Thieves

Ladri di biciclette

Production Company:
Produzioni De Sica

Distributors:
Ente Nazionale Industrie Cinematografiche (ENIC)
Arthur Mayer and Joseph Burstyn

Director:
Vittorio De Sica

Producers:
Guiseppe Amato
Vittorio De Sica

Screenwriters:
Cesare Zavattini
Suso Cecchi d'Amico
Vittorio De Sica
Oreste Biancoli
Adolfo Franci
Gerardo Guerrieri. Based on a novel by Luigi Bartolini

Cinematographer:
Carlo Montuori

Editor:
Eraldo Da Roma

Art Director:
Antonio Traverso

Duration:
87 minutes

Synopsis

Ricci, an unemployed man in post-war Italy, is given a job putting up posters. The work is dependent on his having a bicycle, requiring him to procure one that he had previously pawned. However, whilst engaged in his tasks the following day, Ricci's bicycle is stolen and, after reporting the theft to the police, he organizes a search with a friend in order to try and find it. Accompanied by his young son, they search fruitlessly among the city's bicycle sellers before Ricci believes he recognizes the thief and begins to look for him personally.

Critique

Although *Ladri di biciclette* was far from the first work of neorealism, it nonetheless remains a central, defining point of reference for the movement that changed the landscape of post-war European film-making. An actor and sometime matinee idol since the 1920s, De Sica had been directing commercial features for eight years when he came to *Ladri* (his ninth), and had already made two significant neorealist films in the form of *I bambini ci guardano/The Children are Watching Us* (1944) and *Sciuscià/Shoeshine* (1946). He was thus well placed at the end of the 1940s to employ a wealth of previous experience in order to make a film that feels almost like second-generation neorealism; one that often feels both calculated and calculating in its structure and effect.

Thus, just as *Ossessione* (Luchino Visconti, 1943) is marked by a proto-noir narrative blueprint and *Roma città aperta/Rome, Open City* (Roberto Rossellini, 1945) by the contrastive modes of thriller and melodrama, so De Sica balances writer Cesare Zavattini's ideal of cinema as a form of diary, recording the minutiae of daily life as it is lived among rack and ruin with a determinedly existential study of fate and the vagaries and limits of individual identity within society. To this end it is especially fascinating to see how the protagonist Ricci is, throughout the narrative, contrasted with different groups of people, at one remove from them rather than (as with the central figure in *Umberto D*, 1952) remaining resolutely one of them. The film's depiction of Ricci in this manner is framed

Genre:
Drama

Cast:
Lamberto Maggiorani
Enzo Staiola
Lianella Carrel

Year:
1948

by an opening scene in which his remoteness from his fellow casual labourers is physically stressed when he has to be found across the street in order to answer a call to work, and a bracketing final shot in which he literally disappears into a busy crowd as he walks forlornly home, minus his bicycle and his job. Between these twin narrative and thematic pillars – of singularity in success against commonality in despair – the character's quest is defined at every stage by his having to confront apathetic, at times openly hostile, groups. Each of these groups is comprised of characters whose commonality as such seems to define their identity, pointing to a humanistic import wherein personal togetherness in adversity can help in enduring and overcoming a crisis. It is a notion that is crystallized when Ricci's long-suffering young son grasps his father's hand as they melt into the crowd at the film's end, reminding one not only of De Sica's own child-centred neorealist works but also the end of *Roma città aperta*. All these pictures feature children who factor in a thematic in which the corruption of innocence (Ricci all but ignores his son) nonetheless becomes inextricably linked with a tentative hope for the future, with a view beyond the immediate for a country in a figurative state of infancy that craves national growth and development. For De Sica and Zavattini, this may mean little more than simple familial unity at the expense of all exterior precepts (even religion), but it offers a foundation upon which something more can be built.

Beyond this narrative and thematic dichotomy there is a rigorously-prescribed structure to *Ladri* that builds on a doubling of narrative motifs and situations to mark out Ricci's progression and personal development. The two rhyming scenes of bicycle theft embody this precept most clearly. But the repetition of visits to the fortune teller, where Ricci initially berates his wife for wasting money on such mystical nonsense only to repeat her trip when his situation becomes ever more desperate (and in which, intriguingly, he is offered a prophecy that immediately comes to pass), further reinforces the play of breached boundaries that marks out Ricci's desperation over the course of his cyclical journey. Ultimately, the film traces a voyage through Italy whose implicit postscript is that tomorrow and the next day ad infinitum the same camera could film the same streets and record similar stories featuring all-too-similar people in identical situations; and in this at least, *Ladri* is paradigmatic neorealism.

Adam Bingham

Bitter Rice

Riso amaro

Studio:
Lux

Director:
Giuseppe De Santis

Producer:
Dino De Laurentiis

Screenwriters:
Corrado Alvaro
Giuseppe De Santis
Carlo Lizzani
Franco Monicelli (uncredited)
Mario Monicelli (uncredited)
Carlo Musso
Ivo Perilli
Gianni Puccini

Cinematographer:
Otello Martelli

Art Director:
Carlo Egidi

Editor:
Gabriele Varriale

Duration:
108 minutes

Genre:
Crime/Romance/Drama

Cast:
Silvana Mangano
Doris Dowling
Vittorio Gassman
Raf Vallone

Year:
1948

Synopsis

It is the beginning of the rice-planting season, when thousands of women, named *mondine*, go to work the paddies along the Po in northern Italy. Two thieves, Walter and Francesca, are on the run and hide amongst the *mondine*. Francesca sets to work as a *mondina* but Walter hides in a barn storing the rice. Meanwhile they encounter Silvana, another *mondina*, and a suitor of hers, Marco, a left-wing soldier. The couples switch over, with Silvana attracted to the glittering stolen necklace in Walter's possession and Francesca becoming integrated with the other workers. As rainstorms break, and a *mondina* miscarries, Walter rapes Silvana, but this only brings her closer to the gangster who is now planning to steal the rice. Their plot involves flooding the rice-fields and ruining the work of the *mondine*, and comes to a fateful conclusion during the end-of-season celebrations where Silvana is crowned *Miss Mondina*.

Critique

Can sex and violence educate the workers? Such qualities rendered it unsurprising that the Vatican censors banned its flock from viewing this searing crime melodrama about workers' solidarity. But what dismayed communist film-maker Giuseppe De Santis was the left-wing vituperation which decried *Riso amaro*'s worldwide success as based on 'an immoral offence against the rice workers'.

Riso was intended to help create a popular, socially-conscious form of entertainment. A choral and epic basis is given to the inclusion of the folk rituals, everyday habits, and romantic fantasies of the hundreds of woman seen amongst the rice fields, with the struggle between official and clandestine workers occurring through spontaneous song. Compositions that recall icon painting are edited in ways influenced by Soviet montage. *Riso amaro*'s response to the question of whether popular entertainment can be an adequate vehicle for socially-committed documentation is thus this heady combination of styles, an artistic equivalent of the fundamentally collective vitality of the working class existence it represents.

The film is not without its own moralism, criticizing materialistic fantasies which draw the workers away from realizing their class interests. Silvana, a *mondina*, avidly reads the soap-operatic photostories of *fotoromanzo Grand Hôtel*, a bestseller that was sensationally popular with young women in post-war Italy. Such romantic weakness leaves her prey to gangster Walter (whose violent acquisitiveness is emblematic of capitalist competition). In contrast are Francesca, who leaves Walter's clutches to join the workers, and soldier Marco. Played by Raf Vallone, at the time a journalist on the Communist Party daily *L'Unità*, his character represents the possibility that after the Partisan Resistance the Italian army might become a popular militia (such radical hopes fading with historic events contemporaneous with *Riso*'s production, during which the Italian Communist Party moved into opposition and suffered decisive electoral defeat).

Marco acerbically comments that in America 'everything is electric, even the chairs', but *Riso amaro* is itself electrified by the American boogie-woogie to which Silvana dances and the gangster plot that leads it to its conclusion. Unlike Visconti's contemporaneous *La terra trema/The Earth Trembles* (1948), which also sought to forge a new radical popular culture, *Riso amaro* shares in the same pleasures as the people it aims to represent. Just as *Riso amaro* combines political criticism of America and of romance narratives with admiration for their popular appeal, so it seeks the impossible reconciliation of a folk culture of peasant song and ritual with the mass industrial medium of popular cinema.

The figure upon which the film's ambivalences centre is Silvana, played by Silvana Mangano who thus became the original *maggiorata fisica* – physically well-endowed female – and an instant star. What the pre-feminist, moralistic left saw fit to criticize at the time of the film's release was not the sexual objectification of its central female but the fact that *Riso* dared to offer the public the supposedly politically suspect experience of direct pleasure. Silvana's erotic charge combines with her status as a symbol of natural vitality. Returning to the earth in a local burial ritual at the film's conclusion, she achieves De Santis' aim (developed in the journal *Cinema*) of creating characters who are part of the natural landscape, and thereby representative of a genuine, popular and working-class Italy. The gender politics (undoubtedly not emancipatory) of the battle over Silvana's allegiance co-exist with her position as the film's central political and dramatic dynamic, making *Riso* an all-too-rare example of a political film directly addressed to women.

It is thus in its ambivalences that *Riso* achieves the vitality through which it engages with the dynamics of working class existence.

Louis Bayman

The Earth Trembles

La terra trema: Episodio del mare

Production Company:
Universalia

Director:
Luchino Visconti

Producer:
Salvo D'Angelo

Synopsis

A film about the conditions of work of fishermen in the Sicilian town of Aci Trezza, following their journeys out to sea early each morning and their anger at the local wholesalers who fix low prices for their catches. 'Ntoni, the eldest son of the Valastro family who has recently returned from army service in the mainland, seeks to end this exploitation and mortgages the family's modest home to buy a boat and set up independently. The enterprise is initially a success, and, buoyed by good fortune, the younger members of the family pursue various romantic interests. But when a storm destroys their boat, the family is left destitute, and shunned for their perceived arrogance by their fellow villagers. The grandfather falls ill; Cola, another brother, is persuaded by a shady figure to emigrate to make his fortune; and the rest of the family

The Earth Trembles/La terra trema, Universalia.

Screenwriters:
Antonio Pietrangeli
Luchino Visconti, based on the story 'I Malavoglia' by Giovanni Verga

Cinematographer:
GR Aldo

Editors:
Mario Serandrei

Duration:
160 minutes

Genre:
Drama

Cast:
Antonio Arcidiacono
Giuseppe Arcidiacono
Rosa Costanzo

Year:
1948

must depend for subsistence once again on the mercies of the triumphant wholesalers. 'Ntoni's faith in collective change remains unbowed.

Critique

Almost a manifesto film for neorealism, *La terra trema*'s intentions are stated at the end of the opening credits:

> A story of man's exploitation of man, set in Aci Trezza, Sicily. These are the houses, streets, boats and people of Aci Trezza. There are no actors; these are the inhabitants of Aci Trezza. They speak in their dialect to express their suffering and hopes. In Sicily, Italian is not the language spoken by the poor.

La terra trema's neorealist radicalism thus combines documentary values with political purpose. The use of Sicilian dialect not only records how such workers communicate but militates against their marginalization by centralized national structures. Director Luchino Visconti had been prevented by Fascist censors from filming the Sicilian *verist* author Giovanni Verga's *L'amante di Gramigna*. In these post-war circumstances, Visconti was able now to film Verga's

I Malavoglia, expanding the author's concentrated vision of rural Italian life with long takes of the daily habits of the fishing village, whilst adding the politics of Antonio Gramsci, founder of the Italian Communist Party and believer in the unity of the Southern peasantry with the workers' revolution.

La terra trema was initially intended as the first of three episodes (hence the title 'episodio del mare', episode of the sea) which would end in a victory led by the industrial working class, but its sequels were never to appear. On its own, the film shows the limits of peasant familism after a storm destroys the Valastro boat and, thus, their chance for financial independence. The Valastros' relationship with the elements is repeatedly emphasized and continual metaphors connect them to their natural environment, creating a sense of timeless suffering. As much as Marxist critique, the doom that befalls the family is the working of an inevitable dramatic fate.

La terra trema is not mere naturalistic description of an environment. It seeks instead to express rather less tangible aspects like social dynamics and, tantalizingly, the 'suffering and hopes' of the poor. Showing the decisive influence of Visconti's experience as a theatre and opera director, the film has a pictorial and poetic formalism that increases the realist use of landscape precisely by stylizing the dramatic situations. As the women wait at the shore during the fateful storm, they are seen in a series of longshots that present them as part of their environment, and yet also as a tableau, a signal of dramatic climax conventionalized on the nineteenth-century stage.

While providing a voice-over (narrated in part by then screenwriter Antonio Pietrangeli) for its non-Sicilian audience to understand, there remains a sense that *La terra trema* analyses its subjects from a distance. The long-shot, long-take style creates a detachment from identification with any individual in the film, favouring a broader, Marxist understanding of material and social reality, yet perhaps echoing the gruelling, thankless work of its subjects, *La terra trema* is an arduous 160 minutes. The only characters to realize their hopes are the agents of repression and exploitation: the town police chief and the wholesalers. The film did miserably at the box-office, and marked a defeat for a certain kind of neorealist denial of dramatic conventions.

Visconti (an aristocrat won over to the workers' cause by French film director Jean Renoir) remained, somewhat like 'Ntoni at the film's end, confident in future vindication, blaming the film's commercial failure on his audience which would be ready for such an experience only 'in ten years' time'. Visconti's (commercially successful) return to the subject of Southern workers twelve years later in *Rocco e i suoi fratelli/Rocco and His Brothers* (1960) does not resemble *La terra trema*, but is unrestrained melodrama. Nevertheless, *La terra trema* is the central monument to neorealism, its most radical point politically and artistically.

Louis Bayman

In the Name of the Law

In nome della Legge

Production Company/Distributor:
Lux Film

Director:
Pietro Germi

Producer:
Luigi Rovere

Screenwriters:
Mario Monicelli
Federico Fellini
Tullio Pinelli
Giuseppe Mangione
Pietro Germi, based on the novel Piccolo pretura by GG Loschiavo

Cinematographer:
Leonida Barboni

Production Design:
Gino Morici

Editor:
Rolando Benedetti

Duration:
101 minutes

Genre:
Drama
Western

Cast:
Massimo Girotti
Jone Salinas
Camillo Mastrocinque
Charles Vanel
Saro Urzì

Year:
1949

Synopsis

In a harsh Sicilian landscape, two bandits rob and kill a man driving a cart pulled by mules. Into this remote part of the country comes a young magistrate from Palermo, Guido Schiavi, posted to the small town of Capodarso. He makes his presence felt by investigating the killing, and soon finds himself up again townsfolk reluctant to cooperate, such as the Baron, who is dependent on the local Mafia chief Passalacqua for protection, and the Baron's wife, who warns Schiavi not to get involved. Only the chief of the Carabinieri, Grifò, resolves to help the magistrate. Schiavi's investigation leads him to uncover an issue surrounding the local mine, which has been closed by the Baron, inflaming the large number of unemployed in the community. Schiavi exerts pressure on the Baron's wife to re-open the mine but, in doing so, he incites unrest in the town and puts his own life in danger.

Critique

In nome della Legge is often considered to be a type of Sicilian Western. From the opening murder of the driver on the rocky terrain, and the moment a few minutes later when the new, young magistrate Guido Schiavi (Massimo Girotti) from Palermo arrives by train at the remote town of Capodarso, we are clearly in genre territory, in both senses of the term. The question for viewers is whether the film can stand alongside the best of the Italian cinema of the time or whether it proves simply a pale imitation of American forms.

Certainly, director and co-writer Pietro Germi, making his third feature film, had a self-professed love for those forms. Gian Piero Brunetta observes that '[m]ore than any of the other newcomers, Pietro Germi looked to the models of American cinema and sought to transplant them in an Italian context' (Brunetta 2009: 144). And *In nome della Legge* is a beautifully made drama, with fine contributions from many artists with whom Germi would come to work repeatedly, such as cinematographer Leonida Barboni and composer Carlo Rustichelli, whose score readily evokes the likes of Hollywood greats such as Dimitri Tiomkin and Miklós Rózsa with its stately chords and brassy drama.

The film, however, was not just an exercise in genre transposition. Mira Liehm has noted how '[u]sing elements of traditional action films, [Germi] strove to attract a wide audience to socially committed pictures' (Liehm 1984: 88). Germi's films certainly achieved large attendance figures – *In nome della Legge* was the third biggest Italian film of its year (as noted in Bondanella 2001: 35) – but critics have noted a disjuncture between the film's confident evocation of genre and its inability to engage effectively with the social conditions it purports to depict. Mario Cannella is one commentator who sees in the film a disappointing capitulation into conventional story modes. He acknowledges the film's precise establishment of its milieu and the sincerity of its ideological

stance, but asserts that 'because the starting point is so abstract, this kind of "enlightenment" position does not produce drama: it precludes a deep-going, dialectical explanation of real contradictions, and therefore *necessarily* slides into sentimentalism and melodrama' (Cannella 1973/74: 38).

Even in terms of pure entertainment, we may feel that the film's aesthetic pleasures are declared early on and do not really develop. For Cannella, the absence of grounded social critique in *In nome della Legge* means that, as the story progresses, 'the stylistic features – the American western and naturalistic sequences – are no longer sustained by a unifying passion for insight' (Cannella 1973/74: 38).

Liehm, however, offers a more positive reading of the film's genre accomplishments when she notes that 'this picture helped to uncover part of the hidden face of Sicily, a country torn apart by contradictory interests, poverty, and fear' (Liehm 1984: 88). And if *In nome della Legge* has an inescapable air of pastiche, Liehm observes nevertheless how Germi's imagery, showing the whiteness of the barren mountains as a protective barrier against the outside world, has since become a commonplace in Italian cinema – part of a code of signs along with the sinuous streets and dusty roads, the houses with closed shutters, and the villagers with inscrutable faces. In 1948, all this was new, and to capture it on the screen was an act of courage. (Liehm 1984: 88–9)

For all its faults, then, *In nome della Legge* is a sign of future wonders, for Germi's individuality, while a source of his inconsistent engagement with neorealism, would also prove to be his most distinctive quality.

Ed Lamberti

Miracle in Milan

Miracolo a Milano

Studio:
PDS (Produzioni De Sica) in collaboration with Enic

Director:
Vittorio De Sica

Producer:
Vittorio De Sica

Screenwriters:
Cesare Zavattini and Vittorio De Sica with the collaboration of Suso Cecchi D'Amico
Mario Chiari
Adolfo Franci

Synopsis

Beneath a cabbage in the garden beside her modest home, the elderly Lolotta finds a newborn baby, who she takes in. Little Totò grows up with the old lady, who teaches him the times table, geography, and manners. Some years later, Lolotta dies. After the funeral, Totò, still a child, enters an orphanage; on leaving as an adult, he looks for work. Within a few hours he is invited to stay overnight in a shanty town by Arturo, a tramp whom Totò has given his empty suitcase. Totò soon sets about instituting a more ordered and solid structure to the stacks of corrugated iron and cardboard boxes, and a set of civic regulations. The reconstruction sees participation triumph, but just when all the new lodgings have been assigned they are paid an unexpected visit by the entrepreneurs Brambi, the current owner of the land, and Mobbi, who is interested in buying it. At the thought of ringing cash registers, the deal comes off and the area is sold to Mobbi, who is at first prepared to indulge the presence of the tramps. However, during the

Cinematographer:
GR Aldo (Aldo Graziati)

Art Director:
Guido Fiorini

Editor:
Eraldo Da Roma

Duration:
100 minutes

Genre:
Comedy/Fantasy/Drama

Cast:
Emma Gramatica
Francesco Golisano
Paolo Stoppa

Year:
1951

encampment's opening party, oil beguns to gush from the ground: Mobbi and his people decide on eviction, but the tramps are ready for resistance.

Critique

Like a number of neorealist films, *Miracolo a Milano* has literary origins, being an adaptation of Cesare Zavattini's novel *Totò il buono* (1943). Coming after *Sciuscià* (1946) and *Ladri di biciclette* (1948) and before *Umberto D* (1952), *Miracolo a Milano* forms one part of the so-called 'neorealist tetralogy' created by the partnership of De Sica and Zavattini. The film displays many typical neorealist traits: the use of non-professional actors (including the part of Totò), some of them, like the tramps in the encampment, taken directly from the street; the use of location shooting for most of the film; the political decision to set the story amongst the poorest members of society and emphasize their collectivity, so that it is the crowd of tramps more than their leader that is the real antagonist

Miracle In Milan/Miracolo a Milano, Produzione De Sica.

to the landlord, who is often shot apart and isolated from the others. Furthermore, the story of the eviction and its resistance gives way to digressions, dead time, secondary and accidental episodes, such as the reciprocal gazes of the train passengers and the tramps or the growing attraction between the white girl and the black boy. The interest in childhood and the persistence of a candid viewpoint is one of De Sica-Zavattini's authorial signatures: Totò is an adult who has remained a child, just as the responsible and sharp Bruno Ricci in *Ladri di biciclette* was a child who had already become an adult.

Even if this confirms the film's realist vocation, there are many other elements that categorically negate it: Lolotta's ghost, the miraculous dove, the angels, the ballerina's statue that comes to life, the Méliès-style tricks and disappearing acts (the film's budget was mostly taken up by its special effects). These push the tale into the realms of the fantastic, and two of the commonest phrases used to describe the film are 'realist fairytale' and 'magic realism'. Some of the silent gags, such as the one involving the bucket of water and Edvige the servant girl, have a Chaplinesque flavour of slapstick, with Totò and Edvige reprising the roles of Charlie and the urchin from *Modern Times* (1936).

Miracolo a Milano was viewed with suspicion by critics for this brazen contamination of neorealism with other cinematic and theatrical forms (as well as the circus, comics, songs), rather than an insistent literalism. The film's rhetorical artifice is silently stated with the use of Pieter Brueghel's *Flemish Proverbs* over the opening credits, a painting which brings into play the precepts of popular wisdom (similarly, the film's first scene is an iconic representation of the folkloric image of the origin of babies). If neorealism in its purest phase did indeed make reality the principal subject of cinematic spectacle, *Miracolo a Milano* takes this literally: the sunset becomes a theatrical show, with places to sit and tickets for sale, while the dawn is the 'natural magic' that makes Edvige's wish come true. This extreme simplification is much more radical than the Manichean division between workers and capitalists, the gap between mathematical precision and the duplicity of advertising, or the corrupting power of money. The film's bravest goal is to approach things with wonder, as if they were being seen for the first time, and to use words like a child who has just learnt to pronounce them and give them meaning ('Brambi', 'Mobbi', 'Rappi' sound like the utterances that precede learning to talk). In this sense, the closing flight to the 'land where good morning really means good morning' is not an empty tautology but a concrete hope for renewal.

Elena Gipponi

Ossessione

Studio:
Industrie Cinematografiche Italiane

Director:
Luchino Visconti

Producer:
Libero Solaroli

Screenwriters:
Mario Alicata
Giuseppe De Santis
Alberto Moravia (uncredited)
Antonio Pietrangeli (uncredited)
Gianni Puccini, Luchino Visconti

Cinematographes:
Domenico Scala
Aldo Tonti

Art Director:
Gino Franzi

Editor:
Mario Serandrei

Duration:
140 minutes

Genre:
Crime/Romance

Cast:
Massimo Girotti
Clara Calamai
Elio Marcuzzo
Juan De Landa

Year:
1943

Synopsis

A drifter, Gino, shows up at a service station owned by Bragana and his wife Giovanna. An immediate attraction strikes up between Gino and Giovanna and they begin an affair while Gino briefly works for Bragana. After an abortive attempt at eloping, Gino departs alone. Riding a train, a stranger, Lo Spagnolo, offers to pay for Gino's ticket and the two begin a friendship. Whilst working in Ancona, Gino runs into the Braganas and decides he cannot live without Giovanna. They kill Bragana and make it look like a car accident. Although the police are suspicious they have no evidence against the pair, but guilt renders their relationship fraught. After an unhappy encounter with Lo Spagnolo and then a failed attempt by Gino to leave Giovanna for the arms of a dancer, Anita, their presumed innocence is under threat, until poetic justice intervenes.

Critique

The film that launched – in retrospective accounts – a new direction for Italian cinema was later described by its creators as originating from one principal impulse: an absolute opposition to Fascism. Director Luchino Visconti and screenwriters Mario Alicata, Gianni Puccini, and Giuseppe De Santis (himself soon to become a notable director) had been calling for a renewal of Italian cinema through truth and the realist representation of the national landscape in the pages of *Cinema* (a journal which was allowed some political latitude given the interest in cinema of Mussolini's son, Vittorio). Although only implicitly, they had thereby smuggled a leftist attention to the conditions of the masses into Fascist-era cultural debate. The world *Ossessione* represents is one of poverty and miserable alienation from authority: qualities picked up a few years later by neorealism as proof of a yearning for Italian cinematic culture to express opposition to the dictatorship.

The film is the second version of James M Cain's 1934 novel *The Postman Always Rings Twice* (after the French *Le dernier tournant/The Last Turn* (Pierre Chenal, 1939) and before two Hollywood versions). A drifter starts an affair with a service station owner's wife; together they get away with killing him, but fate pays them back for their murderous lust. *Ossessione* adds the figure of Lo Spagnolo, his comradely solidarity towards Gino edging into veiled homosexuality, an implication whose affront to fascist morality is compounded by the hint that the Spaniard is an anti-Fascist from the recently-ended Spanish Civil War.

The story's concentration on the detail of everyday life is far from bucolic idealization. Heat and hunger create an overwhelming materiality that adds to a presentation of desperate impoverishment to produce an atmosphere of cloying sensuousness. Giovanna fondles Gino in bed after the two make adulterous love; sweat stains Gino's vest while Giovanna clutches herself as if inexplicably cold.

Such a frank tale of crime amongst the lower orders draws on the vivid sensationalism of 1930s US crime writers but also on another trend of pre-war realism, that of French Poetic Realism, already suggested in the reference to *Le dernier tournant* and to which Visconti had contributed in his cinematic apprenticeship in pre-war France with Jean Renoir. The plains around Ferrara and the bustle of the city figure prominently, and the film's central conflict is between a poor but open-air freedom and the imprisonment that Gino's attachment to Giovanna signifies. Yet despite an often dramatic stylization, the environment is not poeticized, the unforgiving sunlight of its marsh-ridden barrenness offering no redemption as the working class characters develop not solidarity but mutual mistrust.

Ossessione suggests a convergence between Poetic Realism, Film Noir, and neorealism, three different cinematic interpretations of the crisis of the moral and social landscapes of the 1930s and 1940s. The closing shot of Gino's tearful face evokes a vulnerable masculinity observable in the other commonly-cited wartime precursors to neorealism *Quattro passi fra le nuvole/Four Steps in the Clouds* (Alessandro Blasetti, 1942) and *I bambini ci guardano/The Children Are Watching Us* (Vittorio De Sica, 1944), which with their shared interest in daily life appeared to challenge the bombast of Fascist rhetoric. And yet unlike post-war neorealism *Ossessione* could neither directly analyse social conditions nor invest its hopes in the active unity of the workers. While Visconti was to do precisely this with the paradigmatic neorealist work *La terra trema*, the absence of a direct Communist critique is here the starting point for something else, actually more constant across Visconti's work: a passionate recreation of the desire which can draw two souls together, but only in an all-consuming, even fatal, isolation.

Louis Bayman

Paisan

Paisà

Studio:
Organizzazione Film Internazionali and Foreign Film Productions

Director:
Roberto Rossellini

Producers:
Rod Geiger
Roberto Rossellini
Mario Conti

Synopsis

Six self-contained episodes. (1) A company of American GIs arrives at a Sicilian village. They take a local girl, Carmela, as a guide, who is left with Joe in a ruined castle. Joe is shot by a German sniper; Carmela retaliates and is also killed. On their return, the Americans find Joe's body and assume that he was killed by Carmela. (2) In Naples, a street urchin steals the boots of a black GI. Later, the GI catches up with the boy and takes him back home to recover his boots; yet 'home' turns out to be a squalid shanty town, and the child's parents are dead. (3) Six months after the Allied liberation of Rome, an Italian woman picks up an American soldier. In bed, he recalls a woman he fell in love with after the liberation and with whom he subsequently lost touch; the same woman he is currently with, but does not recognize. (4) An English nurse and her Italian friend attempt to cross the occupied north side of

Screenwriters:
Sergio Amidei
Federico Fellini
Roberto Rossellini
Rod Geiger
Alfred Hayes
Klaus Mann
Marcello Pagliero

Cinematographer:
Otello Martelli

Editor:
Eraldo Da Roma

Duration:
126 minutes

Genre:
Drama/War

Cast:
Carmelo Sazio
Maria Michi
Gar Moore
Harriet White
Dale Edmonds

Year:
1946

Florence in search of her lover, a partisan. After taking a treacherous path across the city they discover that he is already dead. (5) Three American chaplains – a Catholic, a Protestant, and a Jew – take refuge in a Franciscan monastery. (6) A series of skirmishes between Italian partisans and German soldiers in the Po Valley.

Critique

On its release, *Paisà* was neither as commercially successful nor critically acclaimed as Rossellini's earlier film, *Roma citta aperta/ Rome, Open City* (1945). Nevertheless, it has since gained canonical status and arguably remains a paradigmatic example of neorealism's fundamental characteristics as they have since been understood. In addition to the use of non-professional actors and location shooting, it was above all the film's portmanteau structure that allowed Rossellini to break with the dominant narrative values of both Hollywood and the pre-war Italian cinema, rejecting linear plot development in favour of character, mood and setting. The film is composed of a series of six thematically-related episodes or vignettes that are connected together with newsreel footage. This generates a sensation of immediacy, of real events unfolding onscreen, that defines the film's modus operandi; as Rossellini put it, the desired effect was that *Paisà* should appear 'neither completely fictional nor absolutely true.'

The six segments trace the movement of the Allied troops during the liberation of Italy. Taken individually, the episodes are slight, even inconsequential. Yet, like well-crafted short stories, they offer up brief moments of contemplation, understanding, or even epiphany. As such, the strength of the film lies not in the unfolding of plot but rather in the power of individual instants or images: a drunken African-American GI singing a spiritual among the bombed-out rubble of Naples; a dead partisan floating along the reed beds of the river Po. Perhaps not coincidentally, the episode that has worn the least well is also the most conventional, and the contrived plotting and sentimentality of the Rome segment feels at odds with the stark naturalism offered by some of the other pieces.

Taken together, the six episodes map a physical journey up through war-torn Italy, from Sicily and Naples, to Rome, Florence, and the rural northern settings of the final two segments. Place and location are paramount, from the indelible imagery of historic Italian cities reduced to rubble-strewn voids and waste grounds, to the bleak desperation of the film's final sequence, in which a group of partisans are executed by German soldiers in the desolate, low-level landscape of the Po Valley. Often, war transforms habitual coordinates: for example, in the Florence segment, the Uffizi Gallery is changed from historic landmark or repository of cultural treasures into a strategic point at which to cross the Arno.

Each episode probes a different aspect of the film's central themes – problems of communication, language and understanding and the encounters across cultural divides thrown up by displacement – which are at once rooted in the immediate context of war but are also, for Rossellini, unavoidable aspects of a

wider human experience. Indeed, such concerns would be further explored in Italian films of the 1950s and 1960s, notably Rossellini's own *Viaggio in Italia/Voyage to Italy* (1954). *Paisà* is also fundamentally a film about the relationship between the United States and Italy, and this series of encounters between the American GIs and the Italian people and culture anticipates the complex and problematic transnational exchanges that would shape both Italy and its cinema in the decades to come.

Lawrence Webb

The Railroad Man

Il ferroviere

Production Companies:
ENIC – Ponti-De Laurentiis

Distributor:
ENIC

Director:
Pietro Germi

Producer:
Carlo Ponti

Screenwriters:
Pietro Germi
Alfredo Giannetti
Luciano Vincenzoni, from a story by Alfredo Giannetti

Cinematographer:
Leonida Barboni

Art Direction:
Carlo Egidi

Editor:
Dolores Tamburini

Duration:
118 minutes

Genre:
Drama

Synopsis

Andrea Marcocci is a train driver with a wife and three children; he is seemingly happy, but events will put him and his family under pressure. One day, a young man steps in front of Andrea's train, and Andrea can do nothing to avoid hitting him. Later, having a drink of wine to still his shattered nerves, Andrea crosses a red light and almost causes a fatal accident with another train. He is hauled up in front of the committee and suffers humiliation at work. Meanwhile, his children are having a hard time themselves. His eldest, Marcello, is reluctant to try to get a job, his daughter Giulia falls pregnant and finds herself in an unhappy marriage to Renato. Meanwhile, Andrea's youngest, the impish Sandrino, while clearly bright and a good child, is letting his schoolwork suffer and starting to make trouble. Andrea's wife Sara, meanwhile, is cracking under the strain of trying to support her loved ones. The film follows Andrea and his family over the course of a year, from one Christmas to the next, as they battle heartbreak, unemployment, marital strife, industrial action, and the pressures of a job which has become increasingly uncertain.

Critique

Pietro Germi's 1956 feature *Il ferroviere* is a humane and engaging drama in which the film-maker excels both behind the camera and in the lead role of Andrea Marcocci, railroad and family man who suffers a loss of confidence and dignity at work and whose family is going through crises at every turn. There are, in a sense, two close-knit groups in the film – Andrea's family and his work colleagues – and the film shows how easily things can fall apart in both camps as a result of wounded pride and lack of communication.

This is where the film comes into its own, in its interweaving of the worlds of work and family life. It packs a lot of story into its two-hour running time, primarily because it cares about all of its characters. The events are seen largely through the eyes of the family's youngest member, Sandrino, played by Edoardo Nevola in a terrific child performance: he provides many of the film's lighter moments but is also the unwitting catalyst for some of its most

Cast:
Pietro Germi
Saro Urzì
Edoardo Nevola

Year:
1956

dramatic developments. And if the film's pleasures are essentially derived from standard melodrama, excessive emotionalism is generally kept at bay: *Il ferroviere* has an assured command of tone, shifting from conflict and even tragedy to lighter moments, such as the scene near the start when Andrea and his workmates sing a joyous song together in a bar on Christmas Eve. Here and elsewhere, the film conveys a warmth and love of life that no amount of sentimentalizing can dispel.

Nevertheless, the concentration on the relatively insular world of family makes for an uneasy relationship with the neorealist tradition from which the film, and its director, emerge. The film's social commentary is restricted to a dramatic landscape perhaps too narrow and paradoxically too generalized to speak effectively for Italian society. The abundant warmth and stylistic polish of *Il ferroviere* reveal clear limits to its ability to provoke the viewer into a recognition of real, ongoing social problems. And the film's treatment of Andrea's working conditions, as he crosses a picket line so as to earn money to support his ailing family, helps explain why, as Mira Liehm notes, Germi 'was referred to as 'the director of compromise' and his role in the neorealist movement was questioned' (Liehm 1984: 88).

That may be, however, to misrepresent the film's commitment to its own narrative. Andrea's defiance of the union in the film is a bitter comment on the notion of workers' solidarity, and his desperate brutalization of his family in moments of crisis certainly raises questions over to the film's depiction of masculinity, but in both cases it is too limiting to read Germi's stance as being unequivocally at one with the actions of his central character. There is a sense that Germi was never content to offer a *purely* topical portrait. Rather, one feels that he was always seeking to engage the public with stories that would have a mollifying effect both at the initial time of release and in the long term.

Il ferroviere can now be seen as an example of mid-period Germi, one of the trio, along with *L'uomo di Paglia/A Man of Straw* (1958) and *Un maledetto imbriglio/The Facts of Murder* (1959), of stylish dramas he made before his extraordinary turn towards dark, satiricial comedy in the 1960s. As such, it is perhaps somewhat overshadowed nowadays by the reputation of the later international successes; if this is the case, the film deserves rediscovery as a piece of sincere Italian drama and a work of great charm.

Ed Lamberti

Rome, Open City

Roma città aperta

Studio:
Excelsa Film

Distributor:
Minerva Film

Director:
Roberto Rossellini

Screenwriters:
Sergio Amidei
Federico Fellini

Cinematographer:
Ubaldo Arata

Art Director:
Rosario Megna

Editor:
Eraldo Da Roma

Duration:
100 minutes

Genre:
Drama

Cast:
Anna Magnani
Aldo Fabrizi
Marcello Pagliero
Francesco Grandjacquet

Year:
1945

Synopsis

Rome is under German occupation and, amidst the local population, the Partisans conduct the fight against the Nazis. Engineer Giorgio Manfredi, head of the military organization the Committee for National Liberation, is wanted by the Gestapo and hides in the home of a printer, Francesco, a member of the Communist party. Whilst there, he comes into contact with the Priest Don Pietro, who offers to help the Resistance. Francesco's fiancée Pina also lives in the apartment block: a widow and mother from a previous marriage, she is a proud woman of the people who faces her daily trials and tribulations with honesty and determination. On the morning of their wedding, the Germans surround the apartment building. Despite the solidarity and silent cooperation of the fellow apartment-dwellers, Francesco is arrested in the round-up and Pina is killed by rifle fire while desperately chasing after the jeep that is taking him away. With the help of an Austrian deserter, Manfredi and Don Pietro attempt to continue the Resistance mission but Manfredi's girlfriend, a revue actress seduced by enticements offered by the Nazi officers, informs on them. On their arrest, they face the ultimate price for their faith to the cause of the Liberation.

Critique

Like the subsequent *Paisà/Paisan* (1946) and *Germania anno zero/Germany, Year Zero* (1947), the first part of Rossellini's 'trilogy of war' observes the effects of the Second World War on ordinary people. The film ushered in the era of Italian neorealism, and the first element that signals an important break with the cinema of the past is its subject matter, which is drawn from real events. History resides in the everyday stories of the common experiences of the people of Rome: hunger, fear, patrols and curfews; the threat of torture by the Nazis; discontent over drawn-out hardship and overcrowded housing; widespread social problems and the measures necessary to survive them.

The interweaving storylines (Don Pietro, the militants, Francesco and Pina, the band of child Partisans, and the inhabitants of the housing block) form into a fresco. The choral aspect of the story corresponds to a new conception of the role of the actor; alongside professionals like Anna Magnani and Aldo Fabrizi, who abandon conventional acting styles to give a sense of merely 'existing' in front of the lens (despite some comic and melodramatic touches emanating from Fabrizi's origins in the theatre), appear non-professionals taken from the streets: their ordinariness is marked by a consonance between natural physical type and character, creating an apparent document of reality (this productive amalgamation of character and actor being much praised by André Bazin).

In contrast to the Gestapo officer in charge of 'scientific patrols' who – looking at photographs of wanted Partisans – claims to stroll through the streets of Rome without having to leave his office, Rossellini's camera searches the urban locality for its characters and their stories. People appear intimately bound up in their envi-

ronments and the location shooting reveals a ruined landscape. Instead of subjecting human beings and places to the demands of narrative and spectacle, Rossellini observes stories that seem to emerge naturally from the devastated, bombed-out city.

To adequately document this geographical, human, and social landscape destroyed by the war requires a new cinematic language. Of course, many conventional aspects of film grammar exist alongside more innovatory aspects: the economy of the narrative drive; the use of classical editing and generic conventions; the caricatured aspects of some of the minor characters such as the police sergeant and the sacristan. But the urgency of documenting real-life tragedy and of sticking to the events is manifested in the immediacy of the relation between fiction film and reality. The sense of authenticity to the artistic innovations of *Roma città aperta* comes from its attitude towards reality, its willingness (which Rossellini described as 'waiting') to let reality unfold before the camera rather than re-order it neatly to the dramatic necessities of the story. Rossellini allows chaos into the film's form, and in doing so finds new ways of making its action progress: the ending is left open, the link from cause to effect is slowed down, and space is given to the characters' smallest actions, allowing events to unfold according to their actual duration (as exemplified in the scene where Manfredi is tortured). Breaking apart the harmonious form of classical cinema, *Roma città aperta* brings to the screen the disorder of reality.

Maria Buratti

Stromboli

Stromboli, terra di Dio

Production Company:
RKO Radio Pictures, Berit Films

Distributor:
RKO Radio Pictures

Director:
Roberto Rossellini

Producer:
Roberto Rossellini

Screenwriters:
Roberto Rossellini, Sergio Amidei, Art Cohn, GP Callegari, Renzo Cesana

Cinematographer:
Otello Martelli

Synopsis

Karin Bjiorsen, a young woman from Lithuania, is interred in a displaced person's camp in post-war Italy. After being told she does not have the documentation to travel to Argentina, she marries a fisherman named Antonio in order to escape the camp, and together they go to live at his home on the isolated volcanic island of Stromboli. However, Karin soon tires of the empty life in her new environment. She feels anomalous among the Italians and their social mores, is treated with disdain by Antonio's mother and finds only temporary respite in working to improve her house. She falls pregnant, but her burgeoning relationship with another fisherman further estranges her, and it seems her only way out is to escape the island altogether.

Critique

'It's the mouth of a volcano…a body, a monstrous living body, both male and female. It emits, ejects. It is also an interior, an abyss.'

The Volcano Lover (Susan Sontag)

Roberto Rossellini remains alone among the major neo-realist directors in that his early work within this epochal movement was

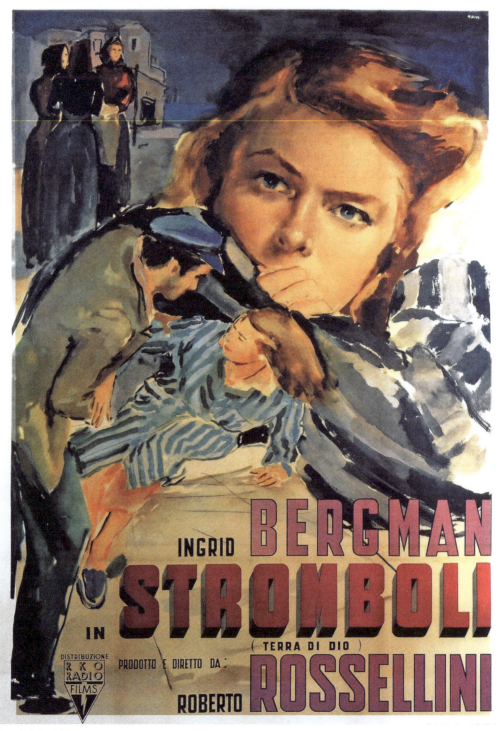

Stromboli, Berit Films.

Editors:
Jolanda Benvenuti, Roland Gross

Art Director:

Duration:
107 minutes

Genre:
Drama

Cast:
Ingrid Bergman, Mario Vitale, Renzo Cesana, Mario Sponzo

Year:
1950

not entirely superseded by his later development as an artist. There are salient aspects of his cinema that remain common to both his first films and those that he subsequently made, and *Stromboli* is a key film in that it can be seen as a transitional work that encapsulates aspects of both eras.

Beginning in an Italian displaced-person's camp in which real refugees play a majority of the characters on view, the documentary aesthetic subsequently predominates in the location shooting on the island and, most especially, in two exhaustively detailed scenes (reminiscent of Visconti's *La terra trema/The Earth Trembles* (1948)) documenting the local fishermen at work.

Alongside this discursive technique the anomalous presence of Ingrid Bergman (by this time a major Hollywood star after moving from her native Sweden in 1942) and her protagonist Karin's progressive internal turmoil bespeaks the nuance and psychological texture of a feature film. Rossellini in fact narrativizes this textual tension by making Karin an alienated stranger in a strange land, left alone by her husband, shunned by his family and other locals and engaged in her own insular, subjective story of problematic romance, desire and religious conviction as a retreat from external pressures and troubles.

As a result, *Stromboli*, like the subsequent, revolutionary *Viaggio in Italia/Journey to Italy* (1954), is characterized by a tension between a documentary framework and a fictive narrative. In addition to acting as an objective correlative to Karin's struggles, it also lends a rough-hewn, unpolished quality to the film. Indeed, Bergman was later to complain of an unprofessional approach to film-making on Rossellini's part, missing somewhat the point that the film's proto-typical modernism arises from a tacit awareness of the impossibility of its own project, the irreconcilability of its constituent modes and its consequent openness in asking its audience to actively construct the meaning for themselves.

Narrative openness is actually a key to *Stromboli*. Like the perennial presence of the unstable Mount Vesuvius in Susan Sontag's historical romance *The Volcano Lover*, the titular mountainous island in Rossellini's film can be read a number of ways. It is both a literal entity (as its eruption at a key point in the narrative suggests) and a manifestation of an inner barrier, something that must be breached (as in the denouement) before personal progress can be made. The film's style reflects this antinomy as much as its narrative, a number of scenes beginning with a prolonged pan around the island's vertiginous topography before coming to rest on a typically immobile Karin, as though to visually underline the fact that she remains at the mercy of her volatile surroundings.

Stromboli found its diegetic depiction of marital strife superseded by the off-screen affair between star and director that caused such a scandal as to see Bergman remain in the Hollywood wilderness for much of the ensuing decade. However, in recent years critics such as Robin Wood and Tag Gallagher have reclaimed its reputation and argued for its status among Rossellini's greatest works; and it certainly deserves to be regarded as such.

Adam Bingham

The Tree of Wooden Clogs

L'albero degli zoccoli

Studio:
RAI Radiotelevisione Italiana,
Ital Noleggio Cinematografico,
GPC – Gruppo Produzione
Cinema – Milano)

Distributor:
Istituto Luce

Director:
Ermanno Olmi

Director of Production:
Attilio Torricelli

Screenwriter:
Ermanno Olmi

Cinematographer:
Ermanno Olmi

Production Design:
Enrico Tovaglieri

Editor:
Ermanno Olmi

Duration:
186 minutes

Genre:
Drama

Cast:
Luigi Ornaghi
Francesca Moriggi
Omar Brignoli
Antonio Ferrari
Teresa Brescianini

Year:
1978

Synopsis

Bergamo, northern Italy, at the end of the nineteenth century. Several families live in a farmhouse and work for the landowner. Over the course of a year, many incidents test the families in their love for each other and their ability to sustain their existences through the unfavourable seasons. Central to this panorama of events is the story of Batistì, who, following an instruction by the village priest, sends his bright young son Minek off to school. The boy's daily journey on foot takes him several miles across the countryside, and when Batistì is chastized for cutting down a tree to make wooden clogs for his son, the family's future on the farm is threatened.

Critique

Many films carry the possessory credit '*un film di*' but not many of them earn it so incontestably as Ermanno Olmi's *L'albero degli zoccoli*. Olmi wrote, directed, photographed and edited this three-hour study of early twentieth-century peasant life, and the film is carved out with the steadfastness of a painting or a piece of organ music.

Olmi's approach is to deploy a largely observational style, through which the film communicates a total commitment to its characters and social milieu. Indeed, it is easy to claim neorealist credentials for this work, which is so evidently drawn from real peasant farming practices and whose cast is made up of non-professionals from the region. If one of the tenets of neorealism is to strip away the artifice of 'standard' narrative film-making to show the 'real' Italy underneath, the film, with its location filming, naturalistic lighting and elucidation of harsh social conditions, surely brings us close to a sense of the lives of peasant farmers of a hundred or more years ago.

But Olmi's style is disciplined to the extent that it is hard to draw a parallel between this film and the melodramatic strains of neorealist classics such as *Roma città aperta*/*Rome, Open City* (Roberto Rossellini, 1945) and *Ladri di biciclette*/*Bicycle Thieves* (Vittorio De Sica, 1948). There, the photographing of contemporary Italian streets in the immediate post-war period had been so powerful that the recourse to melodrama could feel like a necessary clarification of material which otherwise would remain too raw. By contrast, Olmi's serene deployment of a steady camera, a measured pace and JS Bach on the soundtrack represent an absence of urgency that appear to be set in opposition to cinema's polemical potential. Furthermore, the turn-of-the-century setting perhaps occludes a clear socio-political purpose. Manuela Gieri suggests that the film's concentration on the past is 'the result of a profound dissatisfaction with the present' but claims that this evocation 'is not aimed at building a sense of continuity, and thus it is no place of redemption or a milestone on which to construct a better future' (Gieri 1995: 201).

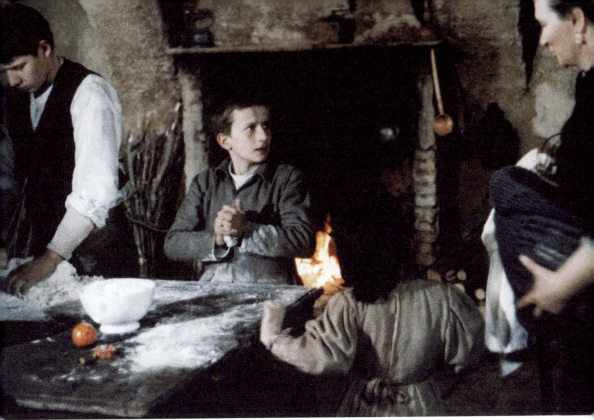

Tree Of Wooden Clogs/L'albero degli zoccoli, RAI/LC/GPC.

Others, however, see the evocation of the past in more progressive terms. Mira Liehm has suggested that the film 'closes the circle begun thirty years earlier by such films as *Paisan* and *Bicycle Thief*' and invokes the Italian philosopher Galvano Della Volpe's notion of 'documentary cinematic poetry' to suggest ways in which Olmi's work can be said to maintain links with neorealism while developing out from it (Liehm 1984: 314).

But to seek to discuss the film as neorealist is, in part, indicative of anxieties over the status of Italian cinema in the 1970s. *L'albero degli zoccoli* was released at a time in which Italian cinema was very much in a state of flux. And while Olmi's film won the country its second Palme d'Or in a row, following the Taviani brothers' *Padre padrone* (1977), such critical successes were to prove few and far between as Italian cinema moved into the early 1980s. Seen from the standpoint of today, however, although *L'albero degli zoccoli* remains a unique achievement in the country's cinematic output from this period, its links to the past and the future are clearer – confirming Liehm's observation from 1984 that Olmi is one of a number of directors who 'seem to have achieved new ways of interrogating the social reality that has always been the challenge and the inspiration of Italian cinema' (Liehm 1984: 317).

Ed Lamberti

The history of melodrama in Italian cinema is yet to be written, but Catherine O'Rawe maps out the terms of its exclusion from the critical mainstream in a recent article that highlights the auteurist, left-wing, and masculine bias of Italian film history (2008). The most important points that she raises with regard to melodrama concern its critical denigration on the basis of an association with female audiences, and the historical instability of terminology around what critical consensus now defines 'melodrama', more frequently referred to in Italian debates about popular cinema that have raged since the mid 1950s as *neorealismo rosa* (pink neorealism), or *cinema d'appendice* (serialized). This complex picture intersects with Anglophone discourse around 'melodrama', posthumously developed since the 1970s around a set of films made in Hollywood in the 1930s and 1940s, as Paolo Noto observes here. Despite anxiety about female audiences in Italy, Anglophone notions of the 'familial melodrama', and the 'woman's film' illuminate, but do not map neatly onto, the Italian context, particularly since we still know very little about the question of gendered address, or empirical audiences in that context.

Italian film history has been interested in addressing 'a cinema that had the function of reflecting and defining the Italian nation' (O'Rawe 2008: 182), but the study of melodrama opens out that history to influences from other cinemas, particularly Hollywood, and to symptomatic readings that are rarely employed in the traditional privileging of the realist aesthetic. Indeed, with its open emphasis on evoking 'affect' rather than political reality, and with its excess, flashbacks, heightened emotionality and coincidences, melodrama strains at the seams of the probable and, in doing so, may open audiences' eyes to the limits of representation and social order itself.

Nonetheless the high point of Italian melodrama is most frequently associated with the director Raffaello Matarazzo, the triumph of his film *Catene/Chains* in 1949, and the conservatism of the early to mid-1950s. A tendency to focus too heavily on Matarazzo (particularly since the author's re-discovery by Aprà and Carabba in 1976) as the überauteur of the genre has excluded a wide range of films from consideration, such as *Le infedeli/The Unfaithful Ones*, and with them whole categories of films, as suggested by Noto. This emphasis has, for example, excluded more challenging readings of women posed by the power of a mode in which they may rebel or express themselves more openly. One might look at *Anna* (Alberto Lattuada, 1951), for example, and its memorable dancing scene, which eclipses the obligatory convent ending in popular memory, as its repetition in Moretti's *Caro diario/Dear Diary* (1993) might suggest. In the earlier *Vulcano/Volcano* (William Dieterle, 1950) the star power of Anna Magnani also stifles any hint of feminine submission implied in her role as prostitute. Furthermore, in its depiction of sisters *Vulcano* draws attention to neglected relations *between* women in which differences and solidarity may emerge: a neglected element of the Italian melodrama that we see stretch from *Le confessioni di una donna* (Amleto Palermi, 1928) to *La sconosciuta/The Unknown Woman* (Giuseppe Tornatore, 2006) in the powerful mother-daughter bond (Hipkins 2008).

Left: *Senso*, Lux Film.

Readings of the genre as conservative because it is female persist: Pierre Sorlin, without any evidence, shamelessly links the demise of 1950s melodrama to the idea that in the late 1950s a more conservative female audience passed on the baton to a more emancipated one (Sorlin 2009: 53). His argument is flawed on two further counts. He suggests that the cinema of postwar reconstruction eschewed melodrama, and yet the second most popular film at the box office in 1945–6 was *La vita ricomincia/Life Begins Anew* (Mario Mattoli, 1945), for the popularity of which Sorlin makes no attempt to account. As I shall argue here, *La vita ricomincia* shows that melodramatic conventions were needed to negotiate the reconstruction of gender identities in the immediate post-war period. Such melodramatic conventions have been recognized as increasingly important, even in the neorealist classics themselves (Landy 2004). In this respect, we see the advantage of regarding melodrama as a mode facilitating 'the consideration of the ways in which a melodramatic sensibility can manifest itself across a range of texts and genres' (Mercer & Shingler 2004, p. 95). In relation to Italian cinema, it casts new light on neorealism, from which criticism had excluded melodrama as a 'demon' (Bazin 2011) and imagines a more productive enmeshing of the two (Wood 2005; O'Rawe 2008). It also encourages us to look for continuity between the likes of *Le confessioni di una donna* and *La signora di tutti* (Max Ophüls, 1934), and later films. As the range of films reviewed here makes clear, melodrama has had its peaks and troughs, but has been a constant in Italian cinema, rather than a one-off event.

Secondly, Sorlin's assumption that audiences for the 1950s films were predominantly female is highly dubious. Recent research confirms that male audiences did dominate in this period (Sprio 2008, Fanchi 2007), which should force us to reconsider the role of the suffering male in many of the popular melodramas of this period, an element which strikes a peculiarly Italian note. Indeed recent Italian cinema has certainly shown a return to the melodramatic mode in the emergence of a middlebrow cinema (O'Leary 2007), particularly in dealing with questions of masculinity, as well as immigration (*La sconosciuta*), and queerness (see O'Rawe 2011), (sometimes all three together, as in the recent *Io l'altro* (Melliti, 2007; see O'Healy 2009). In a recent PhD thesis (Cambridge, 2009) Ella Ide drew attention to the emergence of a male melodrama in late 1990s, to be associated with 'the redrawing of masculine social roles'. The way in which melodrama condenses and reconfigures national anxieties is evident in a melodramatic preoccupation with single fatherhood in contemporary Italian cinema, amply illustrated by *Anche libero va bene/Along the Ridge* (Kim Rossi Stuart, 2006). An insignificant statistical phenomenon in contemporary Italy, single fatherhood looms large in contemporary Italian cinema. Nightmare or fantasy that a female absence from the home may represent for male or female audiences, once again the mixed gender address of Italian cinema produces different models of melodrama to those proposed by Anglophone cinema, and as the history of Italian melodrama begins to stir interest (Caldiron 2004), this specificity certainly makes it one worth writing.

Danielle Hipkins

Along the Ridge
Anche libero va bene

Studio/Distributor:
Palomar/Rai Cinema

Director:
Kim Rossi Stuart

Producers:
Carlo Degli Esposti
Giorgio Magliulo
Andrea Costantini

Screenwriters:
Linda Ferri
Francesco Giammusso
Kim Rossi Stuart
Federico Starnone

Cinematographer:
Stefano Falivene

Art Director:
Stefano Giambanco

Editor:
Marco Spoletini

Duration:
108 minutes

Genre:
Drama

Cast:
Kim Rossi Stuart
Barbora Bobulova
Alessandro Morace
Marta Nobili

Year:
2006

Synopsis

Eleven-year-old Tommi lives in an apartment in Rome with his slightly older sister, Viola and their father, Renato. With his father often busy or away on freelance work, Tommi is forced to assume an early independence from his family, taking care of himself and relying on his wits (and a stash of saved-up pocket money) for survival. When his absent mother Stefania returns home and attempts to re-establish a relationship with the children she has more than once abandoned, Tommi is reluctant at first to forgive her. He finally gives her his trust, but it is not long before she leaves again, sending him only a note of explanation. The violent scenes between his parents when his mother first appears at their home and his father's despair when she leaves see Tommi abandon his aims to become a champion swimmer and spend an increasing amount of time away from home. Thrown out of the house after several furious rows with his increasingly short-tempered father, Tommi spends a growing amount of time with a new friend and his wealthy family in a neighbouring flat. Eventually, he is forced to choose whether to remain in the world of comfort that his substitute family offers or return to his desolate father's side.

Critique

Realism and melodrama come together in Kim Rossi Stuart's directing debut *Anche libero va bene*. The film shares several recurrent themes with other Italian boyhood films of the 1990s and 2000s: from reflections upon new family structures, to dangers within the home, and the increasing role of boys as carers. Like Gabriele Salvatore's *Io non ho paura/I'm Not Afraid* (2003) and Antonio Capuano's *La guerra di Mario/Mario's War* (2005), the narrative in Rossi Stuart's fable of boyhood is played out from the perspective of the son, with the camera often appropriating his vantage point. *Anche libero va bene* explores the way in which the universal transition from childhood to adulthood brings with it anxieties and difficulties specific to the twenty-first century. Masculine youth is portrayed as prematurely cut short as the young protagonist is propelled into places and positions before he is ready. Selected by Rossi Stuart from amongst hundreds of ordinary school children he auditioned across Italy, Morace as Tommi gives a moving and convincing performance as a quiet, sensitive witness to his parents' volatile relationship and reluctant participant in the domestic drama that ensues.

Tommi's journeys through a series of alienating urban locations outside the domestic space capture the uncertainty and anxiety he experiences at the ongoing unravelling, disintegration and reforming of the family structure. He takes refuge from the stresses of home life by sneaking away to a hideaway on the roof of the apartment block: a private place for transcendent play where he perches amongst the aerials and spies on the world below through a pair of binoculars. The film employs metaphors common to coming-of-age

narratives, using physical boundaries to symbolize the threshold between childhood and adulthood. Between the past of childhood and the future of adolescence and adulthood, Tommi's rooftop exists as a kind of precarious present, whilst the traumas associated with this transition are symbolized by his tendency to jump from ledge to ledge, making dangerous leaps back and forth across the threshold of the home.

In the spirit of Italian neorealist films such as Vittorio De Sica's classics, *I bambini ci guardano/The Children Are Watching Us* (1944) and *Ladri di biciclette/Bicycle Thieves* (1948), Rossi Stuart's *Anche libero va bene* examines the cataclysmic consequences of adult transgression on an innocent child. Stefania's repeated abandonment of her family, purportedly in order to seek her own sexual fulfilment, is shown to have traumatic repercussions on both her young children. When she unexpectedly returns home near the beginning of the film, the errant mother is reunited with her children on the staircase of the apartment block. The moment is mirrored in a dramatic and symbolic shadow on the wall in an ironic reference to melodrama's frequent recourse to the portrait of the reunited family. However, the tropes of the traditional melodramatic reunion are inverted here: the stairs lie outside the domestic space, and the image of the newly united family is revealed as no more than a fleeting illusion.

The film flouts our expectations of the conventional family dynamic by visually isolating the suffering characters from one another through bars on elevator shafts, window frames and rooftops that divide the onscreen space and re-imagine melodrama's portrait of the reunited family without the maternal figure. Despite the emotional strain caused by his mother's departure, Tommi initially appears to be able to retain some hold on the childhood world of play that is increasingly absent from his own home through his friendship with his rich friend Antonio. However, in a pivotal moment in the film, the young boy becomes aware of the extent of his father's vulnerability and, in a nod to Italian cinematic tradition, in the end it is the son who must provide emotional and moral support to the father.

Ella Ide

Anna

Studio/Distributor:
Lux

Director:
Alberto Lattuada

Synopsis

Anna is a novice nun and hospital nurse, much valued by the doctors but considered by the Mother Superior to become too emotionally involved in the patients. When a man is rushed in for an emergency operation, Anna recognizes him as Andrea, to whom she was once engaged. She remembers her past life as a singer in a nightclub, engaged to Andrea but irresistibly attracted to the cruel, sensually arrogant barman in the club, Vittorio. She decided to make the break with Vittorio but, on the eve of the wedding to

Anna, Dino De Laurentiis/Lux.

Producers:
Carlo Ponti
Dino De Laurentiis

Screenwriters:
Giuseppe Berto
Franco Brusati
Ivo Perilli
Rodolfo Sonego
Dino Risi
Luigi Malerba

Cinematographer:
Otello Martelli

Art Director:
Piero Filippone

Editor:
Gabriele Varriale

Andrea, Vittorio turned up at the house; the men fought and in the scuffle Vittorio was killed; Andrea, horrified, sent her away. When Andrea comes round from the operation, he again asks Anna to marry him. She must decide whether to accept him or take her vows.

Critique

Sister Anna watches over a male patient recovering from an operation. The screen fades to black and a Latin-American rhythm is heard, continuing as the lights come up on a nightclub stage and a slinky number sung and danced by a woman in a halter top and bolero pants: Anna. Nothing in the film so far (half an hour in) prepares one for this transition, so extraordinary the first time you see it, so eagerly anticipated thereafter. Music has been melodramatic or functional (underlining the busy routine of the hospital): the emergence of this sexy, catchy number is utterly, thrillingly unexpected.

The transition from silent prayer to 'I negro zumbon' is the starkest contrast in a film founded on a ripple of oppositions

Duration:
105 minutes

Genre:
Melodrama

Cast:
Silvana Mangano
Raf Vallone
Vittorio Gassman

Year:
1951

surrounding a central character who says of herself at one point, 'I have two women inside me'. The opposition is one common in melodrama, between duty and desire – here between nursing and the veil, the *ne plus ultra* of service to others and self-denial, and dancing and sex, the tip of the iceberg of Anna's hedonism, whose depths are her masochistic relationship with Vittorio.

It is an opposition present throughout the film in less stark forms: the hospital is not all duty nor the nightclub all desire. Anna's emotionality threatens her vocation. Against the orders of her superiors, she will take an interest in the patients' personal problems. When Andrea arrives, she goes further, leaving the hospital – itself a transgressive act – to fetch the chief surgeon away from La Scala: she puts her feeling for Andrea ahead of proper procedures and obedience. In the nightclub, she refuses to fraternize with the clientele, making her surrender to Vittorio all the more shocking. She also sings there 'Non dimenticar', a classic romantic ballad of true love. Whereas Andrea meets her outside the nightclub after 'I negro zumbon', here he sits gazing at her in the club and she joins him afterwards. Much of the flashback concerns the development of their relationship, including many scenes in his vineyard estate with his mother and sister, all dappled light and church-going, the possibility of a sanctioned, wholesome sexuality.

The sequence of the fight between Andrea and Vittorio takes place in a cellar with a watermill. As they fight, they fall on the mill, causing it to spurt out – the effect heightened by skewed angles and chiaroscuro lighting of the scene. It is a terrific melodramatic climax, but music as such only comes in after Vittorio is shot, with a stinger on Andrea shouting at Anna to go away ('You have made me a murderer!') and then an all-stops-out accompaniment to her staggering away and collapsing on the highway as cars career by. The score is, though, used elsewhere to rework the film's oppositions. The music in the credits moves from searing and threatening to anguished and incipiently tragic before modulating to a feeling of hope, drawing on the conventions for musically portraying sunrise and revelation; what they do not offer is romantic love (let alone sexiness). The music hints at a choice that has all along been available, neither the dullness of dutiful nursing nor the turbulence of emotion, but the transcendence of spirituality. The redemptive music of the credits recurs towards the end as Anna hesitates outside the chapel, tempted not to take her vows and to return to Andrea. **[Spoiler alert: the next sentence gives away the ending of the film]** Her final decision may seem excessively punishing to a secular sensibility, but the story and the music have told us that the safe (perhaps too safe) sexuality of married love is not for Anna, that only the service of God can staunch the otherwise inescapable fury of her desires.

Richard Dyer

Chains

Catene

Studio/Distributor:
Titanus

Director:
Raffaello Matarazzo

Producer:
Goffredo Lombardi

Screenwriters:
Aldo De Benedetti and Nicola Manzaro from a story by Libero Bovio and Gaspare di Maio

Cinematographer:
Carlo Montuori

Art Director:
Ottavio Scotti

Editor:
Mario Serandrei

Duration:
100 minutes

Genre:
Melodrama

Cast:
Amedeo Nazzari
Yvonne Sanson
Aldo Nicodemi

Year:
1949

Synopsis

The happy home of garage-owner Guglielmo, his wife Rosa, mother Anna and two children (Angela and Tonino) is disrupted when Rosa's pre-war boyfriend Emilio appears needing a repair to a broken-down getaway car. Emilio insinuates himself into the family's affairs by proposing a business deal to Guglielmo. Emilio forces Rosa to see him to convince her to flee with him and she goes with the intention of telling him never to see her again, but not before Tonino sees what he mistakenly believes is evidence of their infidelity. Rushing over to the hotel room, Guglielmo believes he has caught Rosa and Emilio in the midst of a tryst, accidentally kills Emilio and escapes to America, but not before instructing his mother never to let Rosa see her children again. He is eventually captured and brought to trial in Italy. Will Rosa falsely testify that she was having an affair with Emilio, enabling Guglielmo to walk free as perpetrator of an 'honour killing', and will Guglielmo learn the truth of Rosa's faithfulness before she kills herself?

Critique

Catene forms the first of a quartet of films (followed by *Tormento/Torment*, 1950, then a remake of the silent film *I figli di nessuno/Nobody's Children*, 1952, and a sequel to it, *L'angelo bianco/The White Angel*, 1955) which sealed director Raffaello Matarazzo's reputation as king of the Italian melodramatists (a reputation shared with Luchino Visconti, with whom he is often contrasted and too rarely compared).

The film opens in Naples as a car screeches past the bay and to a garage. This is 'popular neorealism', low-budget film-making whose accessible dramatic tales of crime, misplaced desire and injustice were common after the war. Amedeo Nazzari, the icon of uniformed manhood during Fascist-era cinema, appears in dirty overalls as mechanic Guglielmo, but such realist grit is of a particular kind in *Catene*, as exemplified later when, as a stowaway on a boat of immigrants, Guglielmo sheds a tear to the strains of 'Lacreme napuletane' (a song which tells the story on which *Catene* is based, played on the boat by Neapolitan singer Roberto Murolo). *Catene* epitomizes the most popular form of Italian melodrama in its desire to share overwhelming and often mournful passions, and is led by a sensibility that is musical rather than documentary.

In fact *Catene* also recalls the world of the *feuilleton*, the serialized literary fiction of the popular presses in the nineteenth century full of sudden and absolute changes of fortune, confrontations, and fatal misunderstandings. Matarazzo scorned this connection to the *feuilleton* because of the coherent emotional logic driving his films. Yet his characters, played by a group of actors who reappear across his films, suggest symbolic and archetypal emotional conflicts and not the individualized psychologies nor the social denunciation of more high-brow realist drama.

Nazzari's partner in Matarazzo's melodramas was the hitherto-unknown Greek actress Yvonne Sanson, here playing his wife Rosa, differentiated from the pin-ups of the era by cutting a conservative, maternal figure. Although the plot revolves around a mistaken belief in her extra-marital affair with her ne'er-do-well ex-boyfriend Emilio, Rosa's innocence rests on her denial of any sexual feeling, her only apparent desire that of being a loving mother to her children. This may separate Sanson from the earth-shattering transgressiveness of the pre-war diva, but they share the fact that it is on the female protagonist that dramatic conflicts centre, and through her that their meaning is given expression.

The focus on the suffering heroine is shown in *Catene*'s dramatic mid-point, at which Guglielmo bursts into a room containing Rosa and Emilio and mistakenly believes he is witnessing a tryst. Forced out of the room and into the hallway as the two men fight and a shot rings out, Rosa's intense sobs and screams – and not the action of the violent death and dramatic escape – carry the scene to its climax. Rosa's restriction to the hallway pushes her emotion to a pitch which her body cannot stand, and she faints away in the tradition of the operatic heroine at the scene's close.

Matarazzo's melodramas confront honest, hard-working (although bourgeois) people with suffering and oppression, pitting random fate against characters who can only cling to family, to Catholic icons, and to the intensity of their own emotions. *Catene*, and the five-year era of melodrama's box-office dominance that it initiated, was decried by critics for reducing neorealism's political and artistic innovation. Matarazzo's response was that '37 million spectators have seen my films'. While such populism may equal a weak answer to criticism, 37 million in a country of 43 million testifies to an extraordinary ability to turn aspects of popular experience into high drama, an ability now receiving critical appreciation.

Louis Bayman

Le confessioni di una donna

Studio:
SACI di Amleto Palermi

Director:
Amleto Palermi

Producer:
SACI

Screenwriter:
Nino Macarones

Synopsis

A young woman is brought into hospital dying of a gun wound. Through flashbacks we learn that, on her father's death, the woman searches for her missing mother in Palermo, only to find that she is an itinerant prostitute. Working then as the companion of a baroness, the heroine falls in love with the baroness's son, Paolo, but his mother sacks the girl when she finds her in Paolo's arms. Two shady companions of the baroness, Jackins and the 'Princess', befriend the heroine and convince Paolo she has become a prostitute. Paolo abandons her, not knowing she is pregnant. The girl's tormentors take her away from her child, and on tour as a high class prostitute. Eventually reunited with her young daughter in Sicily, the heroine takes revenge on Paolo. However, too late she realizes she has been manipulated by Jackins and the Princess (who turns out to be

Cinematographer:
Fernando Risi

Art Director:
Nino Macarones

Duration:
2702 metres or approximately 148 minutes

Genre:
Melodrama

Cast:
Luigi Serventi, Enrica Fantis

Year:
1928

her close relation), so that they can obtain Paolo's fortune. When they kidnap her child, the heroine finally finds the strength to fight against her oppressors, and rescues her daughter and Paolo's money, but gets shot. Back in the hospital, will our woman survive to be reunited with Paolo, her daughter, and her repentant mother?

Critique

Le confessioni di una donna (1928) marked the end of Amleto Palermi's prolific silent production in Italy, although he was to go on to make a substantial number of comedies and melodramas until his death in 1941. The film presents a theme that recurred in his later cinema, that of 'la traviata', the woman led into prostitution by misfortune and malign intervention. It belongs to a handful of films from the silent period that allude to prostitution. Amongst those, Palermi's film is perhaps the most detailed account of a woman's 'fall', and its reconstruction of that descent, structured through flashbacks and a foreground life and death narrative, was to continue into Italian melodramas of the 1950s (see Vittorio Cottafavi, *Traviata '53*, 1953), as a much later example). So too was its obsessive analysis of the lengths to which villains might go to lead a girl astray (see Leonardo De Mitri, *Verginità*, 1952). Above all, its preoccupation with the restoration of a broken bond between mother and daughter was typical of the silent period (see Nino Oxilia, *Sangue bleu/Blue Blood*, 1914), and is another melodramatic preoccupation that has continued largely unnoticed by critics in Italian cinema since then.

It is striking, however, that in both of Palermi's films dealing explicitly with the theme of prostitution, *Le confessioni* and the later *La peccatrice/The Sinner* (1940), the female protagonist is ultimately allowed to survive (in the first she is reunited with her mother, lover and child, in the second there is a more sombre reunion with her mother), a redemptive pattern that was to become very unusual in later melodramas. In many ways, the protagonist of *Le confessioni* clearly benefits from a greater sympathy perhaps afforded actively sexual women during the silent period, although the film comes as close as it can to giving the heroine a voice through the device of the diary. Moving beyond what could be a doctor's voyeuristic penetration of the silent female's cadaverous mystery, the film's inventive visual codes convey the 'masquerade' required of women under patriarchy. The surreal sequence of images that conveys her supposed prostitution shows a split screen: on one half the protagonist wears a series of different outfits, manipulated like a puppet by actual strings attached to her arms; on the other half, men approach her and watch her as she rebuffs them until the word SCANDAL cuts across the screen in futurist fashion. This sequence provides a disruption to the narrative, as sexual exchange itself is elided and even questioned, but the woman's intended status as object is underlined. It is impossible, in fact, not to see in Palermi's opening extract from the woman's diary ('I won't give my name ... I am "a woman"'), a reference to Sibilla Aleramo's feminist text *Una donna* (1906). Aleramo's

choice of the label 'a woman' for herself was a call for sisterhood amongst women, setting herself up as both exemplary and typical. In this clear allusion to female heroism in his depiction of a woman who moves from being the object of the narrative to its subject, and through an ending which brings together three generations of women in possible reconciliation, Palermi addresses a female audience. If we read beyond the ubiquitous stereotypes of innocent prostitutes, good and evil mothers, the message of this film for that audience is powerful: mothers can turn on daughters and vice versa, but female power and survival lie in the fierce defence of a female genealogy, a preservation that requires an active female heroine. The apparent corpse that opens the film must awake to become 'una donna'.

Danielle Hipkins

The Fall of the Rebel Angels

La caduta degli angeli ribelli

Studio:
Filmalpha/RAI Due

Director:
Marco Tullio Giordana

Producer:
Mario Gallo

Screenwriters:
Marco Tullio Giordana
Vincenzo Caretti
Mario Gallo

Cinematographer:
Giuseppe Pinori

Art Director:
Raffaele Balletti

Editor:
Sergio Nuti

Duration:
102 minutes

Genre:
Melodrama

Synopsis

The affluent Cecilia is married, with a young daughter, to a brilliant university professor. She learns that her father is fatally ill and, driving back to Milan from his lakeside home, stops by the side of the highway to weep. A handsome stranger notices her distress and they embrace passionately in her car. Returning to home, work and normality, she is pursued by the stranger and the affair continues. The intense Vittorio, it seems, is some sort of fugitive – a terrorist? Her father dies and Cecilia leaves for Naples with Vittorio, pleading that she needs time alone. In Naples the couple encounter a variety of colourful characters, but the interlude is interrupted by the reappearance of one of her lover's comrades, who Vittorio is obliged to kill. The couple flee to Palermo, where coincidentally Cecilia's husband is teaching at the university. Cecilia visits her husband (now aware of her affair) in his hotel, pleading for understanding, but he sends her back to Vittorio, instructing her to resolve the situation. Vittorio has been condemned to death by his organization, and in their squalid attic, with her lover's behaviour increasingly erratic and brutal, Cecilia is forced into a desperate gesture.

Critique

La caduta degli angeli ribelli was the second feature film by director Marco Tullio Giordana, best known for his work with the screenwriters Sandro Petraglia and Stefano Rulli, including *I cento passi*/*The 100 Steps* (2000) and *La meglio gioventù*/*The Best of Youth* (2003). His first feature, the meta-cinematic and Godardian *Maledetti vi amerò*/*To Love the Damned* (1980), had been a critical hit; this second film was a critical disaster and seems barely to have had a cinema release after its bad reception at the Venice festival. Viewed now (with difficulty – it has never had a DVD release), it is spoiled less by the 'overblown, didactic dialogue' reviled by the *Variety* critic than by some clumsy dubbing of the non-Italian

Cast:
Clio Goldsmith
Vittorio Mezzogiorno
Alida Valli

Year:
1981

actors, especially of the heroine played by the French and exquisite Clio Goldsmith. What intrigues about the film is the fact that it refuses the male homosocial story archetypes, usually Oedipal or Cain and Abel tales, typically employed in the cinema to deal with Italian history. Giordana would have recourse to these more typical modes in the later films mentioned above, but in La caduta degli angeli ribelli he dares to generalize Italian political circumstances in a deliberately melodramatic key (the film alludes to Tristan and Isolde) and filters these circumstances through the eyes and desire of a woman, and an upper class woman at that. Even if critics remembered the example of Visconti's Senso (1954), they were unlikely to be sympathetic.

In doing terrorism in an erotic key the film was not, however, unique. It is one of a small group inspired by Bertolucci's Ultimo tango a Parigi/Last Tango in Paris (1972) that refracts the experience of 1970s terrorism in Italy through the motif of the amour fou, the love affair that consumes the lover. (The fate of Brando's Paul at the end of Ultimo tango gives a clue to that of the terrorist lover in La caduta degli angeli ribelli.) Giordana's film is usefully paired with the equally-little-seen Kleinhoff Hotel (Carlo Lizzani, 1977), in which the beautiful and rich young wife of an architect has a torrid fling with the terrorist in the hotel room next door (he too comes to a bad end). In both cases the affair with the brooding fugitive is a kind of carnal time-out from the mores of normal life and society. The physicality of the terrorist lover – who, paradoxically, given his devotion to political violence, is body rather than ideology – is contrasted to the rationality of the temporarily-abandoned husband, and Cecilia's husband is set up from the opening dialogue as the ultimate representative of the Moral Law: a philosopher of ethics. If the amour fou is a sign of Cecilia's crisis of boredom or grief, it is also a sign of the increasing desperation of Vittorio, the terrorist. The love affair offers him a last (if always already doomed) opportunity of exchanging armed struggle for the traditional imperative of heterosexual communion. However, the 'taken' aspect of the woman, and the cliché, familiar from 'adult' film and literature, of the erotic self-investigation undertaken during a sensual holiday from ordinary life, establishes at the outset that social and marital order will be restored. As such, this is a conservative, reassuring, even cathartic film. The lovers' transgression is associated with the transgression of social rules that is terrorism, and terrorism itself comes to be signified as a crime of passion: a season of mad and impossible desire that can only burn itself out. But the film retains its interest as a rare attempt to refract Italian historical experience through the prism of a female subjectivity.

Alan O'Leary

Hamam – The Turkish Bath

Hamam

Studio:
Sorpasso Film

Director:
Ferzan Özpetek

Producer:
Marco Risi
Maurizio Tedesco

Screenwriter:
Ferzan Özpetek
Stefano Tummolini
Aldo Sambrell

Cinematographer:
Pasquale Mari

Art Director:
Ziya Ulkenciler
Virginia Vianello

Editor:
Mauro Bonanni

Duration:
96 minutes

Genre:
Melodrama

Cast:
Alessandro Gassman
Francesca d'Aloja

Year:
1997

Synopsis

Married couple Francesco and Marta, run an interior design business in Rome. Francesco is suddenly forced to go to Istanbul to sell a property left to him by a forgotten aunt: a Turkish bath, or *hamam*. Welcomed into the Turkish family who looked after his aunt and the bath, his intentions of selling the *hamam* begin to fade and he sets about restoring the place. He forges deeper bonds with the caretaking family and Istanbul, and starts a sexual relationship with the son Mehmet. Marta, apparently preoccupied by the prolonged absence of her husband, comes over to Istanbul. She is shocked to discover her husband making love with Memo in the *hamam*. In the heat of the moment she asks Francesco for a divorce, to which he consents. Marta had actually come over to Istanbul to ask Francesco for a divorce so that she could get together with their colleague Paolo. However, until she found him with Memo, the changes wrought in Francesco had made her realize that she did still love him and that maybe a relationship with him was still possible. Marta is not certain about what she wants anymore, but fate and Istanbul are about to decide for her.

Critique

Ferzan Özpetek is a rare example of a high-profile foreign film director working in Italy. Born in 1959, he left his native Turkey at the age of 20 to embark upon a career in the Italian film industry, where he has now worked for over thirty years. *Hamam* was the first film he directed and set the tone for a series of films staging family melodramas with a queer twist. Its other distinctive element, addressing Özpetek's own hybrid identity by shooting in both Rome and Istanbul and involving both Italian and Turkish characters, carried through more moderately into later subsequent successful works, such as *Le fati ignoranti/The Ignorant Fairies* (2001), situating sexually and ethnically heterogenous groups in an Italian setting. The surprising popularity of Özpetek's unconventional films has been rightly celebrated by the director and critics as a reflection of the increasing liberality of Italian popular culture. However, perhaps because of Özpetek's own insistence on a model of bisexuality that ignores the gender of its love object, and a reluctance to interrogate the representation of homosexuality, critics have overlooked the tendency of this new kind of male melodrama to privilege male sexual agency and to construct women as bearers of an abstract and idealized femininity. This tendency conveniently chimes with dominant notions of femininity in Italy, and explains some of the perplexing weaknesses of Özpetek's cinema. Indeed, those films which do attempt to engage with a female perspective (*La finestra di fronte/Facing Window*, 2003), for example, seem oddly mundane in their depiction of female heterosexual passion. *Hamam* provides a blueprint for the melodrama in which the surprise declaration of homosexuality remains the trump card of the male character, even from beyond the grave, from *Le fati ignoranti*

to the more recent *Mine vaganti/Loose Cannons* (2009).

The potentially orientalizing qualities of the geographical split between Rome and Istanbul have been discussed (Girelli, 2007); however, it is the gendering of those locations as masculine and feminine respectively that polarizes the terms of the melodrama. Francesco's engagement with the feminine is encapsulated by the *hamam* of the title, almost a character in itself, whose nurturing interior allows Francesco symbolically to re-connect with his female side. Significantly, he inherits this building from his aunt, a lost second mother, into whose shoes he steps on his arrival in Turkey. He honours her dedication to the *hamam* and its naked male bodies, freed momentarily from the heteronormativity of Turkish patriarchy, first by maintaining the *hamam* and refusing to sell it to property developers, and secondly by engaging in sexual relations with the boy his aunt saw grow up.

However, in conceiving of the feminine as symbolic 'Other', Özpetek's protagonist, as his gay male characters often do, must slide inevitably towards death, framed significantly as a dark female statue just before Francesco is stabbed on the steps of his new home. It is a vengeful Westernized woman, in the form of an entrepreneur who wishes to modernize the area, who stands behind the killing: the castrating female, and the dark side of the hamam's protective womb. Female characters are maternal (traditional), vengeful (modern), or neutered and neutralized, like Francesco's wife, in Özpetek's solution to an apparent exclusion of women from bisexual flux. Nowhere is it clearer than in his first film, that in conceiving of women as the symbolic feminine, his gay male characters, who must step away from a traditional masculine identity towards the feminine, are unlikely to survive. Özpetek turns to melodrama as a genre precisely because of these unspoken tensions in his stories, which find an outlet in sudden twists, implausible revelations, and fatal endings.

Danielle Hipkins

Life Begins Anew

La vita ricomincia

Studio:
Excelsa Film

Director:
Mario Mattoli

Producer:
Baldassarre Negroni

Synopsis

When former POW Paolo returns from India to his middle-class home in Rome at the end of the war, he is relieved to find his wife Patrizia and young son alive, managing to get by, thanks to Patrizia's business in lampshades. They also enjoy the moral support of the jovial, elderly Neapolitan widower, who is their new neighbour, Il professore. However disaster strikes when Patrizia commits a murder – her response to a mysterious man's attempt to blackmail her to have sex with him. Paolo discovers that, during his absence, in the face of their son's desperate need for a life-saving operation, Patrizia prostituted herself once to the murdered man to raise the funds, a sequence revealed through a flashback sequence (although the encounter itself is elided). Paolo offers to stand trial

Screenwriters:
Aldo De Benedetti
Mario Mattoli and Steno

Cinematographer:
Ubaldo Arata

Art Director:
Gastone Medin

Editor:
Fernando Tropea

Duration:
83 minutes

Genre:
Melodrama

Cast:
Fosco Giachetti
Alida Valli
Eduardo De Filippo

in her place, but the judge sees through his ploy and Patrizia is acquitted anyway. The real crisis for the very angry Paolo turns on the question of whether or not he can forgive Patrizia for her illicit sexual liaison, which he reads as a betrayal rather than an act of heroism. At this point, their wise neighbour has a crucial role to play.

Critique

Mario Mattoli was famous in the pre-war period for his films 'which speak to the heart', critically discarded, but beloved by much of the Italian public. *La vita ricomincia* was no exception, coming second only to *Paisà/Paisan* (Roberto Rossellini) in the box office rankings of 1945–6. Patrizia's misunderstood, virtuous victim-mother, who appears to have sinned, only to have her name cleared after great suffering, was to become an increasingly-popular trope in the 1950s melodramas of Matarazzo, starting with *Catene/Chains* (1949). However, the earlier film's very clear historical location in and around the Second World War (we see the ruins of Monte Cassino in the opening to the film and more than a nod to neorealism in its use of working class characters), gives this story a particular political dynamic that the later films lack. *La vita ricomincia* hints at the gender dilemma that postwar Italy was struggling to resolve: how to reconcile the inevitable female independence of wartime with a return to a traditional, patriarchal model of domesticity. The family melodrama is an apt vehicle through which to express some of these dilemmas, and its reliance on the cipher of prostitution to connote female vulnerability takes a new turn in this postwar period. Patrizia's improbable one-off act of prostitution conveys the idea that women cannot cope morally or financially without men and, if we read Patrizia's real crime as one of earning money without her husband, we have a hint of the bad feeling that women's financial independence had engendered. The explosion of prostitution in post-war cinema was as much about sexualizing and scapegoating all working women as it was a reflection of increased visibility in prostitution, freer sexual mores, or more 'open' film-making.

By making the act of prostitution one taken to save her son's life, however, Mattoli redeems Patrizia's virtue and keeps the audience on her side, contributing to the almost sacred status that the mother-prostitute often achieves in Italian culture of this period. This ambivalent characterization serves to clear up the perhaps murky past of Alida Valli herself, popular with the public in previous Mattoli films (*Stasera niente di nuovo*, 1942, for example, in which she plays a doomed prostitute married on her death-bed) and many others, but tainted by rumours of an association with Fascism. Her tears at the end of the film could be read as cathartic and purifying in this sense; and her performance led to a call from Hollywood. They also serve to release tensions about the absence of Italian men, and heated dialogue between husband and wife actively works out a way to achieve reconciliation in this new world. Women are allowed to express their anger for men's absence (and

even abuse), but they must show teary relief at the return of the scowling and authoritarian patriarch. The patriarch himself must learn to forgive women for their bungled attempts to survive without him.

That huge act of forgiveness is eased by one of the film's brighter characters: bravely played up amongst these more intense co-protagonists by popular Neapolitan comedian Eduardo De Filippo as the friendly neighbour, who earns his money by telling stories on the radio as a pseudo-granny – perhaps a gesture to the compromises older men have also made. Despite his redeeming lack of domesticity on some fronts – at least he cannot cook – De Filippo's emotional learning, acquired through the loss of his wife in a bombing, attempts to soften Paolo's masculine hardline, which suggests that pink neorealism was, as Mary Wood has argued, engaged in negotiating 'new competences' for masculinity (Wood, 2004).

Danielle Hipkins

Rocco and His Brothers

Rocco e i suoi fratelli

Studio/Distributor:
Titanus

Director:
Luchino Visconti

Producer:
Goffredo Lombardi

Screenwriters:
Luchino Visconti
Suso Cecchi d'Amico
Pasquale Festa Campanile
Massimo Franciosa
Enrico Medioli

Cinematographer:
Giuseppe Rotunno

Art Director:
Mario Garbuglia

Editor:
Rocco Serandrei

Duration:
180 minutes

Synopsis

The Parondi family from Southern Italy, a widow and her sons, migrate to Milan. Vincenzo and Ciro get jobs in construction and car manufacture respectively and marry. Simone becomes a boxer, but lacks the discipline to succeed. He takes up with a prostitute, Nadia, and then drops her. Later, another brother, Rocco, and Nadia fall in love. Simone is jealous and rapes Nadia in front of Rocco; Rocco tells her to return to Simone, for he is the elder brother. Simone steals from the impresario Duilio and to pay Duilio off, Rocco signs up to a lucrative boxing contract, even though he hates boxing. Nadia returns to prostitution, but Simone's destructive trajectory is not finished yet.

Critique

Rocco e i suoi fratelli is historical in scope and melodramatic in impulse, with melodrama giving vent to those destroyed by history.

The Parondis are what the influential Marxist literary theorist György Lukács termed 'world historical characters': figures who embody the tensions and transformations of historical events beyond their immediate circumstances. Their experience encapsulates the large-scale migration in Italy from South to North in the period, with the resonances of the longer history of North-South relations in Italy and, broader still, the epochal transition from feudalism to capitalism.

The danger that this might seem schematic is in part avoided by the patina of naturalism, the accumulation of precisely-observed detail, as carefully compiled and deployed here by Visconti and his collaborators, Mario Garbuglia (sets) and Piero Tosi (costumes), as in their period films (e.g. *Senso* 1954, *Il gattopardo/The Leop-*

Genre:
Melodrama

Cast:
Alain Delon, Renato Salvatori, Annie Girardot, Katina Paxinou

Year:
1960

ard 1963). Casting pushes the schematic towards the archetypal. Katina Paxinou's Greekness suggests a yet-deeper Mediterranean identity than even the Italian South; Annie Girardot, slim, beautiful and French, literally embodies an urban, Northern and above all modern identity; Renato Salvatori, an ex-lifeguard known mainly for his role as a slightly thick hunk in comedies such as *Poveri ma belli/Poor, But Handsome* (Dino Risi, 1956) and *I soliti ignoti/Big Deal on Madonna Street* (Mario Monicelli, 1958), here becomes tragic, his physical presence and lack of self-understanding drawing him inexorably downwards; Alain Delon, whose physique does not suggest the successful boxer that Rocco becomes, has a cold, narcissistic beauty that the film renders ascetic, in keeping with the saintliness of his character.

'Rocco is a saint', says Ciro, 'but there is no room in this world for saints.' This is occasioned by Rocco's self-sacrificing decision to dedicate himself to boxing, as the only way to earn enough money to pay back the money Simone has stolen, thus keeping everything within the family, archaically prioritizing family over public order. **[Spoiler alert: a major plot development is given away here]** It does not work, Simone degenerates further; when he kills Nadia, Ciro turns him over to the police, betraying the code of family allegiance in favour of public order. This is progress – yet the emotional weight, and the melodrama, of the film is associated with those who cannot adjust to it: Simone and Rocco.

The film has two extended melodramatic climaxes. The first encompasses the rape of Nadia and, immediately after, Rocco renouncing her on the roof of Milan cathedral; the second cross-cuts Simone murdering Nadia and Rocco boxing, leading to Simone's arrival at the family home and the struggle between Rocco and Ciro – the melodrama here conveyed in the editing and histrionics as well as, relatively sparingly, in the music. Both climaxes focus on the men. After the rape, it is Rocco clutching his weeping face that the camera stays on, not Nadia staggering away; when the sombre, brooding music comes in in the next sequence, it is on Rocco turning away, his face streaked with tears. The cross-cutting in the murder sequence deflects attention from Nadia to the relationship between the brothers, the traumas of which continue in the family flat. In the film's terms, it is right that this is where the emotional emphasis lies, for it is the destruction of the two brothers and of family ties that is most traumatic in the epochal transition to capitalism. But it is Nadia who is raped and murdered. It has long been argued that the weakness of Marxist interpretations of history is that they leave out half of humanity. This can seem like a dry point. In *Rocco* it is not just the epic sweep but the melodramatic suffering attendant on it that excludes women and which also offers the film's most emotionally-searing aesthetic high points.

Richard Dyer

Senso

Production Company:
Lux Film (Lux)

Distributors:
Lux Film
Fleetwood Films Incorporated
Les Acacias
Rey Soria y Cía
SL

Director:
Luchino Visconti

Producers:
Claudio Forges Davanzati
Marcello Giannini
Gabriele Silvestri

Screenwriters:
Suso Cecchi d'Amico
Luchino Visconti
Carlo Alianello
Giorgio Bassani
Giorgio Prosperi
Tennessee Williams (dialogue collaborator)
Paul Bowles (dialogue collaborator). Based on the novella by Camillo Boito

Cinematographers:
GR Aldo
Robert Krasker

Editor:
Mario Serandrei

Art Director:
Ottavio Scotti

Duration:
117 minutes

Genre:
Melodrama/Romance

Cast:
Alida Valli
Farley Granger
Heinz Moog
Rina Morelli
Massimo Girotti

Year:
1954

Synopsis

Venice, 1866, on the eve of war between Italy and Prussia: following a confrontation between an Italian and an Austrian Lieutenant named Mahler, the former is forced into exile. The Italian's cousin, the Countess Livia Serpieri, pleads her relative's case to Mahler, but over the course of a long meeting with him she finds her feelings for the lieutenant developing into affection and love. They begin a passionate relationship but, when Livia's cousin returns, she goes with him to the countryside to prepare for the war. Mahler comes to her in secret, and takes money in order to bribe doctors to say that he is unfit for military service, a plan intended for himself and Livia to be together as the war rages around them. However, when Livia defies her lover's request not to come to him, she is surprised at what she finds.

Critique

After three features variously marked by the tenets of neorealism, *Senso* represented the first flourishing of the grand melodramatic cinema of visual spectacle that would come to define Luchino Visconti's filmic sensibility in the years following *Il gattopardo/The Leopard* (1963). Along with Rainer Werner Fassbinder, Visconti was the most significant purveyor of melodrama in the early years of European art cinema, and brought all his experience as one of Italy's foremost directors of opera to bear on the opulent colour *mise-en-scène* and large-scale, vivid social tapestries that define the narratives of his work in the 1960s.

Senso differs from later works such as *Rocco e i suoi fratelli/Rocco and His Brothers* (1960), *Il gattopardo* and *La caduta degli dei/The Damned* (1969) in that it does not function within the mode of the family melodrama. Indeed, quite the opposite as the narrative is predicated on a marked abstraction of its two protagonists from the immediate familial milieu around them, so that their interpersonal trials and tribulations contrast with the huge social upheaval and conflict in the world outside. Visconti treats the war with Prussia as an overwhelmingly impersonal undertaking, depicting it only briefly in a series of vast narrative tableaux – impressively-designed and detailed master-shot long takes that view from a distance like a helpless deity, as action and implied atrocity on all spatial places converge and conflate in a vision of consuming violence.

In contradistinction, though consuming violence is as apt a term for the love story between the Austrian Lieutenant Mahler and the Italian Countess Serpieri, it is, in this case, figurative rather than literal, emotional as opposed to physical suffering that defines their union. It is a curious mixture of interior need and longing coupled with an unconscious masochism and self-hatred that appears to define the common arena in which the two variously unhappy protagonists meet and come together; and in this *Senso* can be seen to relate personally to its director. The scheming and cowardly

Mahler in *Senso* would ostensibly appear to offer a tainted self-portrait. However, in working within the heightened, stylized and excessive framework of the melodrama, this character's marked transformation in the final scene, defined by Farley Granger's potent mix of emotional fecundity and riotous physicality, undermines itself through an over-investment in disavowal, the cackle of arrogance an actual cry of despair and his apparent hatred of another covering up hate of himself. It is a picture of regret that, as with Burt Lancaster's Prince in *Il gattopardo*, arises from a tacit recognition of a disappearing world that will take him along with it. For Visconti, at least in regards to the representation of class and human relationships, there is a fortuitous discordance, as Senso marked a beginning rather than an end. For in many ways, his cinema starts here.

Adam Bingham

La signora di tutti

Studio/Distributor:
Novella Film/Ripley's Home Video

Director:
Max Ophüls

Producer:
Angelo Rizzoli

Screenwriters:
Curt Alexander, Hans Wilhelm, Max Ophüls

Cinematographer:
Ubaldo Arata

Art Director:
Giuseppe Capponi

Editor:
Ferdinando Poggioli

Duration:
86 minutes

Genre:

Synopsis

The film opens with the revelation of the attempted suicide of film star Gaby Doriot; as she is operated on in an attempt to save her life, she relives the events that brought her to this moment. Beginning with her expulsion from school, the film tracks her hesitant love affair with banker's son Roberto Nanni, an affair interrupted by his possessive invalid mother Alma, who brings Gaby into her home to act as her companion. Roberto's father Leonardo falls in love with her, and as he seduces her in the grounds of his house, a suspicious Alma tumbles downstairs in her wheelchair as she tries to locate them. After the fatal accident, Roberto tells his father he wishes to marry Gaby but his father refuses, and Leonardo and Gaby begin their unhappy life together. Eventually, Leonardo's neglect of his business causes him to be imprisoned for embezzlement, although not before Gaby has left him for his own good. Gaby becomes a famous film star, but when Leonardo, released from prison and destitute, is killed in an accident, the press accuse her of having driven him to despair. The only person who can clear her name is Roberto, but their reunion brings unexpected news.

Critique

La signora di tutti is the only Italian film made by the German emigré director Max Ophüls; it shares many traits with later and more celebrated Ophüls films such as *Letter from an Unknown Woman* (1948), *Madame De...* (1953), and *Lola Montès* (1955), including complex flashback techniques, Ophüls's trademark mobile camerawork and beautiful tracking shots, and a use of music that is intimately connected to the excessive affect generated by the films' fatalistic structures.

Ophüls is known as a classic 'woman's director' and, here, he makes a film that is both a study of the female image – the image

Drama

Cast:
Isa Miranda, Memo Benassi, Tatiana Pawlova, Nelly Corradi

Year:
1934

as lure, as fixed fatality that dooms the heroine Gaby, who repeatedly gazes at herself in the mirror as if trying to understand why her image is so potent – and a study of Isa Miranda, the star. The particular emphasis given to the close-up is connected to the film's obsession with technologies of reproduction: the poster image of Gaby bookends the film – it is the poster of her that Leonardo, her former lover is gazing at when he is killed by a car, and it is the stopping of the printing press that is printing her posters that signals her death and the film's end. The reproduction of her image and its ubiquity is counterposed to the film's 'search' for Gaby. She offers herself to be constructed by the gaze of others throughout. This multiplicity of versions of Gaby offered by technological innovations – the film opens with a recording of her voice singing the title song from her film 'La signora di tutti' (although Miranda was actually dubbed, probably by Nelly Nelson) – is mirrored by the technology of cinema itself. We never see the film-within-the-film, *La signora*

La signora di tutti. Novella Film.

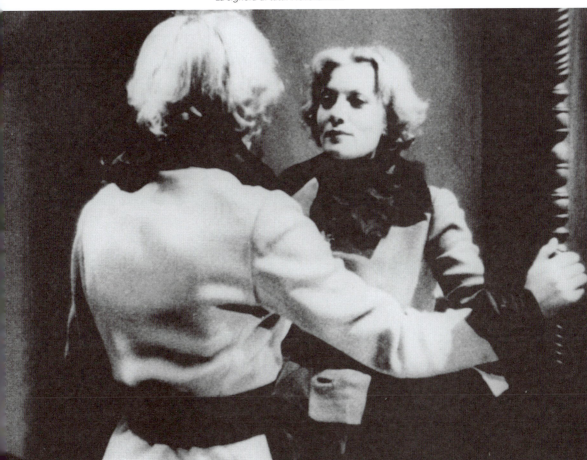

di tutti and it is this absence that is at the heart of the film. The star image stands in for the film itself; likewise the search for Gaby's interior self is always displaced: she exists only in relation to the desire of men and her destiny is sacrifice, suffering and suicide.

The film was based on the Italian novel by Salvatore Gotta and was produced by Angelo Rizzoli, owner of Novella-Film and founder of the Rizzoli publishing house. The novel was published in serial form in Rizzoli's *Novella* magazine and Isa Miranda was 'discovered' as its star through a competition launched by *Novella* (although she had already appeared in several films). The cross-marketing and publicity of the film in Rizzoli's popular press is particularly interesting, given the film's bitter commentary on such marketing – a tie-in book about Gaby's life proclaims her 'happy childhood' at the same time as she is attempting suicide, and the voracious journalists who write about her are equally eager to destroy her reputation for her past indiscretions. Ultimately, it is acknowledged that Gaby's survival is purely as a screen image when she murmurs to her erstwhile love Roberto, now married to her sister, that he will see her 'in the film'. Miranda's ecstatic repetition of 'in the film' signals the last moment of the flashback, and speaks to the potency and durability of the feminine image on screen.

Catherine O'Rawe

The Unfaithfuls

Le infedeli

Studio:
Excelsa-Minerva

Directors:
Mario Monicelli and Steno

Producers:
Dino De Laurentiis
Carlo Ponti

Screenwriters:
Franco Brusati
Mario Monicelli
Ivo Perilli
Steno

Cinematographers:
Aldo Tonti
Luciano Trasatti

Art Director:
Flavio Mogherini

Synopsis

Rome, a few years after the end of World War II. Osvaldo, a private investigator for a shabby agency, is hired by Mr Azzali, a rich man who wishes to obtain evidence of his young and attractive wife's infidelity in order to divorce her and marry the even younger, childish Marina. Azzali proposes that Osvaldo establish an illicit relationship with Azzali's wife. This bizarre agreement leads the investigator to meet Liliana Rogers, a former girlfriend who had left him during the war and married a wealthy Englishman, thereby now belonging to the same social environment as the Azzalis. As Liliana becomes his lover, Osvaldo enters the world of the corrupt Roman upper class. Once he has encountered the vicious behaviour of both sexes, he turns into a devious blackmailer, taking advantage of the hypocritical silence of his victims, one of which is Liliana herself. Not even the suicide of Cesarina, a young servant unjustly charged with theft, seems to affect the tainted milieu.

Critique

Stefano Vanzina (Steno) and Mario Monicelli are well known in the history of Italian cinema for their comedies, the latter usually credited as the founder of *commedia all'italiana*, because of seminal films such as *I soliti ignoti*/*Big Deal on Madonna Street* (1958) and *La grande guerra*/*The Great War* (1959). Nevertheless, looking at the list of the films they – often together – wrote and

Editor:
Renato Cinquini

Duration:
105 minutes

Genre:
Drama

Cast:
May Britt
Pierre Cressoy
Gina Lollobrigida
Anna Maria Ferrero

Year:
1953

directed, one might say that their role in Italian popular cinema of the early 1950s was considerably more complex than this, since their specialization in comedies came at the end of the decade. As screenwriters, for example, they made interesting – and also quite successful – attempts to transfer the narrative and figurative patterns of the American western into the Italian landscape in films like *Il lupo della Sila/Lure of the Sila* (Duilio Coletti, 1949) and *Il brigante Musolino/Outlaw Girl* (Mario Camerini, 1950). Monicelli himself adapted a Grazia Deledda novel in a western-like visual mood in *Proibito/Forbidden* (1954). The most acclaimed film Steno and Monicelli directed together, *Guardie e ladri/Cops and Robbers* (1951), a comedy starring Totò and Aldo Fabrizi, combines neorealist settings, gangster movie figures and the typical bitter humour of the *commedia all'italiana* that was to come.

Considering their experience in combining generic forms, it is hardly surprising that *Le infedeli*, directed by Monicelli alone and credited to both film-makers for contractual reasons, belongs to the broad and uneven area of what is usually referred to as Italian post-war melodrama. Like Hollywood's family melodrama and woman's film, this genre was not acknowledged as such, either, during the 1950s, but rather described by film scholars in the 1970s. One can nevertheless find some of the distinctive features of the genre in *Le infedeli* too, including the present-day settings, the narrative emphasis on female characters, the depiction of women's emotional lives and especially sexual behaviour as threatening the social and familial order, the recurring concerns over sin and moral responsibility, the frequent presence of crime-driven subplots, and male villains whose evil deeds often trigger the story's denouement.

In *Le infedeli* all these elements come together by means of a peculiarly melodramatic figure: the intruder, charged here with an ambiguous role. Osvaldo is the villain who interrupts the quiet and pleasant life of the protagonists, but he is also the outsider who, occasionally acting as an intradiegetic narrator, embodies the moral point of view of the spectators. Although these elements might seem unfamiliar as long as one identifies Italian melodrama solely with the films directed by Raffaello Matarazzo and the like, they indicate that, alongside the traditional families represented by the director of *Catene/Chains* (1949) and his several imitators, melodrama could also effectively address different environments and situations. In this respect, *Le infedeli* takes its place alongside other upper class, female-centred films imbued with melodramatic imagination such as *Cronaca di un amore/Chronicle of a Love* (Michelangelo Antonioni, 1951) and *Europa '51* (Roberto Rossellini, 1952), whose American title was, significantly, *The Greatest Love*. These films, to which one should add the extremely stylized dramas Vittorio Cottafavi directed in the 1950s, tackle the moral concerns of impending modernity from a less traditional point of view and in favour of an urban, higher-class – in sociocultural terms – audience, providing film scholars with an intriguing perspective that widens the field of Italian melodrama.

Paolo Noto

The Unknown Woman

La sconosciuta

Studio/Distributor:
Mediaset Film/Marigolda Film

Director:
Giuseppe Tornatore

Producer:
Laura Fattori

Screenwriters:
Giuseppe Tornatore with Massimo De Rita

Cinematographer:
Fabio Zamarion

Art Director:
Tonino Zera

Editor:
Massimo Quaglia

Duration:
118 minutes

Genre:
Drama/Mystery/Thriller

Cast:
Kseniya Rappoport
Michele Placido
Claudia Gerini

Year:
2006

Synopsis

Irena, a Ukrainian migrant in her thirties, arrives in a northern Italian city determined to find employment at the home of the affluent Adacher couple and their 4-year-old daughter Tea. Flashbacks gradually reveal that many years earlier Irena was trafficked to Italy for prostitution, resulting in her long-term bondage to a gangster nicknamed Muffa. Forced by her tormentor to give birth to nine children for arranged adoptions, Irena finally manages to escape by stabbing him, taking his money, and leaving him for dead. Having gained her freedom, she becomes intent on tracking down the last of the children she was obliged to surrender: a girl born from a clandestine romance with a man she loved. Believing that Tea Adacher is her lost daughter, she devises a ruthless plan to replace the family's long-term housekeeper. Once she has succeeded in becoming their trusted employee, she sets about developing a bond with the child. Her efforts are sabotaged, however, when Muffa reappears in her life, with harrowing consequences for all.

Critique

Best known outside Italy for *Nuovo Cinema Paradiso/Cinema Paradiso*, winner of the Academy Award for Best Foreign Film in 1989, Giuseppe Tornatore has consolidated his early critical and commercial success by releasing several well-received, widely-distributed films over the past twenty years, making him one of the few internationally-recognized directors currently operating in the Italian film industry. Though rather traditional in narrative structure and thematic concerns, his work is visually accomplished and emotionally resonant, appealing to mainstream audiences both at home and abroad. Like most of his output, *La sconosciuta* is a carefully-crafted film, featuring strong performances, striking cinematography and a stirring musical score. Yet in some crucial aspects it diverges from his familiar stylistic signature. The film's most obvious innovation vis-à-vis Tornatore's earlier work lies in its hybridized deployment of different stylistic registers. Though it is primarily a melodrama, much of its emotional impact comes from the creative admixture of conventions borrowed from other genres, particularly from horror and the thriller. Thanks to a process of delayed revelation and complicated narrative twists, *La sconosciuta* rivets the audience's attention, eliciting intense if not conflicting emotions. With marked echoes of Bernard Hermann's work for Alfred Hitchcock, Ennio Morricone's dramatic musical score accompanies the narrative's intricate unfolding, self-consciously heightening the atmosphere of suspense or, alternately, emphasizing the poignancy of Irena's predicament.

La sconosciuta opens with a particularly striking scene, framed as a flashback. Here, in a dimly-lit warehouse, a trio of masked women parade in their underwear for the benefit of a male observer,

who scrutinizes them through a peephole before singling out the woman later identified as Irena. The use of low-key lighting to underscore the women's uncanny self-presentation in identical, full-face masks lends an element of the surreal to the scene, which ostensibly alludes to the contemporary phenomenon of sex trafficking from the former Eastern bloc to more affluent areas of Europe. It becomes clear, however, that Tornatore is less interested in articulating a straightforward critique of a dehumanizing social practice than in creating a self-consciously *cinematic* work that moves beyond the more traditional psychological realism of his earlier films.

As the visual track repeatedly juxtaposes Irena's experiences in the present with the traumatic memories they involuntarily trigger, images anchored in different time frames begin to cohere for the viewer into a single narrative. The protagonist's obsessive effort to achieve closeness with Tea aligns *La sconosciuta* with the maternal melodrama: a subgenre of the so-called woman's film popular in Hollywood cinema during the 1930s and 1940s which featured self-sacrificing women reluctantly or unwillingly separated from their children. Tornatore's film is also reminiscent of Raffaello Matarazzo's Italian melodramas of the 1950s which weave elaborate tales of women's misfortunes, separations, and frustrated experiences of motherhood. Irena, however, is a more complex figure than her antecedents. Though certainly a victim of a terrible history, she is not without agency and is capable of premeditated violence.

At one level the narrative could be read as a paranoid text, reflecting a generalized anxiety about fertility, childbearing and motherhood in a country with a declining birthrate, and one where professional women often entrust their children to the daily custody of foreign-born caretakers. Certainly, the deployment of graphic scenes of violence unsettles any definitive reading of Irena as an entirely benevolent presence. When faced with her objectively-reprehensible actions, however, viewers are consistently encouraged to sympathize with her desperate quest for closeness with the child she believes to be her daughter. Tornatore's complex, polyvalent portrait of the central female character makes *La sconosciuta* one of his most compelling films to date.

Áine O'Healy

Volcano

Vulcano

Studio/Distributor:
Artisti Associati/Panaria Film

Synopsis

Maddalena Natoli, a prostitute, is forced to return to her native Aeolian island of Vulcano by Italian police. Her community, however, is reluctant to forgive her her past, and she is ostracized. Only her sister Maria, and her little brother, show affection toward her. This affection is threatened, however, when they learn the truth about Maddalena; in order to save her sister from the clutches of

Director:
William Dieterle

Producer:
William Dieterle

Screenwriters:
Renzo Avanzo
Mario Chiari

Cinematographer:
Arturo Gallea

Art Director:
Mario Chiari

Editor:
Giancarlo Cappelli

Duration:
102 minutes

Genre:
Drama/Melodrama

Cast:
Anna Magnani
Geraldine Brooks
Rossano Brazzi
Eduardo Ciannelli
Enzo Staiola

Year:
1950

Donato, a deep-sea diver and white slaver who is intent on seducing Maria, Maddalena must decide whether to sacrifice herself, and her relationship with her sister.

Critique

Vulcano is a film that has been overlooked by critics since its release; dismissed as an insignificant melodrama, its notoriety has derived from the fact that it was made and released at the same time as Roberto Rossellini's *Stromboli, terra di Dio* starring Ingrid Bergman. Rossellini and Magnani had been lovers until he left her for the Swedish star, who became pregnant while filming *Stromboli*. The thematic similarity of the two films is striking, as both deal with a female protagonist sent to a remote Aeolian island who has to suffer the suspicion of the islanders, and the harshness of the volcano itself. However, while *Stromboli* has been acclaimed as a neorealist masterpiece, notably by the writers of *Cahiers du cinéma*, *Vulcano*'s generic status as a melodrama, its hyperbolic plot and performances, and the perceived status of Magnani as having made the film as an act of revenge against Rossellini for abandoning her (despite the fact that *Vulcano* was written and conceived first and that Rossellini, if anything, borrowed the premise and idea), have mitigated against its careful critical evaluation. It is important to separate the film from the conditions of its production and reception (the premiere of *Vulcano* was, for instance, overshadowed by the birth of Bergman's son by Rossellini), and attempt to situate it within the context of post-war neorealism and melodrama in Italy. In fact, in many ways *Vulcano* embodies the clash between the techniques of realism and melodrama that characterized much of post-war Italian production, mixing these codes at will; the casting of Enzo Stajola, the little boy from De Sica's *Ladri di biciclette/Bicycle Thieves* (1948) as Maddalena's brother, and the long shots of the barren volcanic landscape certainly signal neorealism, while melodramatic scenes, mainly featuring the exuberant Magnani, are plentiful.

Critical reaction to the film concentrated mainly on Magnani's characteristically over-the-top performance: she sings, dances, laughs hysterically, weeps, shouts, and, in an extraordinary scene, carries out a murder with cold-blooded composure. It is Magnani's film, and she dominates it totally. Discussions of her performance are inevitably couched in a lexicon of the instinctive and the animalesque: critics described her as 'volcanic', 'telluric', 'violent', demonstrating how completely her post-war persona was associated with unruliness, disruptiveness and excess.

The film is notable also because it is one of the many Italian post-war melodramas that thematize prostitution. The inevitable suffering and punishment of the prostitute character, however, do not erase the sympathy that the narrative elicits for her, and the explicit way in which many of these films indict patriarchal values and laws regarding prostitution. *Vulcano* may be, as

critics insisted, a kind of stylistic mélange (and few critics paid attention to the film's technological innovations, such as its ground-breaking use of underwater filming), but it is a significant work, both in terms of Magnani's star persona, and because it illustrates so well the tensions and complexities of the post-war Italian film context.

Catherine O'Rawe

Compared to some of the nation's other successful genres (such as the diva film, the peplum, the spaghetti western or the gothic horror) comedy has had extraordinary longevity. The key genre across the history of Italian cinema, comedy's longevity and its interest in everyday life have allowed it to chart changes in the country as a whole, both in the plots of the films and in recurrent aspects of *mise-en-scène*. Comedy was for decades a place where collective ways of feeling were shared, gathering together common myths, dreams, desires and aspirations, and where we could both represent ourselves and forgive ourselves our vices. Forming a sort of snapshot of the Italian way of life, it depicted a society preoccupied with adapting to the situation and conforming to dominant modes of behaviour. Comedy has registered and absorbed both the smaller and larger traumas in the transformation of a country that has never truly changed, and has clung on to reassuring and inviolable vices and limitations.

Comedy, Italy's most popular genre, has thus not simply reflected but (at least until the end of the 1960s) played a key role in shaping national identity and aspirations, our adaptation to change and social integration. The study of comedy has therefore addressed not only comedy's narrative devices and textual organization, but also its social repercussions. Depicting reality through a distorting lens, comedy has often been thought of as offering a consolatory function for the average Italian, making our national vices acceptable.

Film comedy has drawn on many theatrical and popular Italian forms – including *commedia dell'arte*, music hall, revue, dialect theatre, radio comedy and cartoons – to create a broad spectrum of narrative models: stand-up, comedy of manners, farce, parody, grotesque, portmanteau, and historical film (of which *La grande guerra/The Great War*, Mario Monicelli, 1959, and *L'armata Brancaleone/For Love and Gold*, Mario Monicelli, 1966, remain unsurpassed examples). A meta-genre present in various narrative forms, it was through comedy that Italian cinema gained its cultural hegemony and drew talent (including actors but also dozens of writers, showgirls, and set designers) away from the popular theatre and into cinematic production (simultaneously absorbing and discarding theatrical traditions). If Totò is the most famous example of this inexorable drift from stage to screen, others include Macario, Nino Taranto, the De Filippo brothers, Aldo Fabrizi, Anna Magnani, Carlo Dapporto, Renato Rascel, Franco Franchi, Ciccio Ingrassia or the young Walter Chiari. Reproducing for the big screen the performance styles, gags, and comic personae typical of their stage shows, their popularity guaranteed the success of cinema over traditional forms. Many films are set nostalgically in the world of older forms of popular entertainment, such as *Vita da cani* (Steno and Mario Monicelli, 1949), *Luci del varietà/Variety Lights* (Alberto Lattuada, Federico Fellini, 1950), the episode of *Roma* (Fellini, 1972) set in a revue theatre, or *Risate di gioia/Joyful Laughter* (Monicelli, 1960) with Magnani and Totò stealing the show with their renditions of old Roman songs.

Although comedy is present across the entire history of Italian cinema, two periods in particular stand out: the first is that of the *commedia italiana*, related to the contemporaneous neorealism and during which emerged some of the most famous directors of the Genre:

Left: *The Great War/La grande guerra*, De Laurentiis/Gray Films.

Luigi Comencini, Steno, Luciano Emmer, Camillo Mastrocinque, Alberto Lattuada and Mario Monicelli. The second is that of the commedia all'italiana, a name given by French critics, with *Divorzio all'italiana/Divorce: Italian Style* (Pietro Germi, 1961) in mind, to *Il sorpasso/The Easy Life* (Dino Risi, 1963), christening the cycle as a whole. The term indicates a way of life 'all'italiana': anarchic rules of social behaviour, opportunism, trickery, a lack of responsibility or collective feeling, adding up to a repertory of vices which negates the common heroism of a people who had struggled against the horrors of war and fascism. With danger behind them, there dominates a logic of survival, the old *arte di arrangiarsi* (art of getting by) of the Belpaese. *Commedia all'italiana* is more concerned with disintegration than integration, in synchrony with a society – the Italy of the Economic Boom – in the euphoric grip of consumerism, and unable to deal with its desires, ambitions, and impulses: 'If *commedia italiana* was a "comedy about us", the *commedia all'italiana* was a "satire about me"' (Canova 2009,: 471). A number of directors emerged as masters of the genre in this decade, including Dino Risi, Pietro Germi and Antonio Pietrangeli; Marco Ferreri made black comedies and Ettore Scola took his first steps as a director after years as a scriptwriter. This is the period of comedy's greatest achievements, both in scriptwriting and in the creation of a recognizable national style.

During the Fascist period, comedy used international models to cater to a petty bourgeoisie which the regime was pushing towards a contradictory modernization. This was the era of the lavish decor of the *commedia all'ungherese*, also known as 'white telephone' films, whose bourgeois settings were far removed from the lives of ordinary people, and the lavishness of whose sets seems to suggest sublimated desire. However even in the Fascist period there are examples of realism in popular comedy, above all in the work of Mario Camerini (*Gli uomini, che mascalzoni…/What Rascals Men Are!*, 1932; *Darò un milione*, 1935; *Il signor Max/Mr Max*, 1937 and *Grandi magazzini/Department Store*, 1939, with Vittorio De Sica as the main protagonist) and in *Quattro passi tra le nuvole/Four Steps in the Clouds* (Alessandro Blasetti, 1942), a Capra-esque fable of everyday life which for many anticipates neorealism.

Immediately after the war came forms of neorealist comedy like *Vivere in pace/To Live in Peace* and *L'onorevole Angelina/Angelina MP*, both 1947 and directed by Luigi Zampa, Gennaro Righelli's *Abbasso la miseria!/Down With Misery!* (1945) and *Abbasso la ricchezza!/Down With Riches!* (1946), and Camerini's *Molti sogni per le strade/The Street has Many Dreams* (1948). Each (with the exception of *Vivere*) starring Anna Magnani, these light-heartedly recount the desire of the poor for justice and dignity. This combination of realism with generic elements developed by the 1950s into *neorealismo rosa* (pink neorealism), a combination which signalled that the discovery of 'a marginal and different country was fading into a vision of a rustic Arcadia and the ragamuffin, happy vitality of two pennorth of hope and of bread, love and fantasy' (Ferrero 1999: 239). Highly successful films like *Due soldi di speranza/Two Pennorth of Hope* (Renato Castellani, 1952), *Prima comunione/First Communion* (1950) and *Peccato che sia una canaglia/Too Bad She's Bad* (1954), both by Blasetti, *Pane, amore e fantasia/Bread, Love and Dreams* (Luigi Comencini, 1953), or Luciano Emmer's trilogy – *Domenica d'agosto/Sunday in August* (1950), *Le ragazze di Piazza di Spagna/Girls of the Spanish Steps* (1952) and *Terza liceo/High School* (1954) – are often wise and sharp sociological observations of enclosed worlds, tales of everyday life and common people whose hopes and wants (love, marriage, family, work, a decent life) are easy to identify with, and which display the desire to start anew that animated that decade. The results are often of stereotypes within a picturesque country that has not given up its faith in and determination for a better life.

In the mediation of change which cinema, and in particular comedy, set itself, centre-stage was taken by the construction of a national star system which could embody new social identities and teach the public new expectations and behaviour. Emmer's trilogy launched Marcello Mastroianni, discovered Renato Salvatori (the icon of the *poveri ma belli* of Roman comedy) and Ave Ninchi (a milder version of the energetic mother and woman of the people played by Magnani). Lollobrigida was established as the definitive eroticized female body in Italian cinema – provocative but naive, with an innocent sexuality – in the role of La Bersagliera in

Pane, amore e fantasia; while in *Peccato che sia una canaglia* Blasetti launched the pairing of Sophia Loren and Marcello Mastroianni. The new types of protagonists to emerge in these films are marked by and restricted to their particular region, and who, unlike in neorealism, deal with personal problems more than social ones. In these movies, the accumulation of realist details and the inclusion of the characters' wider environment are scenic aspects of decor, marking a more populist and less socially-critical cinema than was found in neorealism.

If the 1950s were marked by the presence of women whose energy and fertility seemed to symbolize the country's inexorable growth, the 1960s – like most cinema in the years to come – were male-dominated: actors included comedy's 'four musketeers' Alberto Sordi, Vittorio Gassman, Nino Manfredi and Ugo Tognazzi and, more generally, the explosive boom years tend to be experienced through the eyes of male protagonists. Alberto Sordi is paradigmatic as the embodiment of the average Italian, the collective projection of a people and of an epoch, and the scoundrel, cowardly and opportunist face of boom Italy.

A few exceptions used female protagonists to view changes in Italian society, often by making them victims of a superficial modernity that offers them no escape from the sacred realms of the hearth. Antonio Pietrangeli created a female universe with rare psychological depth, the stand-out characters being Pina (Sandra Milo) in *La visita/The Visitor* (1963), her horizons limited to marriage and family, and Adriana Astarelli (Stefania Sandrelli) in *Io la conoscevo bene/I Knew Her Well* (1965), an agonizing tale of the fantasy world that cinema offers as a surrogate for real life. But Italian cinema, above all comedy, seems to model its idea of woman and her body on the Fellinian imaginary of the female: images of loving and oppressive mothers, of seductresses, sirens and witches. The female body, even in its outstanding beauty, is never important in its own right but is subordinated to the desiring male gaze, framed and defined, observed and described according to the needs of the male. Such trends are prevalent in Italian culture and society and found throughout Italian cinema, which seems largely unable to register the real changes in female identity brought about by modernity.

Central to the *commedia all'italiana* is the body as a social mask, a site where the ego guards its image and where identity is made visible. Through the inability to be oneself, Italian cinema represents the traumatic passage of history and the approach of a modernity that, however superficially understood and accepted, remains alienating.

The detachment of subject from society, and of tradition and modernity, is central to many comedies which feature as heroes cowardly, crafty opportunists unable to master the new and, therefore, prey to wicked compromise solutions: Germi in particular attacks provincial vices in *Divorzio all'italiana* and *Signori e signore/The Birds, the Bees and the Italians* (1965), but a vitriolic tone is also present in *I mostri* (Dino Risi, 1963), *La donna scimmia/The Ape Woman*, (Marco Ferreri, 1963), *Un borghese piccolo piccolo/An Average Little Man* (Mario Monicelli, 1977) and *Brutti, sporchi e cattivi/Ugly, Dirty and Bad* (Ettore Scola, 1976).

The crisis in the 1970s and the loss of cinema's central cultural place meant production was geared around quick box-office returns. Comedy responded to an assumed need to 'see all' with the trash aesthetic of the *pecoreccia* (vulgar) comedy of uninhibited female teachers and soldiers, and wicked aunts, offering a series of sketches featuring stereotyped caricatures. There were some exceptions: Maurizio Nichetti's debut *Ratataplan* (1979) was a triumph of Tati-esque comedy; Gabriele Salvatores charted the succumbing of the post-68 generation to nostalgia; and finally, Carlo Verdone and Roberto Benigni. Verdone created a gallery of comic characters who were products of the – mostly Roman – social scene, while Benigni created anarchic comedy with subversive and poetic power.

In an age where the public is accustomed to the rhythms and faces of television, a number of directors have tried to recapture the inheritance of the *commedia all'italiana*, including Paolo Virzì, Gabriele Muccino, Daniele Luchetti and Carlo Mazzacurati, although the chance of them attaining the historical place of their forebears seems open to question.

Luisella Farinotti

An American in Rome

Un americano a Roma

Studio/Distributor:
Excelsa Film

Director:
Steno

Producers:
Dino De Lareuntiis
Carlo Ponti

Screenwriters:
Sandro Continenza (as Alessandro Continenza)
Lucio Fulci
Ettore Scola
Alberto Sordi
Steno

Cinematographer:
Carlo Montuori

Art Director:
Piero Filippone

Editor:
Giuliana Attenni

Duration:
85 minutes

Genre:
Comedy

Cast:
Alberto Sordi
Maria Pia Casilio
Carlo Delle Piane
Giulio Calì

Year:
1954

Synopsis

Nando Moriconi is a young Roman who thinks he is an American. His dream is to emigrate to Kansas City. Trying to get his big break, Nando performs at a variety theatre as Santi Bailor, 'the Italian Gene Kelly'. The show is a disaster and Nando is sacked by the manager. Desperate, he climbs the Colosseum and threatens to jump unless he gets a passport and passage to America. As a crowd gathers, his loved ones recount past incidents describing his obsession with America. In a POW camp, Nando pretends to speak English to communicate with US forces. On a Sunday excursion, dressed as the Sheriff of Kansas City, his directions in mangled English cause a car accident, injuring a wealthy American. He mistakes an American artist's request to pose for a portrait as a marriage proposal, eventually fleeing over the roof tops where he is caught naked on live television. In a gesture of goodwill, the American ambassador offers to meet Nando's demands. But he turns out to be the American gentleman injured by Nando the week before. Rather than Kansas City, Nando's final destination is the hospital. But the question remains, has he been cured of his obsession?

Critique

Alberto Sordi had already played the American-obsessed Roman youth Nando Moriconi in a sketch in Steno's previous film *Un giorno in pretura/A Day in Court* (1954). *Un americano a Roma* fleshes out the character's earlier appearance into an entire feature-length bravura performance by the comic actor. Nando is an extreme caricature of a certain type of Italian fascination with America. He dresses in jeans and baseball cap, reads cowboy comics and constantly talks in a bizarre mixture of mangled American phrases and invented sounds which he passes off as English. Nando is particularly influenced by American film. We see him at the cinema watching a Hoppalong Cassidy film, whose gestures and phrases he imitates. His artistic persona, Santi Bailor, is modelled on Gene Kelly and Fred Astaire and his suicide attempt is inspired by a poster outside a cinema for Henry Hathaway's *Fourteen Hours* (1951).

Despite the overarching thread of Nando's threatened suicide, the narrative is structured as a sketch film, with flashbacks to various events in Nando's life initiated by the stories of his father, girlfriend and best friend. The transitions between the main narrative and the flashbacks are quite abrupt, but the star performance of Alberto Sordi dominates proceedings and prevents the film from losing coherence. Sordi's Nando is unpleasant, self-centred, opportunistic and servile to authority. The performance develops Sordi's onscreen persona of an average Italian 'everyman' antihero, which had begun to emerge in his previous starring roles in Fellini's *Lo sceicco bianco/The White Sheik* (1952) and *I vitelloni/The Calves* (1953), and which he would continue to refine over the whole of his

career. Despite Nando's unpleasantness, Sordi's comic exuberance is difficult to resist. His comic style is heavily reliant on speech and dialogue, adding a layer of verbal humour to some of the film's more farcical or slapstick moments.

The film's use of television is of particular interest. Released the same year in which national television began broadcasting in Italy, *Un americano a Roma* is one of the first Italian films to represent the production and consumption of television to comic effect. When Nando accidentally wanders into the filming of a television programme, the scene capitalizes on the fact that early Italian television was broadcast live, showing the shocked reaction of viewers at home as the production team frantically try to remove Nando's naked body from the shot.

The film has now firmly established itself within the canon of classic Italian comedies. One scene in particular has ensured this lasting popularity. Nando returns from the cinema and refuses to eat the plate of spaghetti his mother has left for him, declaring that he will only eat American food such as a jam, yoghurt, mustard and milk sandwich that he prepares for himself. Rejecting the disgusting sandwich, he devours the spaghetti. The now iconic image of Alberto Sordi in baseball cap stuffing his face with spaghetti has come to encapsulate an entire generation's hybrid relationship to American culture which the film satirizes to such great effect.

Natalie Fullwood

The Beach

La spiaggia

Studio:
Titanus and Gamma Film

Director:
Alberto Lattuada

Screenwriters:
Alberto Lattuada
Luigi Malerba
Rodolfo Sonego
Charles Spaak

Photographer:
Mario Craveri

Art Directors:
Dario Cecchi
Maurizio Serra Chiari

Editor:
Mario Serandrei

Synopsis

Annamaria, a beautiful and elegant prostitute aged 30, takes her daughter Caterina to the seaside for the summer holidays. In the small, exclusive resort of Pontorno on the Ligurian Riviera she meets an array of holidaymakers – industrialists with their gossipy wives, vamps and spoilt children – who all gravitate towards a mysterious and bad-tempered local millionaire. Initially received enthusiastically by the other holidaymakers and shyly courted by mayor Silvio, Annamaria receives some unwelcome attention when, due to an unlucky coincidence, her true profession is discovered…

Critique

At the beginning of the film, at the train station where she is waiting to meet her daughter to leave for the seaside, Annamaria quickly wipes off her lipstick: she has to hide from the Sisters who look after the girl through the year the fact that she is a prostitute from the big city.

This is only the first of many acts of dissimulation in Lattuada's film, which takes its title from its principal setting, a fashionable Ligurian beach (its fictional name, Pontorno, barely concealing the real identity of the locale, Spotorno). The beach is a stage on which members of the upper-middle classes play their parts, having

Duration:
100 minutes

Genre:
Comedy

Cast:
Martine Carol
Raf Vallone
Mario Carotenuto
Valeria Moriconi

Year:
1954

removed their clothing but certainly not the inner trappings of their social class. *La spiaggia* thus prefigures the golden era of the *commedia all'italiana*, its comedy hinging on a particular place and moment – a holiday at the seaside – which is symptomatic of an entire society's headlong rush towards modernity. Indeed some of the types that would be common in the comedy of the 1960s are already present here (wealthy industrialists, arrogant army commanders, kept women), as is an abrasive point of view which would become a hallmark of the best films of the genre.

Lattuada tells his story with ill-concealed scorn for the hypocrisy of the holidaying bourgeoisie, and for a society made up of well-off people who are quick to condemn their neighbours (such as the beautiful prostitute who is in search of some respect while on holiday with her daughter) for offences which, behind the cover of class respectability, they are the first to commit. And so the seaside wives are happy to cheat on their husbands at work in the city, and the husbands are the first to boast of visiting brothels.

The film's technological novelty, Ferraniacolor, is well used by its director: *La spiaggia*'s colour palette excludes red, whose metaphorical significance would be too simplistic, and privileges pale, dull, almost monochrome tones to suggest a form of moral pallor. In conveying his moral about social class, Lattuada – who as well as directing wrote the screenplay with Luigi Malerba, Rodolfo Sonego and the Frenchman Charles Spaak (who contributed in particular to the mordant dialogues) – was paradoxically accused of immorality by a section of critics and public opinion, the film's nudity (in particular that of the young existentialist played by Valeria Moriconi) forming the pretext to attack it. A number of cuts were made to *La spiaggia*, establishing a difficult relationship between Lattuada and the censors which worsened in his subsequent films given his increasing interest in the female body.

But the real polemic lies in Lattuada's sarcastic *j'accuse*, behind which many right-wing and Catholic critics glimpsed an apologia for communism (in particular in the figure of the mayor Silvio, played by Raf Vallone) and an invitation to subvert the social order. Above all, Lattuada was not forgiven for the film's ending: when Annamaria is embraced by the misanthropic millionaire whose opinion counts for everything on the beach, everyone else, having ostracized her after discovering her profession, comes back respectfully, and she is redeemed not by love but by capital. Passing from prostitute to a woman kept in luxury, she can make her return to the petty world of the bourgeoisie that revolves around the beach in Pontorno. 'Don't greet me or her, greet the millionaire' is the bitter conclusion to a parable about human nature which is crueller than it may seem on first viewing.

Rocco Moccagatta

Big Deal on Madonna Street

I soliti ignoti

Studio/Distributor:
Lux Film

Director:
Mario Monicelli

Producer:
Franco Cristaldi

Screenwriters:
Age
Scarpelli
Suso Cecchi D'Amico
Mario Monicelli

Cinematographer:
Gianni Di Venanzo

Art Director:
Piero Gherardi

Editor:
Adriana Novelli

Duration:
111 minutes

Genre:
Comedy/Crime

Cast:
Vittorio Gassman
Marcello Mastroianni
Renato Salvatori
Claudia Cardinale, with a special appearance by Totò

Year:
1958

Synopsis

Rome, the end of the 1950s. Cosimo, a suburban criminal, is caught stealing a car and put in jail. Whilst inside, he receives some valuable information about a big heist. Impatient to get out and perform the heist, he gets his accomplice Capannelle to find a fall guy who, in exchange for 100,000 lire, will confess to the crime and guarantee Cosimo's innocence. Capannelle proposes the deal to Mario, an orphaned mummy's boy; Mario refuses but suggests Ferribotte, a Sicilian who is fiercely protective of his sister; Ferribotte also refuses but accompanies them to the house of Tiberio, a photographer with a baby to look after, its mother in prison; Tiberio refuses and suggests Peppe er Pantera, a mentally unsound boxer with no criminal record. Peppe accepts. However the preparations do not go to plan and Peppe ends up briefly in jail. After tricking Cosimo to get the details of the 'big deal' out of him (a robbery of the jewel safe in the Monte di Pietà [a pawn shop]), Peppe gets out with a suspended sentence, having decided to do the job himself. However he had not counted on Capannelle, Mario, Ferribotte and Tiberio lying in wait for him, eager to snatch the booty. Now all that remains is to combine their forces, and their wits…

Critique

One of the most prolific directors of the 1950s, *I soliti ignoti* was perhaps Mario Monicelli's greatest commercial and critical triumph. The film is a winning combination of farce and drama: Piero Umiliani's jazz score evokes the mood of an American gangster movie, while the plot is clearly a comic re-write of the French noir *Du Rififi chez les hommes/Rififi* (1955) by Jules Dassin. The film parodies the state-of-the-art technology which professional criminals conventionally possess, as the petty thieves of this film, taught by the maestro Dante Cruciani, put together a clumsy and useless set of equipment which includes a carjack and a sink plunger; the only modern piece of machinery is the cine camera stolen from a secondhand stall and used completely inappropriately by Tiberio, who accidentally erases some important images with his amateur footage.

The incongruence of their assumed skill (with Peppe er Pantera the worst show-off, both as a boxer and a criminal) with their actual ineptitude (Peppe ends up on the floor in record time and makes a catastrophic mistake at the end) is thus the principal motor of the comedy. Brutally muting the laughter, however, are some truly dramatic moments. Although largely beneath the surface, the film is given a tragic edge by the destitute conditions of its lumpenproletariat protagonists: each speaks a different regional dialect and together they represent the country as a whole, thereby defining Italy as a place of privation and need. This is particularly true for Capannelle, who is irresistibly attracted to anything edible that he can find. Monicelli's bitter comedy also extends to the target of the

crime: the band of 'persons unknown' (as the original Italian title translates) does not steal from the rich to give to the poor, having no pretension to any democratic redistribution of wealth, but drills into the Monte dei Pegni, running the risk of hurting other poor and deprived people.

The director and screenwriters presciently skewer the social and cultural transformation that was only to reach its full force with the economic boom in the subsequent decade. The precedents of the consumerist and get-rich-quick society can be found in the characters' desire for material goods: status symbols like the fur coat that Cosimo promises his girlfriend if the heist comes off, and comforts like the mattress that Tiberio's wife asks him for, or the four-roomed flat that Tiberio dreams of buying with the money. The improvement of one's conditions justifies any means used to get it, including theft and trickery as practised by the maid Nicoletta, with her string of rich suitors and boasts of noble birth. The female characters seem more emancipated than their male counterparts, being already more prepared for the impact of an incipient modernity. These include a very young Claudia Cardinale as Carmelina, who always tries to elude her brother's surveillance. Even the men, though, despite being braggarts, gradually reveal a psychological complexity (Mario's filial love, the softening of the irreprehensible Ferribotte, Peppe's loyalty towards Nicoletta) that makes them more than simple caricatures. The facets to their personalities make them progenitors of the more complex characterizations in Italian comedy in the following decade: their cowardliness is compensated by a naive candour and rehabilitation occurs by a fitting punishment behind the gates of a building site.

Elena Gipponi

Bread, Love and Dreams

Pane, amore e fantasia

Production Company:
Titanus

Distributor:
Titanus Distribuzione

Directed by:
Luigi Comencini

Director of Production:
Nino Misiano

Executive Producer:
Marcello Girosi

Synopsis

Police Marshal Antonio Carotenuto arrives in the small central Italian mountain village of Sagliena to take up a new position. Suave and charismatic but vain, he meets, and falls for, the young and voluptuous peasant worker Maria, 'La Bersagliera', but he has a rival for her affections: Pietro, the shy but handsome Carabiniere. Carotenuto resolves to have Pietro transferred to Rome to take him out of the equation. Meanwhile, the Marshal also becomes attracted to a midwife closer to his own age, Annarella, but she harbours a secret which, if revealed, could be a barrier to their love affair. Will the various lovers find happiness – and if so, with which partner?

Critique

Pane, amore e fantasia was one of 1950s Italian cinema's big popular successes. A highlight of both the pink neorealism (*neorealismo rosa*) cycle and the career of director/co-writer Luigi Comencini, the film can be seen as representative of a transitional period in Italian

Screenwriters:
Ettore M. Margadonna
Luigi Comencini

Cinematographer:
Arturo Gallea

Production Design:
Gastone Medin
Gino Rissone

Art Direction:
Gastone Medin

Editor:
Mario Serandrei

Duration:
93 minutes

Genre:
Comedy/Romance

Cast:
Vittorio De Sica
Gina Lollobrigida
Marisa Merlini

Year:
1953

cinema in the 1950s, retaining neorealism's location shooting and concentration on poor, 'everyday' characters while allowing more comical and fantastical elements to sit alongside its social realist preoccupations.

In this respect, its title says it all; and for Millicent Marcus, this conflation of neorealism with the fantastical makes for a compromised and somewhat ineffectual vision. Drawing on the work of Northrop Frye, Marcus argues that the comedic mode, if deployed across an entire film, can be seen as unsuited to a socially realist project: 'Comedy, with its unabashed artifice, its arbitrary manipulation of plot, and its celebration of formal boundaries, is by its very nature antagonistic to the realists' representational needs' (Marcus 1986: 132). For Marcus, therefore, *Pane, amore e fantasia* is 'an ahistoric classic comedy with a patina of realism that has no actual bearing on its conservative comic ideology' (1986: 133).

The film does indeed prioritize its beguiling but essentially frivolous romantic entanglements over any deeper portrayal of social change in post-war Italy. But this is not to say that it is free of an awareness of continuing themes. Shot in the village of Castel San Pietro Romano to the east of Rome, the film's excellent location photography goes a long way towards rounding out the romantic story with depictions of economic hardship and adverse conditions. And the close-knit portrayal of the life of the village can be seen to constitute, however implicitly, a microcosm of a country struggling with progress, tradition and a collective need to rebuild and develop.

Furthermore, the tight narrative structure creates a framework in which the performers can shine. An actor since the 1920s, De Sica was, by the time of *Pane, amore e fantasia*, also well established as a director in his own right, having made a string of classics such as *Sciuscià/Shoeshine* (1946), *Ladri di biciclette/Bicycle Thieves* (1948), *Miracolo a Milano/Miracle in Milan* (1951) and *Umberto D* (1952). De Sica, who would go on to play the part of Carotenuto in two further *Pane, amore e...* movies, is a charming presence, nicely essaying both the marshal's womanizing ways and his tender feelings for the two women who have captured his attention. As the younger of these, Gina Lollobrigida gives a performance of such vivacity that it is not difficult at all to see how she would become one of the sensations of the period. But her work here, like De Sica's, impressively does not detract from the rural atmosphere and the mixture of familiar and unknown faces.

The intelligence of Comencini's light-hearted directing is to allow his appealing ensemble cast ample room to demonstrate their comedic passion and cross-purposes. And while his *mise-en-scène* is perhaps less immediately vivid than those of contemporaries such as Federico Fellini, Pietro Germi and De Sica himself, the understated warmth of *Pane, amore e fantasia* has proven a timeless quality; Aldo Viganò has noted that the film is an example 'of the best of Italian comedy, where the dramatic dimension takes precedence over that of the visual' (Viganò 1998: 52, my translation). It is a compromised vision in many ways – but *Pane, amore e fantasia* also remains an unpretentious, exuberant delight.

Ed Lamberti

Divorce: Italian Style

Divorzio all'italiana

Studio:
Lux Film

Director:
Pietro Germi

Producer:
Franco Cristaldi

Screenwriters:
Alfredo Giannetti
Ennio De Concini
Pietro Germi

Cinematographers:
Leonida Barboni
Carlo Di Palma

Art Director:
Carlo Egidi

Editor:
Roberto Cinquini

Duration:
101 minutes

Genre:
Comedy

Cast:
Marcello Mastroianni
Daniela Rocca
Stefania Sandrelli
Leopoldo Trieste

Year:
1961

Synopsis

Baron Ferdinando (Fefè) Cefalù, an impoverished aristocrat, sits in a train headed home to the Sicilian town of Agramonte. Along the journey he casts his mind back to recent events: Fefè, married to Rosalia, has harboured a secret crush on his 16-year-old maiden cousin Angela. When he found out that she eagerly requited his love for her, Fefè, mad with passion, remembered the murder of local woman Mariannina Terranova and thought of a 'legal' way of freeing himself once and for all from his wife: according to article 587 of the penal code, Italian law stipulates a reduced sentence (3–7 years imprisonment) for a crime of passion, that is, the killing of a spouse unexpectedly caught in flagrante delicto. Fefè discovers that Rosalia still thinks of her childhood sweetheart, the painter Carmelino Patanè, who is now married with children. Pushing her towards the arms of Patanè by asking him to restore a fresco in the Cefalù mansion, Fefè does not bargain on the two lovers eloping, and thus a further stain appears on the honour of a family which has become a local laughing-stock.

Critique

With *Divorzio all'italiana* Pietro Germi, already an acclaimed director of high-quality genre films (western, crime film, melodrama), moved into comedy with the first in a kind of 'trilogy of malice' that also includes *Sedotta e abbandonata/Seduced and Abandoned* (1963) and *Signore e signori/The Birds, The Bees and the Italians* (1965). *Divorzio all'italiana*'s story is at first glance dramatic, and only turns into a grotesque farce in the manner of its telling. Such farcical satire is thanks to screenwriters Giannetti and De Concini, who, along with Germi, and unusually for an Italian film, received an Oscar for best original screenplay. Although comic, the narrative displays a decidedly black humour from the outset as over the opening credits a love song plays on a mandolin (the principal folk instrument of the Italian South) but quickly turns into a solemn funeral march played by brass band.

The first part of the film is marked by Fefè's fantasies of possible methods of doing away with Rosalia: dissolved in a boiling cauldron to make soap, swallowed up by quick sand, even sent into orbit around the Earth. The repetition of certain situations is one of the film's favourite comic mechanisms, used to show that married life between Fefè and Rosalia is the same as that of his ageing parents, and in the many scenes where sister Agnese and her boyfriend Saro Mulè are interrupted whilst exchanging tendernesses. Recurrent repetition (the plan for the murder and the subsequent trial echo the case of Mariannina Terranova) adds up to a portrayal of a social and familial world in which daily habits and collective rituals are handed down the generations in the name of a strict respect for tradition and an unchanging sense of identity (on the surface at least). The film's malice is aimed at the persistence of antiquated and stubborn moral and social codes

(the honour of the Latin male) in the face of situations in which they have become hopelessly outdated: Don Ferdinando Cefalù cannot stand his wife but instead of demanding the modernization of local custom and of the law (divorce was only legalized in Italy in the 1970s) he prefers to adopt a hypocritical respect for tradition (legislation on crimes of passion goes back to the Fascist era and was not repealed until the 1980s) and settle with the status quo.

The *all'italiana* of the title, therefore, refers to the co-presence of backwardness and modernity, each of which are exploited by the characters when it suits them. Thus it is not only Fefè and his family who are *all'italiana*, but the whole town of Agramonte, which is conformist and tightly-knit, negotiating the wicked prurience of enthusiasm for Federico Fellini's scandalous *La dolce vita* (1960) with penitence in the face of the priest in his pulpit. Stylistically, Agramonte and its inhabitants are presented with a sharp and vigilant eye which differs from the realistic and invisible directorial style of many contemporary comedies: Fefè's thoughts are rendered by zooms, panoramas and slapstick fast-motion, establishing an ambiguous and subtle relationship between his narrational voice and its filmic enunciation. The director also emphasizes the aspects of caricature in the protagonists (Rosalia's facial hair, thick eyebrows and low forehead, Fefè's tics, the over-rhetorical language of the lawyer and so on) from whom our cynical detachment continually increases up to the film's unexpected finale

Elena Gipponi

The Easy Life

Il sorpasso

Studio:
Fair Film
Incei Film
Sancro Film

Director:
Dino Risi

Producer:
Mario Cecchi Gori

Screenwriters:
Dino Risi
Ettore Scola
Ruggero Maccari

Photographer:
Alfio Contini

Synopsis

Mid-August bank holiday in Rome: shy Roberto, who reluctantly must study for his exams, is convinced by the boisterous Bruno Cortona to come in his new sports car, first for an apertif, then for lunch outside of the city, and finally for a trip cavorting down Via Aurelia. They travel non-stop from one random meeting to the next: Roberto takes his new friend to his aunt and uncle's in the countryside, while Bruno takes them on a trip to the sea to see his wife, from whom he is amicably separated, and daughter, who is engaged to a man her father's age. By the time Roberto has caught Bruno's sense of irresponsibility, on the umpteenth mad rush and round the final bend, destiny lies in wait…

Critique

Frenetic: there is no better way of describing Dino Risi's film and the breakneck drive in a sports-car through the sultry August heat by the daredevil Bruno Cortona, played by a Vittorio Gassman at last given full reign in a realistic comic role (unlike his heavily-made-up performance in his comic breakthrough *I soliti ignoti*/*Big Deal on Madonna Street*, 1958, Mario Monicelli).

Art Director:
Ugo Pericoli

Editor:
Maurizio Lucidi

Duration:
108 minutes

Genre:
Comedy

Cast:
Vittorio Gassman
Jean-Louis Trintignant
Catherine Spaak
Claudio Gora

Year:
1962

Il sorpasso is one of the classic examples of the *commedia all'italiana*, and one of the best collaborations between Gassman and Risi: previously brought together in *Il mattatore/Love and Larceny* (1960) and *La marcia su Roma/March on Rome* (1962, alongside Ugo Tognazzi, his acting partner in the subsequent and equally classic portmanteau film *I mostri*, 1963, with Risi directing again), the two would again reach a perfect, if more melancholic, harmony in the autumnal *Profumo di donna/That Female Scent* (1974). It is difficult to imagine the film as initially conceived with Sordi in the lead role; Gassman seems made for a script that, although based on an original (and uncredited) idea by Sonego, came to fruition in the director's collaboration with Scola and Maccari, and was deeply admired abroad (even providing the inspiration for *Easy Rider*, Dennis Hopper,1968).

But beneath a surface as dazzling as the chrome on Bruno's sports car, *Il sorpasso* is also an extremely sharp analysis of the Italy of the 1960s and of the economic boom being pushed perilously close to the precipice. Bruno Cortona exemplifies this Italy perfectly: restless, always with a ready quip, eager to please and ineffectual, and basically a scoundrel (a 'fanfaron' – braggart – to give the film its French title), he swallows life down in bite-size chunks with an interest only in immediate pleasures and no concern for the future or memory of the past. Risi sensed the atmosphere of the time in a perhaps more direct but also more effective way than many of his colleagues (directing some venomous barbs through Cortona at Antonioni and incommunicability during one of the character's many monologues).

The Easy Life/Il Sorpasso, Incei Film/Fair Film/Sancro Film.

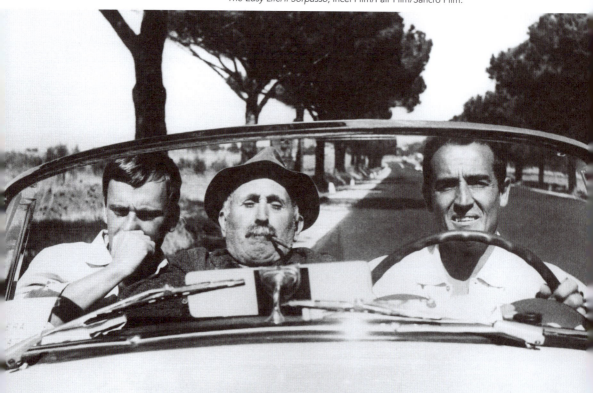

Cortona's indecisiveness is mimicked by his insane driving of his sports car up and down the Via Aurelia to the continual accompaniment of songs and musical themes. Together the two map out a country balanced uneasily between the comfort of tradition and the joys of modernity, travelling from deserted cities to a countryside burnt by the sun and beaches preyed upon by nascent mass tourism. The car is a technological fetish object that represents a modernization that is more undergone than understood, and becomes the symbol and catalyst of a story which makes explicit its metaphorical importance despite continual episodic digressions.

[Warning: spoiler alert] Around the final bend lies death, the surprise ending almost a final reckoning for the irresponsibility of a whole society and a presage of times to come. It is not Cortona who pays but his meek travelling companion Roberto, a law student involved in the day's folly against his will from the start; the exact opposite of Bruno (Trintignant plays the character as fundamentally shy) into whose image he is gradually remoulded, becoming by the end a perfect scapegoat. It is no accident that it is he who pushes his new friend to fatally accelerate, receiving a miserable and stuttered elegy in the film's final line, as impoverished as Cortona's personality and world: 'His name was Roberto, I don't know his surname, I only met him yesterday morning.'

Rocco Moccagatta

The Great War

La grande guerra

Studio:
Dino De Laurentiis Cinemtografica spa

Director:
Mario Monicelli

Producer:
Dino De Laurentiis

Screenwriters:
Agenore Incrocci
Mario Monicelli
Carlo Salsa
Furio Scarpelli
Luciano Vincenzoni

Cinematographers:
Roberto Gerardi
Giuseppe Rotunno

Art Director:
Mario Garbuglia

Synopsis

Giovanni Busacca and Oreste Jacovacci, two small-time wheeler-dealers from Milan and Rome, respectively, find themselves thrown into grudging camaraderie on the frontline trenches of the First World War as disposable infantry at the mercy of Italian higher command. The terrible conditions they face there and their own quips, wiles, and cynicism chip away at weak attempts to instill patriotic fervour. The plot unfolds between moments of farce and tragic loss, as Busacca and Jacovacci try every trick in the book to avoid work and danger, always contriving to be on a less-dangerous mission when their companions brave the battlefield or suffer attack. The lessons in heroism to which they are occasionally exposed appear to roll off them like water off proverbial ducks' backs, but a fragile moral core that they endeavour to disguise is nonetheless exposed now and then: in Busacca's tender feeling for the prostitute Costantina, and in the men's reluctant donation of some dubious earnings to the wife of a dead friend. It is this moral core, which has nothing to do with patriotism and everything to do with a sense of loyalty to friends, that will eventually be put to the test when the two men are mistaken for spies by the Austrian enemy.

Critique

La grande guerra is a film of many firsts. Together with Monicelli's film of 1958, *I soliti ignoti*/*Big Deal on Madonna Street*, it is

Editor:
Adriana Novelli

Duration:
130 minutes

Genre:
Comedy

Cast:
Alberto Sordi
Vittorio Gassman
Silvana Mangano

Year:
1959

regarded as having pushed Italian comedy to a different level. Thus began the era of *commedia all'italiana*, the infusion of the comic with a serious moral and political intent: in this case throwing into question a patriotic vision of Italian history in which classes united in meaningful, willing sacrifice to the greater good. One of the film's minor characters, for example, performs acts of outstanding bravery in no-man's land, relieving his comrades of their duties, but in exchange for money, which he passes on to his wife and large family. In this context, it was one of the first films to return to the repressed, vexed question of Italy's role in the two World Wars. The film was hotly debated in the Italian parliament even before it went into production, although Andreotti's defence of it hinted at the pending softening of censorship law.

It was also one of the first films to offer a serious interrogation of the 'italiano medio', the ordinary Italian, who was to become a stock comic character often incarnated by Alberto Sordi and Vittorio Gassman, who developed their quite distinct star incarnations of 'l'arte di arrangiarsi' (the art of getting by) with exquisite regional inflections in this film. Lazy and self-serving, but occasionally generous; boastful, but cowardly; quick to temper, but equally quick to laughter; garrulous and quick-witted in Gassman's case; prone to overweaning, but misplaced self-confidence in Sordi's, this character was to become one of the most contentious features of the *commedia* genre. Was he an incisive and unsettling dissection of the Italian psyche, or did the laughter he generated stem from smug self-approbation on the part of Italian audiences with whom he was so unfailingly popular for the best part of a decade? Alan O'Leary has suggested that the 'satirical proximity' audiences might have felt in relation to the fond, but cutting depiction of these characters was able to provoke a level of self-reflection that some critics have doubted (O'Leary 2007).

From the perspective of Italian film history, then, *La grande guerra* has a very significant place in the canon. However, it is a film that still deserves greater international recognition as an outstanding anti-war film, to be ranked alongside the likes of Milestone's *All Quiet on the Western Front* (1930) and Rossellini's *Paisà/Paisan* (1946). Peter Bondanella reminds us that *La grande guerra* combines 'the conventions of film comedy with those of the historical colossal and the war film' (Bondanella 2001: 146). Indeed, there is no doubt that much of the film's power arises from the fact that it does not simply gesture towards a wartime setting, but used 'a large budget, a huge cast, and Cinemascope' to attempt a detailed, and sometimes painful, reconstruction of the Italian front, with its brutal massacres, everyday drudgery and borderline starvation, bungled orders, its rare instances of heroism and good sense in the command but, more often, its commanding officers' absurd sense of entitlement. Much of this is conveyed when one infantryman insists to his superior that the messenger within reach of their trench will die if ordered forwards. The lieutenant overrides this advice and brings the messenger into the trench, causing his death. The important message he bears is that they should distribute chocolate and grappa in celebration of Christmas. Here, as so often in this film, a darkly ironic mistiming

prevails. This story does not proceed steadily towards a moment of sentimental catharsis but towards an accidental and typically impetuous single act of heroism that challenges the established notion of a wartime hero, and strips the film of any military or patriotic logic, making it the anti-war film par excellence.

Danielle Hipkins

Mediterraneo

Studio/Distributor:
Penta Film

Director:
Gabriele Salvatores

Producers:
Mario and Vittorio Cecchi Gori (Penta film) and Gianni Minervini (Ama film)

Screenwriter:
Enzo Monteleone

Cinematographer:
Italo Petriccione

Art Director:
Thalia Istikopoulou

Editor:
Nino Baragli

Duration:
98 minutes (86 minutes in the international version)

Genre:
Comedy/Drama/War

Cast:
Claudio Bigagli
Diego Abatantuono
Ugo Conti
Gigio Alberti
Claudio Bisio
Giuseppe Cederna

Year:
1991

Synopsis

During the Second World War, in June 1941, an ad-hoc platoon of Italian soldiers is sent to garrison a small Augean island called Medisti. The soldiers are the coarse Sgt Lo Russo, his trusted radio operator Colasanti, mule-driver Strazzabosco, the Munaron brothers from the mountains, clumsy batman Farina and the habitual deserter Noventa. They are headed by Lieutenant Montini, a secondary-school teacher with a passion for painting. The island seems at first to be deserted, and when the inhabitants of the village start to appear there are only women, the elderly, and children; the men have been deported by the Germans. The soldiers abandon themselves to idleness and romance. During a football match, an Italian pilot who lands on the island announces that there has been an armistice. The group realizes that three years have passed. The men return to the island and after some time the British repatriate the soldiers, except for Farina, now married, and Noventa, who escaped on a boat. Years later, the elderly Montini, informed by Farina of his wife's death, arrives on an island now swarming with tourists. Lo Russo is also on the island, having returned disappointed by the betrayed hopes of post-war Italy.

Critique

Gabriele Salvatores's fifth film, and winner of the Best Foreign Film Oscar in 1992, *Mediterraneo* was the third of three pictures filmed continuously in just three years. It follows *Marrakech Express* (1989) and *Turné/On Tour* (1990), the three often being linked as the 'trilogy of escape'. *Mediterraneo* is the first and only historical film by Salvatores, but it is clear from the opening scenes that we are dealing with a war film *sui generis*: there are no representations of military activity (glimpsed only from afar, on the first night, in brief flashes from a battle), of tragedy (the only deaths are a hen and a donkey) or of epic direction. The result is a demythologization of war in the tradition of the *commedia all'italiana*, from which *Mediterraneo* inherits the task of creating a realistic portrayal of the era, especially in the rapport it presents between the integration and the exclusion of the individual from society. The protagonists, a somewhat random collection of vain and destitute men, are marked by regional characteristics that suggest an Italy of small, isolated fragments (the Tuscan Lieutenant who is also a poet, the reserved mountain-dwellers from the Veneto, the Milanese show-off, the vague Sicilian pilot). At the

start of the film, the characters move in dysfunctional pairs (the two Munaron brothers, Strazzabosco and the donkey, the batman and the lieutenant, the sergeant and the radio operator) as if expressing a fragmented collectivity in search of a place to regroup. As a whole, however, they are reduced to the repeated line 'Italians: one face, one race', a self-absolving opinion characteristic of Salvatores' anti-heroes but which is also a homage to a film tradition in which farcical derision rarely adds up to a real critique.

Mediterraneo oscillates between a realistic setting and surreal abstraction. The warm and welcoming light of the imaginary Medisti island, where it is always summer, shines on a species of elderly people, lovely women and happy children, a kind of primordial Eden, a mythological place predating human history. Medisti is a place where the past can be cancelled out and the future reimagined. The citation by Henry Laborit at the start of the film ('In times like these escape is the only way to stay alive and continue to dream') gives the idea of escape as a kind of precondition for the redefinition – or the persistence – of dreams. The soldiers' previous lives are only acknowledged retrospectively whilst on the island (with the exception of Noventa, who returns to his pregnant wife in Italy), and nothing is learnt of what happens to the characters in the ellipsis between the soldiers' return home and the film's epilogue. Instead we find them, disappointed, as if time had contracted in expectation of a bitter realization at the film's end.

Salvatores' young soldiers, who, 'at an age where one is unsure whether to start a family or lose oneself around the world', play football, have their first sexual experiences (including a *ménage à trois*), discover their homosexuality, smoke chillums and make fun of the Fascist regime, represent a symbolic generation born not of the downfall of Mussolini in 1943 but of the loss of the ideals of 1968 by the time of the political scandals of the early 1990s. The heritage of the '68 generation, Salvatores seems to suggest, can be found in personal interactions, in small collectives and their artisanal modes of production. As the film's ending suggests, when Lieutenant Montini goes back to work with his old comrades, this is less about escaping than simply about getting back together again.

Mimmo Gianneri

The Sign of Venus

Il segno di Venere

Studio/Distributor:
Titanus

Director:
Dino Risi

Synopsis

Cesira, a typist, consults Pina, a woman downstairs who reads cards. Pina tells her that she is fortunate to be just now under the sign of Venus, and that she will meet three men, one of whom will be the one for her. First she meets Romolo, a swaggering and incompetent car thief, who, when apprehended, turns out to be a whingeing mother's boy. She next meets Alessio, a shabby, self-declared poet who leads her along until he meets the obviously wealthier and more worldly Pina. Finally, she meets Ignazio when she is a bystander at a minor accident he is involved in; he falls in

Producer:
Marcello Girosi

Screenwriters:
Edoardo Anton
Ennio Flaiano
Franca Valeri
Dino Risi with Cesare Zavattini
Ettore M. Margadonna
Age (Agenore Incrocci)
Furio Scarpelli

Cinematographer:
Carlo Montuori

Art Director:
Gastone Medin

Editor:
Mario Serandrei

Duration:
100 minutes

Genre:
Comedy

Cast:
Franca Valeri
Sophia Loren
Peppino De Filippo
Alberto Sordi
Vittorio De Sica
Raf Vallone
Lina Gennari
Leopoldo Trieste

Year:
1955

love with the cousin she lives with, Agnese, and she with him. By the end of the film, Agnese is pregnant and she and Ignazio are set to marry, and Cesira is still alone.

Critique

Il segno di Venere is built around its cast. At its centre is Franca Valeri, the only comic actress to achieve the kind of stardom attained by three of her co-stars here: De Filippo, De Sica and Sordi. Beginning as a monologist in salons, cabaret and radio, writing (as here) her own material, she honed a range of characters based on a template of pretentiousness, of aspiration to a misapprehended gentility or sophistication. The detail of the performance is precise and witty but if there is an underlying sadness, there is also a vein of misanthropy and even misogyny in the characterizations.

One of the cruellest strokes in *Il segno de Venere* is casting her opposite Sophia Loren. They were to have been sisters but the contrast in their appearance was deemed to make that implausible. It is not just the unfairness of the perceived distribution of beauty that makes the casting cruel but the contrast between Loren's confidence and ease in her body over against Valeri's stiffness and unhappiness (themselves, of course, a source of humour and poignancy). Cesira introduces Agnese to Ignazio – Raf Vallone, as handsomely, relaxedly virile as Loren is sumptuously, sensually feminine. When they bid him goodbye, there is a somewhat crudely-comic, heartbreaking shot of Agnese and Cesira looking at him, Agnese clutching a milk bottle to her breast, beaming in the pleasure of desiring and being desired, and, only coming up to her shoulder, Cesira, head slightly cocked to one side, smiling uncertainly, wanting to believe that she is the one he is interested in. As they turn from him, both raise their right hand in a gesture of self-conscious refinement and sway their hips as they walk off, but the moment they think he is out of sight, Agnese drops the pose and relaxes into her body. For a moment, she has behaved like Cesira, but it is just a gag, whereas such unease coming out as pretension is Cesira's – which is to say Valeri's – stock in trade.

The joys of casting do not end here. Romolo builds on Alberto Sordi's braggadocio persona, his lordly mistreatment of women, over-reaching scams and underlying spinelessness. Vittorio De Sica's Alessio is a development of his 1930s persona in such films as *Gli uomini, che mascalzoni…/What Rascals Men Are!* (1932) and *Il signor Max/Mr Max* (1937), passing himself off as something that in class terms he is not, but handsome, guileless, charming, a characterization become seedy, phony and manipulative by 1955. Add in De Filippo as a friend and colleague hopelessly but, as is Peppino's way, cautiously in love with Agnese, as well as such beloved character actors Lina Gennari, Tina Pica, Virgilio Riento and Leopoldo Trieste, and you have a dream cast, to whose talents the film was consciously crafted.

Such riches do not always, perhaps not even usually, jell. The source of the achievement of *Il segno di Venere* is suggested by its

scriptwriting team, which includes, on the one hand, Valeri alongside Age and Scarpelli, stalwarts of Italian comedy, and, on the other, Zavattini (*Ladri di biciclette/Bicycle Thieves* (1948), *Umberto D* (1951)) and Flaiano, Fellini's regular collaborator. *Il segno di Venere* marries the episodic, often inconclusive structures of neorealism with the sketch-based skills of its cast (Loren and Vallone, one a Miss Italy, the other an ex-footballer, providing the ballast). Sketches are liable to be bitty but are difficult to sustain for the entire length of a film. By interlacing their stories and placing them within a patina of location-shot everyday life, the film not only solves the problem of sketchiness but also draws out the complexity and ambiguity of the standard characterizations of its principle players.

Richard Dyer

The Private Secretary

La segretaria privata

Studio/Distributor:
Cines

Director:
Goffedo Alessandrini

Producer:
Stefano Pittaluga

Screenwriter:
Goffredo Alessandrini from the film screenplay by Franz Schulz based on the book Die Privatsekretärin by Istvám Szomaházy and the operetta by István Békaffi

Cinematographer:
Massimo Terzano

Art Director:
Vinicio Paladini

Editor:
Guy Simon
Goffredo Alessandrini

Duration:
73 minutes

Genre:
Comedy

Synopsis

Elsa Lorenzi arrives in the big city in search of employment as a typist. Having found residence in a boarding house for single young women she manages to bypass the competition and wheedle her way into a job in a large bank by befriending one of the employees. However, she soon encounters the hostility of the head of personnel, who only offered her the job in the hope of obtaining sexual favours. Forced to work late, she meets the bank's director, Roberto Berri, and, believing him to be a simple employee, agrees to go out on a date. However, when he invites her back to his house she turns him down claiming that she hopes to marry someone more affluent and thus avoid a lifetime of drudgery. On discovering his true identity the next day, she tries to reawaken his interest; however a series of misunderstandings and complications continue to obstruct their burgeoning love for one another.

Critique

La segretaria privata is adapted from the novel of the same name by the Hungarian author Istvám Szomaházy, which had already been adapted into an operetta by István Békaffi. Made shortly after the introduction of synchronized sound technology – the first Italian talkie, *La canzone dell'amore* (Gennaro Righelli), was released only the year before – it was, like many European films of the period, produced in three different language versions, shot more or less simultaneously with a different cast and crew. *La segretaria privata* is thus the Italian adaptation of the original German version, *Die Privatsekretärin*, directed by Wilhelm Thiele; an English version directed by Victor Saville, *Sunshine Suzie*, was also produced, and a French version, *Dactylo*, also directed by Thiele in 1931. While the German and English versions both featured Renate Müller in the title role, the Italian version starred Elsa Merlini in her film debut (her cinema career was to continue into the late 1950s and her TV work for another two decades). To direct the Italian version producer Stefano Pittaluga selected Goffredo Alessandrini, who had already served as assistant

Cast:
Elsa Merlini
Nino Besozzi
Sergio Tofano
Cesare Zoppetti
Umberto Sacripante

Year:
1931

director to Alessandro Blasetti and made several documentaries but was also making his feature-film debut. He was later to become better know for making fascist-inflected epics like *Cavalleria* (1936), *Luciano Serra pilota/Luciano Serra, Pilot* (1938) and *Abuna Messias/Cardinal Messias* (1939). *La segretaria privata*, however, is a very different proposition. Its origins in operetta are clearly in evidence in its combination of light, frothy romantic comedy spiced up with a handful of musically unambitious, but instantly hummable, tunes (arranged by Paul Abraham from music originally composed by Lajos Lajtai). Indeed while it is often regarded simply as a comedy, with its song and dance routines, *La segretaria privata* can also be seen as Italy's first musical (although *La canzone dell'amore* also exploited the new sound technology to the full by making its protagonists musicians).

As in the films that Mario Camerini was making during the period, much of the comedy in *La segretaria privata* derives from a series of complications and misunderstandings that arise when characters either pretend (in the case of Roberto Berri) or desire (in the case of Elsa Lorenzi) to be something they are not. However, whereas Camerini lampoons the pretence of possessing a higher social status in *Gli uomini, che mascalzoni…/What Rascals Men Are!* (1932) and *Il Signor Max/Mr Max* (1937) and has the characters played by Vittorio De Sica ultimately accept their position and find happiness with a girl of the same class, Alessandrini has Elsa Lorenzi achieve her dream of marrying a rich banker; one cannot help feeling that in managing to reconcile both wealth and true love, she succeeds in having her cake and eating it. Despite its simplistic ideology and modest ambitions, *La segretaria privata* remains an easy film to like – its cast give winning performances, Alessandrini keeps the pace moving quickly through the short running time, and the musical and comic routines are often delightful. Thus the film testifies to the fact that, following the virtual collapse of the Italian film industry in the late 1920s, by 1931 its recovery was already well under way.

Alex Marlow-Mann

Totò, Peppino and the Hussy

Totò, Peppino e la malafemmina

Studio/Distributor:
D.D.L.

Director:
Camillo Mastrocinque

Producers:
Isidoro Broggi
Renato Libassi

Synopsis

Brothers Antonio and Peppino Capone, who live on a farm in the countryside of Campania, are engaged in a feud with their neighbour Mezzacapa. Their nephew Gianni studies medicine in Naples. One night Gianni encounters a showgirl, Marisa Florian, and falls in love. The couple embark on an affair and, when Marisa goes on tour, Gianni follows her to Milan. When an anonymous letter arrives at the farm claiming that Gianni is neglecting his studies for a woman of ill-virtue, Antonio, Peppino and Gianni's mother, Lucia, set off for Milan determined to end the affair.

Critique

Following the success of Roberto Amoroso's *Malaspina* (1945), the years 1945–1959 saw a conspicuous production of musical

Screenwriters:
Nicola Manzari
Edoardo Anton
Sandro Continenza
Francesco Thellung
Camillo Mastrocinque

Cinematographer:
Mario Albertelli

Art Director:
Alberto Boccianti

Editor:
Gisa Radicchi Levi

Duration:
118 minutes

Genre:
Comedy

Cast:
Totò
Peppino De Filippo
Dorian Gray
Teddy Reno
Vittoria Crispo

Year:
1956

melodramas based around classic and contemporary Neapolitan songs. Most of these films – often referred to as the 'Neapolitan Formula' – narrated tragic love stories of women led astray or men doomed by their passion for a beautiful but treacherous woman. *Totò, Peppino e la malafemmina* is probably the only example of a film from this period which is based on such a song and recounts such a story, but in a comic vein. It was based on the extremely popular *Malafemmena*, a heart-wrenching love song written in Neapolitan dialect by the comedian Totò in 1951 and apparently dedicated to his wife, from whom he was separated, although for many years it was believed to have been inspired by Silvana Pampanini, his co-star in *47 morto che parla* (Carlo Ludovico Bragaglia, 1950). During the course of the film, the song is performed – along with several other popular Neapolitan songs – by the singer Teddy Reno, who plays Gianni and who also appeared in Camillo Mastrocinque's *Totò, Peppino e i fuorilegge* earlier the same year. The Neapolitan Formula frequently revolved around the question of female morality and sexual propriety and *Totò, Peppino e la malafemmina* plays on this idea to comic effect. When trying to track down Marisa after she disappears on the night of their first encounter, Gianni muses to his friend 'I can't imagine what category of woman she belongs to…' Subsequently his mother assumes that she is a woman of ill-virtue out to exploit Gianni, basing this supposition solely on the basis of her profession, only to revise her opinion when she eventually meets her.

However, the song and the narrative it inspires are really nothing more than a pretext to support the comic antics of the two leads, which constitute the film's true *raison d'être*. This was the fifth of the eighteen films that Totò and Peppino De Filippo made together and it remains one of their best-loved titles. The journey to Milan provides the opportunity for some amusing comic routines concerning their ignorance about Northern Italy and its culture – from their arrival in Milan dressed in outfits more suited to mountain climes to their attempts to communicate with a traffic warden they assume to be an Austrian general. (A similar situation was also mined to comic effect three years earlier in a film by Peppino's brother, Eduardo De Filippo, in *Napoletani a Milano/Neapolitans in Milan*; it would also recur six years later in Giorgio Bianchi's *Totò e Peppino divisi a Berlino/Totò and Peppino Divided in Berlin*.) The film's undoubted highlight, however, is the letter that Totò dictates to Peppino in order to convince Marisa to renounce Gianni. With its grammatical errors and nonsensical logic, it is a masterpiece of linguistic invention that was later to inspire Roberto Benigni and Massimo Troisi to produce a similar – and equally inventive – dictated letter in *Non ci resta che piangere/Nothing Left to Do but Cry* (1985). But this scene also helps explain why this unpretentious comic gem has never received distribution outside of Italy: despite the fact that Totò was a supremely talented physical comedian, so much of his comedy depended on wordplay and linguistic deformation that it remains resolutely untranslatable and unexportable. Yet, for Italians, Totò and Peppino remain something akin to a national treasure, and *Totò, Peppino e la malafemmina* offers a perfect demonstration of their talents.

Alex Marlow-Mann

What Rascals Men Are!

Gli uomini, che mascalzoni…

Studio/Distributor:
Cines

Director:
Mario Camerini

Producer:
Emilio Cecchi

Screenwriters:
Mario Camerini
Aldo De Benedetti
Mario Soldati

Cinematographers:
Massimo Terzano
Domenico Scala

Art Director:
Gastone Medin

Editor:
Fernando Tropea

Duration:
66 minutes

Genre:
Comedy

Cast:
Lia Franca
Vittorio De Sica
Cesare Zoppetti
Aldo Moschino

Year:
1932

Synopsis

In Milan a young chauffeur, Bruno, encounters an attractive shop-assistant, Mariuccia. Pretending that the car he drives belongs to him, he invites her on a day trip to the lakes, only to be forced to abandon her without an explanation when he unexpectedly encounters his employer. They meet again when Mariuccia accepts the invitation of a ride from his new boss solely because she recognizes that Bruno is the chauffeur. However, when the man makes unwanted advances on Mariuccia, Bruno resigns and abandons car, employer and passenger in the middle of traffic. He subsequently tracks Mariuccia to the Milan Fair, where she uses her influence with the owner to help him find new employment. However, Bruno soon becomes suspicious and jealous of her relationship with his new benefactor.

Critique

Gli uomini, che mascalzoni… is the first of the five romantic comedies that Vittorio De Sica made for Mario Camerini in the 1930s and the only one in which he was not paired with Assia Noris. These films remain the works for which Camerini is best remembered and arguably constitute the cinematic highpoint of the Fascist period. By 1932 De Sica had been active on the stage for nearly a decade and had already appeared in four films; however, this was his first role as protagonist and the one that would make him a star. The film also featured his performance of *Parlami d'amore Mariù*, which would go on to become one of the most famous Italian songs of the period.

De Sica was later to acknowledge Camerini as the main influence on his directorial work and it is possible to identify certain qualities of his later films prefigured in *Gli uomini, che mascalzoni…*. Most obviously, Camerini's focus on ordinary working class people and his attempt to inject a sense of poetry into their lives anticipates De Sica's later neorealist films. The scene depicting Mariuccia's morning routine even anticipates a similar scene featuring the maid in *Umberto D* (1952) – a scene which, it is often claimed, constitutes the perfect embodiment of what De Sica and Zavattini were trying to achieve in the films they made together. However, we should be careful not to overstate Camerini's influence or create an unrealistically teleological account of De Sica's career. Indeed, the aforementioned scene also serves a crucial narrative function in that it sets up a later comic sequence in which Mariuccia has to sneak back into the house and pretend to have slept in her bed after Bruno has abandoned her at the lakes. The corresponding scene in *Umberto D*, on the other hand, is not made functional to the broader narrative design and has no purpose beyond conveying Maria's mundane routine and state of mind.

Gli uomini, che mascalzoni… is remarkable not primarily because it prefigures the later development of De Sica's (or Camerini's) career, but rather because it stands out so dramatically from the context of Italian cinema of the period. In the early 1930s the Fascist government was keen to help Italian cinema out of the protracted crisis it had fallen into shortly after they had assumed

power. Camerini was at the forefront of this process, having directed one of the two silent films which helped revitalize Italian cinema in 1929 – *Rotaie/Rails* (the other was Alessandro Blasetti's *Sole*). The extraordinary modernity and inventive use of the cinematic medium evidenced by *Rotaie* is also present in *Gli uomini, che mascalzoni...*. Shot largely on location – including key sequences at the Milan Fair – and utilizing a highly mobile camera and occasionally dramatic editing strategies, the film belies the idea that the technology of early sound cinema necessitated a loss of the aesthetic innovations of late silent cinema and that Italian cinema of the Fascist period was stylistically unadventurous.

It is possible to object that the narrative is slight and not terribly original and that its ideology is overwhelmingly petit bourgeois. However, it is the deftness of touch with which Camerini develops this material and the charisma and charm with which De Sica imbues the protagonist that make the film come alive. And it is these qualities which they would bring to their subsequent collaboration – the equally wonderful *Il Signor Max/Mr Max* (1937), which also deals with the romantic complications that ensue when the protagonist disguises his humble origins and pretends to be something he is not – qualities which are sadly lacking from Glauco Pellegrini's 1953 remake of *Gli uomini, che mascalzoni...* starring Walter Chiari and Antonella Lualdi.

Alex Marlow-Mann

The Visitor

La visita

Studio:
Zebra film and Aera film

Director:
Antonio Pietrangeli

Producer:
Moris Ergas

Screenwriters:
Antonio Pietrangeli
Ruggero Maccari
Ettore Scola

Cinematographer:
Armando Nannuzzi

Art Director:
Luigi Scaccianoce

Editor:
Eraldo Da Roma

Synopsis

As a train travels through the countryside, the voices of a man and a woman are heard reading out letters they have sent each other in response to a lonely hearts ad. On Pina's bashful suggestion that they meet, Mr Adolfo Di Palma, a 40-year-old bookshop assistant from Rome, is on his way to the town of San Benedetto Po in northern Italy, where the 36-year-old Pina works on the local farmers' co-operative. In the car from the station to her house, Adolfo attracts the attention of the locals and the suspicion of Cucaracha, the village idiot. On their arrival, Pina proudly shows Adolfo her most treasured possessions and introduces him to her pets. However he seems to be more interested in money matters: he reminds her how much the pens he gave her cost, estimates how worthwhile it would be to open a bookshop in the area, and speculates over the relative cost of living between city and countryside. Left on his own for a minute, he even starts to think up a new way of arranging her furniture, breaks a lamp and hides the pieces. This is just the beginning of a long day that will test the foundations of their potential married life together.

Critique

The first half of the 1960s was Pietrangeli's most prolific period, during which he directed six out of the ten feature films that comprise his filmography and that have established him as an auteur of comedy (some of his most celebrated works include *La parmigiana/*

Duration:
105 minutes

Genre:
Comedy/Romance

Cast:
Sandra Milo
François Périer
Mario Adorf
Gastone Moschin

Year:
1963

The Girl From Parma, 1963; *Il magnifico cornuto/The Magnificent Cuckold*, 1964; and *Io la conoscevo bene/I Knew Her Well*, 1965. He died unexpectedly in 1968). The most obvious mark of his authorship is the privileged narrative position occupied by female characters. It soon becomes clear that *La visita* takes Pina's side as she gradually evolves from a naive provincial stereotype into a complex dramatic representative of crucial changes in Italian cultural history and tradition. De-glamorized and with fattened hips, Sandra Milo gives form to a decisively modern woman. However Pina's intelligence is less that of the scholar of literature or Latin, in which Adolfo shows off his no-more-than-school-level knowledge, as it is an emotional intelligence. Pina works, drives, knows how to look after a boat, demands respect in the male-only environment of the cooperative and, above all, manages her private life according to a personal morality that rejects traditional values (in one of the flashbacks that punctuate the story her doomed relationship with Renato, a truck driver who is married with children, is represented as a picture of serene fulfillment, however fleeting, and is experienced by both of them as the epitome of truth and sincerity). Pina's acuity is expressed in her final confrontation with Adolfo, in which she shows sophisticated powers of observation and analysis that put her character in a new light (as she turns out to be defined not by inattentiveness, but discretion). Pina ends up pointing out a string of defects which show her potential partner to possess the opposite of the qualities she put in the advert: 'sensitive, dynamic, democratic, a lover of small children and animals.'

Adolfo, a portrayal of the average Italian (who oddly resembles Hitler) is a small-minded and hypocritical little man who does not develop through the course of the film. During the aforementioned conversation his only merit seems to be an ability to recognize his own shortcomings, but even this brief insight is vain and superficial. Pina's hopeless dissatisfaction seems, however, to suggest a radical change in the relationship between men and women and the desire for a true equality between the sexes that may, on the one hand, seek to challenge male dominance (infidelity is the eternal obsession of husbands and boyfriends who are themselves unfaithful), but has not, on the other hand, developed into the feminism of the 1970s. Instead Pina is presented as someone who takes gleeful part in the consumerist boom of the 1960s, preoccupied with goods such as the TV, refrigerator, lawnmower; once economic prosperity has spread across the land, including the countryside, it has become more urgent than ever to update social roles in line with new lifestyles. Pina does not recognize herself in the figure of the old wetnurse Angelina, the angel of the hearth who is entirely dedicated to her family, nor tries to copy her neighbour Chiaretta, the charming 16-year-old who nevertheless treats Adolfo as a joke. At the film's end, in perfect symmetry with the beginning, Adolfo and Pina's different trajectories form an ominous sign for the couple's future and a harsh judgment on the possibility of healing a rift which divides the country. As his train gathers speed, a comfortable system of well-worn oppositions seems to be re-established: man/woman, north/south, city/countryside.

Elena Gipponi

Even taking into account the Western as refracted though the Latin imaginations of Leone and co., the Italian horror film was probably the finest flower of the country's popular cinema, but of equal long-term significance is the stylish murder thriller (*giallo; pl gialli*). The most adroit exponents of the latter fields (apart from the groundbreaking Riccardo Freda) were Mario Bava, Dario Argento, Sergio Martino and the less talented Lucio Fulci. Once a despised genre internationally (principally because of the crass dubbing to which they were invariably subjected), *gialli* have undergone a major critical re-assessment, with their visual stylishness and bizarre plotting now celebrated. These grisly whodunnits, inspired by the yellow-jacketed thriller paperbacks of the1930s/40s, that enjoyed immense success among Italian readers, represented something of a sleight of hand in their strategies. With their high-gloss surfaces (widescreen and colour are almost always *de rigueur* for the genre), the essential paradigms were a sumptuously photographed series of murder set pieces in upscale apartments (with the victims usually beautifully dressed, sensuous women), apparently committed by a sex-obsessed psychopath. The murder weapon is customarily a knife, brandished in a black-gloved hand. But this twisted-psychopathology motive is almost invariably a red herring; mammon is usually at the centre of the killings, with greed and financial gain being the leitmotif as the source of the bloodletting (the *reductio ad absurdum* of this schematic is Bava's *Reazione a catena/A Bay of Blood*, 1971, where the treatment of the murder motivation is almost absurdly casual).

So what sort of work populated the genre? The film that might be considered one of the first *gialli*, Mario Bava's *Sei donne per l'assassino/Blood and Black Lace* (1964), is comfortably the director's most influential film on the cinema of other countries – and a key work in the field, with narrative and visual tropes that instantly became templates for the glossy catalogues of mayhem in the films of Argento and others.

However, directors whose names have acquired very little cachet over the years produced provocative work in the genre, such as Paolo Cavara, whose *La tarantola dal ventre nero/The Black Belly of the Tarantula* (1971) has gleaned a certain reputation (which may be partly due to the fact that it was unseeable for several years). Regrettably, however, while flashes of inspiration are to be found, it is a fairly workaday effort, with occasional moments of imagination illuminating the grim proceedings. The method of the killings is notable: a similar technique to that by which certain wasps paralyse tarantulas before eviscerating them. Erotic elements are foregrounded here quite as much as any violence, with a nude Barbara Bouchet undergoing a sensuous massage before she is bloodily slaughtered.

Eccentricity (of a self-conscious variety) is a hallmark of the genre. *La casa dalle finestre che ridono/The House with the Laughing Windows* (1976), directed by Pupi Avati, sports another outlandish title and, in this case, is a suitably outlandish film to match. Avati engineers an ingenious (if absurd) narrative that functions intriguingly in its own right, rather than being a way of stitching together

Left: *Tenebrae*, Sigma.

a variety of bloody set pieces. In 1950s Italy, a painter accepts an invitation to repair a fresco in a local church. The artist originally responsible for the piece enjoys a poor reputation in the town, and his fresco shows Saint Sebastian undergoing torture. Right from its opening sequence (in which a bloody stabbing is repeated seemingly *ad infinitum*), this is another piece firmly aimed at the exploitation market. But that is not to say that Avati is not capable of the visual invention of more ambitious films.

There is a fascinating – and phoney – internationalism to the *giallo*. The pseudonymous credits attempting to fool Italian audiences into thinking they were not watching a low-prestige local product were one tactic; another deception extended to the use of foreign locations: some cursory pickup shots in a foreign city would be intercut with sumptuous interiors shot in a Rome studio. When *gialli* choose London as their setting, the results are often very odd indeed. In *Gli occhi freddi della paura/The Cold Eyes of Fear*, directed by Enzo G Castellari in 1971, the off-kilter London scenes add another stratum of delirium to the generally odd proceedings.

Bizarrely-poetic titles are another fingerprint of the genre, as with *Passi di danza su una lama di rasoio/Death Carries a Cane* (1972), directed by Maurizio Pradeaux. The Italian title of the film translates as 'Dance Steps on the Edge of a Razor', which is actually a better title than the one that its English and American producers chose to go with. (The movie itself, in this case, is entertainingly grotesque, with performances pitched at nigh-operatic levels.)

But how relevant to *giallo* credibility are auteur credentials for the director? Luciano Ercoli's *Le foto proibite di una signora per bene/The Forbidden Photos of a Lady Above Suspicion* (1970) demonstrates that second-rank directors could make substantial contributions to the *giallo* genre. A perfectly calculated genre exercize with minimal inspiration from its journeyman helmsman, it is also an exemplar of an attitude to female sexuality typical of the genre, with its fetishistic and menacing games with a knife. In the *giallo* field, of course, fetishistic imagery is the order of the day, and those looking for a more enlightened, feminist view of female sexuality should look elsewhere (in fact, it would probably be a good idea for such individuals to ignore the *giallo* genre altogether). But for those prepared to take the controversial fare on offer without being offended, the feast of violently unsettling and erotic imagery frequently has a charge that Baudelaire and Poe would have applauded.

For all their delirious visual invention, plotting is not the strong suit of the *giallo* – what mostly serves for plotting is a tortuous stitching together of disparate narrative elements to provide integument for the blood-drenched set pieces. But the same charge might be levelled at the masterpieces of Hitchcock – except that the English director was canny enough to hire the best screenwriters to provide such texture along with psychological verisimilitude, another element only fitfully present in most *gialli*. If such quality writing is in shorter supply in the Italian films, the exuberant staging, sanguinary inventiveness and constant visual flourishes provide more than sufficient frissons.

Barry Forshaw

A Bay of Blood

Reazione a catena
Aka Antefatto/Twitch of the Death Nerve

Production Company:
Nuova Linea Cinematografica

Distributors:
Hallmark Releasing Corp
Ambassador Film Distributors
Alberto Bitelli Intl. Films
Internacional Films Distribución

Director:
Mario Bava

Producer:
Giuseppe Zaccariello

Screenwriters:
Mario Bava
Filippo Ottoni
Giuseppe Zaccariello (as Joseph McLee)
Dardano Sacchetti (story)
Franco Barberi (story)

Cinematographer:
Mario Bava

Editor:
Carlo Reali

Art Director:
Sergio Canevari

Duration:
85 minutes

Genre:
Giallo/Horror

Cast:
Claudine Auger
Luigi Pistilli
Claudio Camaso
Leopoldo Trieste
Isa Miranda

Year:
1971

Synopsis

An elderly countess is murdered by her husband, Filipo Donati, at her large home in a picturesque rural bay, and the death is made to look like a suicide. Soon after, her husband is himself killed by a mystery assailant, and it transpires that real-estate agent Frank Ventura has been attempting to acquire this location in order to build new and lucrative properties. Other residents of the bay, the entomologist Paolo and his wife Anna, along with the countess's illegitimate son Simon, have their own views on what has happened, and, after four teenagers are murdered, Donati's estranged daughter and her husband arrive to ascertain what has happened, leading to conflicting personal agendas that threaten further violence and death.

Critique

By the time he made *Reazione a catena* in 1971, Mario Bava had already secured his name and international reputation as a significant horror Director: the first, trailblazing figure in what would soon become a disreputably venerable, distinctly Italian genre and *the* key artistic progenitor of such film-makers as Dario Argento, Lucio Fulci and Ruggero Deodata among numerous others. He had played a significant role in the return of Italian horror after a long-standing fascist ban when he photographed, designed and finished directing both *I vampiri/Lust of the Vampire* (Riccardo Freda, 1956) and *Caltiki the Undying Monster/Caltiki – il mostro immortale* (Riccardo Freda, 1958) (Freda had stepped aside to allow his younger protégé a chance to show his ability). Bava directed what is generally considered the first real *giallo* film, *La ragazza che sapeva troppo/The Girl Who Knew Too Much* (1963), in addition to making science-fiction, delirious, Universal/Hammer-inspired gothic horror, and ghost stories.

In so doing, Bava developed a signature style predicated on baroque, primary colour-saturated *mise-en-scène*, stylized cinematography and convoluted plots. These narratives frequently develop in a centrifugal manner, tracing a heritage of violence that seems to spread between characters like a disease. His films also feature graphic bloodletting and sexuality (frequently interrelated, with murder and intercourse figured as mirror images), conflate a number of different horror tropes (as noted, from Universal to Hammer), and centre on a thematic emphasis on good and evil as coterminous rather than mutually-exclusive states.

Reazione takes its place among its director's plethora of diverse horror texts by virtue of its status as a proto-typical slasher film. Bava had earlier helped develop the form with *Sei donne per l'assassino/Blood and Black Lace* (1964), but the director here ups the ante by introducing several motifs that would soon dominate the sub-genre. In particular, the emphasis on voyeurism and the narrative hook of having young characters in a remote location finding themselves the targets of horror and violence anticipated

the groundbreaking American horror *Black Christmas* (Bob Clark, 1974), as well as *The Texas Chainsaw Massacre* (Tobe Hooper, 1974), and other such films which came in its wake.

What distinguishes Bava's film from its progeny in both Europe and America is its heightened style. In particular, the director's frantic use of the zoom lens perpetually serves to destabilize space and point of view, as though the whole narrative was being refracted through an imbalanced psyche and told by a distinctly unreliable narrator. Bava also makes particularly connotative use of scene transitions early in *Reazione a catena* in order to suggest connections between otherwise disparate characters and underline their nature as potential victims or killers, predator or prey. This strategy, coupled with an explicit discourse on killing and the human beast that arises when two characters discuss their respective pastimes of fishing and entomology, alludes to Bava's perennial obsession with the innate violence that potentially lies within all of us, requiring only facilitation and release.

Indeed, with this latter point in mind, the entomologist figures as something of a diegetic personification of the director. He studies his precious insects with care and affection much as Bava at times seems to visually probe, penetrate and study his characters, and indeed invite the viewer to do likewise – to stand back and observe rather than identify with them, and examine their behaviour and avowed motivations and decide for themselves the 'truth' of the sceanrio. In actual fact, as a corollary of the above, numerous other potential Bava substitutes abound in the film's plethora of figurative film-makers, characters engaged in nefarious plots to manipulate and control events to their own ends. It is a subtly self-reflexive, at times almost playful, ploy, and offsets the grimly relentless violence elsewhere and even anticipates the Wes Craven-led slasher film makeover in the 1990s with *Scream* (Wes Craven, 1995), making *Reazione* a truly seminal work by a seminal director.

Adam Bingham

The Bird with the Crystal Plumage

L'uccello dalle piume di cristallo

Studio:
Seda Spettacoli/CCC Filmkunst

Director:
Dario Argento

Synopsis

Sam Dalmas, an American writer living in Rome, is walking home one night when he witnesses a violent altercation through the window of an art gallery: a young woman is struggling with a sinister figure wearing a black coat. Dalmas rushes to help the young woman, but finds himself trapped between the art gallery's glass doors, which are electronically operated. The attacker disappears, and the young woman is left lying on the floor, bleeding copiously from a vicious knife attack. The Italian police subject Dalmas to a rigorous cross-examination about the event, and his author's eye is able to supply a host of details. It transpires that the assault is only one of a series – mostly fatal – on young women. But Dalmas is not satisfied with the full extent of his own recollection, and strains

Producers:
Goffredo Lombardo
Salvatore Argento

Screenwriter:
Dario Argento

Cinematographer:
Vittorio Storaro

Art Director:
Dario Micheli

Editor:
Franco Fraticelli

Duration:
96 minutes

Genre:
Giallo

Cast:
Tony Musante
Suzy Kendall
Eva Renzi
Enrico Maria Salerno
Umberto Raho

Year:
1970

his memory to come up with one missing detail which will make the scene clear for him. He knows that there is a false note in his picture of the incident, but his attempts to clarify his memory (hampered by the intrusive attention of the unsympathetic police) serve to make the writer a target for a particularly implacable killer.

Critique

Despite comprehensively squandering the good will of his admirers with a recent series of truly woeful efforts, the key director of the modern *giallo* is the brilliantly talented Dario Argento – the ultimate craftsman in the field. In his earlier films, Argento's astonishing visual and aural assaults on the sensibilities of the viewer put the emphasis on the total experience of film rather than intellectual appreciation of a well-crafted script (Argento's horror films are definitely not for those who demand carefully-constructed, literate screenplays!). Usually to the throbbing, high-decibel accompaniment of the music of Claudio Simonetti's Goblin (his long-time collaborator), Argento's films are a rollercoaster ride of painterly visuals and graphic horror. Argento's 1970 feature film debut, the poetically titled *L'uccello dalle piume di cristallo/The Bird with the Crystal Plumage*, augured well for his career – a commercial success in its day, it now comes across as a fascinating dry run for many ideas to be more fully developed in later films. Tony Musante plays an American writer in Italy who witnesses a murderous assault through glass (prefiguring David Hemmings in the later *Profondo rosso/Deep Red*, 1976); he is trapped between sliding glass doors while attempting to aid the bleeding victim (Eva Renzi). This sequence seems to be the one people remember over the years – probably because Musante's subsequent tracking down of the black-leather-clad murderer is handled with rather less panache than Argento was to develop in his later films. There are of course visual delights galore – a marvellously Hitchcockian chase of a yellow-jacketed hired killer (one of several loose ends not really tied up) that ends with a joke worthy of *North by Northwest* (1959): a murder by razor that utilizes sound as chillingly as Polanski did in *Repulsion* (1965). And a word would be in order here about the score (Goblin not yet in place as house musicians): Ennio Morricone's mesmeric music is cleverly used throughout. The suspenseful siege of Dalmas's girlfriend (Suzy Kendall) in her flat is text-book stuff – the murderer's knife cutting through the door invites another comparison: the demolition job done on a similar door in Hitchcock's *The Birds* (1963) – but this does not prevent the sequence from being claustrophobically pulse-racing. Quibbles apart, the film is essential viewing for admirers of the director – though it remains a tyro effort, however dazzling.

Barry Forshaw

Blood and Black Lace

Sei donne per l'assassino

Studio:
Emmepi Cinematografica
Georges de Beauregard
Monachia Film

Director:
Mario Bava

Producers:
Massimo Patrizi
Alfredo Mirabile

Screenwriters:
Marcello Fondato
Giuseppe Barillà
Mario Bava

Cinematographer:
Ubaldo Terzano

Art Director:
Arrigo Breschi

Editor:
Mario Serandrei

Duration:
86 minutes

Genre:
Giallo

Cast:
Eva Bartok
Cameron Mitchell
Thomas Reiner
Arianna Gorini

Year:
1964

Synopsis

The camera prowls around the gaudy exterior of a fashion house lashed by rain and wind, its sign broken loose and swinging. One of the models, Isabella, is stalked through the stormy night by a masked assailant, who brutally batters and murders her. Another model from the fashion house, Nicole, comes across the dead girl's diary, which is a truly incendiary document. It details the sexual (and other) secrets of many of those associated with or working at the company. Inevitably, Nicole also bloodily falls victim to the murderous, disguised figure, her death even more brutal than that of the first woman. As the body count continues to rise, the dour Inspector Silvestri rounds up a shifty selection of male suspects – each looking more guilty than the last. Obviously, the dead girl's blackmail-friendly diary is the key to the continuing murders and mutilations, even after it appears to have been burned. And what connection is there between the bloody events and a soignée countess and her smooth lover?

Critique

Sei donne per l'assassino was Bava's delirious tale of a masked killer prowling a fashion house, and remains the most influential *giallo* ever made. In the UK, the film was sometimes hooted off the screen for the achingly crass dubbing, the besetting sin of virtually every giallo to gain a nationwide circuit release in both this country and the US. But the availability of Italian-language prints have made it possible for viewers to feast on the visual delights afforded by chiffon, marble, and the director's catlike camera prowling through the exquisitely decadent production design (the latter clearly as much the loving creation of the director as that of credited production designer Arrigo Breschi). British censor John Trevelyan took his scissors to the exuberant mayhem at the time of the film's release, creating a cinematic *coitus interruptus* in which elaborate orchestration of suspense becomes a prelude to frustrating, barely-glimpsed pay-offs. However, the crippling censorship cuts that truncated every murder in the UK have been restored in new prints, and the elegantly rendered tension is now unspoilt.

Bava's calling card movie looks ever more decadently gorgeous as the years pass, and continues to be his most influential film (apart from *Reazione a catena*, 1971, whose catalogue of grisly murders was the blueprint for the *Friday the 13th* movies and their many imitations). Needless to say, characterization is pitched at the most generous level (no nuanced playing here), with the saturated colour, wonderfully excessive production design (redolent of 1950s recreations of Italian *verismo* opera productions) and exuberantly staged scenes of murder maintaining the viewer's interest rather than any narrative rigour. If the film (and its many successors) possesses a vision beyond the desire to thrill and alarm the viewer, it is a notably dyspeptic view of human nature in which venal instincts comprehensively outpace the demands of the libido; the

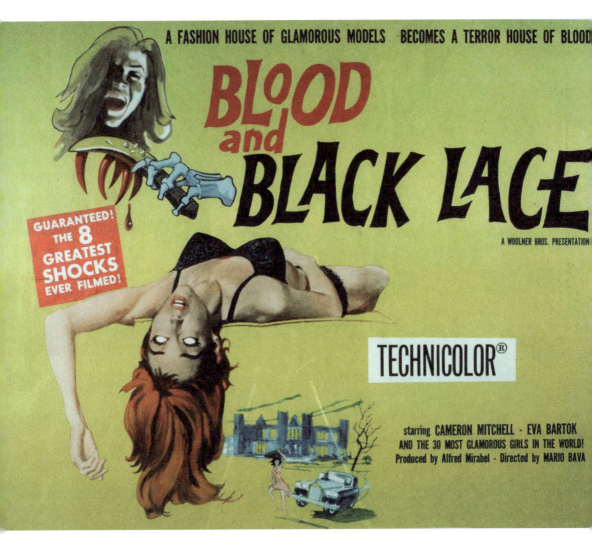

Blood and Black Lace/Sei donne per l'assassino, Monarchia.

beautifully-photographed sensuousness of the female victims is a smokescreen (as so often in the *giallo* genre) for a single-minded pursuit of filthy lucre.

Perhaps the most immediate effect of Bava's groundbreaking film is on the work of Dario Argento, which simply would not exist in the form that it does without this glossy template. The carefully-calculated multinational casting ensured the film's saleability to a variety of markets (American Cameron Mitchell, Hungarian Eva Bartok, a cluster of much-employed Italian character actors, such as the wonderfully oleaginous Dante di Paolo as a drug-addicted red herring).

Barry Forshaw

The Case of the Scorpion's Tail

La coda dello scorpione

Studio:
Devon
Copercines

Director:
Sergio Martino

Producer:
Luciano Martino

Screenwriters:
Eduardo Maria Brochero
Ernesto Gastaldi
Sauro Scavolini

Cinematographer:
Emilio Foriscot

Editor:
Eugenio Alabiso

Duration:
93 minutes

Genre:
Giallo

Cast:
George Hilton
Anita Strindberg
Evelyn Stewart
Luigi Pistilli

Year:
1970

Synopsis

London. Lisa Baumer is enjoying the attention of her lover when her life is changed inexorably. A plane explodes in midair – and one of the passengers is her husband Kurt. The result of his death is that Lisa is $1 million richer, but she has to pay a high price for her new financial status. An old boyfriend attempts to blackmail her, but dies under mysterious circumstances. Lisa makes a trip to Athens in order to collect her legacy, but insurance investigator Peter Lynch has been assigned to the case and is on her tail. A series of menacing encounters begins for her: she is terrified in a derelict theatre by her dead husband's mistress, Lara Florakis, and the latter's lawyer, Sharif, and is only able to escape the encounter when she is helped by the insurance investigator Lynch. Lisa collects the insurance and begins to pack for a trip to Tokyo. But a razor-wielding assailant in black gloves has other ideas…

Critique

Despite the inconsistency of Sergio Martino's career as a director, the Spanish-Italian co-production *La coda dello scorpione* is unquestionably one of his most assured and confident pieces, with the clichés of the genre playfully inverted or given a novel twist by a director enjoying the fact that he is so completely in charge of his material (Martino has admitted that Henri-Georges Clouzot's film of the Pierre Boileau/Thomas Narcejac novel *Les Diaboliques* (1955) was a template for his work – as it was for Hammer Studio's earlier series of black-and-white psycho thrillers). Beneath the seductive surface of the movie (with its kinetic, blood-boltered set pieces, Hitchcockian flourishes and perfectly judged widescreen *mise-en-scène*), the plot, as so often with such movies, is absurd – and bears little scrutiny. But aficionados customarily grit their teeth and take such shortcomings on the chin, and *La coda* is actually a more satisfyingly labyrinthine entry than many in the field. Martino (who enjoyed the cosmopolitan, Babel-like atmosphere of a multi-national project such as this) is particularly good at his offkilter rendering of locations, and peoples his film with a *dramatis personae* of sharply-drawn murderous/vulnerable protagonists, with particular attention paid to the various red herrings (a *sine qua non* of the genre).

Another piquant element of the movie is its impressive cast of charismatic European actresses, notably Evelyn Stewart and Anita Strindberg (who between them serve the function of female lead – though one of the actresses serves a function similar to that of Janet Leigh in *Psycho* (Alfred Hitchcock, 1960). Male lead George Hilton delivers his customary efficient ambiguous performance (albeit one cast in the same mould as those he served up for a variety of other directors). The continuing influence of Antonioni's *Blow Up* (1966) is evident in the use of a significant photographic clue to the killer's identity, and such are Martino's creative stagings that one can forgive such infelicities as the maladroit model work of the

plane explosion at the beginning of the movie that sets the plot in motion. As so often in the genre, human venality is the plot engine here, but there are piquantly novel touches, such as the double helping of vicious murderers to match the duo of toothsome heroines. As so often, the director's wryly expressed self-deprecation of his own work in a variety of interviews undervalues his sheer craftsmanship, which is seen at full stretch in La coda dello scorpione.

Barry Forshaw

Deep Red
Profondo rosso

Studio:
Seda Spettacoli

Director:
Dario Argento

Producer:
Claudio Argento

Screenwriters:
Dario Argento
Bernardino Zapponi

Cinematographer:
Luigi Kuveiller

Art Director:
Giuseppe Bassan

Editor:
Franco Fraticelli

Duration:
130 minutes

Genre:
Giallo

Cast:
David Hemmings
Daria Nicolodi
Gabriele Lavia
Carla Calamai

Year:
1975

Synopsis

At a conference discussing the subject of parapsychology, celebrated psychic Helga Ulmann is deeply disturbed when she realizes that the audience she is addressing contains a murderer. Deeply frightened, she informs a fellow guest, Professor Giordani, that she will communicate to him the identity of the killer the next day. That night, Marc Daley, an English pianist living in Rome, is spending time with his inebriated friend Carlo in the square outside his house when he witnesses a horrific sight: Helga Ulmann being bloodily dispatched at her window. Marc rushes to her aid, but by the time he reaches her apartment, her life has ebbed away. Marc is subsequently obliged to fend off the attentions of the police and an aggressive reporter, Gianna Brezzi. But later, he realizes that there is a detail fixed in his mind – something he saw in the dead psychic's hallway. Unwisely, he initiates his own investigation into the killing, and begins to get closer and closer to an utterly ruthless psychopath. At the same time, the killer is implacably (and imaginatively) murdering anyone who might possibly reveal their well-concealed identity.

Critique

While a case might be made for *Suspiria* (1977) as the Argento film that offers a total sensory immersion via its thoroughgoing utilization of poster-colour visuals and high-decibel aural effects, in terms of structure, *Profondo rosso* is unquestionably his most fully-realized work, rigorously detailed and showing an attention to narrative that is largely absent from most of the director's haphazard scenarios. Of course, the presence of the understated English actor David Hemmings in the cast is salutary: he comes carrying (as the film-savvy Argento is fully aware) the baggage of his appearance in Michelangelo Antonioni's *Blow Up* (1966), and in many ways his character here cannily reprises elements of the earlier film, with its existential whodunnit structure. Hemmings' character in the Argento film is much more motivated (and single-minded) than the aimless, alienated photographer of the earlier movie; Argento is far less interested in fashioning a vision of an alienated, hedonistic society than in demonstrating his virtuoso mastery of the language of cinema, and uses Hemmings as a shorthand image of the

accidentally involved onlooker. But (despite not having a great deal of material to work with) Hemmings grants the character a genuine verisimilitude, using the most economical means.

Profondo rosso is, however, every inch an Argento movie, and in no other film in the director's oeuvre are his visual pyrotechnics used to such exhilarating effect. It is obvious that the director's real interests lie in the heady, sensuous exploration of baroque architecture in front of which his characters are gorily dispatched. Hemmings, with the ambiguous aid of a young newswoman (played by the director's then-partner, Daria Nicolodi), threads his hesitant way through several menacing expressionist settings before, inevitably, confronting the deranged killer (a logically-motivated character rather than the arbitrary figures thrown up in so many gialli). The gruesome murders along the way are imaginatively mounted – the

Deep Red/Profondo rosso, Rizzoli Film/Seda Spettaloli.

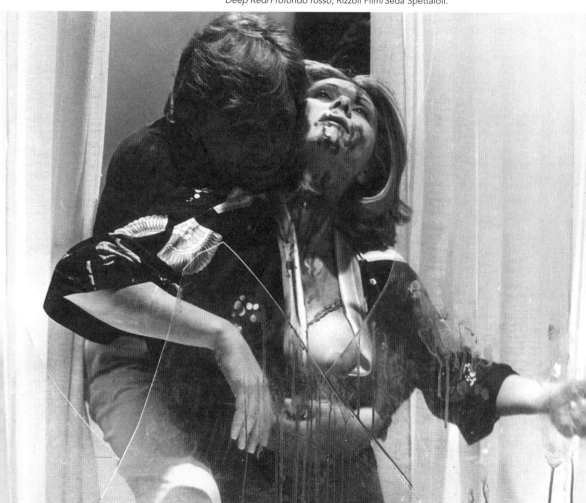

death-by-boiling-water sequence is particularly unsettling, even when viewed in the twenty-first centry, when ultra-violent death in film is commonplace. Several frissons are provided by the effects created by a pre-*ET* (Steven Spielberg, 1982) Carlo Rambaldi – the most shocking being decapitation by a combination of necklace and moving lift. From the credits onwards, the surface of the movie glitters with a sinister iridescence. As so often in Argento's work (and in that of most of his contemporaries), the underlying sexual politics of the film are not notably enlightened, but viewers who can put any notions of policetical correctness in abeyance for 100 minutes or so will find themselves transported by this most fully achieved work from a deeply inconsistent director.

Barry Forshaw

The House with the Laughing Windows

La casa dalle finestre che ridono

Studio/Distributor:
AMA Film

Director:
Pupi Avati

Producers:
Gianni Minervini
Pupi Avati

Screenwriters:
Antonio Avati
Pupi Avati
Gianni Cavina
Maurizio Costanzo

Cinematographer:
Pasquale Rachini

Art Director:
Luciana Morosetti

Editor:
Giuseppe Baghdighian

Duration:
110 minutes

Synopsis

Stefano is hired by the residents of a small sleepy town near Ferrara to restore an early twentieth-century church fresco depicting the martyrdom of St Sebastian, painted by deceased local artist Buono Legnani, known as 'the painter of agony'. Threatening phone calls warn Stefano off; people who say they have information for him die in mysterious circumstances before they can tell him. He begins a relationship with the schoolteacher, Francesca, and they move into a big old house inhabited only by a bedridden old woman. Francesca is raped and both she and Lidio, her assailant, are killed. Stefano witnesses Lidio's murder and is himself attacked, but he manages to escape. However he finds that no one in the town will take him in and even the local priest, who does, turns out not to be all he seems.

Critique

[Warning: this review gives away major plot twists in the film] The denouements of most gialli, when we find out who did the murders and why, are generally perfunctory and unconvincing, but occasionally they give a crazed coherence to all that has gone before. This is especially true of *La casa dalle finestre che ridono*, but to explain which involves revealing its – double – denouement.

Stefano, having already found Francesca dead in the attic of the old house, later hears cries emanating from it. He ventures up and discovers the supposedly bedridden old woman and her equally elderly sister killing Lidio. They reveal that they kill to provide models for their brother, the painter of agony. They have preserved his body, now a skeleton, in formalin and play tape-recordings of his voice: they keep him alive and bring him models, even claiming that he painted Francesca as she was dying.

The sense of the uncanny quality of modern technology runs through many *gialli* – tape recorders and phones make dead or absent voices present, chemicals render bodies undead. This gives

Genre:
Giallo

Cast:
Lino Capolicchio
Francesca Marciano
Gianni Cavina

Year:
1976

a mad sense to the sisters' claims. Moreover, what the sisters are facilitating is the production of images of agony by their brother – but what Buono paints, what his sisters stage manage, is the spectacle of pain and death that is the core of the film – and the giallo – itself. Just as the sisters use modern technology to produce images of suffering, so too does *La casa* use film to the same end.

The fact that the killers are women also builds on *giallo* tropes. In *gialli*, women are commonly multiple murderers (at massive variance to their incidence in actual crimes), and, even more commonly, killers, as here, do what they do for the sake of the family. The sense of perversity is screwed up a notch or two by the second denouement. Stefano is given shelter by the local priest, only to discover he is in reality one of the sisters in disguise. This may seem like a twist too far, but it reverberates back through what has gone before. Buono's sisters look like nuns, no more so than when they are slaughtering Lidio. More significant still is Buono's gender identification. Stefano is told that Buono considered himself ugly and as a result could not find women willing to model nude for him; so he decided to use himself as model. This information is prompted by one of Buono's paintings showing a shapely, naked female body with an ugly male head: he painted himself as a woman. Moreover, in the brief flashback showing this act, he literally paints his own body. There is, then, gender confusion aplenty in the film before the final twist, which itself plays upon the curious position of priests in Italy, fathers who by definition are not fathers.

La casa dalle finestre che ridono is for the most part shot in bright sunlight, bringing out glowing greens and bleached white buildings. Yet the town is a decaying backwater. It has to be reached by ferry and its main source of income, eels, is dying out. It hides literal, economic death as well as the perverse, death-loving culture of inbred family and religion. The film ends with the hysterical laughter of the sisters before Stefano's horror at the ultimate revelation. Maybe the police are arriving from the mainland – we see the local mayor making a telephone call, we hear sirens – but will Stefano be believed? And even if he is, will anyone wish to dislodge the archaic hold of family and church? A very Italian dilemma.

Richard Dyer

A Lizard in a Woman's Skin

Una lucertola nella pelle di una donna

Studio:
Fida Cinematografica
International Apollo Film
Les Films Corona
Atlantida Film

Director:
Lucio Fulci

Producer:
Edmondo Amati

Screenwriters:
Lucio Fulci
Roberto Gianviti
José Luis Martinez Molla
André Tranché

Cinematographer:
Luigi Kuveiller

Art Director:
Maurizio Chiari

Editor:
Giorgio Serralonga

Duration:
105 minutes

Genre:
Giallo

Cast:
Florinda Bolkan
Jean Sorel
Stanley Baker
Leo Genn

Year:
1971

Synopsis

Socialite Carol Hammond, during a session with her psychiatrist, talks about a persistent nightmare she is experiencing in which she attacks her boisterous neighbour Julia Durer with a knife. The day after the session, Julia is discovered, stabbed to death exactly as in Carol's nightmare. When several of Carol's belongings are discovered near the body, her involvement seems clear, and she is arrested. But her lawyer father decides to build her defence around the testimony of the psychiatrist and he secures Carol's release. However, shortly after this she finds herself persecuted by a hippie figure who has appeared in the recurring nightmare. Carol's step-daughter, Joan, is working to discover a witness – her reward is to be bloodily murdered, her throat cut. The hippie is arrested and admits to Joan's killing, but maintains that he had nothing to do with the death of Carol's neighbour, being incapacitated by an acid trip. Carol's lawyer father reveals that a woman has been blackmailing him – and, surprisingly, he claims that he was the killer of Julia. But the short-tempered Inspector Corvin is not persuaded, and is convinced that the real murderer is still at liberty.

Critique

A fascinating misfire, *Una lucertula nella pelle di una donna*, while compromised, is an intriguing pointer to later ideas in Fulci's more sanguinary 'living dead' movies. Basically a Hitchcock-style crime thriller set in a jaded 'Swinging London' milieu, it has several virtuoso set pieces, such as a brilliantly shot chase in a deserted church which is almost a text-book example of how to utilize location shooting (as well as demonstrating a lesson Fulci has now apparently forgotten – that *one* flesh-rending knife thrust can be infinitely more shocking than a full-scale evisceration: the heroine's one ghastly wound in this scene reminds viewers of the throat-catching jump of Donald Sutherland's death in *Don't Look Now*, Nicolas Roeg, 1973). Carol Rambaldi's pre-*ET* (Steven Spielberg, 1982) contribution consists of disembowelled dogs (for which Rambaldi had to produce synthetic models to save Fulci from outraged legal proceedings), but this is not a Fulci 'splatter' movie.

For many years, Fulci's seminal *giallo* was unavailable; it is now possible to see it in a print that does more justice to his vision, but things are complicated: only a panned-and-scanned Italian-language print contains the uncensored cut (the language, with subtitles, is not a problem, but the panning and scanning is), while the restored, surround-sound English-language print looks and sounds wonderful. The attraction of the latter, of course, is that so many of the actors in the cast are performing in English, with their own voices, notably Stanley Baker. This was one of the underrated British actor's last films, and his performance shows just what a major presence he was in British cinema. In fact, his part (a police inspector suspicious of a society woman's involvement in the murder of her decadent neighbour) is nothing to write home about,

being somewhat underwritten (Fulci and co-writer Roberto Gianviti characterized the detective only in terms of the tuneless whistle he is prone to). Baker's mere presence fills out the role admirably; similarly effective is another reliable British actor, Leo Genn, as the father of Florinda Bolkan, the woman under suspicion. Bolkan is, of course, an iconic figure in the genre, and delivers one of her most impressive performances as a woman suffering from strange, surreal dreams in which she appears to bloodily murder her neighbour after lesbian advances (to which she initially does not seem averse).

This is the film that caused something of a sensation in Italy, involving a court case (as mentioned earlier) in which Fulci was accused of cruelty to animals. At one point (in one of her nightmares), Bolkan stumbles into a hospital laboratory where eviscerated dogs are stretched out on racks, their pulsing hearts and other organs clearly visible while receptacles catch their dripping blood. Amazingly, it was felt that these (to modern eyes) fairly obvious Rambaldi models were the real thing, and the special effects technician had to produce them in an Italian court to prove that real dogs had not been subjected to cruel treatment! The otherwise splendid-looking English-language print does not have this most famous sequence, and all the violence and nudity is trimmed (in the English-language print, Bolkan appears to be dressed when she commits the murders; the Italian print makes it clear that she, like her victim, is nude).

Barry Forshaw

The Killer Must Kill Again

L'assassino è costretto a uccidere ancora

Director:
Luigi Cozzi

Producers:
Umberto Lenzi (as Umberto Linzi)
Giuseppe Tortorella

Screenwriters:
Luigi Cozzi
Daniele Del Giudice

Dialogue:
Adriano Bolzoni

Synopsis

Giorgio Mainardi, an unfaithful husband with financial problems, is threatened with divorce by his wealthy wife Norma. After witnessing a man disposing of a corpse, he decides to have Norma murdered, enlisting the killer with a combination of financial incentives and blackmail. While the plan goes smoothly at first, the car containing Norma's body is stolen by Luca and Laura, two young joy riders, obliging the killer to go in pursuit.

Critique

L'assassino è costretto a uccidere ancora has been promoted – not least by its writer-director – as a deliberate subversion of giallo conventions, centred on genre stalwart George Hilton. From the start, however, Luigi Cozzi's invocation of the giallo clichés is not matched by a consistent or even coherent form of critical distancing or comment. While the killer's face is revealed early on – the most obvious twist on the giallo formula – his identity, background and motivations remain unknown. The film opens with a genre staple, the corpse of a young woman, and the killer's prolonged caressing of her hair, face and body accentuates the necrophiliac aspect implicit in the conception, production, promotion and

Directors of photography:
Riccardo Pallottini
Franco Di Giacomo (uncredited)

Art Director:
Luciana Schiratti

Editing:
Alberto Moro

Music:
Nando De Luca

Duration:
90 minutes

Genre:
Giallo

Cast:
George Hilton
Michel Antoine
Femi Benussi

Year:
1975

consumption of the genre. The mutually-loathing, bourgeois couple are held together by interdependence both financial, for Giorgio, and sexual, for Norma. This gender divide is marked further by accusations of male infidelity and female insanity, recurring elements in numerous production line *gialli*.

The film does offer an implicit critique of amoral, often brutish masculine hedonism, lust and greed. Giorgio will murder his wife to ensure financial security and freedom to pursue his sexual adventures. Luca orders Laura to expose her breasts to distract a petrol station attendant, enabling them to rob the latter. When Laura compares herself and Luca to Bonnie and Clyde, her boyfriend immediately focuses on the latter's alleged impotence, suggesting a sexual anxiety confirmed when he reasserts his masculinity in a backseat fumble with an obliging blonde pick-up. The soothing of ego and exercise of power through sexual conquest finds its most extreme manifestation in the killer. The latter beats and rapes the naive, virginal Laura as 'punishment' for stealing the car and compromising his potency, as represented by the successful completion of the murder plot and associated financial gain.

Cozzi is unable to develop this theme, allowing *giallo* conventions to dominate his material and highlight its fragile construction. The emphasis on the female form, clothed and unclothed, places the spectator in a familiar position of identification with the male predators. The belated transformation of Laura from passive woman-in-peril to resourceful heroine is undercut by the swift narrative switch to the police pursuit of Giorgio. The inspector's paternal reassurance that order is restored seems blatantly inadequate, yet the violated, traumatized Laura and cheating, battered Luca are marked as a mutually-supportive and healing couple and promptly removed from the diegesis. In any case, the tentative critique of the *giallo*'s sexual politics unravels entirely during the sequence where Luca's liaison with the blonde is cross-cut with the killer's rape of Laura. This 'ironic' juxtaposition achieves nothing more than an eroticization of sexual violence long associated with the genre. Cozzi may aim to subvert the *giallo* formula but proves unable to transcend, let alone transform its inherent limitations and restrictions, ultimately endorsing the clichés with a dogged lack of imagination.

Daniel O'Brien

The Scorpion With Two Tails

Assassinio al cimitero etrusco
Aka Murder in An Etruscan Cemetery

Studio:
Dania Film

Director:
'Christian Plummer '(Sergio Martino)

Producer:
Luciano Martino

Screenwriter:
Ernesto Gastaldi

Cinematographer:
Giancarlo Ferrando

Art Director:
Massimo Antonello Geleng

Editor:
Daniele Alabiso
Eugenio Alabiso

Duration:
98 minutes

Genre:
Giallo/Horror

Cast:
Elvire Audray
John Saxon
Marliù Tolo
Van Johnson

Year:
1982

Synopsis

Joan is the New York-based young wife of an archaeologist who is away working on an exploratory dig in Italy on behalf of her father's company. She begins having strange premonitions which appear to involve sacrificial rites carried out by Etruscans where the sacrificial victims have their heads twisted one hundred and eighty degrees. Soon she foresees the brutal death of her husband in the same manner. After her premonitions are realized in grim fashion, Joan heads to Italy to investigate his death. She is met with stern resistance from the Contessa Maria Volumna, on whose behalf her husband had also been working. She also receives a cold shoulder from the local detectives, who are keen to sweep the matter under the carpet. However, the murders continue apace and Joan sees the connecting feature between the victims to be their involvement with the archaeological dig and consequent raiding of the Etruscan tombs. As the excavations and killings continue, a disturbing likeness is found between Joan and a wall painting depicting a beautiful Etruscan noblewoman. This is the same lady who features in Joan's premonitions and who leads the sacrifices. The locals and the archaeological experts cite the Etruscan belief in the cyclical nature of life and immortality which Joan can scarcely believe.

Critique

A bizarre concatenation of B-movie genres and ciphers, the muddled naming and re-naming of this film relays something of its confused identity. It is ostensibly an attempt by renowned Giallo director Sergio Martino (here operating under the Americanized pseudonym of 'Christian Plummer') to draw on Italian history in order to re-energize (and legitimize?) the *giallo* genre. It also perhaps draws on the earlier 1972 picture by Armando Crispino *L'etrusco uccide ancora/The Etruscan Kills Again* for inspiration but the film ends up in a woolly mess of tangled plot knots and ugly exposition.

Stylistically, the film resembles an inexpensive television drama (indeed, it was originally conceived as such), all rapid close-ups and pull-aways, and slightly off-kilter framing. The performances are comically broad, the dialogue clay-footed and cumbersome and is delivered in a glazed monotone for the most part.

As the lead protagonist Joan (Elvire Audray) uncovers the dark plotting and skulduggery behind her husband's nasty end (linking the immorality of tomb raiding with the illegality of drug smuggling), the story melds historical adventure with contemporary thriller elements without ever resorting to the gore that genre fans prefer.

The *giallo* often incorporates a ludic approach to sight within its narratives and here the director appears to make reference to that generic convention with recurring images of maggots outpouring from eye sockets of the dead, statues and the living, which, when combined with the heroine's apparent 'gift' of second sight, creates

a playful approach to sight on the part of the film (which is also a generic trait of the giallo). The method of sacrificial murder by twisting the neck to make the human head face the other direction could also be taken as another (slightly obfuscatory) reference to that convention, or it could equally relate more simply to the protagonist's mortal dilemma of the need to watch her back or, indeed, to look back into history to find the solution to her mystery.

The twelve cases of archaeological relics (one of which is being used for drug-smuggling) are referred to in the film as being representative of the twelve major cities of Etruria. The number twelve, as well as being attributable to the dodecopoli of major Etruscan cities, did indeed appear to have ritual significance in Etruscan culture.

However, the film is essentially a clumsy medley of tropes, plot elements and constituent parts pawned from other genre staples, its closest cinematic relative being the superior Crispino film mentioned above and also trading a little on Sergio Martino's other, more successful work *La coda dello scorpione/The Case of the Scorpion's Tail* from 1971. Even the soundtrack appears to be directly pilfered from other films in the genre.

Matthew Pink

The Strange Vice of Mrs Wardh

Lo strano vizio della Signora Wardh
Aka Blade of the Killer
Aka The Next Victim!

Studio:
Copercines

Directors:
Sergio Martino
Antonio Crescenzi

Producer:
Luciano Martino

Screenwriter:
Ernesto Gastaldi

Cinematographers:
Emilio Foriscot
Floriano Trenker

Synopsis

Arriving in Vienna, Julie Wardh, glamorous and attractive, is married to the diplomat Neil, but is increasingly dissatisfied sexually. She is haunted by a dark, disturbing affair in her past with the violent (and potentially homicidal) Jean. Their relationship consisted of destructive sexual encounters where Jean would all but rape Julie, often tearing at her clothes with the jagged edges of a broken bottle. Meanwhile a razor-wielding serial killer is on the loose in Vienna.

One night at a dissolute party, Julie notices Jean, who has been sending Julie flowers with ominous messages relating to his knowledge of Julie's hidden vices. At the party Julie flirts with the caddish George, who is apparently the cousin of her newly wealthy best friend Carol. George and Julie begin a passionate affair, but this results in blackmail, murder and threats to Julie's life. Carol becomes involved, but is brutally slain in the same manner as the victims of the serial killer. The murders continue…

Critique

One of the better-known films of the prolific *giallo* director Sergio Martino, who was a mere 29 years old when he completed this film, part of a 'new wave' of *gialli* which arrived in the same flurry of attention as the films of Dario Argento in the early 1970s.

Given that this is only Martino's second film (his first was within another pulpish genre, the exploitation film) it is impressively shot, paced at a zippy tempo and operates around a plot predicating

Art Director:
None given

Editor:
Eugenio Alabiso

Duration:
98 minutes

Genre:
Giallo/Horror

Cast:
George Hilton
Edwige Fenech
Ivan Rassimov

Year:
1971

many tropes of the genre to come, all psycho-sexual peccadilloes and fetishistic murder. It also carries – relatively lightly – a series of plot pretzel twists. The film is generally considered to be one of the more superior pieces within not only this director's career but also the genre as a whole.

Martino demonstrates here his keen eye for aesthetically-pleasing uses of colour and light with some élan. He operates largely and successfully from a wide frame, knowing when to compose an image with jagged edges and clashing shapes, and also when to pull back – emptying the frame and exposing the dilemma (often mortal danger) of his characters.

This film cemented Martino's regular team of collaborators who would work with him on many of his future films, including the Edgar Allan Poe fan and screenwriter Ernesto Gastaldi, Martino's producing brother Luciano and actors including the feline Edwige Fenech (so often his terrorized leading lady), the sinister-eyed Ivan Rassimov and the swarthy George Hilton.

Martino paints Vienna and its hoi-polloi international society as something of a den of iniquity, where hidden sexual desires are played out at druggy parties. This closed society, of which Fenech's character and that of Rassimov are a part, takes on an additional menacing edge given the context of the city at the time the film is set – a serial killer is on the loose and slicing up beautiful young girls. At first, like Spike Lee's *Summer of Sam* (1999) or Jane Campion's *In The Cut* (2003), the serial killer operates only at the periphery of the central story but the film's tension and drive are largely derived from the manner in which both strands (Julie and Jean's violently tempestuous past, and the serial killer aspect) are assimilated.

In fact it is the rather gonzo sexual predilections of Fenech's Julie that gives this film its off-the-wall feel – that 'Strange Vice' of the title. Quite why she and Jean began their relationship, involving broken bottles, pseudo-rape and rolling around in shattered glass, is never really explained, giving the film a dark undertow.

Matthew Pink

Tenebrae

Tenebre

Studio/Distributor:
Titanus

Director:
Dario Argento

Producers:
Salvatore Argento
Claudio Argento

Synopsis

An American crime writer, Peter Neal, travels to Rome to promote his new book, *Tenebre*. There are a series of murders are committed; in one case, pages of *Tenebre* are stuffed in the victim's mouth and Peter receives menacing phone calls and messages. The killer is unmasked – but the killings do not stop, getting closer to Peter (his ex-wife and her lover, Peter's agent; his assistant) until at the end the fatalities reach epic proportions.

Critique

Tenebre is a tease, perhaps the apotheosis of one of the core pleasures of detective fiction: being outwitted, wrong-footed, led up the

Screenwriter:
Dario Argento

Cinematographer:
Luciano Tovoli

Art Director:
Giuseppe Bassan

Editor:
Franco Fraticelli

Duration:
110 minutes

Genre:
Giallo

Cast:
Anthony Franciosa
Daria Nicolodi
Giuliano Gemma
Veronica Lario
Eva Robbins

Year:
1982

garden path. The playfulness is evident in the film's central conceit (**to reveal which is also a spoiler**): a crime writer whose books provide an inspiration for actual murders, who then kills the murderer and himself becomes – as perhaps he always has been – a murderer. The teasing is also present in the very organization of the film.

Take the title. Seldom can a tenebrous thriller have been so full of light. Even sequences shot at night have strong, unnatural light sources falling across them. The murder of Peter's agent takes place in a crowded, open-air shopping centre in broad daylight. Interpolated sequences of a young woman humiliating a man and then being stabbed to death are shot overexposed. At one point the camera pans around an empty room, coming to rest on a huge metal sculpture, whose tip gleams with light; though the sculpture may point forward to the sculpture in another location that at the end of the film pierces and kills Peter, there is really no point to the image here except to suggest the sinister, threatening quality of its gleaming tip: fear of light in a film called dark.

Then there is the use of editing. The interpolated sequences are sometimes introduced by shots of pills and the sound of running water, but only at the end of the film do we learn that Peter may have killed a young woman in his youth, suggesting that these sequences may show this woman and may be Peter's nightmares. Peter's ex-wife Jane receives a pair of red shoes, just like those of the woman in the sequences; after the murder of the agent, there is a close-up on a pair of red shoes walking and then hesitating: the killer? Or just a passer-by who happens to have the same pair of shoes? We expect details in a film to contribute to the story and have difficulty accepting they may just be evidence of the world passing by. This notion is most strongly played on in a shot of a plane taking off, after Peter has packed his bags and set off to go home; we learn (**another spoiler coming**) that he never went home, the plane is just any plane; but the way films organize narrative tricks us into thinking that the plane must be Peter's plane.

Tenebre also teases sexually, suggesting a web of anxiety around female and perverse sexuality. The killer kills sexually-active women. The murder of two lesbians involves a long, spectacular crane shot over their dwelling to a throbbing rock score, a shot impossible to treat as a point-of-view shot and yet which, in its seeming to search for an open window through which to see the women and in a hand finally entering the frame at the end of the take, evokes the voyeurism of soft-porn lesbianism. The woman killed in the interpolated sequences is played by Eva Robbins, well known in the period as a pre-operative transsexual.

All of this suggests unresolved psychic anxieties and moral ambiguities – and this is where the film leaves us. The ironies, absurdities and irrelevances of the film are in tandem with graphically-represented murders that provoke gasps and giggles in equal measure. And the film ends with the one survivor, screaming in the torrential rain at the sight of several grotesquely mutilated corpses, as if beneath all the cleverness and wit there is only the inchoate turmoil of terror.

Richard Dyer

Torso

I corpi presentano tracce di violenza carnale
Aka The Bodies Present Traces of Carnal Violence

Studio:
Compagnia Cinematografica Champion

Director:
Sergio Martino

Producer:
Carlo Ponti

Screenwriters:
Sergio Martino
Ernesto Gastaldi

Cinematographer:
Giancarlo Ferrando

Art Director:
Giantito Burchiellaro

Editor:
Eugenio Alabiso

Duration:
93 minutes

Genre:
Giallo

Cast:
Suzy Kendall
Tina Aumont
Luc Merenda
John Richardson

Year:
1973

Synopsis

Carol and Florence, two students taking a course in fine art, fall victim to a masked murderer wielding a hacksaw. There is a clue to the identity of the killer: an embroidered red scarf is discovered on the body of one of the victims. Art student Daniela believes that she has seen the scarf before, but before she can ascertain where, she begins to receive threatening phone calls. The scarf was sold by a street trader who tries (extremely unwisely) to blackmail the murderer – with the inevitable lethal results. Meanwhile, Daniela and her friends, Ursula, Jane and Katia, decide to live together in an out-of-the-way country villa. This, unsurprisingly, is an extremely bad move, as they have been followed by the murderer, who begins to ruthlessly pick them off one by one. Soon the villa is a charnel house littered with body parts, and the identity of the murderer looks set to remain undisclosed...

Critique

Julian Barry? Christian Plummer? Martin Dolman? In fact, the film-maker Sergio Martino (like so many of his peers) was obliged to work under a variety of pseudonyms. His real break as a director came in the wave of *Mondo Cane*-style documentaries, with their crowd-pleasing mix of authentic grisly footage and reconstructions of the same. He then took the route that had tempted so many Italian Directors: anodyne comedies (often with soft-core sexual situations). But the director's true talent was to appear only when he moved into the genre that became his metier: the *giallo*. *Gialli* are, of course, notorious for their unwieldy, slightly ungrammatical titles (both in Italian and when translated into English), and Martino came up with one of the most memorable in *I corpi presentano tracce di violenza carnale/The Bodies Present Traces of Carnal Violence* (1974). This, however, was shortened to *Torso*, and is his best known film as well as being one of the most assured and atmospheric entries in the genre (and, in fact, less graphic than its title might suggest, although recently more complete prints have become available).

Using English actors such as John Richardson, Martino creates here an admirably disturbing piece, even if the identity of the killer is not that difficult to discern. The casting of Suzy Kendall as the menaced victim in this one – a function she also performed for Argento – is another reason for the film's success. And it is certainly a more impressive entry in the genre than *Lo strano vizio della Signora Wardh/The Strange Vice of Mrs Wardh* (1970). Although *Lo strano vizio* builds a fair measure of tension, it remains no more than a merely craftsmanlike piece, without the more comprehensive grip of *Torso*. Two years later, in *Tutti i colori del buio/All the Colours of Darkness* (1972), Martino utilized a strange, almost somnambulant narrative as a vehicle for a similarly intelligent use of both camera and *mise-en-scène*. The

other main influence on Martino (apart from Bava's and Argento's *gialli*) was, of course, the subgenre of thriller forged in the wake of Boileau and Narcejac's *Les Diaboliques*, with elaborate double-crosses and plots behind otherwise inexplicable actions. If, in retrospect, Martino's career is notable for more duds than successes, those successes show that, while as a director he was not in the same league as Argento and Bava, Martino (as *Torso* demonstrated) was in fact one of the most idiosyncratic and imaginative makers of Italian popular cinema.

Barry Forshaw

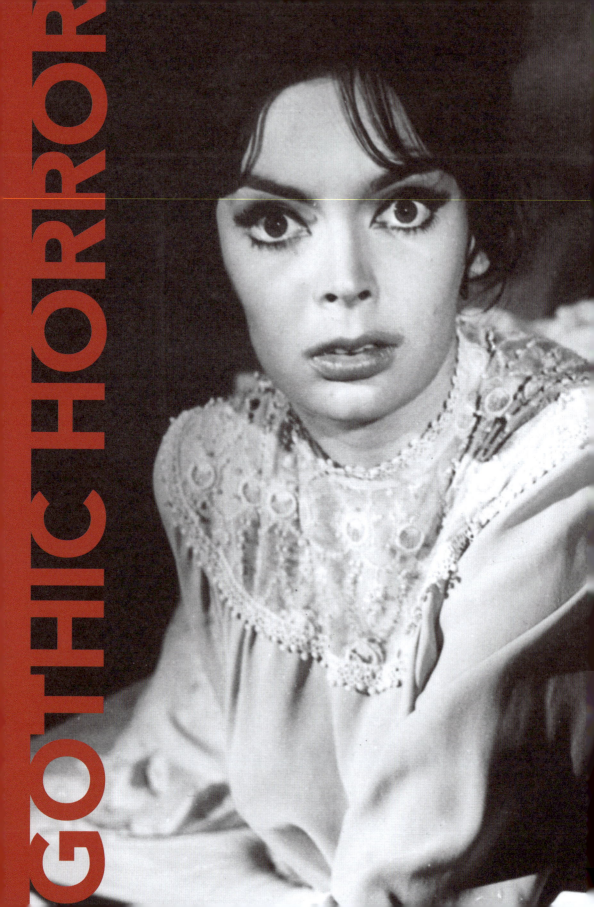

During its first half-century, Italian cinema lacked an indigenous horror-fantasy tradition (the principal exception being *Il mostro di Frankenstein/Frankenstein's Monster* (Eugenio Testa, 1921). While there were occasional films which contained fantastic or horrific elements, most of these films rooted these qualities within an entirely different generic framework – adventure, in the case of *Maciste all'inferno* (Guido Brignone, 1925), comedy in the case of *Totò all'inferno* (Camillo Mastrocinque, 1955). The literary tradition of the gothic was less developed in Italy than in England and this also deprived Italian cinema of the kinds of influences and antecedents enjoyed by the Hammer studios, although Antonio Fogazzaro's female gothic *Malombra* (1881) was adapted by both Carmine Gallone in 1917 and Mario Soldati in 1942.

With *I vampiri/The Devil's Commandment* (Riccardo Freda, 1956) the Italian gothic horror film emerged fully formed and apparently out of nowhere, slightly anticipating *Dracula* (Terence Fisher, 1958), which launched Hammer's cycle of English gothic. With its tale of an older woman rejuvenating herself with the blood of younger women, *I vampiri* established a narrative template that was to dominate Italian gothic horror films for the next decade. These films revolved around paranoia about death, ageing and the loss of female beauty, resolving themselves in a perverse and fatal attachment to an illusory permanence. The endless repetition of this narrative over the next decade is, depending on one's point of view, either evidence of the fundamentally-imitative nature of the Italian *filone* system or testament to a genuine obsession. Set in Paris, drawing most of its inspiration from the Irish writer Joseph Sheridan Le Fanu's *Carmilla* (1872) and with a narrative and themes that anticipate other horror films from mainland Europe like *Les Yeux sanx visage/Eyes without a Face* (Georges Franju, 1959) and *Gritos en la noche/The Awful Dr. Orloff* (Jess Franco, 1962), *I vampiri* is markedly different from the products of the British Hammer studios that would follow in its wake. However, it was a commercial failure and the Italian gothic cycle was really inaugurated by the phenomenal international success of *La maschera del demonio/Black Sunday* (1960), the directing debut of Mario Bava, who handled the cinematography, special effects and additional (uncredited) directorial chores on Freda's film. Once again the literary source was European but neither English nor Italian: Nikolai Gogol's *Vij* (1835). Here the vampiric older woman becomes a witch preying on her young descendent, thus reinforcing the theme of the (female) doppelganger so central to the literary gothic. Both roles were played by British actress Barbara Steele, who would go on to appear in nine Italian gothic horror films over the next six years and, in so doing, become an international horror icon. That Steele should have made such an impression was arguably due to the way in which she constituted a fetish object (Jenks 1992), the perfect embodiment of the gothic's sense of the uncanny and the incarnation of what Barbara Creed (1993) has termed the 'monstrous feminine' in the horror film. The centrality afforded to female characters in the gothic allowed for an increased emphasis on eroticism, which was gradually permeating Italian cinema of the period; however it is significant that in the gothic the woman is typically the

Left: *The Terror of Doctor Hichcock*, Panda Film.

embodiment of the forces of evil. The Italian gothic can thus be seen as the expression of a neurosis, portraying women as object of both desire and disgust or fear.

The Italian gothic horror film constituted one of the many *filoni* that characterized the boom in Italian popular cinema of the 1960s and, like the peplum, by the mid–late 1960s had more or less died out. The intensity with which this genre was mined for such a brief period – before being briefly resurrected a decade later – undoubtedly reflects the imitative, ephemeral and cyclical nature of the *filone* system. However, as Stefano Della Casa has observed, it also provided a vehicle for an exploration of the darker side of human sexuality during a period of rapid social change in which increasing affluence and a shift from a predominantly rural to an increasingly urban culture had a sizeable impact on the social and sexual mores of a predominantly conservative, Catholic culture like Italy (Della Casa 2001: 323–25). However, these social changes also ultimately led to the demise of the genre, whose themes and iconography were firmly rooted in the culture of centuries past. Thus the gothic horror was superseded by the *giallo*, which can be seen as an expression of, and response to, the new, transnational, metropolitan, consumerist society of the post-Boom period. The *giallo* absorbed and developed elements pioneered by the gothic, most notably the sado-eroticism of films like *La maschera del demonio*, *La frustra e il corpo/The Whip and the Body* (Mario Bava, 1963) and *Amanti d'oltretomba/Nightmare Castle* (Mario Caiano, 1965). Moreover, it revolved around the idea of the unexpected eruption of the irrational into the status quo of ordinary reality (McDonagh 1991: 7) and this, too, was a key trope of the gothic, which was typically founded on the opposition between the rational voice of an emergent scientific culture and the explosion of an irrational horror derived from the superstitions of centuries past (*La cripta e l'incubo/Crypt of Horror*, Camillo Mastrocinque, 1964), of psycho-sexual insanity (*L'orribile segreto del Dr. Hichcock/The Horrible Dr. Hichcock*, Riccardo Freda, 1962), or the perverting force of – typically female – sexuality or evil (*Un angelo per Satana/An Angel for Satan*, Camillo Mastrocinque, 1966).

The revival of the gothic in the late 1970s with Dario Argento's *Suspiria* (1977) and *Inferno* (1980) was arguably, and significantly, due to a female influence, in the form of Argento's partner and muse Daria Nicolodi, who apparently based the idea for the films on her grandmother's experiences in a dance school which supposedly concealed a coven of witches. Argento extended the irrationality and sensuality of the 1960s gothic by focalizing *Suspiria* through child-like protagonists and filtering *Inferno* through the opium-fuelled delirium of Thomas De Quincy's *Levana and Our Ladies of Sorrow* (1845). Shortly after, Lucio Fulci began to draw not on the structural and thematic qualities of the gothic present in Argento's films but, rather, on its iconography and atmosphere. Unlike the other splatter films produced in Italy in the early 1980s, Fulci's zombie films are dripping with gothic dread; both *L'aldilà/The Beyond* (1981), and *Quella villa accanto al cimitero/The House by the Cemetary* (1981) revolve around cursed mansions that hark back to earlier films like Antonio Margheriti's *Danza macabra/Castle of Blood* (1964), while *Paura nella città dei morti viventi/City of the Living Dead* (1980) contains one of the most sustained gothic atmospheres the cinema has yet offered.

By the mid-1980s the Italian gothic had died out once more. Although there were sporadic and isolated attempts to revive it in the 1990s, the Italian film industry – and its reduced export market – seem no longer to have been able to support them. Mario Baiano was forced to make *Dark Waters* (1994), an effective homage to this tradition, in Russia, while Lamberto Bava's attempts to maintain his father's legacy on both the big and the small screen have all been failures, most emblematically in his dire updating of the genre's prototype in *La maschera del demonio/Black Sunday* (1989).

Alex Marlow-Mann

The Arcane Sorcerer

L'arcano incantatore
Aka The Mysterious Enchanter

Studio/Distributor:
Filmauro
Duea Film

Director:
Pupi Avati

Producers:
Antonio Avati
Aurelio De Laurentiis

Screenwriter:
Pupi Avati

Cinematographer:
Cesare Bastelli

Art Director:
Giuseppe Pirrotta

Editor:
Amedeo Salfa

Duration:
96 minutes

Genre:
Gothic horror

Cast:
Carlo Cecchi
Stefano Dionisi
Andrea Scorzoni
Mario Erpichini

Year:
1996

Synopsis

Bologna, 1750. After having being expelled from the seminary for making a woman pregnant and then persuading her to have an abortion, Giacomo accepts an assigment as an assistant and scribe to a priest who has been excommunicated for his research into esoteric practices and now lives isolated in a tower in the countryside. Giacomo soon hears rumours that his predecessor, Nerio, who is now buried in unconsecrated ground in the tower's grounds, was suspected of having been a disciple of the Devil and of having murdered two nuns. As Giacomo assists the priest in his experiments and delivers secret messages in code, strange nocturnal events begin to transpire and Giacomo begins to believe that there may be some truth to the rumours about Nerio.

Critique

Although best known for his work in other genres, Pupi Avati also directed a number of horror films in the 1970s, including the remarkable *La casa dalle finestre che ridono/The House of the Laughing Windows* (1976) and *Zeder* (1983). His return to the genre with *L'arcano incantatore* is notable above all for being the only significant example of the gothic horror genre to be produced in Italy over the past two decades. Like most of Avati's work, it is in an independent production by the company he runs with his brother Antonio, Duea Film (in collaboration with Filmauro), and takes place in the countryside of his native Emilia Romania. The geographical and temporal setting is central to the film's project and Avati goes to great lengths to convey the intellectual and religious culture of seventeenth-century rural Italy. By establishing a climate of superstition and belief in the supernatural, Avati helps render plausible the kind of events that early Italian gothic films mostly took for granted. This attention to historical reconstruction is reminiscent of Umberto Eco's *Il nome della rosa/The Name of the Rose*, which also revolved around crimes within a religious setting and hinged on the discovery of a secret manuscript and the deciphering of a code.

Like so much of Avati's cinema, the film is elegantly realized with a care and attention to detail lacking from the more formulaic Italian gothic horrors of the 1960s. Particularly notable is the film's play with light and shadow, which perfectly dramatizes the film's central theme of the persistence of superstitious beliefs prior to the Enlightenment. Yet the film is both less transgressive and less perverse than earlier Italian gothic horror films and for this reason it comes across as less incisive. (It is significant that, despite the dearth of Italian horror films in the 1990s, the film has not enjoyed the attention from genre aficionados afforded to Avati's earlier genre efforts or more recent films like *Dellamorte Dellamore/Cemetery Man*, Michele Soavi, 1994). Although there are some effectively spooky moments – above all a scene in the library when a figure Giacomo believes to be the priest turns out to be someone

else entirely – the ending is somewhat flat and the film's horrors never achieve the frisson of Avati's earlier work in the genre. Nevertheless, *L'arcano incantatore* is an intelligent, mature and stylish work that proves that Italian cinema remains capable of producing quality films within the genre of gothic horror.

Alex Marlow-Mann

Black Sabbath

I tre volti della paura

Studio/Distributor:
Emmepi Cinematografica
Lyre Cinematographique
Galatea

Director:
Mario Bava

Producer:
none given

Screenwriters:
Marcello Fondato, with the collaboration of Alberto Bevilacqua
Mario Bava, based on stories by Cechov, Tolstoi, Maupassant

Cinematographer:
Ubaldo Terzano

Art Director:
Giorgio Giovannini

Editor:
Mario Serandrei

Duration:
93 minutes

Genre:
Gothic horror

Cast:
Boris Karloff
Michèle Mercier
Lydia Alfonsi
Mark Damon

Year:
1963

Synopsis

Boris Karloff introduces three tales of horror. In 'The Telephone' a young woman receives threatening phone calls from her former lover, who was arrested after she denounced him to the police. She invites a friend over to protect her but the friend turns out to have a secret agenda. In 'The Wurdalak' a man kills a vampire who only preys on those he loves. However, when he returns home only after the prescribed period of time has expired and begins acting strangely, his family begin to fear that he too may have become a Wurdalak. And in 'The Drop of Water' a nurse steals a ring from the finger of a dead medium only for her spirit to return to reclaim it.

Critique

The anthology was a common feature of 1960s cinema, both in the Italian arthouse (*Boccaccio '70*, Mario Monicelli, Luchino Visconti, Federico Fellini and Vittorio De Sica, 1962) and the international horror genre (*Tales of Terror*, Roger Corman, 1962), not to mention films that straddled both categories (*Histoires Extraordinaires/Tre passi nel delirio/Spirits of the Dead*, Louis Malle, Roger Vadim, Federico Fellini, 1968). *I tre volti della paura* was commissioned by the American distributor AIP, who had made a small fortune out of Bava's directorial debut *La maschera del demonio/Black Sunday* (1960), as a vehicle for horror icon Boris Karloff, the star of several of Roger Corman's films for AIP, not to mention the iconic monsters of Universal's original *Frankenstein* (James Whale, 1931) and *The Mummy* (Karl Freund, 1932). However the incestuous killings of 'The Wurdalak', the implied lesbianism of 'The Telephone', and the genuinely terrifying atmospherics of 'The Drop of Water' proved to be far too strong and perverse for AIP, whose horror films were aimed predominantly at a juvenile audience, and they asked Bava to soften the film. Bava responded by improvising an extraordinary ending which sabotaged the atmosphere he had so carefully created by revealing the artifice behind the film's construction. In so doing, he anticipated the direction he was to take in later works like *5 bambole per la luna d'agosto/Five Dolls for an August Moon* (1970) and *Reazione a catena/A Bay of Blood* (1971), establishing a predilection for irony and self-reflexivity that Stefano Della Casa (2001) has argued is the trait which distinguishes Bava from Freda and his other colleagues. However, even this was too much for AIP, who completely re-edited the film before releasing it as *Black*

Sabbath to cash in on the success of *La maschera del demonio/ Black Sunday*.

The original version of *I tre volti della paura* is arguably Bava's masterpiece, even if his is a career studded with genuinely ground-breaking, genre-defining films. 'The Telephone' anticipates the *giallo* genre in its fusion of sexual transgression and murder and, together with Bava's *Sei donne per l'assassino/Blood and Black Lace* (1964), gave rise to the moniker 'red telephone movie' occasionally used in Italy at the time to characterize such films. (The term is a play on the 'white telephone' films of the Fascist era.) 'The Wurdalak' gives the idea of vampirism a uniquely unsettling twist by locating it squarely within the family – typically the provenance of melodrama – and the scene in which a woman kills her husband when he attempts to restrain her from running out to aid their vampire son, who is begging for help from outside the window, remains one of horror cinema's most unsettling and subtly transgressive moments. But it is arguably the final episode, 'A Drop of Water', which remains the film's outstanding episode. Here the famously timid and anxiety-ridden Bava perfectly demonstrated his belief that the greatest of terrors are experienced when one is alone in a room, an idea he returned to at the end of his career with *Shock* (1977). Bava was a master cinematographer and an expert at generating atmosphere and in 'A Drop of Water' he conveys the sensation of fear better than anyone has before or since through the simplest of sounds, sights and household objects. The animation of the medium's corpse (a wax sculpture by his father, Eugenio) during the climax must have been a genuinely terrifying spectacle in 1963; certainly Vincent Price's reanimation in the similarly-themed 'The Case of M. Valdemar' episode of Roger Corman's *Tales of Terror* pales by comparison. If Bava made more influential films than *I tre volti della paura*, none provided a better demonstration of the power of the mechanism of cinema to convey the emotion of fear, or of Bava's mastery of it.

Alex Marlow-Mann

Black Sunday

La maschera del demonio
Aka The Mask of the Demon/The Mask of Satan/Revenge of the Vampire

Studio/Distributor:
Galatea and Jolly Film

Director:
Mario Bava

Synopsis

In seventeenth-century Moldavia a woman, Asa, is put to a horrible death as a witch, along with her lover Iavutich, on the orders of her brother; she dies vowing revenge on her family. Two centuries later her tomb is disturbed by two travellers, Dr. Krujavan and the younger Dr. Andrej Gorobek; in the process they allow Asa to come back from the dead. She summons Iavutich from his grave to effect the death of her descendant, prince Vajda, through controlling Dr. Krujavan; she also seeks to substitute herself for his daughter, Katia, who is identical to her. Andrej, in love with Katia, is persuaded by Asa that Katia, lying in a trance on Asa's tomb, is Asa and he is about to destroy her, when he sees the crucifix at Katia's neck, revealing who the true Asa is. The townsfolk burn Asa, Katia and Andrej are together.

Producer:
Massimo de Rita

Screenwriters:
Ennio de Concini
Mario Serandrei

Cinematographer:
Mario Bava

Art Director:
Giorgio Giovannini

Editor:
Mario Serandrei

Duration:
84 minutes

Genre:
Gothic horror

Cast:
Barbara Steele
John Richardson
Andrea Checchi
Ivo Garrani
Arturo Dominici

Year:
1960

Critique

La maschera del demonio is a film about possession – in its plot: Asa, possessed of the devil, seeks to possess Katia; Iavutich does possess Dr. Krujavan, controlling him to cause the death of prince Vajda, also in its style, evoking an overall sense of possession rather than any particular character's experience of it.

Nowhere is this more mesmerizingly achieved than in the first appearance of Katia. We have already seen the execution of Asa and the disturbance of her tomb and the beginnings of her coming back to life. As the two doctors leave the crypt, they see Katia standing at the entrance. They could be seeing Asa, for they are identical (as we know better than they) and there has been no mention of the character of Katia up to this point. Much adds to the impression of strangeness. The camera dollies in a curving movement, travelling beyond the men that it has been following, taking on an uncanny existence of its own. At the moment the camera breaks free of the men, non-diegetic music comes in and Katia is seen in the distance. The music, piano and orchestra (in the original Italian scoring by Roberto Nicolosi), is in a very late Romantic style, melodic but heavily chromatic, gorgeous, sickly, oneiric, morbid, evoking here, and in its use in the rest of the film, at once love (Andrej is instantly smitten) and disquiet. Katia is first seen in silhouette, framed by the arc of the ruined crypt, with two Great Danes by her side; she is perfectly still – the framing and the stillness suggest a vision. Via a shot of the two men looking, we come to a mid-shot of her, disclosing her similarity to Asa and that she is Barbara Steele.

This was, apart from very minor roles, the first film for Steele, who was to become the muse of European Gothic cinema. Her long, raven hair and her face, with its bee-sting mouth, is capable of being at once sensuous, sensual, cruel and childlike. This first shot of her, in all its weird dreaminess, catches that ambivalence: out of context, her face could be that of the ingénue, the severity of her expression suggesting wariness; in context, it might be that of a witch. The shot, like the whole film, stands or falls on the capacity of Steele's presence to hold the cinematography and music lavished on it. Like, of course, Andrej, like perhaps Katia herself, we must feel possessed.

The sense of possession, as evoked by the film, might be described as an easeful entanglement, re-enacted in the detail of the film. Compositions often fill the screen with convolutions of branches, cobwebs, candlesticks, baroque furnishings and ironwork, coming between us and the characters and events, seeing them through a filigree miasma. Music remains within the register of high, swooning Romanticism, supplemented by sinister, sometimes driving, wind. Steele's presence registers not only in her face but also in her hand movements: sinuous, grasping, contorted, but never fast or jerky. Camera movement, strongly narrational in drawing our attention to events such as Asa's gradual awakening or Iavutich emerging from his grave, consists of sinuous dollies and slow-ish zooms. When Katia bids farewell to the doctors after their

first meeting, cross-cutting between her looking after them shows her surrounded by darkness but them in full daylight, a continuity error also suggesting a dream-like blurring of the coordinates of time. In short, *La maschera del demonio* offers us the possibility of experiencing the woozy pleasures of possession.

Richard Dyer

Castle of Blood

Danza macabra

Studio/Distributor:
Giovanni Addessi Produzione Cinematografica
Vulsinia Film
Ulysse Productions

Director:
Anthony Dawson (Antonio Margheriti), with the un-credited collaboration of Sergio Corbucci

Producers:
Frank Belty (Franco Belotti)
Walter Sarch (Walter Zarghetta)

Screenwriters:
Jean Grimaud (Gianni Grimaldi)
Gordon Wilson Jr (Bruno Corbucci), based on a story by Edgar Allan Poe (erroneously cited as a narrative inspiration)

Cinematographer:
Richard Kramer (Riccardo Pallottini)

Art Director:
Warner Scott (Ottavio Scotti)

Editor:
Otel Langhel (Otello Colangeli)

Duration:
89 minutes

Genre:
Gothic horror

Synopsis

Alan Foster, a journalist for *The Times*, is sent to interview Edgar Allan Poe. When Poe suggests that he is not a novelist but a reporter like Foster and that all his stories are based on fact, Foster reacts with scepticism, claiming that there is no such thing as life beyond the grave. To prove his point he accepts a wager to spend 31 October ('the Night of the Dead') in the haunted castle of Lord Thomas Blackwood, despite the fact that none of the people who previously chose to do so ever returned. In the castle he meets Blackwood's sister, Elisabeth, with whom he falls in love. After Elisabeth is murdered by a mysterious man, who bursts in on them making love, Foster encounters the missing metaphysicist Dr Carmus, who claims that on the Night of the Dead the castle is haunted by all those who died there. But is Dr. Carmus telling the whole truth and can Foster make it out alive to claim his wager?

Critique

Danza macabra is pure gothic. More than any other film in the Italian *filone* it revolves around the quintessential locus of the gothic tradition – the haunted castle – and Margheriti makes effective use of this setting, showcasing most of the iconography typically associated with the Genre: cemeteries, crypts, cobwebs, black cats, paintings, the lovely but enigmatic woman, and so on (to achieve this on such a low budget Margheriti re-utilized the sets of *Il monaco di Monza/The Monk of Monza* (1963, Sergio Corbucci). The film also neatly fits the gothic tradition on a structural and thematic level, as it revolves around a series of binary oppositions characteristic of the Genre: rational/irrational, life/death, day/night, this world/the beyond. Alan Foster is the embodiment of rationality, the sceptical journalist disbelieving of the afterlife or anything that he cannot see and touch, but the events he experiences during the course of the film undermine this world view. His conduit into the other world is the writer Edgar Allan Poe – arguably a silly choice, but within the film's internal logic also an extremely congruous one – and the metaphysicist Dr Carmus, both of whom have seen and know more than Foster. It is Foster's obtuseness that makes him a victim; given the circumstances anyone less sceptical would have immediately been suspicious of Elisabeth, and not solely because she displays the uniquely unsettling physical characteristics that made Barbara Steele such

Castle of Blood/Danza macabra, Vulsinia/Jolly/Ulysse.

Cast:
Barbara Steele
Georges Rivière
Margrete Robsahm
Henry Kruger (Arturo Dominici)

Year:
1964

a horror icon. But Foster takes things at face value, allowing himself to fall for her charms and, in so doing, assuming a role in the endless play of life and death that the castle's inhabitants are forced to enact.

Danza macabra, then, is a textbook film; neither innovative nor exceptional but, rather, a well-realized and exemplary piece of gothic film-making. And this is what one has come to expect from Antonio Margheriti, a director who over four decades turned his hand to whatever genre was in fashion (*pepla*, sci-fi, spy films, spaghetti westerns, *gialli*, war films, etc) producing effective and perfectly serviceable films cheaply and efficiently but without ever innovating like Mario Bava or achieving the kind of delirious and perverse intensity exhibited by Riccardo Freda's best work. In short, Margheriti is a craftsman, and *Danza macabra* is a polished artefact. It is indicative of Margheriti's approach to film that he chose to remake the film when the horror genre was back in vogue as *Nella stretta morsa del ragno/Web of the Spider* (1971, with Anthony Franciosa as Foster, Michèle Mercier as Elisabeth and, in a nice piece of casting, Klaus Kinski as Poe). The remake is neither an improvement on nor a betrayal of the original, merely another

well-made product from the Margheriti factory line. Shortly after completing *Danza macabra* Margheriti was re-united with Steele for another of her more effective gothic horror films, *I lunghi capelli della morte*/*The Long Hair of Death* (1964).

Alex Marlow-Mann

Crypt of Horror
La cripta e l'incubo

Studio/Distributor:
Mec Cinematografica
Hispamer Film

Director:
Thomas Miller (Camillo Mastrocinque)

Producer:
William Mulligan (Mario Mariani)

Screenwriters:
Robert Bohr (Bruno Valeri)
Julian Berry (Ernesto Gastaldi)

Cinematographers:
Julio Ortas
Giuseppe Aquari

Art Director:
Demos Philos (Demofilo Fidani)

Editor:
Herbert Markle

Duration:
85 minutes

Genre:
Gothic horror

Cast:
Christopher Lee
Audrey Amber (Adrianna Abesi)
Ursula Davis (Pier Anna Quaglia), José Campos

Year:
1964

Synopsis

A young woman, Laura Karnstein, becomes convinced that she is the latest victim of a curse placed on her family by one of her ancestors, Sheena Karnstein, who was suspected of witchcraft and put to death in centuries past. Concerned for his daughter's state of mind, Count Karnstein hires a young restorer, Friedrich Klauss, to investigate his family's history and locate a portrait depicting Sheena in order to prove that she bears no resemblance to his daughter. The unexpected arrival of a young woman, Lyuba, to the isolated castle offers Laura friendship and solace, but her nightmares persist and Friedrich soon uncovers a secret in the castle crypt.

Critique

Following the success of Hammer's horror films, Christopher Lee appeared in a number of Italian gothic horrors throughout the early 1960s: *Ercole al centro della terra*/*Hercules in the Centre of the Earth* (Mario Bava, 1961), *La vergine di Norimberga*/*The Virgin of Nuremberg* (Antonio Margheriti, 1963), *La frustra e il corpo*/*The Whip and the Body* (Mario Bava, 1963), *Il castello dei morti vivi*/*Castle of the Living Dead* (Luciano Ricci, Lorenzo Sabatini and – uncredited – Michael Reeves, 1964), not to mention the parodic *Tempi duri per i vampiri* (Steno, 1959). However, his participation in these films was often minimal: a few days shooting so that his presence could serve as a box-office draw without compromising the minimal budget. And so it is in *La cripta e l'incubo*, where he is under-utilized in a role that does not call on him to be menacing because, as in so many of the Italian gothic horrors, the threat here is a female one. The film implicitly suggests lesbianism in the relationship between Laura and Lyube and thus invites the question of whether Sheena's crime might actually have been a transgression of sexual, rather than religious, convention. As in so many Italian gothic horrors, female sexuality is the implicit motor behind the narrative, while the men provide the voice of rationality.

The film's lesbian angle derives from Joseph Sheridan Le Fanu's *Carmilla* (1872), which had already been adapted by Roger Vadim as *Et mourir de plaisir*/*Blood and Roses* (1960). The script also clearly references the Italian gothic horror cycle's prototype *La maschera del demonio*/*Black Sunday* (1960) in its tale of a witch visiting a curse on her young ancestor. Bava's film is also repeatedly referenced in the iconography – most obviously in Lyuba's horse-

drawn carriage, the execution of Sheena, and the resemblance between the painting of Sheena and her ancestor. Unfortunately, these references only serve to highlight the extent to which Adriana Ambesi and Ursula Davis are poor substitutes for Barbara Steele, lacking both her unique appearance – by turns attractive and unsettling – and totemic quality.

Although Camillo Mastrocinque was to make the effective Barbara Steele vehicle *Un angelo per Satana/An Angel for Satan* two years later, in 1964 he was better known for comedy – particularly a long string of Totò vehicles including the horror parody *Totò all'inferno* (1955). This inexperience in the genre shows in the slightly leaden pace, the formulaic narrative and the lack of any real *frisson* of horror or transgression. However, Mastrocinque does show a certain gift for the oneiric elements of the film's second half, most notably in a series of striking images: a dog pulling at the ankles of his master's hanged body; a decaying hand with candles made from human fat serving as fingers; and ghostly women in white nightgowns wafting through a nocturnal landscape that recall *Les Yeux sanx visage/Eyes without a Face* (Georges Franju, 1959) and anticipate the films of Jean Rollin.

Alex Marlow-Mann

The Horrible Dr Hichcock

L'orribile segreto del dottor Hichcock
Aka The Terror of Dr Hichcock

Studio:
Panda Cinematografica

Director:
Robert Hampton (Riccardo Freda)

Producers:
Louis Mann (Ermanno Donati and Luigi Carpentieri)

Cinematographer:
Donald Green (Raffaele Masciocchi)

Screenwriter:
Julian Berry (Ernesto Gastaldi)

Synopsis

The famous Dr Hichcock, a surgeon of great repute and extraordinary abilities, hides a troubling secret: he harbours dark necrophiliac desires from which he finds relief by anaesthetizing his compliant wife Margaretha with the complicity of the housekeeper, Martha, to make her appear dead. Continually increasing the doses of anaesthetic, he accidentally causes the death of the woman and then moves away, distraught. He returns ten years later with his second wife, Cynthia, who, unaware of her husband's desires, finds herself in the middle of a dark series of events overseen by the acidic Martha. Who is it moving around at night in Hichcock's ghostly mansion? What does the doctor really do in the secrecy of his medical laboratory?

Critique

Six years after *I vampiri/Lust of the Vampire*, which passed almost unnoticed in Italy, Freda tried his hand once more at Gothic Horror, which had established itself in the meantime as a small domestic genre thanks to a series of notable films (above all *La maschera del demonio/Black Sunday*, Mario Bava, 1960). The decision to hide, like the rest of the technical and artistic team, behind an Anglosaxon pseudonym (Robert Hampton, one of several occasionally used by the director) reveals a desire to position the film in the wake of the relative success of a number of English and

Art Director:
Joseph Goodman

Editor:
Donna Christie (Ornella Micheli)

Duration:
94 minutes

Genre:
Gothic horror

Cast:
Robert Fleming
Barbara Steele
Harriet Medin-White
Teresa Fitzgerald (Maria Teresa Vianello)

Year:
1962

American horrors from Hammer and AIP. Hitchcock, too, is an obvious inspiration, as much in the plot (which has echoes of *Rebecca*, 1940 and *Suspicion*, 1941, and perhaps even *Psycho*, 1960), as in the protagonist's name, slightly changed from that of the celebrated director (Hichcock, with the 't' missing).

But *L'orribile segreto del dottor Hichcock* is a film that stands on its own – not only within Freda's filmography but also within the genre as a whole, cleverly transcending the modest production values which motivate the film's almost total confinement to interiors.

In fact Freda, who organizes his very precise direction around tightly-controlled camera movements, emphasizes the plot's sense of claustrophobia by using the confined and oppressive spaces of Hichcock's mansion to create a visual correspondence to the film's main theme: the inexorable sexual deviance from which Hichcock can find no escape. Through skilful editing, the construction of an irrational geography prevents the viewer from being orientated within the interiors of the gloomy mansion and facilitates the viewer's entry into a suspended universe that is corroded by the main character's febrile delirium.

Hichcock's necrophilia, hidden behind the timid and respectable appearance of the surgeon, emerges almost exclusively in this other space embodied by the mansion. By purposefully contrasting the mansion with more conventional and rational locations like the clinic, the film creates the dialectic of science/deviance so dear to Freda. The mansion is where Hichcock indulges in sexual fantasies with his first wife, Margaretha, thanks to the complicity of a sinister-looking housekeeper who leads a double life, just like the employer to whom she gravitates: indeed she is a precious ally in his forbidden practices, and together they hide Margaretha's survival as Hichcock falls further into madness.

[Spolier alert: this paragraph gives away a major plot twist]
When Hichcock, encouraged by his housekeeper, decides to strip his new wife Cynthia of her beauty and her life and use her blood to feed the withered Margaretha, Freda gives rise to a major twist: while, initially, the protagonist tried to recreate the appearance of death in life, now he wants to recreate life from death. This final piece of doubling, which is also a nod to the plot of the earlier *I vampiri*, points to a fascinating motif which is mostly hidden beneath the film's surface and which constitutes the true thematic heart of the Italian gothic: that of the female body turned into a thing, transformed into an object to be remoulded by male delirium.

Here, as in the subsequent *Lo spettro/The Ghost*, 1963 (a sequel of sorts to *L'orribile segreto del dottor Hichcock*), Freda relies on the quintessential actress of the genre, Barbara Steele, who had already served as a fetish object for Bava. Steele's physical presence can also be said to embody the doubling at the heart of the film, her provocative figure contrasting with a nocturnal, possessed gaze that Freda summed up as 'her De Chirico eyes'.

Rocco Moccagatta

Inferno

Studio:
Produzioni Intersound

Director:
Dario Argento

Producer:
Claudio Argento

Screenwriter:
Dario Argento

Cinematographer:
Romano Albani

Art Director:
Giuseppe Bassan

Editor:
Franco Fraticelli

Duration:
107 minutes

Genre:
Gothic horror

Cast:
Leigh McCloskey
Irene Miracle
Eleonora Giorgi
Daria Nicolodi
Alida Valli

Year:
1980

Synopsis

Rose Elliot is a poet living in a bizarre New York apartment building. She comes across an ancient leather-bound volume detailing the legend of the Three Mothers. These supernatural entities, from houses in Rome, Freiburg and New York, disseminate evil and misery– first, throughout the surrounding area and, ultimately, the world. Rose becomes convinced that she is living in one of these benighted houses, and sends a letter to her brother Mark, who is studying music in Rome. She asks him to come to New York and help investigate the sinister mystery she has stumbled upon. But events soon take a horrifying turn: Sara, Mark's girlfriend, comes across a letter from Rose and shortly afterwards is bloodily dispatched. Mark ever-more frantically tries to communicate with his sister, and when he eventually arrives in New York, he finds that she has vanished. He speaks to her neighbour, the highly strung Countess Elise, but she only compounds his fears, and Mark is forced to make his way down the dark and threatening corridors of the building in which Rose has disappeared. What he finds is evil of a cosmic order.

Critique

Suspiria (1977) was touted as being the first part in a projected trilogy; the second segment, *Inferno*, had a limited cinema release in 1980 (virtually buried by the distributors – their lack of faith being very short-sighted in the light of *Suspiria*'s financial success). *Inferno* is certainly a falling off from its predecessor, despite the film's virtues. Regarding the much-delayed (and anti-climactic) third part of the trilogy, *La terza madre/Mother of Tears* (which appeared, belatedly, in 2007), it is perhaps kindest to draw a veil over this ill-judged conclusion to a sequence that started with such panache.

One of *Inferno*'s failings is its over-long running time of 107 minutes, with a typically slim story unfolding in a rather leisurely way, though a filmic representation of a dream state is mesmerically conjured by the director. The plot involves Irene Miracle as a young woman who discovers, via an occult book (shades of *Rosemary's Baby*, Roman Polanski, 1968), that the New York apartment house into which she has moved is one of three designed by an architect named Varelli for the sinister Three Mothers of Whispers, Tears and Darkness (here we have the tie-in with *Suspiria*); the breathtaking – and unique – sequence in a water-submerged room near the beginning, in which Mario Bava was involved, is unquestionably the best thing in the film; dream-like horror has never been captured so persuasively on celluloid. Miracle's subsequent death (savagely butchered along with a friend, Carlo) and its investigation by her brother Mark (Leigh McCloskey) comes across as a less tense reworking of *Suspiria*; nevertheless, as with any Argento film, some very satisfying felicities catch the eye – the bravura use of massive close-ups of door locks as a character is menacingly pursued, and

a grisly attack by rats in a park which has a marvellous twist at the end of the sequence. The score by Keith Emerson (instead of the customary Goblin) is very effectively used – like Hitchcock with the inestimable Bernard Herrmann, Argento knows the immense value of music in suspense situations – even the chorus from Verdi's *Nabucco* is employed with great effect in the film. Certainly, the already converted will find much to enjoy in the film, and a less-than-perfect Argento from this period is more impressive than the work of most of his peers. The director's utilization of a familiar trope – the cursed mansion – is given a fresh and innovative spin, linking the film to preoccupations of the gothic genre. But perhaps the film seemed more disappointing because of viewers' high expectations, although the last reel of the film unquestionably *is* a disappointment – an unsatisfactory, slightly risible death of one major villain, and a very conventional conflagration to round things off. Notwithstanding these qualifications, *Inferno* is still the intriguing product of a totally cinematic consciousness.

Barry Forshaw

Lust of the Vampire

I vampiri
Aka The Devil's Commandment

Studio:
Athena Cinematografica/Titanus

Director:
Riccardo Freda

Producers:
Ermanno Donati and Luigi Carpentieri

Screenwriters:
Riccardo Freda
Piero Regnoli and Rijk Sijstrom
(from a story by P Regnoli and R Sijstrom)

Cinematographer:
Mario Bava

Art Director:
Beni Montresor

Editor:
Roberto Cinquini

Synopsis

Paris, the early 1950s. The discovery of the bodies of several young women who have bled to death breeds fear and sensationalism, while the police are left groping in the dark and journalists run wild with the story. All leads seem to point to a sinister Gothic castle belonging to the Baroness Du Grand in the centre of Paris. The old noblewoman's young and beautiful niece, Marguerite, harbours a long-standing love for the handsome journalist Pierre, who is invited to the castle. Performing his own investigation into the disturbing disappearances, he discovers horrific parascientific experiments secretly going on in the castle.

Critique

I vampiri, the prototype of the Italian gothic (and fantasy) genre, precedes by a few years the great flowering of the genre that occurred above all thanks to Riccardo Freda, Mario Bava (who acts as director of photography on this film) and Antonio Margheriti. In it we can see the codification of the principal characteristics of the genre. Freda increases the prevalence of shadow that was common in 1950s melodrama and intensifies the excessive visuals permitted by the story. In this he is helped above all by the lighting by Mario Bava, who was also responsible for the creation of the film's striking ageing effects through the use of coloured filters.

While *I vampiri* anticipates some elements that the English Hammer films would soon after push in another direction, its true nature as a melodrama with isolated horror traits is evident in the centrality afforded to a female character: the Baroness Du Grand, who tries to escape from the natural process of ageing through a

Duration:
85 minutes

Genre:
Gothic horror

Cast:
Gianna Maria Canale
Carlo D'Angelo
Dario Michaelis
Wandisa Guida

Year:
1956

particular form of parascientific vampirism that requires the blood of young women. For the part (and for that of the rejuvenated figure of her presumed niece Marguerite), Freda chose Gianna Maria Canale, an actress of radiant beauty and his partner at the time, and the role serves as a macabre memento offered by the director to his muse.

The director's typical themes, including the futility of beauty and strength and the conflict between scientific rationality and wayward sensuality, find a coherent visual translation in the baroque and decadent *mise-en-scène*, well exemplified by the castle in which much of the film is set. Thanks to the work of art director Beni Montresor, the castle's suffocating, excessive decor, with its interiors shrouded by curtains, is a space with a double significance: a putrid organism that reflects the truth about its owner.

Lust of the Vampire/I vampiri, America/Athena/Titanus.

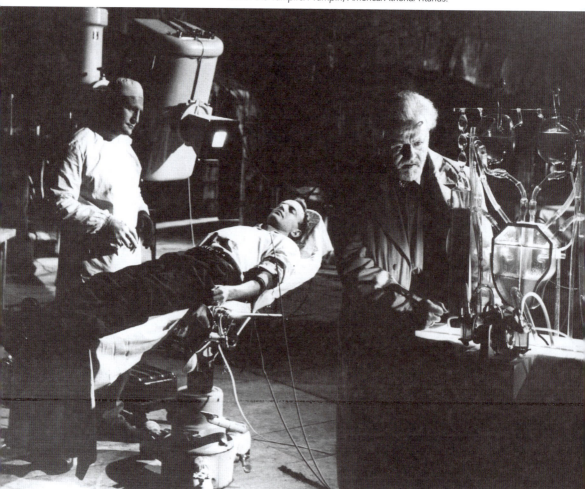

Just before dying, an incautious admirer of Marguerite who has crept into the castle explains the dark fascination of her beauty and, in so doing, points towards the film's central theme of faces: 'Let me see her, it is enough to see her face.' Indeed, Freda concentrates his directorial attention on this theme, his visionary style benefiting from Bava's beautiful black-and-white photography. The producers, however, felt the need to correct his vision through the addition of a framing device which offers a reassuring narrative of detection, believing the main story to be too subversive.

I vampiri can also ultimately be seen as a caesura in the career of its director. Up until the mid-1950s, Freda was the quintessential director of Italian action films and Hollywood-style adventures, with numerous literary adaptations and costume dramas to his name. Openly challenging the prevalence of neorealism, he was the only person to believe in the possibility of making such cinema in Italy. However, with *I vampiri* Freda started to be associated with the minor and popular genres of the Italian B-movie, which were unstable productions made with shoestring budgets and marginalized from the main circuits of Italian cinema.

In fact the film came about because of what was practically a bet: Freda's desire to prove to the producers Donati and Carpentieri that he could direct a film in ten days. The decision to make a horror film was taken in part because it could be made on a limited budget, restricting the shoot to the claustrophobic interiors of a villa in the Roman hills and passing off the few exterior scenes as Paris thanks to Bava's typically ingenious optical effects.

Rocco Moccagatta

Mill of the Stone Women

Il mulino delle donne di pietra
Aka Drops of Blood

Studio/Distributors:
Wanguard Film
Faro Film
Explorer Film '58
CEC – Comptoir d'Expansion Cinématographique

Director:
Giorgio Ferroni

Producer:
Giorgio Venturini

Synopsis

A journalist, Hans von Arnim, is sent to write an article on the centenary of 'the mill of the stone women' – a windmill that has been converted into a carousel showcasing replicas of the deaths of famous women. He is seduced by the mill-owner's daughter, Elfie Wahl, who suffers from a rare disease which means that the slightest shock or emotional disturbance could prove fatal. When Hans rejects Elfie in favour of his childhood friend Liselotte Kornheim, the shock kills her. Wracked by guilt Hans confesses all to Elfie's father, Professor Gregorius Wahl, only to be told that Elfie is alive and well and that the whole thing was a hallucination. However, Hans soon comes to doubt this version of events and to suspect that the Professor and Elfie's doctor, Loren Bohlem, harbour a dark secret and that the mill is not all it appears to be.

Critique

[Spoiler warning: this review gives away a major plot twist] The first half of *Il mulino delle donne di pietra* plays more like a conventional melodrama than a horror film, focusing on Hans' romantic

Screenwriters:
Remigio del Grosso
Giorgio Ferroni
Ugo Liberatore
Giorgio Stegani, based on the story of the same name in 'Flemmish Tales' by Pieter Van Veigen (The Dutch author Pieter Van Veigen is actually an invention of the film-makers)

Cinematographer:
Pier Ludovico Pavoni

Art Director:
Arrigo Equini

Editor:
Antonietta Zita

Duration:
95 minutes

Genre:
Gothic horror

Cast:
Pierre Brice
Scilla Gabel
Wolfgang Preiss
Dany Carrell
Herbert Boehme

Year:
1960

entanglements, the consequences of an act of sexual transgression and the suffering of a young woman who strays from the path of sexual purity. It is with the apparent death of Elfie that the film shifts gear, moving into an extended sequence of nightmarish hallucinations seemingly brought on by Hans' sense of guilt. The revelation that he was drugged and that Elfie is really dead, and has been repeatedly re-animated by Dr Bohlem using the blood of local women, should come as no surprise to viewers who have seen Riccardo Freda's *I vampiri/Lust of the Vampire* (1957) or, indeed, any of the many Italian gothic horrors it inspired. Here, too, we have a man obsessed with keeping a woman alive and at the height of her youth and beauty. What distinguishes the film from its counterparts is the way in which Professor Wahl disposes of his victims' bodies, mummifying them and displaying them on his macabre carousel. One obviously needs to overlook the absurd lapse in logic underpinning this idea; would a murderer really choose to make a public spectacle of the evidence of his crime rather than disposing of the bodies? Would nobody recognize the missing local girls in the figures on the carousel? If one can accept these incongruities as poetic licence, the film's central conceit then becomes a highly suggestive one. Certainly the spectacle of a carousel of hanged, beheaded and immolated women is extraordinarily grotesque and the fact that it only displays female victims raises questions about the misogyny underpinning both Wahl's efforts to preserve his daughter and his public's desire to see such a spectacle. On this level the film assumes a certain degree of self-reflexivity, holding a mirror up to the horror-film audience's own fascination with (female) death and suffering. With hindsight, it is hard not to see this aspect of the film as a prototype for the *gialli* which would supplant the Italian gothic horror a decade later. Indeed, the carousel with its jaunty musical theme anticipates the preserved corpses in the freezer of Mario Bava's equally self-reflexive (and considerably more parodic) *5 bambole per la luna d'agosto/Five Dolls for an August Moon* (1970), while the mummified female figures that litter Wahl's workshop prefigure Bava's own obsession with mannequins, as evidenced by films like the proto-*giallo Sei donne per l'assassino/Blood and Black Lace* (1964).

Il mulino delle donne di pietra was the first horror film by veteran director Giorgio Ferroni, who had directed nearly 30 films in a variety of genres including the neorealist *Tombolo, paradiso nero/Tombolo, Black Paradise* (1947). He was to make only one more foray into the genre with the less effective *La notte dei diavoli/Night of the Devils* (1972). His first effort in the genre, however, is an inventive and visually distinguished work which, despite being shot predominantly on a Roman sound stage, capitalizes well on its Dutch setting. The use of the mill is particularly effective and makes a welcome change from the English castles of so many other Italian gothic horrors. The film was the most successful at the domestic box-office of the several gothic horror films released in 1960, even trumping Mario Bava's more famous international hit *La maschera del demonio/Black Sunday*.

Alex Marlow-Mann

Nightmare Castle

Amanti d'oltretomba
Aka Night of the Doomed

Studio/Distributor:
La cinematografia EmmeCi

Director:
Allan Grünewald (Mario Caiano)

Producer:
Carlo Caiano

Screenwriters:
Mario Caiano
Fabio De Agostini

Cinematographer:
Enzo Barboni

Art Director:
Mario Giorsi

Editor:
Renato Cinquini

Duration:
99 minutes

Genre:
Gothic horror

Cast:
Barbara Steele
Paul Muller
Helga Liné
Laurence Clift
John McDouglas (Giuseppe Addobbati), Rik Battaglia

Year:
1965

Synopsis

Dr Stephen Arrowsmith, a scientist experimenting with rejuvenation by electrolysing blood, discovers that his wife Muriel is having an affair with their gardener. He tortures and kills them both and uses her blood to rejuvenate their housekeeper Solange, who becomes his mistress. On learning that Muriel altered her will in favour of her neurotic identical half-sister Jenny, he conspires to marry her, then have her institutionalized in order to gain possession of Muriel's mansion and riches. However, Jenny soon becomes possessed by Muriel's spirit and, when Stephen summons Jenny's doctor, Dereck Joyce, the fateful romantic triangle seems set to repeat itself.

Critique

Amanti d'oltretomba was the seventh of the gothic horror films Barbara Steele made in Italy and the script recycles many of the elements present in her earlier works. Once again Steele plays dual roles; as in *La maschera del demonio/Black Sunday* (Mario Bava, 1960) and *I lunghi capelli della morte/The Long Hair of Death* (1964), these two roles are structured to emphasize two sides of femininity, with the blonde-haired Jenny depicted as innocent, romantic and excessively emotional and the dark-haired Muriel as manipulative, seductive and vengeful. The characterization of Jenny, who had already been institutionalized prior to meeting Stephen and who is so open to suggestion that he renounces the need for hallucinogens in his plan to send her mad, is particularly notable for the emphasis placed on the notion of female neurosis, given that the gothic is often conceived of as a female genre which revolves around the supposed emotionalism and irrationality of the feminine. In *Amanti d'oltretomba* both of the male characters are scientists and thus representative of the rational order. It is feminine passion, in the form of Muriel's infidelity, which upsets this order, while Jenny's neurosis provides the conduit to the supernatural which ultimately moves the film into the realm of the fantastic. When Muriel finally returns as a ghost to exact her revenge, her half-decayed face provides one of the most effective and explicit representations of the duality on which both the gothic and the Steele persona depended.

That said, it is worth recalling that Stephen is also depicted as a 'mad doctor', whose corruption of science constitutes the most explicit embodiment of evil in the film. His attempts to rejuvenate Solange through blood explicitly recall both *I vampiri/Lust of the Vampire* (Riccardo Freda, 1957) and *L'orribile segreto del Dr. Hichcock/The Horrible Dr. Hichcock* (Freda, 1962) as well as influential European horrors like *Les Yeux sanx visage/Eyes without a Face* (Georges Franju, 1959) and *Gritos en la noche/The Awful Dr. Orloff* (Jess Franco, 1962). The character of Stephen also allows Caiano to push the sado-eroticism of Bava's *La maschera del demonio/Black Sunday* (1960) and *La frustra e il corpo/The Whip and the Body* (Mario Bava, 1963) still further in the extraordinarily brutal scene

of the torture and murder of Muriel and her lover. When Stephen ultimately concedes to Muriel's ghost that he 'punished her for her crime' she retorts, 'No. You gave me extreme pleasure. You taught me the pleasures of the torment of the flesh.'

Mario Caiano is primarily known as a director of *pepla*, spaghetti westerns and *polizieschi* (cop films) and *Amanti d'oltretomba* constitutes a rare departure into the horror genre. Although the script is, like so many of the Barbara Steele vehicles, highly derivative of Bava and Freda's first horrors, the film is not without interest in its own right and several scenes anticipate later, better-known horror films. The sado-masochistic declaration of Muriel's vengeful ghost, a surprisingly bold conceit for 1965, undoubtedly looks forward both to the sexualized violence of the *giallo* and to the sadomasochistic demons of Clive Barker's *Hellraiser* (1987). Similarly, the scene in which Muriel advances on Stephen demanding a kiss, only to draw back the long dark hair that has been concealing her face to reveal partial decomposition, cannot fail to anticipate both the female ghosts of J-Horror and Jack Torrence's nightmare in room 237 in *The Shining* (Stanley Kubrick, 1980).

Alex Marlow-Mann

The Other Side

L'aldilà – e tu vivrai nel terrore

Director:
Lucio Fulci

Producer:
Fabrizio De Angelis

Screenwriter:
Dardano Sacchetti

Cinematographer:
Sergio Salvati

Production Design:
Massimo Lentini

Editor:
Vincenzo Tomassi

Duration:
87 minutes

Genre:
Gothic horror

Synopsis

1927: the Louisiana swamps. An artist named Schweick painting a barren, body-strewn landscape is attacked by a mob that arrives silently by torch-lit boat. The mob believes Schweick to be a warlock and he is tortured, crucified and covered in quicklime. Decades later, a New Yorker named Liza inherits the building, now a hotel, in which Schweick was murdered, and which she plans to re-open. Her renovations, however, only succeed in re-opening the gateway to Hell (one of seven) which the artist's murder originally invoked. This triggers a horrific chain of events, leading to the grisly deaths of several locals. Liza encounters a blind girl and her alsation, and the girl warns her of imminent horror, urging her to leave. Despite these warnings Liza persists, seeking answers in a tome called the Eibon, but she also begins to experience frightening visions. The deaths continue and the portal to Hell is now flooding the locality with the undead. Liza, with the help of a doctor from the hospital, tries to defend herself. However, even when they flee the hospital, they bafflingly find themselves back in the depths of the hotel. Soon after they become adrift in that body-strewn landscape, first sighted in Schweik's painting.

Critique

L'aldilà: e tu vivrai nel terrore is director Lucio Fulci's attempt to translate the dramaturgical theology of Antonin Artaud into cinematic language.

Cast:
Catriona MacColl
David Warbeck
Cinzia Monreale

Year:
1981

Artaud was the leading proponent of that sub-division of the Surrealist movement – The Theatre of Cruelty. This theatrical strand was based around the conceptual belief that the audience should be shocked into action through violent imagery, language and innovative dramatic structure. He intended to invent a new kind of dramatic language which lingered somewhere in the open ground between thought and gesture.

To this end, in both Fulci's filmic versions and the work of Artaud, the dramatic narrative places much less emphasis on diegetic coherence or linearity; instead, it focuses on the intrinsic powers of melding image and sound in an almost expressionistic fashion. Violent events occur within these narratives, at the deliberate expense of all physical logic, often unexpectedly and with no ethical, dramaturgical or diegetic justification. When the violent events occur they do so in a swirl of colour, explicit gore and overwhelming sound design comprised of disorientating or deliberately dissonant music and fx.

Audiences thus find it more difficult to follow the story (indeed, if there is one at all) and often complain that they do not understand what the films is about or what the film-maker is trying to do.

In this film, however, having apparently had as a starting point a rough idea of a haunted house where he could explore metaphysical ideas of the afterlife bleeding into the present, Fulci felt the strong arm of financial clout on his shoulder. At the time, zombie movies were still very much *en vogue* and retained great popularity with the European cinema-going audience. The films delivered strong returns to the distributors who pushed the films to an increasingly loyal and demanding public. As a result, the German distributors of the film – Fulci's key financiers – demanded that Fulci rewrite the film to include, in basic terms, more zombies and clear-cut action, preferably involving shoot-outs.

Consequently what is already a fairly loosely-structured film became even more fractured in personality and full of non-sequiturs and bizarre diegetic divergence. However, in a curious way, this rather crude revisionism of the original idea paradoxically lends the film a more suitable tone and form, given Fulci's original content. The flights into the oneiric, the almost stubborn refusal to accept general conventions of reality and the sheer absence of logic rub against each other to spark something quite original, roughshod though it is.

In 1998 the film was notably re-released into selected theatres in the US by Quentin Tarantino's short-lived cult film distribution company Rolling Thunder (after the 1977 John Flynn film). Tarantino has been well known to cite Fulci as a great source of inspiration in both cinematic spirit and technique; there is certainly a common sense of the mischievous anarchic to be found in both directors' works.

Matthew Pink

Suspiria

Studio:
Seda Spettacoli

Director:
Dario Argento

Producer:
Claudio Argento

Screenwriters:
Dario Argento
Daria Nicolodi

Cinematographer:
Luciano Tovoli

Art Director:
Giuseppe Bassan

Editor:
Franco Fraticelli

Duration:
100 minutes

Genre:
Gothic horror

Cast:
Jessica Harper
Joan Bennett
Alida Valli
Udo Kier

Year:
1977

Synopsis

Young dance student Suzy Banyon, aspiring to a career in ballet, travels from the US to the prestigious Freiburg Dance Academy in Germany. Her arrival at the airport is met by a titanic storm, and she finds the Academy to be a grotesque, minatory place, with its baroque architecture and mysterious corridors. Suzy's first encounter at the Academy is a terrifying one: as the storm lashes, she witnesses, dashing into the woods, a young girl who is shortly to be subjected to gruesome mutilation and murder. Suzy finds that her fellow students are a gossipy and unpleasant group, with one exception, Sara, who is not popular with her superficial fellow dancers. The fact that Suzy befriends her is an indication of the former's good nature. The Academy's administrators are, in their different ways, off-putting: the outwardly pleasant, insincere Madame Blanc and the ferocious, forbidding Miss Tanner. Shortly afterwards, Sara vanishes – and Suzy discovers to her horror that the Academy is actually a hotbed of witches, devoted to the service of an evil sorceress, Helena Markos. The stage is set for a horrifying confrontation in the witch's lair.

Critique

The actress Alida Valli's career included important American roles in Alfred Hitchcock's *The Paradine Case* (1947) and, of course, Carol Reed's *The Third Man* (1949). For the cinema of the macabre, Valli also made important contributions to Georges Franju's *Les Yeux sans visage/Eyes Without a Face* (1959). And she was used totemically (with her illustrious past firmly in mind) by Dario Argento in his *chef d'oeuvre*, *Suspiria* (1977), the film that firmly established the director's name in the UK. The success of the film was due to two principal factors: unlike his earlier films (and *Suspiria*'s successor, *Inferno*, 1980), the film received strong London West End exposure, and gleaned unanimity of critical acclaim, along with unprecedented word-of-mouth for a film of this nature. *Suspiria* was unlike anything audiences had seen before – a visually delirious *tour de force* scored with a thumping wall-to-wall score by Claudio Simonetti's group Goblin (which combined the sustained menace of more conventional symphonic scoring with atmospheric rock rhythms). The plot (minimal, to say the least) has Jessica Harper (of *Phantom of the Paradise*, Brian De Palma, 1974) as a new student in the sinister and opulent Freiberg Academy in Germany; students and staff are decimated in spectacular fashion (the opening sequence, in which Argento makes the heroine's arrival look like a magical passage into some Dante-esque nether world, is followed by the most stunning double murder ever filmed, climaxing in a blood-spattered corpse crashing through a coloured-glass roof); in fact, this memorably gruesome, calling-card sequence being placed at the beginning of the film rather than functioning as its climax, is perhaps a nod to Argento's much-admired inspiration Hitchcock, who placed the most violent sequence near the

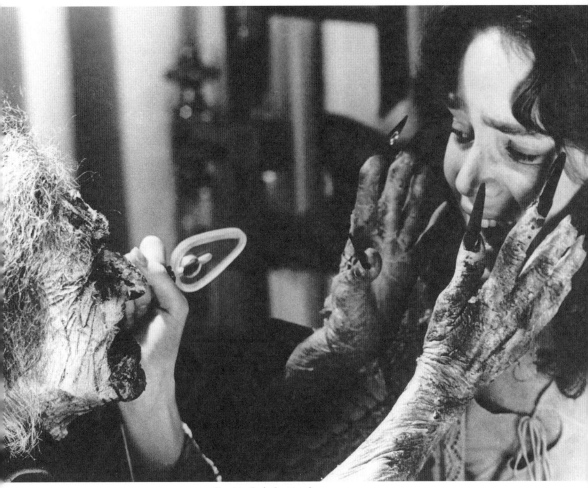

Suspiria, Seda Spettacoli.

beginning of his masterpiece *Psycho* (1960), subsequently diminishing the violence in the later set-pieces.

After much investigation of deeply-Freudian corridors lit in primary colours, Harper's confrontation with the hideous, ancient witch Helena Markos – the diabolic force behind the Academy – satisfyingly rounds off a film brimming with visual brio; the latter aspect was finessed by the fact that Argento and his director of photography, Luciano Tovoli, dusted off the virtually moribund three-strip version of Technicolor to create a peculiarly saturated colour pallet whose qualities emphasizes the fable-like qualities of the narrative. In fact, this motif – the anti-realist, fable-like ethos of the film – is hardly surprising in a work that has (according to the director) the fairy tale *Snow White* as its *locus classicus:* Argento originally toyed with the notion of casting the film with children.

Barry Forshaw

PEPLUM

Depending on the criteria applied, the *peplum*, or sword and sandal film, is either one of the hardest genres to define or one of the easiest. The word 'peplum' was first applied to the genre by French critics and refers to a short garment often worn in these films. Some scholars argue that any film set during the classical era qualifies as a *peplum*, with or without a muscular hero bearing mythological or pseudo-mythological associations. Others limit the genre to the time period under discussion here yet maintain that swashbucklers or pirate films also belong in the *peplum* category. In both instances, I would suggest this offers a genre categorization too broad and vague to be of practical use in the furtherance of film studies. For the purposes of this chapter, I will characterize the *peplum* as the cycle of mythological/classical action films made in Italy from the late 1950s to the mid-1960s, centring on a muscular hero and his extraordinary exploits in an ancient historical or pre-historical setting. Beginning with *Le fatiche di Ercole/Hercules* (Pietro Francisci, 1958), starring former 'Mr Universe' Steve Reeves, the films invariably focused on the exposed physiques of their leading men, often bodybuilders with little or no prior acting experience. Deploying his considerable muscles in the service of a worthy cause – usually liberating an oppressed people from tyrant rulers or supernatural menaces – the *peplum* hero embodied, quite literally, unconditional virtue and valour as expressed through action.

The origins of the *peplum* can be traced back at least as far as the Italian-made epics of the silent era. The Christians vs Romans saga *Quo Vadis?* (Enrico Guazzoni, 1912) features Ursus, the heroine's bull-wrestling protector, while *Cabiria* (Giovanni Pastrone, 1914) introduced the figure of Maciste, the Roman hero's giant-sized sidekick, whose popularity led to a long series of spin-off films that lasted into the mid-1920s. Post World War II, the revival of Hollywood film production in Italy, largely for financial reasons, prompted a new cycle of classical epics, beginning with a 1951 remake of *Quo Vadis?* (Mervin LeRoy). A number of these films were Italian co-productions, notably *Ulisse/Ulysses* (Mario Camerini, 1954), starring Kirk Douglas, a proto-*peplum* chronicling the Greek hero's many struggles as he returns home after the Trojan War.

Critically dismissed or ignored for the most part, the *peplum* proved enormously successful both in Italy and elsewhere, finding appreciative audiences all over Europe, the Far East, South America, Africa, and Australia. According to contemporary reports, in 1960 the most popular film on general release in the UK was *Ercole e la regina di Lidia/Hercules Unchained* (Pietro Francisci, 1959), an achievement reported with some horror in both specialist film publications and the mainstream press. Most crucially, the *peplum* broke the North American market, with distributors rushing to buy new titles after *Le fatiche di Ercole* and *Ercole e la regina di Lidia* were box-office hits. While the *peplum* proved a short-lived genre, its success enabled dubbed Italian imports to gain a lucrative foothold in the international film market that would last for nearly fifteen years.

After its demise in the 1960s, the *peplum* was superseded and overshadowed by other forms of popular Italian genre cinema: gothic horror, the western, the *giallo*. This commercial eclipse was

Left: *The Last Days of Pompeii/Gli ultimi giorni di Pompei*, Procusa/Transocean.

reflected in the relative dearth of critical and fan appreciation of the *peplum*, quickly relegated to the realm of 'camp' or 'kitsch' and providing fodder for humorous references in *The Rocky Horror Picture Show* (Jim Sharman, 1975) and *Airplane!* (Jim Abrahams, David Zucker, Jerry Zucker, 1980). Furthermore, the *peplum* lacked auteur figures to match horror maestro Mario Bava, western pioneers Sergio Leone and Sergio Corbucci or *giallo* king Dario Argento. At best, the genre served as a useful training ground for the likes of Bava, Leone and Corbucci – who all worked on a number of *pepla* in various capacities – but was of little interest in and of itself.

It should be noted the *peplum* did find some critical champions during its lifetime. The French publication *Cahiers du Cinéma* devoted several articles to the genre, praising in particular *Ercole alla conquista di Atlantide/Hercules Conquers Atlantis* (1961) and suggesting its director Vittorio Cottafavi merited auteur status. While some British and Italian critics followed this lead, Cottafavi did not achieve lasting cult status outside France and Italy and his international reputation rests largely on this one film, his other work, *peplum* or non-*peplum*, still neglected. An unrelated sequel, *Ercole al centro della terra/Hercules in the Centre of the Earth* (1961) is arguably now better known, due largely to the contributions of director Mario Bava and co-star Christopher Lee and a liberal use of gothic horror elements.

In terms of academic study, since the 1980s scholars such as Richard Dyer have led the way in re-evaluating the *peplum* films as significant cinematic texts which reveal much about the era of their production and reception. A number of key themes were identified: the valorization of the strong (white) male body in ever more industrialized and technopolitan societies; the latent homoeroticism of the proudly-displayed, muscular male physique; the fascist undercurrents of these strong bodies in a country recently ruled by the Mussolini dictatorship, which many felt celebrated the same qualities; the marginalization, domestication or demonization of femininity at a time when more women were coming into the workplace and achieving new economic and social independence. While these elements can suggest a largely reactionary cinematic form, many *pepla* resist such a straightforward reading, due largely to the inherent tensions and contradictions associated with the powerful, displayed male body and what it is (mis)taken to represent.

The success of *Le fatiche di Ercole* prompted the production of scores of *pepla* and the films discussed in this chapter represent only a small fraction of the total output. As with other popular genres, many *pepla* were made quickly and cheaply by small companies with an eye to short-term profits from minimal outlay. Among these production-line efforts, however, are a number of titles that bear more considered analysis, not least the film that launched the genre.

Daniel O'Brien

The Colossus of Rhodes

Il colosso di Rodi

Studio:
Cineproduzioni Associate
Procusa Film
Comptoir Français du Film

Director:
Sergio Leone

Producer:
Michele Scaglione

Screenwriters:
Luciano Chitarrini
Ennio De Concini
Carlo Gualtieri
Sergio Leone
Luciano Martino
Aggeo Savioli
Cesare Seccia
Duccio Tessari

Cinematographer:
Antonio López Ballesteros

Art Director:
Ramiro Gómez

Editor:
Eraldo da Roma

Duration:
127 minutes

Genre:
Peplum

Cast:
Rory Calhoun
Lea Massari
Georges Marchal

Year:
1961

Synopsis

Athenian war hero Dario seeks relaxation on the island of Rhodes, home of the imposing Colossus that guards the harbour. Thar, the King's counsellor, is plotting with the Phoenicians to take control of the island. Simultaneously, there is much unrest resulting from the tyrannical construction of the statue. Dario pursues Diala, unaware that she is in league with Thar. A group of rebels hopes that Dario can persuade Athens to help save the island but they and he are captured, before being freed by other rebels. Dario also pursues Mirte, sister of the rebel leaders who plan to penetrate the Colossus and free political prisoners held within it. Thinking their plan is suicidal, Dario goes to Diala for aid and tells her where the rebels are hidden. She has him arrested, and the rebels are re-imprisoned. Dario redeems himself by aiding the rebels in the arena and trying to release the prisoners from the Colossus. He is captured, Diala defers his execution, the Phoenician armada arrives to carry out Thar's plan, and an earthquake erupts, along with a rebellion. Diala frees Dario only to become killed by the quake. Thar escapes the Colossus and is killed by a rebel. When the quake subsides, Dario and Mirte reunite and stay on Rhodes.

Critique

Il colosso di Rodi is Sergio Leone's first film as credited director and shows marked improvement over his uncredited *Gli ultimi giorni di Pompei/The Last Days of Pompeii* (1959). It has a stronger script and a more interesting plot. It is well acted and well shot, the sets are impressive, and the catastrophic climax is more intricate and better paced than that of *Gli ultimi giorni di Pompei* – especially in the Italian remastered DVD version. Numerous horseback moments and an elevated level of torture and violence presage Leone's spaghetti westerns.

Inspired by the enormous statue built on Rhodes between 292 and 280 BC, then destroyed by an earthquake 56 years later, Leone's film is a pseudo-historical rather than pseudo-mythological *peplum*. The most obvious theme of the film – the inflated egoism of humanity (the Colossus) in contrast with its fundamental insignificance (the swiftness with which nature can level a civilization) – is handled competently, and lends itself to part of the parody that dominates the film. Leone borrowed from Alfred Hitchcock's *North By Northwest* (1959) for his representation of a kind of monumentalism – the Colossus recalls Hitchcock's Mount Rushmore – that miniaturizes all humans. The Colossus' size and placement in a harbour evoke the Statue of Liberty, reprising it as a symbol of tyranny that, instead of 'welcoming the huddled masses', pours boiling liquid upon them. The monumentalism also evokes Fascism and is thus generalized to embrace a host of authoritarian governments, from ancient to contemporary, that end up dwarfed by the march of time, the power of nature, and/or the destructive forces they themselves unleash.

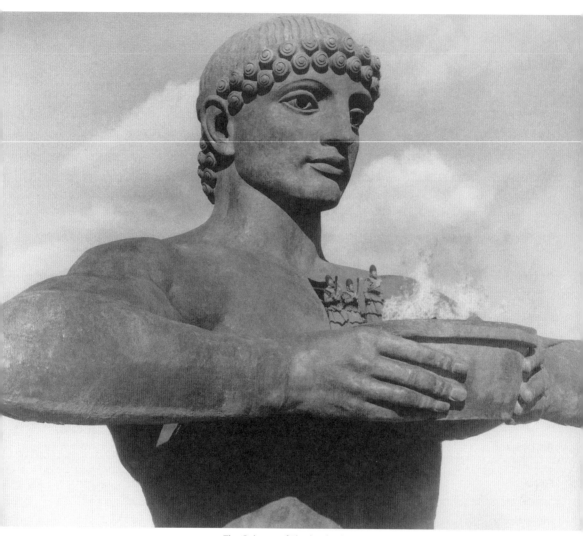

The Colossus of Rhodes/Il colosso di Rodi, Cinepruduzioni Associate.

The film's 'size matters' parody is accompanied by a satiric view of the (American) hero, again with a nod to *North By Northwest*. Leone has linked Dario to Hitchcock's Roger O Thornhill, describing both as spoiled children involved in circumstances they cannot fathom. The parody of Dario begins with costuming: not so much standard *peplum* garb as a mixture of *peplum* and women's summer fashions. More metrosexual than muscleman, he gets trapped in a labyrinth by Diala and knocked out with one punch by Peliocles. He spends most of the rebellion locked up in the Colossus and has to be spared and untied by Diala. His heroism comes and goes with comic unpredictability. The American focus of Leone's parody is implicit in Rory Calhoun's nationality – as well as in Dario's role, like that of Hercules, as a hero from

outside, (supposedly) cleaning up other people's messes. His initial unwillingness to get involved reflects American isolationism. He is shallow and naive, extroverted, friendly, and swashbuckling – a compendium of clichés identifiable as 'American', particularly from a European perspective.

Less parodic than cynical is Leone's take on the revolutionary *peplum* of which *Il colosso di Rodi* might be considered a part. As in *Gli ultimi giorni di Pompei*, political or social change takes place only because of a natural catastrophe and, in this case, the rebels' earnest and principled activities (like all else) seem largely trivial in the face of forces beyond human control.

Ably played by Lea Massari (the enigmatic Anna of Michelangelo Antonioni's *L'avventura*, 1959), Diala is an even more complex female protagonist than Giulia of *Gli ultimi giorni di Pompei*, concealing and expressing a wide range of conflicting motives and emotions, and the characteristic *peplum* opposition of 'good' versus 'evil' woman is complicated by the fact that her antithesis, the angelic Mirte, uses her sexuality with great ease to get men (including Dario) to do what she wants.

Rory Calhoun's 'tired nonchalance' (Leone's words) inspired the Clint Eastwood persona of the dollars trilogy, an intense exploration of (anti)heroism that clearly had its roots in *Il colosso di Rodi*.

Frank Burke

Duel of the Titans

Romolo e Remo

Director:
Sergio Corbucci

Producer:
Alessandro Jacovoni

Screenwriters:
Sergio Corbucci
Luciano Martino
Giorgio Prosperi
Franco Rossetti
Ennio De Concini
Duccio Tessari

Original story:
Sergio Corbucci
Luciano Martino
Sergio Leone

Synopsis

Romulus and Remus are the twin sons of Rhea Silvia and the god Mars, nurtured by a she-wolf and raised by the shepherd Faustolo. In defiance of the tyrant king Amulius, they take advantage of a pagan celebration to steal horses from his stable. Romulus is captivated by Julia, daughter of Sabine king Tatius, and abducts her during the raid. Though resentful of Romulus' presumption, Julia clearly reciprocates his romantic interest. Captured, tortured and forced to fight in the arena, Romulus is rescued by Remus, who seeks to overthrow Amulius and claim a kingdom for himself. Having defeated Amulius, the brothers lead an exodus to find a new home in a valley surrounded by seven hills, pursued by the army of Tatius. En route, they quarrel and divide their followers into two camps. Remus' group are caught in a volcanic eruption, while Romulus and his people face Tatius' forces in battle and emerge triumphant. With Julia's urging, Romulus spares Tatius' life and forges an alliance with the king. Remus returns to challenge Romulus to single combat. Romulus is the victor and the city of Rome is founded.

Critique

Five years before *Django* (1966), one of the most influential Italian westerns, Sergio Corbucci established himself as a leading

Cinematography:
Enzo Barboni
Dario Di Palma

Art Director:
Saverio D'Eugenio

Editor:
Gabriele Varriale

Music:
Piero Piccioni

Duration:
107 minutes

Genre:
Peplum

Cast:
Steve Reeves
Gordon Scott
Jacques Sernas
Massimo Girotti

Year:
1961

director of *pepla* with *Romolo e Remo* and *Il figlio di Spartacus/ Son of Spartacus* (1962), both starring sword-and-sandal icon Steve Reeves. In a genre prone to bland production-line assemblage, Corbucci's *pepla* stand out in terms of narrative development, pacing, characterization, technical finesse, visual imagination and thematic interest. *Romolo e Remo* was also the first – and arguably only – major *peplum* to feature a second muscle-bound star, in this instance former Tarzan Gordon Scott.

Romolo e Remo is unusual among the *pepla* for its emphasis on male vulnerability as opposed to invincible strength. While Reeves' Hercules is a fully-formed hero of established status, Romulus and Remus are first seen as helpless infants, dependent on maternal protection, whether human or lupine. The brothers are also associated with powerlessness – being trapped, captured and tortured; Romulus is tied to a wheel and whipped, while Remus barely survives the erupting volcano. Only one of the brothers will evolve into a heroic figure exhibiting great strength of both body and character.

Duel of the Titans/Romolo e Remo, Paramount.

Romulus' relationship with Sabine princess Julia has an equality rarely found in the *peplum*. She saves him from summary execution when his physical strength and combat prowess prove inadequate against superior numbers. On a visual level, his dark hair and light tunic are complemented by her blonde hair and dark costumes. It is notable that the famous Reeves torso is exposed over just three sequences and, furthermore, displayed voluntarily for Julia's eyes only. Depicted as an independent woman, Julia perhaps reflects the changing social and economic climate in Italy and elsewhere at the time of the film's production. Whereas other *pepla* often mark powerful, self-sufficient women as both hostile and 'unnatural' – such as the Amazons in *Le fatiche di Ercole/Hercules* (Pietro Francisci, 1958) – Julia is represented as an ally rather than an enemy.

The casting of Scott plays with viewer expectations: the former Lord of the Jungle transformed from hero to fallen idol, if not outright villain. While Remus is established as a noble, if authoritarian leader of the oppressed, he addresses directly the fascist subtext often associated with the *peplum*. Learning of his semi-divine origins, Remus expresses his now-dismissive attitude to ordinary men: 'Something different flows in my veins; something superior to the others.' Former allies and friends are now just 'spineless shepherds' as meek and powerless as their sheep. The gradual and inevitable distancing of the brothers – on moral, ideological and political levels – is underlined in the associated framing, composition, and costuming of the actors. The climactic struggle between Remus and Romulus is arguably that between totalitarianism and democracy. Having defied both men and gods, Remus pays the price: Roman mythology's most famous – and justifiable – act of fratricide.

Daniel O'Brien

The Giant of Marathon

La battaglia di Maratona

Directors:
Jacques Tourneur
Bruno Vailati
Mario Bava (uncredited)

Producer:
Bruno Vailati

Screenwriters:
Ennio De Concini
Augusto Frassinetti
Bruno Vailati

Synopsis

490AD: Persian tyrant Darius plots to conquer the Greek city state of Athens aided by a group of traitors under the leadership of Theocritus, a powerful and ruthless politician. Resistance is led by Philippides, champion athlete and captain of the Sacred Guard. Having fallen in love with Andromeda, daughter of Theocritus' ally Creuso, Philippides must put aside his emotions in favour of his civic duty. Aware that Athens' soldiers are heavily outnumbered, he calls on rival city state Sparta to join the defence of Greece. With Darius' army and navy poised to strike, time is running out for the Athenians.

Critique

La battaglia di Maratona displays key *peplum* characteristics in concentrated form, while also subverting a number of the genre's conventions. The film draws a direct parallel between athletic competition, in this instance the Olympic Games, and warfare, which

Cinematographer:
Mario Bava

Art Director:
Marcello de Prato

Editor:
Mario Serandrei

Music:
Roberto Nicolosi

Duration:
87 minutes

Genre:
Peplum

Cast:
Steve Reeves
Mylène Demongeot
Daniella Rocca
Sergio Fantoni

Year:
1959

calls for the same physical and mental skills and stamina. The various sports in which Philippides excels – wrestling, javelin, swimming, running – are shown to be essential preparation and training for the battle campaign that follows. The simple white loincloths worn by Philippides and his fellow athletes and Sacred Guards become a 'uniform' of both contest and combat. The Persians, by contrast, depend heavily on technology, whether body armour or catapults, and clearly lack the Athenians' strength of body and mind.

In political terms, the film places the democracy of Athens and the dictatorship embodied by Darius in direct opposition. Philippides declares: 'If there's war, then every citizen, every citizen will be a soldier.' The repeated stress on citizenry underlines the responsibilities – military and otherwise – that come with the privileges of belonging to Athenian society. He also admits that Athens alone cannot defeat the Persian aggressors, looking to Sparta for aid. The various Greek city states are likened to components of a single body; united they have a strength in which each plays a vital part. It is relatively unusual for a *peplum* hero to both require assistance and acknowledge his dependence on others, especially in terms of physical strength and fighting prowess. Furthermore, Philippides' individual power or potency is clearly finite. His exertions during an epic and hazardous journey from Marathon to Athens see him stumbling, injured and exhausted. The climactic military triumph is dependent on the group, not the individual.

Far from being a demigod or royalty, Philippides is depicted as an honest peasant – associated with the plough and oxen – whose athletic supremacy and consequent social progress is purely through merit. On another level, Philippides is more sexually forward than some of Steve Reeves' other *peplum* heroes, making explicit his immediate romantic interest in Andromeda. This open display of heterosexual desire is countered by both narrative complication – Philippides wrongly believing Andromeda to be a traitor – and the consistent visual emphasis on the exposed male body. A low angle shot of Philippides flanked by two large nude male statues encapsulates in a single image the latent homoeroticism associated with the *peplum* genre. The bloody underwater combat highlights arrow and spear-pierced male bodies, again clad only in loincloths, evoking both the martyrdom of Saint Sebastian and its gay icon status.

Having literally won his laurels and been heralded by Athenian society, Philippides proves himself incorruptible. Discussing strength versus intelligence, he makes the pertinent, if obvious, point that both can be used well or badly, as neither is intrinsically virtuous. He is unimpressed by Karisse's hired wrestlers, dismissing them as brutish thugs who do not bear comparison with real athletes. Inspired by Philippides' example, the 'bad' woman Karisse sacrifices herself to save him and all of Athens from Persian forces, achieving both redemption and the status of a true Athenian patriot. Both strong and wise, Philippides knows when to put down his weapon and return to the land. The final shot of the film shows the silhouetted Philippides and Andromeda walking into the distance, his sword planted in the earth and his yoked oxen waiting on the horizon.

Daniel O'Brien

Hercules

Le fatiche di Ercole
Aka The Labors of Hercules

Studio:
OSCAR Film and Galatea Film

Director:
Pietro Francisci

Producers:
Federico Teti
Lionello Santi

Screenwriters:
Ennio De Concini
Pietro Francisci
Gaio Fratini

Art Director:
Flavio Mogherini

Editor:
Mario Serandrei

Duration:
105 minutes

Genre:
Peplum

Cast:
Steve Reeves
Sylva Koscina
Ivo Garrani
Gianna Maria Canale

Year:
1958

Synopsis

Having saved the beautiful princess Iole from certain death, Hercules reaches the court of her father Pelias, the king of Iolcos, a victim of the gods' fury after killing his brother Esone and usurping the throne. The treacherous Eurysteus, advisor to Pelias, tries to humiliate the demigod Hercules by sending him to complete labours of increasing difficulty. Hercules not only triumphs each time, he also finds Jason, Esone's son and the legitimate heir to the throne, who has been missing for many years. Together with Jason and a crew of fellow heroes, Hercules organizes the voyage of the Argonauts to find the Golden Fleece, returning triumphantly to defeat Pelias and place Jason on the throne.

Critique

Shortly after the opening credits, Hercules arrives to tame the raging horses of Iole's chariot, uprooting a tree to do so. For the Italian spectator of 1958 this was truly an epiphany. It was also the beginning of a genre, with *Le fatiche di Ercole* considered the prototype of the *peplum* (a Latinate christening by French critics, the first to take a serious interest in it). A major form of Italian popular cinema, the *peplum* reflected an industry strategy to produce films on a smaller scale than the Hollywood epics made in Italy, and at much lower cost, to supply the huge circuit of popular cinemas for mass audiences that then proliferated in Italy.

The *peplum* also marked a new type of stardom centred on the exaggerated yet harmonized bodies of American bodybuilders, which dominate every shot in which they appear. *Le fatiche di Ercole* shows this right from the start, and during the games at Iolcos, Hercules/Steve Reeves (who won Mr Universe in 1950) is raised up between Castor and Pollux as if he were on an Olympic platform.

Le fatiche di Ercole, then, codified the genre for the intensive exploitation that was to come, with the *peplum* garnering high box-office receipts for a good five years, up to 1963/64 when the Spaghetti Western replaced it in the tastes of the cinema-going public. The formula was relatively simple, and co-producers Galatea Film and OSCAR Film found the ideal director in Pietro Francisci, an experienced documentarist who moved effortlessly into popular historical reconstructions (from *Antonio da Padova/Anthony of Padua*, 1949, to *Attila/Attila the Hun*, 1953, and including *La regina di Saba/The Queen of Sheba*, 1952).

The ostentatious display of Reeves's sculpted physique is the film's greatest special effect and it overshadows the ingenious optical trickery which director of photography Mario Bava uses for the hero to accomplish his legendary labours, making the film look more spectacular and richer than it really is. Co-writer Ennio De Concini revives and reworks figures from mythology (here, in vague terms, 'The Argonauts' by Apollonius of Rhodes), taking them from the relative obscurity of scholastic culture and catapulting

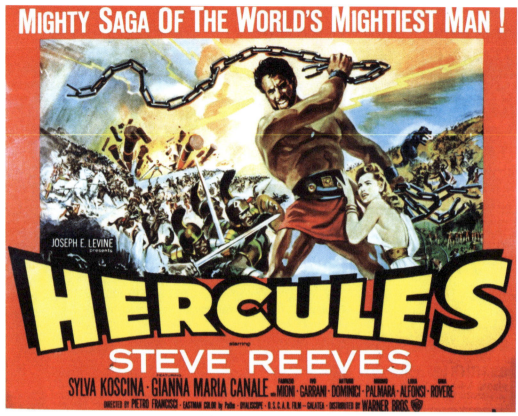

Hercules/Le fatiche di Ercole, Galatea Film.

them into a thrilling tale of tyranny defeated and young princesses rescued.

Shot in glorious Eastmancolor and Dyaliscope, one of the new widescreen formats that Italian cinema used so well, *Le fatiche di Ercole* performed a true miracle: it not only relaunched national film production onto domestic screens, but turned it also into a valued commodity for export even in the difficult North American market, where Francisci's film gained notable success in a redubbed version. The 1959 sequel *Ercole e la regina di Lidia/Hercules Unchained* (Pietro Francisci), which employed many of the same artistic and technical crew, consolidated the public's appetite for the newborn genre.

Rocco Moccagatta

Hercules Conquers Atlantis

Ercole alla conquista di Atlantide
Aka Hercules and the Captive Women

Studio/Distributor:
Spa Cinematografica and Comptor Français du film

Director:
Vittorio Cottafavi

Producer:
Achille Piazzi

Screenwriters:
Duccio Tessari
Vittorio Cottafavi
Sandro Continenza

Cinematographer:
Carlo Carlini

Art Director:
Franco Lolli

Editor:
Maurizio Lucidi

Duration:
101 minutes

Genre:
Peplum

Cast:
Reg Park
Fay Spain
Ettore Manni
Laura Altan

Year:
1961

Synopsis

Androcles, King of Thebes, believes that the kingdom is menaced by a power from the West and sets sail to combat it, taking with him a reluctant Hercules. During a storm, Androcles is swept overboard, fetching up on the island of Atlantis, where he is taken prisoner by its queen, Antinea. Helped by a vision from his father, Zeus, Hercules makes his way to Atlantis, where he finds that Antinea is cloning a race of robotic soldiers. She does this by means of a mineral on the island, to which she has access by making human sacrifices, including in intention her own daughter Ismene, to the God Uranus, enslaving her people to do so. Hercules discovers the means to destroy the mineral, by causing the sun to fall on it; he rescues Androcles and sets free the people even as his action causes Atlantis to erupt and fall beneath the ocean. He returns home with Androcles and Ismene.

Critique

Ercole alla conquista di Atlantide manages to be among the most serious of *pepla*, while also not taking itself too seriously.

What Hercules discovers in Atlantis are evils with very evident twentieth-century reference. The Queen's clones are bleached-blonde soldiers, a eugenic Aryan master race. Hercules' discovery of them has him wielding a club, iconographically associated with him, against the armour-clad soldiers, with yet more serried ranks appearing. The critique of fascism is thus not only in their appearance but also in his, pitting old fashioned weaponry and a single bare body against new-fangled technology, the identical, massed rows recalling the spectacles of the regime. Similarly, the design of the court recalls the monumentalism of Italian Fascist architecture, the depiction of the enslaved people, concentration camps, and the destruction of Atlantis, the atom bomb.

All this is carried off with panache. There are the generic set pieces of action: Hercules has his labours: single-handedly pulling a ship to the shore; fighting shape-shifting prison guard Proteus on his arrival in Atlantis; taking on the cloned ranks with his single club. His body is displayed in these set pieces, but also in his lying across the widescreen frame while the court of Thebes deliberates, or Antinea runs her hand over his chest. The film is also lovingly crafted. The music contrasts an inspirational fanfare-based theme against evocative and thrilling arrangements for percussion and electronic instruments at the court of Atlantis. The scale and splendour of the sets at court are emphasized just as it is about to be destroyed: Hercules driving a chariot and team of horses through underground tunnels, emerging beneath a massive, indeed Herculean, gold statue.

Much of this touches on a contradiction common in the *peplum*. The decadent, sadistic court is more interesting and enticing than the rather dull one in Thebes. The body at the centre of the film is,

in its heroic muscularity, much of the kind promoted by the regime, not least through the presentation of Mussolini.

What saves the film from being itself fascistic, apart from the clarity of its critique of Fascism, is the casting of Reg Park. The stars of the *peplum* were always American, or American-seeming, bodybuilders, something removing them from the taint of Fascism and associating them with the liberatory ideals of the US. Park, however, (in fact British) has neither the square-jawed handsomeness and sculpted body of the most successful *peplum* star, Steve Reeves, nor the street-kid haircut and beach-boy muscles of Kirk Morris (real name Adriano Bellini, the only Italian *peplum* hero star); Park's face is genial, comfortable, his body massive and chunky. This makes him well able to carry off one of the film's central conceits: that he never wanted to go on this mission in the first place. This Hercules is not interested in fighting and conquering. In a brawl scene in a tavern at the start of the film, he sits tranquilly eating and drinking, indifferent to what is going on around him. He is only on the voyage because Androcles drugged him. This gives the film humour, the reluctant, even lazy and bored, action hero (and Park smiles a lot) amused at the antics of literally lesser mortals. This refusal to take things quite seriously not only allows the film to make its serious and aesthetically-relished points, but is also in itself an attitude the antithesis of the grim seriousness of Atlantis, Antinea, her clones and slaves. By not taking itself too seriously, *Ercole alla conquista di Atlantide* succeeds in being serious.

Richard Dyer

Hercules in the Centre of the Earth

Ercole al centro della terra
Aka Hercules in the Haunted World

Director:
Mario Bava

Producer:
Achille Piazzi

Screenwriters:
Alessandro Continenza
Mario Bava
Duccio Tessari
Franco Prosperi

Synopsis

Hercules returns home to Ecalia, where his fiancée Deianira, the rightful queen, has fallen into a mysterious catatonic state. He learns the only cure is the magical stone of life, to be found in the depths of Hades. Hercules and his friend Theseus undertake the hazardous journey, facing a number of perils including monsters and phantoms. While Hercules retrieves the stone, Theseus incurs the wrath of the god Hades by falling in love with his daughter Persephone and taking her from the underworld. With all of Ecalia facing disaster, Hercules discovers that Deianira has been entranced by her guardian Lyco, who will sacrifice her that night to steal the kingdom.

Critique

Ercole al centro della terra is perhaps best known for being Mario Bava's first film as credited director in colour and anamorphic widescreen. As a *peplum*, it is notable mainly for the spectacular visual effects and a trans-generic aspect achieved largely through the casting of Christopher Lee, a horror star associated with the role of

Cinematographer:
Mario Bava

Art Director:
Franco Lolli

Editor:
Mario Serandrei

Music:
Armando Trovajoli

Duration:
81 minutes

Genre:
Peplum

Cast:
Reg Park
Christopher Lee
Leonora Ruffo
Giorgio Ardisson

Year:
1961

Count Dracula. In terms of mise-en-scène, Bava achieves atmospheric results on a famously miniscule budget. The more fantastical elements include a living stone giant, walking corpses, bleeding creepers and a vast hellish landscape dominated by jagged mountains and a sea of lava. Working with few sets and props from stock, he shows a flair for pillar placement that puts many peplum directors to shame. However, Bava's limitations as a film-maker undercut his visual imagination and resourcefulness. He exhibits little ability to stage action scenes, a notable drawback in a genre dependent on setpieces of contest and combat. Nor does he seem concerned with pacing, narrative clarity or characterization.

The contrast and conflict between Hercules and Lyco carries some potential, despite its rigid adherence to the standard good/evil duality. Hercules is associated with daylight and nature and the film opens with the camera tilting up a waterfall to reveal him standing at the top, grooming his exposed muscular torso. The powerful stream of water corresponds with the demigod's own potency and life force. His expected feats of strength include restraining a team of wild horses and hurling a vast boulder with an improvised slingshot. Lyco is a creature of the night, often dressed in black, and commanding malevolent forces. While he is not identified as a vampire, the casting of Lee and the character's association with the twilight world between life and death invoke both the horror genre and the figure of Dracula. Deianira is first seen emerging from a stone tomb, like a placid vampire, gliding towards Lyco with unnatural – or supernatural – smoothness. Lyco must drink Deianira's blood to gain her kingdom and power. He looms over a prone female victim and recoils from the glowing stone of life like a vampire from a crucifix. Unfortunately, the battle between the supernatural Lyco and the supernatural Hercules is resolved in perfunctory fashion with an excess of rock-tossing, undermined further by the clearly fake props. While Lyco sizzles in the sunlight in best Dracula fashion, Bava's fusion of peplum and Gothic horror is an intriguing yet unfulfilling generic mismatch.

Daniel O'Brien

Hercules Unchained

Ercole e la regina di Lidia

Studio:
Lux Film
Galatea
Lux Compagnie Cinematografique de France

Synopsis

Hercules and Iole set out for Thebes with Ulysses. After disposing of Antaeus, Hercules meets Oedipus and seeks to resolve a conflict between his sons Eteocles and Polynices over control of Thebes. Eteocles agrees to give up the throne, but before Hercules can communicate this to Polynices, he drinks from a magic spring and loses his memory. He falls under the spell of Omphale, Queen of Lydia, who collects lovers and, tiring of them, has them embalmed and turned into statues. Meanwhile Eteocles thinks Hercules has betrayed him to join up with Polynices, and the latter, unaware of Eteocles' willingness to concede power, has enlisted an army of

Director:
Pietro Francisci

Producer:
Bruno Vailati

Screenwriters:
Ennio De Concini
Pietro Francisci

Cinematographer:
Mario Bava

Art Director:
Flavio Mogherini

Editor:
Mario Serandrei

Duration:
96 minutes

Genre:
Peplum

Cast:
Steve Reeves
Sylva Koscina
Sylvia Lopez

Year:
1959

Argives to attack Thebes. Ulysses finally brings Hercules back to his senses and, along with a small band of Ithacans who have come to Ulysses' and Hercules' aid, they escape Lydia and return to Thebes. Omphale, who has come to love Hercules, throws herself in a vat of embalming fluid. A duel between Eteocles and Polynices leaves both dead, Hercules leads the Thebans (with the Ithacans) to victory against the Argives, and he and Iole are reunited.

Critique

Ercole e la regina di Lidia served as the sequel to *Le fatiche di Ercole/Hercules* (Pietro Francisci, 1958). It earned even more than its predecessor in Italy and like *Le fatiche* was propelled by the marketing inventiveness of distributor Joseph E Levine to significant box-office success outside Italy. Together with *Le fatiche*, *Ercole e la regina di Lidia* set the template for the peplum, leading to hundreds of spin-offs over the next five or so years. Although Steve Reeves stars in both films, the sequel paved the way for what can be termed a 'seriality of difference', in which the same character appears over and over again in different and even contradictory circumstances, with different wives and lovers, and played by different actors.

Ercole e la regina di Lidia confirmed a number of fundamental peplum characteristics: escapism and fantasy (in sharp contrast to the neorealist films of the 1940s); a return to pre-industrial, pre-modern times with a privileging of rural simplicity; an emphasis on spectacle (widescreen, colour, action, the body-on-display) above narrative and character; a strongman hero (appealing particularly to rural southern Italian audiences and reprising silent film heroes such as Ursus and Maciste); hyper-masculinity mixed in with homoeroticism and comic-book heterosexuality; a parody of foundational Western literature (playing fast, loose, and humorously with Greek mythology); a pervasive silliness and irreverence with obvious appeal to an emerging youth culture and audience; and an openness to multiple entertainment and film forms (music, dance, science fiction, horror) accompanied by a vertiginous intermingling of literary genres: fairy tale, epic, theatre, melodrama, and action/adventure. Much of this suggests a subversion of cultural tradition and canonicity consistent with many forms of popular cultural expression.

In terms of artistic merit, *Ercole e la regina di Lidia* can, like so many *pepla*, be faulted for implausibility, tackiness, technical lapses, historical inaccuracies, and the thespian deficiencies of its star, but the pleasure of the film lies as much in its defects (including postproduction factors such as poor dubbing) as in its virtues, which lie mostly in the realm of spectacle, and especially in the visual dynamics of Maria Bava's cinematography and special effects. The film's weaknesses are liberatingly comic, contributing not so much to individual aesthetic pleasure as to the kind of recollective group pleasure characteristic of cult movies. In keeping with this, *Ercole e la regina di Lidia* was one of the pepla chosen for full-length screening and parodic commentary by *Mystery Science Theatre 3000*.

As with any cultural product, *Ercole e la regina di Lidia* reflects issues and concerns that are independent of its entertainment objectives but inevitable given its cultural situatedness. Most obvious seems to be an anxiety about masculinity. At the beginning, Hercules and Iole playfully discuss the 'chains' she has placed on him in marriage. Then Omphale's matriarchy proves a source of great evil that turns Hercules into an impotent and pampered house pet. To escape from her domain Hercules must hold apart the clamping vagina dentata of a huge door. Masculinity is restored only when women assume their rightful role as passive victims: Iole under threat in Thebes becomes metonymy for the city itself, both in need of Hercules' protection. Despite this normalization, heterosexual masculinity is highly qualified as Hercules and Ulysses prove to be the film's most important couple, spending more time together than either Hercules and Omphale or Hercules and Iole.

The Italian foundational myth of fratricide (Romulus and Remus) is reprised in the deadly conflict between Eteocles and Polynices. The implied need for a strong ruler recalls Fascism, while the fact that might and right are embodied by an American actor invites discussion of Italy's liberation in the Second World War and, more metaphorically, the role of America in post-war Italy. The death of the two brothers ends rule by succession, suggesting a major rupture with the past, consistent with numerous aspects of Italy's post-war political and social reconfiguration, including the movement from monarchy to republic.

Frank Burke

The Loves of Hercules

Gli amori di Ercole
Aka Hercules vs the Hydra

Studio:
Grandi Schermi Italiani

Director:
Carlo Ludovico Bragaglia

Producer:
Alberto Manca

Screenwriters:
Alessandro (Sandro) Continenza
Luciano Doria; story
Alberto Manca

Synopsis

Megara, the wife of Hercules, is killed on the orders of Eurytus, king of Oechalia, who then is killed by Lichas, who schemes for the throne. Hercules comes to avenge Megara's death and meets Deianeira, daughter of Eurytus. They fall in love, though she is betrothed to Acheleus. Lichas has Acheleus killed, framing Hercules, hoping to turn Deianeira against Hercules and win her hand. Pursuing Acheleus' killer, Hercules fights and defeats the Hydra, a three-headed dragon. He is severely injured and saved by the Amazon Nemea, then brought to the Amazon Queen Hippolite, who, upon tiring of her lovers, has them turned into tree trunks in the Forest of Death. Hippolyte is transformed into the image of Deianeira and seduces Hercules. Nemea saves him, but is killed by Hippolite in the Forest of Death, where she herself is killed by one of the man-trees. Back in Oechalia, Lichas tortures political opponents and imprisons Deianira for refusing his proposal of marriage. The people of Oechalia rebel against Lichas, while he orders mass killings and some soldiers throw down their arms in order not to fight brother against brother. Lichas then drags Deianeira to a cave, where he is killed by an apeman whom Hercules must vanquish.

Cinematographer:
Enzo Serafin

Art Director:
Alberto Boccianti

Editor:
Renato Cinquini

Duration:
102 minutes

Genre:
Peplum

Cast:
Jayne Mansfield
Mickey Hargitay
Massimo Serato

Year:
1960

Critique

Gli amori di Ercole is most notable for starring the then hot tabloid couple Mickey Hargitay (Hungarian-American Mr Universe) and Jayne Mansfield. It was produced to exploit Mansfield's fame for an American market, but, with that fame in decline, the film was not released in the United States until six years after it was made. Neither Hargitay nor Mansfield furnishes a particularly strong performance, the Hydra and Forest of Death are tacky, the apeman clichéd, and Hercules' 'labours' predictable, but these limitations from a traditional artistic perspective are pluses from a comic, sub-genre, cult point of view. A persistent emphasis on monsters, magic, religious superstition, and the grotesque evoke a world of marvels and of danger on, just beyond, or at times within the borders of organized life – reflecting both Greek mythology and fairy tale but also embodying something crucial to the pseudo-mythological *peplum*. A sense that anything can happen, coupled with a clear rejection of standards of perfection (narrative, technical, theatrical, and so on), give the genre a potentially anti-rationalist bias that is arguably counter-cultural and progressive.

The massing of the populace against sadistic authority, with references to soldiers potentially forced to fight against kin, recalls the end of the Second World War, which pitted not only Italians against Germans but Italians against one another (partisans vs fascists). Here, as in so many *pepla*, resolution is achieved through American-identified might from outside (Hargitay-as-Hercules). The usual *peplum* gender issues are in evidence, with women divided into good and evil, men allowed to have multiple relationships (cf the title of the film), women vilified if they do the same, and masculinity at risk in the presence of strong women (Hippolite and, of course, the highly compromised 'phalli' of the Forest of Death). The fact that Hercules can be in love with two different women as long as they appear the same suggests that women are merely appearance or masquerade. On the other hand, women drive the narrative. Megara's death precipitates the major action. Deianeira is strong, particularly at the beginning. Nemea rescues the hero from his own weaknesses. And Elea, Deianeira's lady in waiting, uncovers the evil plottings of Lichas.

The film exemplifies common *peplum* implications around weightlifting, body hair, colonization, and nature vs culture. Hercules' near-naked body would normally be coded 'natural', but because it is built and almost ludicrously hairless, it is clearly also 'cultured'. Shaved, it is also, in part, 'feminine'. As body, Hercules is a physical creature, but as trained body, he embodies planning, control, intellect. His body is unmistakably white, but also tanned, making it 'of colour', though its coloration (like its hairlessness and contouring) reflects choice not determination. In short, Hercules occupies all positions possible in terms of naturalness and primitivity, civilization and culture, masculinity and femininity, white and other. His hairlessness contrasts with the decadent (over-cultivated) beards of his enemies and the hirsute physical aggression of the apeman; his whiteness overcomes the darkness of the other,

whether it be a black bull he kills in defence of Deianeira or the racially-different caveman; his masculinity is a guarantee against effeminacy; his 'natural reason' the perfect weapon against civilized irrationality and its craving for power.

One is led to conclude that the film comes down on the side of nature. The caveman is as tender towards Deianeira as he is threatening to everyone else. He kills the villain of the piece, Lichas. And the film ends with the hero and heroine on horseback in a natural setting, moving away from civilization. However, the extreme close-ups of the faces of the hero and heroine, just prior, suggest what the film has been about all along: not heroes from a classical past but merely Hargitay and Mansfield themselves, two popular stars who, though waning, help proclaim the emerging dominance of celebrity culture.

Frank Burke

The Last Days of Pompeii

Gli ultimi giorni di Pompei

Studio:
Cineproduzioni Associate
Procusa Film

Director:
Mario Bonnard (credited)
Sergio Leone (uncredited)

Producer:
Paolo Moffa

Screenwriters:
Ennio de Concini
Sergio Leone
Duccio Tessari
Luigi Emmanuale
Sergio Corbucci

Cinematographer:
Antonio López Ballesteros
Enzo Barboni

Art Director:
Aldo Tomassini
Ramiro Gómez

Editor:
Eraldo da Roma
Julio Peña

Synopsis

A gang of masked riders stages a raid on a Pompeii estate, stealing treasure and brutally killing the inhabitants. They leave in their wake a sign of the cross. Legionnaire Glaucus Cesonius returns from war to his native Pompeii. He discovers that outlaws have killed his father. It is not Christians, as the sign of the cross implies, but Roman Consul Ascanius' wife Giulia and the high priest Arbacès who are responsible for the raids. As Egyptians, they hate the Romans, who killed Giulia's family and abducted her as a child, and turn those whom they colonize into slaves. Giulia and the high priest are robbing the rich to raise money to hire mercenaries to liberate Egypt. At first Glaucus suspects the Christians, but their displays of innocence in the face of torture, his love for Ascanius' daughter Ione, who increasingly commits to Christianity, and evidence unearthed about Giulia and Arbacès persuade him otherwise. Giulia kills Ascanius, blaming Glaucus. Ione is imprisoned to die with the Christians, as is Glaucus. He escapes and is defending Ione and the Christians in the arena when Vesuvius erupts. Ione escapes the city on a boat, and Glaucus joins her.

Critique

Gli ultimi giorni di Pompei is based loosely on the eponymous Edward Bulwer-Lytton novel (1834) that has given rise to eight movies and a TV mini-series. It is a religious-historical rather than a pseudo-mythological *peplum*, set during the rise of Christianity amidst Roman rule with a seriousness of tone that recalls the Italian *Fabiola* (Alessandro Blasetti, 1949) and the American *Quo Vadis?* (Mervyn LeRoy, 1951). The story reflects the strong post-war turn to Christianity both in Italy and the United States. Though credited as a Mario Bonnard film, it was directed by Sergio Leone, which explains the marked American and, in many respects, western,

Duration:
103 minutes

Genre:
Peplum

Cast:
Steve Reeves
Christine Kaufmann
Fernando Rey
Barbara Carroll

Year:
1959

iconography of the opening moments: a raid on horseback, hoods recalling the Ku Klux Klan; black servants among the victims. Leone took over the project because Bonnard fell ill, and the project dovetailed with Leone's sword-and-sandal experience working on *Quo Vadis?*, *Helen of Troy* (Robert Wise, 1956), and *Ben-Hur* (William Wyler, 1959). The film departs from many films depicting the persecution of early Christians in that, here, the faithful are oppressed not because of their religion but in order to mask unrelated criminal (and ultimately political) activities.

Though not on a par with Leone's best work, the film is surprisingly coherent given the last minute substitution of directors and a rather large number of scriptwriters. On the other hand, Reeves is not up to the dramatic demands made upon him by a serious role, and the Hercules-style feats that seem invented for him (fighting a crocodile, for example) seem out of place. The music is poor and at times jarring (Ennio Morricone has not yet arrived on the scene), and there are some notable plot inconsistencies.

The emphasis on imperialism, slavery, race, and revolution, with Egypt as a focal point, is resonant given the decolonization of Africa, emerging civil rights movement, wars of liberation, and Middle East tensions that characterized the 1950s and beyond. The global context seemed to dictate a shift away from the representation of Egyptians as racialized villains that was typical of the Italian silent-film versions of the story. They are presented as ruthless in pursuit of their political aims, but the Romans are guilty of even more: child abduction, enslavement, torture. Giulia is by far the most complex character in the film (interesting from a gender point of view as well). Her hatred of Rome does not blind her to the virtues of Glaucus, to whom she shows compassion and understanding. She and Arbacès are presented as having valid reasons for their political activity, even if ends do not justify means. The moral limitations of the Egyptians seem much less the result of prejudicial villainization than of Leone's career-long scepticism towards political ideology of any sort, even the most seemingly progressive.

Since ancient times, Pompeii has been interpreted as divine retribution for a society out of control. However Leone's film resists any clear link between the eruption of Vesuvius and divine providence. In fact, for a film on the seeming topic of emergent Christianity, *Gli ultimi giorni di Pompei* remains secular and even cynical. Glaucus never converts, and the most devout character, Nydia (Ione's blind servant), is killed in a way that emphasizes tragic loss not transcendence. The focus on devastation – including the shot of a lost toddler ignored by all who pass by – makes it difficult to attribute anything divinely positive to the event. There is a strong emphasis on people just looking out for themselves: looters, robbers, a woman who competes with the lava flow for objects of worth, people who seek out only loved ones with no attention to others in need. Much of the above, including a *deus ex machina* apocalypse minus the *deus*, will recur in the earthquake-driven conclusion of Leone's *Il colosso di Rodi/The Colossus of Rhodes* (1961).

Frank Burke

Son of Spartacus

Il figlio di Spartacus
Aka The Slave

Director:
Sergio Corbucci

Producer:
Franco Palaggi

Screenwriters:
Adriano Bolzoni
Bruno Corbucci
Gianni Grimaldi

Cinematography:
Enzo Barboni

Art Director:
Ottavio Scotti

Editor:
Ruggero Mastroianni

Music:
Piero Piccioni

Duration:
102 minutes

Genre:
Peplum

Cast:
Steve Reeves
Gianna Maria Canale
Ivo Garrani
Jacques Sernas

Year:
1962

Synopsis

Roman centurion Randus, a favourite of Julius Caesar, is dispatched to a remote African province to report on its governor, the wealthy and powerful Crassus, who is suspected of plotting against Caesar. En route, Randus is shipwrecked and captured by slave traders. A fellow slave recognizes a medallion worn by Randus and declares him the son of Spartacus, the Thracian rebel who was crucified on Crassus' orders 20 years earlier. Freed by Crassus' soldiers, an initially-sceptical Randus is reluctant to accept his heritage. Angered by the suffering of Crassus' subjects, he takes up his father's helmet and sword, leading a campaign of rebellion. Having defied the might of Rome, Randus accepts that his actions must inevitably bring him into conflict with Caesar, whose army draws ever closer.

Critique

Il figlio di Spartacus marks the last *peplum* role for genre icon Steve Reeves, who achieved stardom in *Le fatiche di Ercole/Hercules* (Pietro Francisci, 1958), and is also an unofficial sequel to the Hollywood epic *Spartacus* (Stanley Kubrick, 1960), providing a happy ending denied the original rebel against Rome. As a centurion and representative of Caesar, Randus serves initially as an establishment figure, supporting the status quo. His political consciousness and conscience are awakened gradually – a transformation hinted at in the opening scene. Confronted with a crucified enemy of Caesar, Randus defies the law and grants the man's wish for a quick death, framed in a dramatic low angle to emphasize the upward thrust of his sword. The experience of slavery takes this education a stage further: Randus tied in a crucified position, evoking the fate of his father, his earlier act of mercy killing, and anticipating the film's climax. Raging against injustice, Randus becomes a bare-chested saviour on a white horse, highlighting the established Reeves persona (the film also references Californian freedom fighter Zorro, familiar to 1960s audiences worldwide from the Disney television series, first broadcast 1957–1959. Where Zorro's mark is a signature 'Z', Randus scratches an 'S' for Spartacus). Randus' grudge against Crassus personalizes the struggle for freedom and, by extension, revenge. Crassus' fate – forced to drink molten gold – is approved by Randus as a just sentence and is also a telling comment on the corrupting nature of greed, the tyrant destroyed from the inside by his ill-gotten wealth. Aware of the wider picture, Randus admits the slave culture exploited by Crassus is endemic to the entire Roman Empire: 'If Rome is for slavery then I am against Rome.'

Randus' multi-ethnic band of followers represents racial unity and harmony, yet it is notable that he kills many black warriors, most of whom wear stereotypically 'savage' leopard-skin headgear. While this image risks evoking notions of white supremacy and fascism, the film resists a simplistic reading, also suggesting that oppression, persecution and tyranny are hardly exclusive to one racial or

ethnic group. There is some irony in Randus being a figure Spartacus would have hated – a Roman centurion – yet achieving his father's dream of freedom with the tacit consent of Julius Caesar himself. The film stresses Caesar's paternal yet expedient relationship to Randus. A political realist, Caesar will sacrifice anyone – including his favourite centurion – to preserve the security and authority of Rome and therefore his own power.

Unlike most *peplum* heroes, Randus' extraordinary strength of mind and body is insufficient to defeat his opponent, in this instance the entire Roman Empire. Delivering himself to Caesar's justice, he is sentenced to share his father's fate on the cross. Randus' salvation lies with his followers, who challenge Caesar to crucify them all, an evocation of the famous 'I'm Spartacus' scene in the Kubrick film which, in this instance, results not in execution but freedom – Caesar the populist overriding Caesar the despot. As Randus walks into the distance with girlfriend Seila, the cross topples symbolically into the desert sand, trampled by the freed slaves. While *Il figlio di Spartacus* challenges the institution of slavery rather than the social, economic and cultural attitudes and structures that both permit and depend on it, the film is surprisingly radical for the *peplum* genre (in this respect, the film anticipates Sergio Corbucci's avowedly political westerns *Il mercenario/The Mercenary*, 1968 and *Vamos a matar companeros!/Companeros*, 1970). The triumphant Randus returns the sword of Spartacus to its resting place in the City of the Sun, awaiting the next deliverer to call the oppressed to arms.

Daniel O'Brien

Sons of Thunder

Arrivano i Titani
Aka My Son, the Hero

Director:
Duccio Tessari

Producer:
Franco Cristaldi

Screenwriters:
Ennio De Concini
Duccio Tessari

Cinematographer:
Alfio Contini

Art Director:
Ottavio Scotti

Synopsis

After sacrificing his queen to the powers of darkness, Cadmus, King of Crete, is rendered invulnerable to weapons and proclaims himself a god. Determined to punish Cadmus for his arrogance, Zeus makes a bargain with the captive titan Crios. He and his brother titans will be released from imprisonment in Tartarus if Crios undertakes a mission to destroy Cadmus. Arriving in Crete as an ordinary mortal, Crios relies on his intelligence and cunning to impress Cadmus and win his confidence. His plans are threatened, however, when he refuses to let the slave Rator be killed for sport, rendering both their lives forfeit.

Critique

While *Arrivano i Titani* is often characterized as parody *peplum* or outright comedy, it offers an imaginative and faithful rendering of Greco-Roman mythological figures, with appearances from Prometheus, Tantalus, Sisyphus, Medusa, the Fates and a Cyclops. The film is mainly of interest for its alternative depiction of heroic masculinity, which consciously eschews the genre's standard

Editor:
Renzo Lucidi

Music:
Carlo Rustichelli

Duration:
111 minutes

Genre:
Peplum

Cast:
Pedro Armendáriz
Giuliano Gemma
Antonella Lualdi

Year:
1962

muscle-bound liberator of superhuman strength and endurance. *Arrivano i Titani* is also intriguing for an unusual, if undeveloped and problematic focus on racial difference, embodied in the relationship between Crios and eventual ally Rator.

Crios is blond-haired and clean-shaven, in marked contrast to his dark, bearded brothers who adhere to the standard Herculean look pioneered by Steve Reeves in *Le fatiche di Ercole/Hercules* (Pietro Francisci, 1958). Lacking bodybuilder dimensions, Crios' athletic appearance is matched by his dexterity and grace, actor Giuliano Gemma performing many of his own stunts. An extended sequence where Crios evades Cadmus' guards by rolling down a street in a barrel, scaling walls and rooftops and treating shop awnings as trampolines, is arguably a more persuasive display of physical training and skill than the rock lifting and lion wrestling seen in numerous production-line *pepla*. Crios is noted for his intellect and guile, which become his chief assets in the plot to defeat Cadmus. Rendered mortal for his trip to Crete, he must rely on his wits for self-preservation. However, Crios also makes use of magical devices, such as a helmet of invisibility and Zeus' own portable lightning bolts, which could be characterized as advanced technology, another sign of the superior mind.

Crios is contrasted with the black captive Rator, played by champion bodybuilder Serge Nubret. Rator is first seen in chains, his arm pinned in a crucified position, emphasizing both his imposing physique and paradoxical helplessness and vulnerability – an image also associated with the racially-tinged iconography of enslavement. Nevertheless, Rator is marked explicitly as representing brutish brawn; as Crios notes, 'It's like I said, all muscles, no brains.' Ordered to fight for Cadmus's entertainment, Crios demonstrates his superior combat skills against Rator yet proves merciful to his fallen enemy. This compassion is undercut by a shot of Crios grinding his heel into the prone Rator's hand, the whiter-than-white victor punishing further his already-vanquished black opponent. Rator subsequently becomes Cadmus's prey, hunted by dogs and soldiers on horseback – the black man seen as the white man's sport and quarry. The film sidesteps these troubling racial politics to highlight a growing 'buddy' relationship that transcends ethnicity, class and the human-titan divide. Crios saves Rator from Cadmus's arrow and they dive off a cliff together, affirming their brotherhood. Unlike most *peplum* heroes, Crios cannot beat the villain single-handed and, already injured, looks certain to be punctured with arrows before his titan brothers appear in the nick of time. The defeat of Cadmus is thus a collective endeavour, enabling Rator to become an honorary Titan and affirming his incorporation into this heroic homo-social group.

Daniel O'Brien

The Witch's Curse

Maciste all'inferno

Studio:
Panda Cinematografica

Director:
Riccardo Freda

Producers:
Ermanno Donati and Luigi Carpentieri

Screenwriters:
Oreste Biancoli
Piero Pierotti, from a story by Eddie H Given (Ennio De Concini)

Art Director:
Andrea Crisanti

Editor:
Ornella Micheli

Duration:
90 minutes

Genre:
Peplum

Cast:
Kirk Morris (Adriano Bellini)
Hélène Chanel
Andrea Bosic

Year:
1962

Synopsis

Scotland, the end of the sixteenth century. The young Martha Gunt, descendant of a cruel witch still widely feared, gains possession of her family manor and meets with local hostility. The heaven-sent intervention of Maciste keeps an angry mob at bay, but he must descend to Hell to confront the witch, who continues to cast evil spells on earth, and save the innocent Martha from being burnt at the stake by the superstitious locals.

Critique

In its own way, *Maciste all'inferno* proves that only a few years after the dawn of the genre anything was possible in the world of the *peplum*. These films aimed to excite a largely uneducated mass audience in search of new variations on the basic *peplum* ingredients (the mighty hero, a blonde angel in peril, a wicked brunette, the fight against tyranny, and the usual pack of monstrous creatures), a tendency which culminated in the absurdities of *Zorro contro Maciste/Samson and the Slave Queen* (Umberto Lenzi, 1963) and *Maciste alla corte dello zar/Giant of the Lost Tomb* (Tanio Boccia, 1964). Maciste lends himself readily to a succession of novel, often outlandish deeds and settings, whereas screen rival Hercules is confined – relatively speaking – by the legacy of classical antiquity to the basic tenets of his mythological origins. First played by Bartolomeo Pagano, Maciste debuted in the silent epic *Cabiria* (Giovanni Pastrone, 1914) and had recently been revived in *Maciste nella valle dei re/Son of Samson* (Carlo Campogalliani, 1960) which took many liberties with the original. As a character Maciste carries a kind of free pass in the cultural imagination, allowing him to travel with impunity through time and space with no concern for verisimilitude.

Maciste all'inferno, which retains only the title of the 1925 film (directed by Guido Brignone) to which it makes no other reference, reflects the intermittent delirium of a genre in a phase of rapid exhaustion. At the same time it bears the stamp of Riccardo Freda, quintessential director of the Italian adventure story. Freda had for some years been making low-budget genre films that allowed him to realize more personal projects, even if this meant having to operate within extremely tight budgets and difficult production conditions. *Maciste all'inferno* is a perfect example of the latter. Producers Luigi Carpentieri and Ermanno Donati, who worked with Freda on *I vampiri/Lust of the Vampire* (1956) and *Maciste alla corte del Gran Khan/Goliath and the Golden City* (1961), imposed many restrictions on the director. In fact, to make up the running time, Maciste has a prolonged flashback to his past adventures, taking the form of footage from previous films in the series (despite the actors who play the hero not being the same). However, Freda still managed to prove his skills as a *metteur en scène*, transforming in a few expertly-lit shots the dramatic natural setting of the Grotte di Castellana into a pagan and Dante-esque Hell. Working

The Witch's Curse/Maciste all'inferno, Panda Film.

with meagre resources, the director gives free reign to his vision, employing the style and action characteristic of his previous work, adapting himself to the changed production context without regard for plot, dialogue or acting. He cut almost all the lines written for Maciste, played by Venetian actor Adriano Bellini. Having no confidence in Bellini's acting abilities, Freda preferred him to be simply a piece of mighty flesh at the camera's disposal, and to use his rampant physicality to move the film's rhythm along.

Rocco Moccagatta

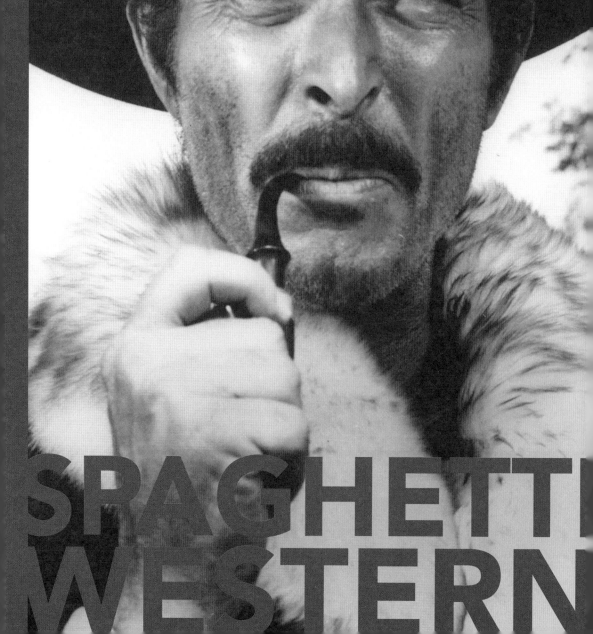

SPAGHETTI WESTERN

There can be few more tangible symbols of Italians' post-war engagement with transatlantic popular culture than the proliferation of home-grown western movies which began in the early 1960s, and persisted into the mid-1970s. This bastard cousin of Hollywood's hallowed foundation myth – now known the world over as the 'spaghetti' western – was from its inception a wilfully reactive film-making trend. Yet the Italian version is no subordinate clause, beholden to the syntax of US cinema. By their very nature as playfully trans-cultural undertakings, these films register a certain kind of 'Italian-ness': one within which Americana has of course become an ever-present factor, but also one which has taken possession of this iconography in a diverse, at times complex, dialogue. From the imitative to the iconoclastic, the pedestrian to the downright eccentric, the array of cultural reference points therein offers an intriguing glimpse into the transitional nature of Italy's popular culture in the 1960s.

One director above all others has become synonymous with the global spaghetti brand. The stylistic panache and sardonic irreverence of Sergio Leone have left an indelible mark upon global cinema, but the international visibility of this now-esteemed auteur has served to conceal the diversity of an amorphous collection of films. Leone's phenomenally successful western debut *Per un pugno di dollari/A Fistful of Dollars* (1964) was a decisive influence, but not the lone 'founding text'. Instead, numerous strands of popular culture converged within, and emanated from, this fascinating cinematic tangle (in this among other ways, the 'spaghetti' moniker seems symbolically apt). The whims of the market dictated an uneasy balance between repetition and innovation in rapidly-produced, overlapping cycles known locally as *filoni*; such was the incremental, formulaic nature of popular Italian film-making in this era.

The point can be illustrated by a mere smidgeon of the western *filone*'s vast scope (which totals between 450 and 500 films, depending on one's definitions). Many early contributions capitalized on Leone's success rather tentatively. *Una pistola per Ringo/A Pistol for Ringo* (Duccio Tessari, 1965) and *Johnny Oro/Ringo and His Golden Pistol* (Sergio Corbucci, 1966), for example, both present a curious network of citations, where direct references to such classic Hollywood westerns as *Shane* (George Stevens, 1953) rub shoulders uneasily with the cynicism and dry wit of the still nascent Italian version. An alternative trajectory saw Leone's archetypal 'servant of two masters' plot schema merge with influences from Italian horror in such brooding, nihilistic films as *Django* (Corbucci, 1966), *Se sei vivo, spara!/Django, Kill! (If You Live Shoot!)* (Giulio Questi, 1967), *Il grande Silenzio/The Great Silence* (Corbucci, 1968) and *Django il bastardo/Django the Bastard* (Sergio Garrone, 1969). The dismal vision of a corrupt, avaricious western society in these and other spaghettis in turn merged with Italy's contemporaneous political cinematic trends in a group of films espousing the radicalism of emergent countercultures: *El chuncho, quien sabe?/A Bullet for the General* (Damiano Damiani, 1966), *La resa dei conti/The Big Gundown* (Sergio Sollima, 1967), *Faccia a faccia/Face to Face* (Sollima, 1967) and *Vamos a matar, compañeros/Companeros* (Corbucci, 1970), to name but a few. This bleak social outlook continued in a

Left: *The Big Gundown/La resa dei conti*, P.E.A./RPC.

considerably more comic vein throughout the series of 'Sabata' and 'Sartana' films of the late 1960s and early 1970s, which themselves helped spawn the outright slapstick of *Lo chiamavano Trinità/My Name is Trinity* (Enzo Barboni, 1970). Finally, the Italian western's death-rattle was signalled by a return to horror-inflected intensity in such 'twilight' films as *Keoma* (Enzo G Castellari, 1976) and *Mannaja/A Man Called Blade* (Sergio Martino, 1977). If the selection of just one of Sergio Leone's films in this chapter raises an eyebrow, therefore, it is to be hoped that the reader will delight in the oft-overlooked breadth of artistic expression to be found in this much-loved *filone*.

Given this array of interlocking and somewhat nebulous variants, wherein lies the specifically 'Italian' nature of these films? What is it that puts spaghetti in the western? Certain stylistic features arise time and again, and can broadly be said to distinguish the Italian version from its Hollywood counterpart. The mischievously irreverent burlesque on show across the various adventures of Ringo, Sabata, Sartana and Trinity is a hallmark of the humour and raucousness pervading the popular output of Roman studios in this era. So too has the extravagant deployment of extreme close-ups and low-angle, deep-focus shots that characterizes some of the most accomplished Italian westerns embedded itself in the popular imagination. The instantly recognizable musical refrains of Ennio Morricone which punctuate so many spaghettis also give a clear indication that these films are culturally, as well as geographically, distant from Californian film-making practices prior to the late 1960s.

However, while searching for distinctive traits is a rewarding pursuit it can be a red herring. Perhaps the question should not be how the Italian western differs from the American 'original' so much as what it tells us about the ever-more globalized mores of the 1960s and 1970s. If this *filone* shows us anything, it is surely that the boundaries of post-war popular culture have become, in a variety of ways, increasingly blurred. It is commonplace to assert, for example, that the double-crossing, the cynical, world-weary antiheroes, the nihilistic world-view and the gleeful levels of sadistic violence that have contributed to the spaghetti western's enduring appeal amounted to a novel reworking of Hollywood's tired, monolithic founding myth. These features do indeed characterize many of the Italian films, but it would be misleading to view them in such binary terms. As any student of the American genre will confirm, the ever-changing western had been exploring its own ideological crises for years before the Italians twisted the knife. Just see *Vera Cruz* (Robert Aldrich, 1954), *Johnny Guitar* (Nicholas Ray, 1954), *Man of the West* (Anthony Mann, 1958) and John Ford's own unravelling of a nation's mythic past, *The Man Who Shot Liberty Valance* (1962), for a glimpse of how Hollywood's traditional emphasis on regenerative violence was becoming ever more problematic as the Cold War intensified. The Italian western is more appropriately viewed as a site of cultural exchange, which both exploited and exacerbated an already present sea-change in popular cinema and its patterns of consumption.

Ultimately, of course, spaghetti westerns are there to entertain, and in this purpose above all others they rarely disappoint. Only around one fifth were released outside Italy, and these were greeted overwhelmingly with hostility and bewilderment from critical establishments. Nevertheless, from the moment these films came into contact with the global marketplace, shoehorned into action double bills at grindhouses and fleapits around the world, enraptured audiences were taking ownership of this offbeat, droll approach to low-budget film-making. The numerous tributes to this *filone* throughout the work of such giants of contemporary independent cinema as Quentin Tarantino and Robert Rodriguez display such active celebration in its most culturally visible terms. Long since a behemoth of cult cinema and shorthand for laconic 'cool', the spaghetti western's legacy has entered the mainstream, and shows no sign of abating.

Austin Fisher

The Big Gundown

La resa dei conti

Studios:
Produzioni Europee Associati (PEA)
Rome Produizone Cinematografica
Tulio Demicheli PC

Director:
Sergio Sollima

Producer:
Alberto Grimaldi

Screenwriters:
Sergio Sollima
Sergio Donati (from a story by Franco Solinas and Fernando Morandi)

Cinematographer:
Carlo Carlini

Composer:
Ennio Morricone

Art Director:
Carlo Simi

Editor:
Gaby Peñalba

Duration:
111 minutes

Genre:
Western

Cast:
Lee Van Cleef
Tomas Milian
Walter Barnes

Year:
1967

Synopsis

Jonathan Corbett is a legendary former sheriff whose work has made Texas a more peaceful place. Brokston, a rich entrepreneur, pushes him to take on the job of Senator: after being elected Corbett will be able to facilitate Brokston's plan to construct a railway that runs all the way to Mexico and will make him even richer. As a final job, Corbett sets out to capture a peasant accused of raping and killing a young girl. The accused is Manuel 'Cuchillo' Sanchez, a Mexican peon who lives by his wits; a man with cat-like reflexes who is cunning and expert with a knife. The hunt for Cuchillo turns out to be harder than anticipated: Corbett comes close to capturing him several times, but Cuchillo always manages to find a way to escape. The chase becomes personal for Corbett, who follows Cuchillo out of his jurisdiction and into Mexico. Meanwhile, Brokston has decided to put an end to the hunt and unleashes his men, including the Prussian Baron Von Schulenberg, a crack shot. In the epic final duel, Corbett must decide which side to take…

Critique

La resa dei conti is the first of three spaghetti westerns directed by Sergio Sollima between 1967 and 1968 (the other two being *Faccia a faccia* in the same year, and *Corri uomo corri*/*Run, Man, Run* in 1968), at the height of the *filone*'s golden age. The film was developed from an original idea by Franco Solinas, and it gained enormous public success and some modest critical acclaim on its initial release. Like other 'political' Italian westerns, the film allegorizes the radicalism of the era, including the notion of conflict as the motor of change and a general 'Third Worldist' attitude.

The plot of *La resa dei conti* develops in a way typical of the thriller (a man assumed guilty, the search for evidence, the final resolution of the plot) but like many Italian westerns it also owes a lot to the picaresque tradition: in the contrast it presents between the privileged and the oppressed; in its tone combining farce and tragedy; and, above all, in the character of Cuchillo – one of the era's most effective dramatic archetypes. Cuchillo is played by Tomas Milian, an actor of Cuban origin until then largely known for his dramatic roles but who was to be a key character in Sollima's subsequent westerns and who would become the face of this *filone* in Italy. The character is down on his luck and prey to his own base instincts; forced into an existence somewhere between human and animal; egalitarian; able to evade his enemies through wit and disguise and not averse to double-crossing when he needs to; and yet endowed with an instinctive political consciousness ('The world is split into two parts', he says in the Italian language soundtrack; 'one half flees and the other half chases'). Lee Van Cleef's role as Jonathan Corbett is very similar to his portrayal of the infallible bounty killer Douglas Mortimer in *Per qualche dollaro in più*/*For a Few Dollars More*

(Sergio Leone, 1965). However, behind the impassive face of the gunslinger, Corbett from the outset adopts different guises to trap his foe (in the first scene we seem him pretend to befriend three criminals, before killing them). By the end he succeeds in effecting a change in his behaviour, which until then has involved a Manichean distinction between good and evil ('You thought I'd shoot first and then think. You were mistaken', he tells Brokston at the end of the film). The relationship between the two protagonists develops through unexpected parallels which lead to a very surprising ending. *La resa dei conti* can be seen as a portrayal of the period through the relationship between the two main characters, who, although apparently irreconcilable, are shown to have a similar attachment to iron moral principles, a rebelliousness in the face of authority, and the ability to wear disguises either to escape from justice or to uphold it personally.

[Spoiler alert]: The double-duel finale is highly memorable: in the first, Cuchillo confronts Brokston's son-in-law armed with his trusty knife while his rival wields a pistol; in the second, Corbett confronts the mercenary Baron Von Schulenberg in a classic depiction of the revenge of the dispossessed over the murky workings of power. The scene unfolds to the accompaniment of *The Verdict*, composed by Ennio Morricone after Beethoven's *Für Elise*. The piece, re-used by Quentin Tarantino in *Inglourious Basterds* (2009) in homage to one of his favourite films, alternates between the well-known melody by Beethoven and guitar arpeggios common to the emotional crescendos of Morricone's spaghetti western scores. The duel thus becomes an effective display of the *filone*'s combination of elements from different historical epochs: the re-use of images (the repertoire of standard western clichés) and of audio from the past (the European musical tradition) together create an innovative cinematographic style.

The vitality of the character of Cuchillo signals the gradual blending of the western *filone* with elements of comedy and farce, which contributed in subsequent years to its transformation and eventual extinction.

Mimmo Gianneri

A Bullet for the General

El chuncho, quien sabe?

Studio:
MCM

Director:
Damiano Damiani

Synopsis

Mysterious gringo Bill Tate ventures south of the border at the height of the Mexican Revolution. When his train is ambushed by bandits he befriends their leader – an exuberant outlaw by the name of Chuncho – and lends a hand in the group's insurrectionary activities. After they have carried out explosive assaults on government forts and liberated the town of San Miguel from its feudal thrall, Chuncho is faced with a tough choice: stay to defend San Miguel's desperate peasants from governmental reprisals or continue his gun-running to the mountain hideout of rebel guerrilla

Producer:
Bianco Manini

Screenwriters:
Franco Solinas
Salvatore Laurani

Cinematographer:
Antonio Secchi

Composer:
Luis Bacalov

Editor:
Renato Cinquini

Duration:
115 minutes

Genre:
Western

Cast:
Gian Maria Volonté
Lou Castel
Klaus Kinski

Year:
1966

leader General Elias? The gang, influenced by Tate, decide on the latter. After losing most of their number en route, Chuncho and Tate at last arrive at Elias's encampment. Here, Chuncho's dilemma between revolutionary commitment and mercenary opportunism intensifies as Tate's true purpose in Mexico reveals itself to the audience.

Critique

When questioned in later years, director Damiano Damiani would insist that this was no western but 'a film about the Mexican Revolution…it is clearly a political film and nothing else.' His analysis is flawed, the false dichotomy he constructs displaying nothing so much as the fallacy of authorial intent. It is certainly true that the narrative structure, characterization and didactic ideological positioning of *El chuncho, quien sabe?* place the film within the oeuvre of its famed Marxist screenwriter Franco Solinas (a close resemblance to the later *Queimada/Burn!*, Gillo Pontecorvo, 1969, in particular insisting that such an association be made). Damiani's comment, however, both disregards the extent to which his film is entwined with the conventions of the Hollywood genre, and overlooks the curious fusion of populism and revolutionary sentiment that characterizes his influential left-wing spaghetti western.

A Bullet for the General/El chuncho, quien sabe?, MCM.

A direct and confrontational appropriation of the Hollywood western's Cold War 'south of the border' format, *El chuncho, quien sabe?* delivers a firm rebuke to such films as *Vera Cruz* (Robert Aldrich, 1954) and *The Magnificent Seven* (John Sturges, 1960). While these movies used revolutionary Mexico to allegorize US interventionism in the Third World in affirmative terms, Damiani's film employs the same conceit while pouring scorn on that very ideology. The gringo adventurer in Mexico is no longer, as in the American films, a beneficent paladin come to right the wrongs of feudal injustice, but a distinctly shady and arrogant interloper.

The narrative thrust belongs to the Mexican bandit Chuncho, his ambiguous relationship with Bill Tate a catalyst for his gradual revolutionary awakening. To this end, the film-makers are purposeful in their manipulation of camerawork, *mise-en-scène* and musical refrains, incrementally leading the hero towards epiphany. Gian Maria Volonté's bipolar performance, meanwhile, effectively conveys the character's inner struggle: by turns uninquisitive exuberance and studied contemplation. This schizophrenia, indeed, is infused throughout the film, as formulaic action-packed western spectacle rubs shoulders with far-left didacticism. So we find a train ambush and a succession of thrilling, and increasingly explosive, fortress assaults spliced with ideological disquisitions lifted straight out of Frantz Fanon's seminal postcolonial tract, *The Wretched of the Earth* (1961). The episode in the rebel village of San Miguel in particular provides a studied revolutionary vignette, with the peasants violently rising up against the landowner Don Felipe and attempting to establish a new, egalitarian society. The single most memorable moment comes with Chuncho's final awakening, which affirms the righteousness of Third World resistance against the might of the West, or so the film-makers intended.

The result is an entertaining, intriguing, at times incoherent morass of mid-1960s political contradictions. If Solinas's meticulous adherence to Fanonist tenets is lost amidst the carnage, the contemporary message is at least clear enough and the film was genuinely influential. A number of leftist spaghetti westerns set in a similarly allegorical Mexican Revolution followed on its heels, most notably *Il mercenario/The Mercenary* (Sergio Corbucci, 1968), *Tepepa* (Giulio Petroni, 1968) and *Vamos a matar, compañeros/Companeros* (Corbucci, 1970). Moreover, that Damiani's film has since attained the status of cult classic becomes abundantly clear upon viewing Robert Rodriguez's spaghetti homage *Once Upon a Time in Mexico* (2003).

Austin Fisher

Day of Anger

I giorni dell'ira

Studios:
Sancrosiap
Corona Filmproduktion
KG Davina Film

Director:
Tonino Valerii

Producers:
Alfonso Sansone
Henryk Chrosicki (as Sansone and Chrosicky)

Screenwriters:
Ernesto Gastaldi
Renzo Genta
Tonino Valerii

Cinematographer:
Enzo Serafin

Composer:
Riz Ortolani

Art Director:
Carlo Simi

Editor:
Franco Fraticelli

Duration:
115 minutes

Genre:
Western

Cast:
Lee Van Cleef
Giuliano Gemma
Walter Rilla
Andrea Bosic

Year:
1967

Synopsis

Downtrodden town outcast Scott Mary, pushed around and belittled by the mean-spirited elders of Clifton, dreams of getting a pistol and commanding respect from his persecutors. When charismatic gunman Frank Talby rides into town he shows some kindness to the youngster and soon takes him on as a pupil/partner as he strives to obtain his own revenge on the same town elders. It transpires that these pillars of the community are not quite as honest and upstanding as they would appear and Talby sets about demanding the $50,000 from them which he is owed by their criminal associate, Wild Jack. Talby soon commands a position of wealth and power in the town but the elders are not ready to give up so easily. Meanwhile, young Scott has been transformed from town dogsbody to skilled gunman and, for him, nothing will be the same again. What unfolds is a morality tale of mixed loyalties, two mentors and a poisoned chalice; where Scott finds his revenge but loses his innocence.

Critique

In the United Kingdom and America, Lee Van Cleef was, and still is, a name synonymous with the spaghetti western. His narrow, piercing eyes and angular features, so familiar from Sergio Leone's massively popular 'Dollar' films, linked him forever with the *western all'italiana* and rekindled a fading career into an internationally-successful one. But in the domestic Italian market throughout the 1960s there was only one king of the western and that was local boy Giuliano Gemma. Of the fifteen most successful locally-made westerns released up to and including this one in 1967, an impressive nine of them featured Gemma's name above the marquee. So the teaming of the two stars in this film along with Leone protégé Tonino Valerii in the director's chair was something of a box-office dream team at the time. Thankfully, the combination works on film as well as on paper and *I giorni dell'ira* remains a fine example of all three men's work in the *filone* without necessarily challenging their very best.

The story is constructed around the familiar themes of a young man's journey under the influence of an older mentor until his inevitable questioning of the teacher's character forces a showdown. Our hero is seduced by the temptations of a darker path and ultimately has to choose between the two men to whom he owes the most: Talby, who taught him how to survive; and Murph (played by the outstanding German stage actor Walter Rilla), who taught him what to believe in. This dynamic is helped along by the fact that we are never quite sure how good or bad Talby is. Certainly in comparison to the prominent townsmen of Clifton he appears positively saintly but tensions build as the narrative unfolds and we learn just how far he will go to get what he believes he is due.

I giorni dell'ira benefits from a number of factors. The musical score from Riz Ortolani is one of the most memorable in the

filone, combining screaming brass, twanging Stratocaster and a driving rhythm. This rousing theme opens the film with a blast and maintains its hook throughout. There are also some excellent set pieces which finely balance tension and release, foremost of which are a brutal shootout between Talby and Wild Jack (played by the wonderfully craggy-faced Al Mulock) and a headlong duel on horseback featuring muzzle-loaded rifles, this time between Talby and a bounty killer (played by master-of-arms Benito Stefanelli). In addition, Valerii's direction is sound and well thought out throughout. Giuliano Gemma has stated that Valerii was a meticulous planner and set up all the camera framing himself, never leaving it to cinematographer Enzo Serafin. If so, it was time well spent on the director's part as the film is always visually engaging.

For the two main stars this film became something of a high water mark. If neither actor's best film in this *filone* it was one of their last before the general quality and popularity of their westerns began to diminish. Apart from the highly entertaining *Ehi amico… c'è Sabata, hai chiuso!/Sabata* (Gianfranco Parolini, 1969), it would be Van Cleef's last Italian western of real merit. Although Gemma would continue to make many successful movies it would be the last, outside of the occasional exception, of his serious westerns as he followed the industry's trend towards more light-hearted buddy westerns (for example *Amico, stammi lontano almeno un palmo/Ben and Charlie* (Michele Lupo 1972) *Vivi o, preferibilmente, morti/Alive or Preferably Dead* (Duccio Tessari, 1969)), a sub-*filone* he was very adept in but which never reached the heights of his earlier work.

I giorni dell'ira, if not outstanding in any area bar Ortolani's scorching theme tune, is consistently well-crafted and works on just about every level required to earn its place among the upper echelons of the western *filone*. It is a film which benefits from repeated viewings and cries out for a major DVD release.

Phil Hardcastle

Django

Studios:
BRC Produzione Film
Tecisa Film

Director:
Sergio Corbucci

Producers:
Manolo Bolognini
Sergio Corbucci

Screenwriters:
Bruno Corbucci
Sergio Corbucci

Synopsis

The film opens with the now-iconic image of Django dragging a coffin through mud-soaked terrain on the US-Mexico border. After our antihero rescues the beautiful Maria from bandits, he finds himself caught in the middle of a war between a group of KKK-styled vigilantes led by Major Jackson and a band of Mexican revolutionaries led by General Hugo Rodriguez. Setting up base in the local saloon run by downtrodden owner Nataniele, Django is soon forced to demonstrate exactly what it is that he keeps in that mysterious coffin, inevitably leaving a trail of death and destruction in his wake.

Critique

While not as financially successful or as critically acclaimed as Sergio Leone's *Per un pugno di dollari/A Fistful of Dollars* (1964), it

José Gutiérrez Maesso
Franco Rossetti
Piero Vivarelli

Cinematographer:
Enzo Barboni

Art Director:
Carlo Simi

Editors:
Nino Baragli
Sergio Montanari

Duration:
93 minutes

Genre:
Western

Cast:
Franco Nero
José Bódalo
Eduardo Fajardo
Loredana Nusciak

Year:
1966

Django, BRC/Tesica.

is Sergio Corbucci's *Django* which is arguably the more influential and significant film for the development of the spaghetti western *filone*. Pioneering the dark, almost nihilistic tone which permeated the cycle in its early days, Corbucci saw *Django* as an 'anti-western' which would replace the iconic western landscape with mud and grit. The success of the film on its domestic release prompted at least 31 unofficial sequels produced in quick succession – the only official sequel, *Django 2: il grande ritorno/Django Strikes Again* (Nello Rossati, 1987), came much later – and this helped shape the distinctive Italian western tradition for years to come.

A variation on the 'servant of two masters' archetype, with Django playing off Major Jackson's men against the Mexican revolutionaries, the film allows star Franco Nero to establish the enigmatic persona with which he became forever associated. Ironically,

this role was originally to be played by Mark Damon – an actor who had earlier played *Johnny Oro/Ringo and his Golden Pistol* (1966) for Corbucci. Given *Django's* tone of gothic horror, it is arguable whether it could have had the same impact without Nero's brooding performance at its core. As Corbucci said of his lead actor, 'John Ford has John Wayne, Sergio Leone has Clint Eastwood and I have Franco Nero.'

The film develops some of the narrative motifs which Corbucci had established in his earlier western *Minnesota Clay* (1964), such as the warring factions and a temporarily crippled hero, although they are here combined with a deep pessimism and a relish for almost comic sbook-style violence. These elements are, of course, part of the film's appeal – from the absurdly high body count to the gratuitous mud-wrestling sequence. Most notoriously, however, the ear slicing sequence which Quentin Tarantino has acknowledged as inspiration for *Reservoir Dogs* (1992) helped the film get banned in the United Kingdom until 1993.

The film has gone on to establish a fascinating trans-cultural afterlife, from its screening in Jamaican crime classic *The Harder They Come* (Perry Henzell, 1972) right up to the recent Takashi Miike tribute *Sukiyaki Western Django* (2007). Admittedly, however, some aspects of the film itself have not stood the test of time. In particular, the second half of the film is wildly uneven and lacklustre, especially after such a powerful opening 30 minutes. Furthermore, the English language dubbed dialogue often enters 'so bad it's good' territory with lines such as 'I'm glad I made you feel like a real woman.' Nevertheless, that central image of Django dragging a coffin through the mud has proven highly iconic and memorable, and the film fully deserves its status as a classic of this *filone*. So while it may lack the gravitas of Sergio Leone's best work, or the political nous of Sergio Sollima's oeuvre, *Django* still holds up as one of the most fascinating westerns ever produced.

Iain Robert Smith

Django, Kill! (If You Live Shoot!)

Se sei vivo, spara!

Studios:
GIA Cinematografica
Hispamer Film

Director:
Giulio Questi

Synopsis

During the American Civil War, a nameless half-Mexican outlaw ('The Stranger') and his gang ambush a Yankee patrol and steal a fortune in gold from them. Before he can divide the spoils, The Stranger is betrayed by one of his colleagues, who decides to keep all of the gold for his own faction, massacring The Stranger and his Mexican accomplices in the middle of the desert before heading to a nearby town. As night falls, The Stranger emerges, zombie-like, from the grave and is discovered by two Native Americans, who tend to his wounds and help him recover. Hell-bent on revenge, haunted by his violent past and driven by his lust for the gold, The Stranger follows Oaks' mob into town only to find their bodies hanging, lynched, in the main street, beginning a long and bloody

Producers:
Alex J Rascal (Alessandro Jacovoni)
Giulio Questi

Screenwriters:
Franco Arcalli
Benedetto Benedetti
Giulio Questi

Cinematographer:
Franco Delli Colli

Art Director:
José Luis Galicia
Jaime Pérez Cubero

Composer:
Ivan Vandor

Editor:
Franco Arcalli

Duration:
117 minutes

Genre:
Western

Cast:
Tomas Milian
Piero Lulli
Milo Quesada
Roberto Camardiel

Year:
1967

struggle for the gold with a corrupt storekeeper, the leader of the mob and a Mexican bandit and his gang of sadistic gauchos. A whirlwind of chaos, betrayal, torture and violence ensues as The Stranger seeks to reclaim the gold that is rightfully his…by any means necessary.

Critique

A soil-streaked claw bursting out of a dusty grave; a man being scalped in bloody extreme close-up; a teenage boy being gang-raped; a colony of blood-sucking vampire bats…at first glance the central motifs of the surreal *Se sei vivo, spara!* – Questi's first and only western – seem far more rooted in the Italian horror cycle than the films of the canonical Italian western directors, and it is often hyperbolized by cult film fans as 'the most violent' of its *filone*. While it is true that a handful of the film's violent scenes are a good deal more visceral than is the norm in the western cycle, in truth it is *Se sei vivo, spara!*'s ostentatious style rather than its level of violence that makes it so remarkable. Much of the action is shot in gaudy, disproportionate and often extreme close-up, with lingering facial shots of grotesque grins and lip-licking, sweaty sadists serving only to exaggerate the film's eerie and perverse atmosphere. Coupled with this overemphasis on stylized close-ups and bizarre framings is the jagged and disorienting editing style that it adopts during its key scenes. This is made nowhere more apparent than in The Stranger's numerous 'flashbacks', where staccato bursts of contrasting, unrelated and even upside-down shots are fired onto the screen: the effect is both disorienting and brutal, two effects which Questi – a noted Communist – purportedly wanted to inflict on his audience. His own comments in subsequent interviews actively encourage a political reading of the film, where the disorientating brutality of the acts it depicts can be seen to reflect his own experiences fighting against Fascist Blackshirts during World War Two.

This idea finds its shocking apotheosis in one of *Se sei vivo, spara!*'s climactic scenes where The Stranger rigs a horse with explosives and spurs it towards a suicide mission to destroy Zorro's (also black-shirted) gauchos. Rather than attempt to depict the detonation and subsequent carnage in realistic wide shot (an act that Questi's limited production budget would have struggled to achieve), the film instead conveys the violence through a rapid sequence of edits between shots of explosions, extreme close-ups of bloodied limbs, broken faces and dynamite – accompanied by screams and loud banging noises – before finishing on a low-angle extreme close-up of tin soldiers on a board being knocked over. Whether a conscious nod to Soviet montage directors or not, this extremely visible, confrontational style of editing is one of *Se sei vivo, spara!*'s most interesting facets.

Of course, with this marked emphasis on spectacle and formal experimentation comes the inevitable weakening of narrative cohesion common across the Italian *filone* cycles. The Stranger's quest for vengeance against Oaks is satisfied as early as the end of the film's first reel, and the plots and sub-plots which ensue

are convoluted and hard to follow amidst the battles and torture scenes that punctuate the film. But it is not from the conventional narrative norms of characterization, motivation and closure that *Se sei vivo, spara!*'s central pleasures are to be derived: besides its aerobic editing style and generic intertextuality, also noteworthy are the miniscule surrealist touches littered throughout the film. The naked boy standing in a windswept porch; the vampire bats crawling on the camera; the villain encased in molten gold; the alcoholic, abusive parrot in Zorro's lair…all work to reinforce the brutal, otherworldly atmosphere that makes the film stand out from its peers. When, at the end of the film, the traditional western 'ride into the sunset' is overshadowed by the spectacle of a boy and a girl contorting their faces with string and arguing over who is the ugliest, this comes as absolutely no surprise, for *Se sei vivo, spara!*'s central achievement is the way in which its unusual visual style makes brutally apparent the ugliness of the world depicted.

Robbie Edmonstone

Face to Face

Faccia a faccia

Studios:
Produzioni Europee Associati (PEA)
Arturo González Producciones Cinematográficas

Director:
Sergio Sollima

Producers:
Arturo González
Alberto Grimaldi

Screenwriters:
Sergio Donati, Sergio Sollima

Cinematographers:
Emilio Foriscot, Rafael Pacheco

Composer:
Ennio Morricone

Art Director:
Carlo Simi

Editor:
Eugenio Alabiso

Synopsis

Liberal-minded New England professor Brad Fletcher quits his university job and heads west for health reasons. Upon his arrival in Texas, he is abducted by notorious bandit Beauregard Bennett, and comes face to face with the violent struggle for survival which defines the outlaw's life. As the two men grow closer, Professor Fletcher's compassionate worldview is increasingly undermined as he himself becomes 'educated' by the harsh realities of the Wild West and joins Bennett's gang. Infiltrated by Pinkerton Agent Charlie Siringo, the gang arrives in the mountain community of Puerto del Fuego, where Fletcher gradually comes to realize his own power and takes control. Bennett becomes ever more circumspect, while Fletcher descends into megalomania and the authorities vow to eradicate the outlaws altogether. As a posse of vigilantes sets out to attack the commune, the social conflict between the law and the bandits, and the personal one between Fletcher, Bennett and Siringo, draw to their explosive finales.

Critique

At first glance, *Faccia a faccia* is an anomaly amongst spaghetti westerns. Loquaciously philosophical and contemplative, Sergio Sollima's second foray in this popular *filone* is distinctive and eccentric in equal measure. This is not to say that the film is a total departure from its industrial norms; more that it uses pre-existing strands of westerns both Hollywood and spaghetti, deploying them to novel, and ostensibly incongruous, political ends. Sollima intended that this tale of a good man turned power-crazed killer should dramatize the dangerously seductive nature of fascist brutality, which the director had experienced firsthand when serving in the wartime Resistance.

Duration:
111 minutes

Genre:
Western

Cast:
Gian Maria Volonté, Tomas Milian, William Berger, Jolanda Modio

Year:
1967

The urbane easterner becoming revitalized by the wilderness out west is a narrative device as old as the hills (Owen Wister's novel *The Virginian* kick-started the cinematic western with precisely this trope in 1902), but Professor Fletcher's virile awakening is altogether more sinister: cowboy boots swapped for jackboots, if you will. Themes of inner tension and latent power within the individual are introduced as key components before the opening credits have even rolled, when Fletcher delivers a parting lecture to his class, and this sets the tone of the morality tale to come. His is a decidedly Nietzschean transformation, as his liberal humanitarian outlook is gradually surpassed by a brutal self-serving *realpolitik* ('What is surprising is that a man like me can remain all those years watching life as a spectator before he discovered the force that was in him'). The Professor's meticulous and intellectual application of brute force is memorably encapsulated as he tortures a bound lawman while calmly expounding his 'philosophy of violence': 'One violent man is an outlaw; a hundred violent men are a gang; a hundred thousand, an army. This is the point: beyond the confines of individual violence, which is criminal, one can reach the violence of the masses, which is history!'

That violence, avarice and self-preservation hide behind civilized appearances is a recurrent spaghetti-western notion: one which *Faccia a faccia* inherits and explores in unusually philosophical depth. If this film offers a warning about the monsters that lurk beneath the façade of propriety, however, the diabolical transformation it depicts is also exhilarating. Coupled with the political admonition, there is ambiguity surrounding Brad Fletcher's awakening, which casts doubt upon the overall effectiveness of the intended message: the morally-upstanding Brad is weak, sickly, cowardly and sexually repressed; the monster, strong, brave and virile. This is entirely in keeping with the western's traditional emphasis on masculine vitality and regenerative violence. If Sollima indeed set out to condemn the seductive nature of brutality and power, he chose an odd medium.

The central character's Jekyll-and-Hyde transformation therefore provides the film with its key, if convoluted, political purpose; but Sollima also inserts a fair dose of modish radical sentiment, which bestows the story with a curious, and inadvertent, prescience. This depiction of a corrupted, fascistic academic authority figure takes on a singularly contemporary resonance when one considers that the Italian student demonstrations were erupting at precisely the time of *Faccia a faccia*'s release. At this seminal cultural moment, as Italy's post-war generation gap was erupting into open confrontation, the conspicuously long-haired dropout Beauregard Bennett represents an alternative social vision to a vicious officialdom. His gang and their non-conformist mountain refuge constitute a hippie commune way out west, a good three years before New Hollywood cottoned on with Arthur Penn's *Little Big Man* (1970).

Greeted with a mixture of bemusement and indifference upon its international release, *Faccia a faccia* remains a spaghetti oddity, if only for its purposeful denial of action-packed spectacle. Such an idiosyncratic film was never going to spawn a glut of imitations. It displays instead this *filone*'s ability to surprise, as well as to entertain.

Austin Fisher

A Fistful of Dollars

Per un pugno di dollari

Studios:
Constantin Film Produktion
Jolly Film
Ocean Films

Director:
Bob Robertson (Sergio Leone)

Producers:
Harry Colombo (Arrigo Colombo)
George Papi (Giorgio Papi)

Screenwriters:
A Bonzzoni
Víctor Andrés Catena
Sergio Leone

Cinematographer:
Jack Dalmas (Massimo Dallamano)

Art Director:
Charles Simons (Carlo Simi)

Composer:
Dan Savio (Ennio Morricone)

Editor:
Bob Quintle (Roberto Cinquini)

Duration:
99 minutes

Genre:
Western

Cast:
Clint Eastwood
Johnny Wels (Gian Maria Volonté)
Marianne Koch
José Calvo

Year:
1964

Synopsis

A stranger in a poncho rides on a mule into the small town of San Miguel, just south of the Mexican-American border. He learns from the bartender Silvanito that the town is being run by two rival gangs – the American Baxters (gunrunners) and the Mexican Rojos (liquor smugglers). First selling his services to the Rojos, then the Baxters, the stranger plays one side against the other and profits from both, to the delight of coffin-maker Piripero. He witnesses Ramon Rojo ruthlessly stealing a shipment of gold from the Federales, at the Rio Bravo canyon. Returning to San Miguel, the stranger secretly rescues a Mexican family from the Rojos – Marisol, Julian and little Jesus – but is discovered and savagely beaten. After he has managed to escape in a coffin, and after the furious Rojos have burnt down the Baxter house, massacring the entire family, the stranger returns to town, heralding his arrival with a dynamite explosion, and has a shootout with the Rojos in the main square. In the final duel, with Colt 45 versus Winchester rifle, there is more than a fistful of dollars at stake.

Critique

Originally filmed under the title *The Magnificent Stranger* (*The Magnificent Seven*, John Sturges, 1960, having been a big box-office hit in Italy), this was not the first of the Italian or Italian-Spanish westerns – Sergio Leone reckoned it was the twenty-fifth; it depends how you count – but earlier ones, on the whole, had tended to be pale imitations of Hollywood 'B' or TV westerns. Hollywood was producing fewer and fewer feature westerns, while Italian audiences, especially in the South, were still as keen as ever on seeing them. *Per un pugno di dollari* brought together, for the first time, director Leone, production designer Carlo Simi, and composer Ennio Morricone, each making a distinctive contribution to the 'Italianizing' of the western: the south-western locale (really Spain – near Madrid and in Almería); the larger-than-life interiors; the raucous musical score (Fender Stratocaster guitar, whipcracks, bells, yelling chorus, drum-beats and whistles); the blend of convincingly grungy detail and mythic core; the rhetorical use of the visual 'codes' of the Hollywood western; references to hallowed moments from favourite western movies – in this case *Shane* (George Stevens, 1953), *Warlock* (Edward Dmytryk, 1959) and Budd Boetticher's Ranown cycle; the promotion of delinquent and streetwise western characters from background to foreground; an obsession with dollars; and the use of distancing devices such as irony, gallows humour, and the voice of a character saying 'it's like playing cowboys and Indians'.

As the Italian novelist Alberto Moravia was to put it: '…the Hollywood western was born from a myth; the Italian one is born from a myth about a myth…The dominant theme is the scramble for money…[which] contrasts radically with the grand settings and epic tone of the western genre.' Sergio Leone wanted to keep his

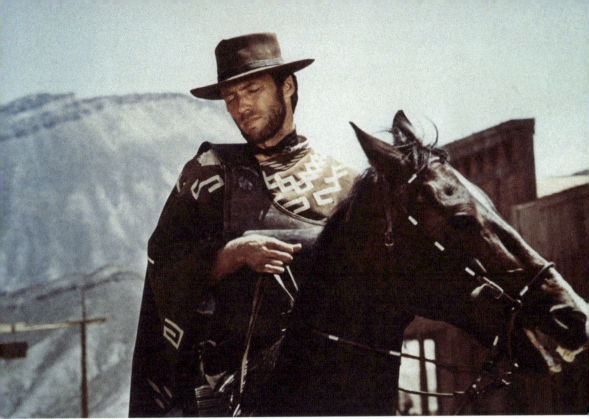

A Fistful of Dollars/Per un pugno di dollari, Jolly/Constantin/Ocean.

'fairytale for grown-ups' as realistic (by which he meant cynical) as possible, putting an emphasis on the unpredictable, pumping up 'the spectacle' (as far as the low budget would allow) and creating a hero more in tune with the times than the ageing stars who still dominated the Hollywood product. So the fourth key individual in the mix was Clint Eastwood, cast as the stranger – called 'Joe' (in the script) or 'The Man With No Name' (on the American posters). Eastwood had appeared in ten features between 1955 and 1958, usually as a walk-on, before featuring as the second lead in the long-running CBS television series *Rawhide*. He was cast in *Pugno* – after James Coburn, Charles Bronson and others had turned the part down – as the result of a viewing in Rome of Episode 91 of *Rawhide*.

Per un pugno di dollari was loosely based on Akira Kurosawa's samurai film *Yojimbo/The Bodyguard* (1961), which Leone had seen in Rome in autumn 1963. *The Magnificent Seven*, too, had been based on a Kurosawa original. But this time, someone forgot to clear the rights and the film became the subject of a legal battle resulting in Kurosawa being awarded distribution rights in the Far East – where the film was a huge success – plus a slice of the world-wide profits. Another result was delayed distribution in America. Apart from the Rio Bravo canyon sequence and a cemetery gun battle with decoy corpses, the main differences between *Pugno* and *Yojimbo* include the absence in *Pugno* of reference to any 'outside world'; the comic-book characterization of the laid-back

stranger, with his stubble and cigar; and the story's complete indifference to law (or indeed to any form of legitimate authority). *Pugno* also ignores any 'civilizing' implications of settlement. In San Miguel, there is no sense of progress, resource or development. This, too, was a radical departure from the traditional western.

Sergio Leone called this his first 'personal film'. It made Clint Eastwood a superstar in Europe, and it relaunched and redefined the entire Italian western craze that would last until the early 1970s. In that sense, *Per un pugno di dollari* really WAS the first of the Italian westerns.

Christopher Frayling

Keoma

Studio:
Uranos Cinematografica

Director:
Enzo G Castellari

Producer:
Manolo Bolognini

Screenwriters:
Enzo G Castellari
Nico Ducci
George Eastman
Mino Roli

Cinematographer:
Aiace Parolin

Art Director:
Carlo Simi

Editor:
Gianfranco Amicucci

Duration:
101 minutes

Genre:
Western

Cast:
Franco Nero
William Berger
Olga Karlatos
Donald O'Brien

Year:
1976

Synopsis

On his return from fighting in the Civil War, the mixed-race Keoma discovers that his home town is now under the control of the merciless Caldwell. The town is ravaged by the plague and, to make matters worse, Caldwell and his gang of ex-soldiers are forcing inhabitants to move into an abandoned mine shaft with no hope of medical attention. Defying Caldwell's men by rescuing the pregnant Lisa from this fate, Keoma soon discovers that even his own half-brothers are collaborators. Dejected, he joins forces with the town drunk George and the local doctor to concoct a plan to secure medical supplies and finally free the local people from the tyrannical rule of Caldwell.

Critique

Often described as a twilight spaghetti western, *Keoma* functions as an elegy to the *filone* which director Enzo Castellari and star Franco Nero so loved. Coming at the tail end of the cycle, the film is infused with a mournful, poetic quality far removed from the crude excesses of its forebears. Indeed, this was to be one of the last attempts to make a serious spaghetti western at a time when the *filone* had descended into self-parody. Released in the United States under the title *Django Rides Again*, the film marks the return to the western of Franco Nero: a fact alluded to in a reflexive opening sequence which pointedly asks 'Why did you come back?' As if to answer, the film then plays out like a greatest-hits package from those early spaghetti westerns, adapting and reworking many of the clichés of the cycle, from the lone hero who arrives in a deserted town, through to the alcoholic gunslinger who is forced to redeem himself.

Keoma, therefore, returns the *filone* to its individualist roots, after a shift towards more Marxist communitarian values in the political westerns of the late 1960s and early 1970s. As Keoma himself declares, 'I have to do it alone because I am alone.' This allows Franco Nero, bearded and dishevelled in the title role, to recapture some of that enigmatic outsider quality which so defined

his portrayal of Django ten years earlier. The cross-fertilization with the US western is also very much in evidence with Enzo Castellari's use of slow-motion paying an obvious debt to the films of Sam Peckinpah – a body of work which was, in turn, deeply influenced by the early spaghetti westerns. In addition, Castellari lends some gravitas to these familiar generic tropes with repeated allusions towards biblical stories and contemporaneous civil rights struggles.

Nevertheless, *Keoma* is not without its problems. Most notoriously, the score by the De Angelis brothers acts as an awkwardly self-conscious Greek chorus to proceedings – with two folk singers narrating the action in painfully literal terms. Inspired by the Leonard Cohen score for *McCabe and Mrs Miller* (Robert Altman, 1971), this is one innovation that sadly does not succeed and it detracts from some otherwise very effective set pieces. Furthermore, the po-faced seriousness of the treatment acts in tension with some of the more trashy elements of the action, unfortunately resulting in some moments of pure naive camp.

Ultimately, the film ends with an explosive confrontation and Keoma celebrating the birth of a newborn baby. He defiantly declares that this child cannot die because 'a man who is free never dies.' Concluding the film's allegorical treatment of life and death, this is perhaps Keoma's most enduring statement regarding the spaghetti western. This *filone* may have been on its last legs in its current incarnation, but it would still live on. The spaghetti western is dead. Long live the spaghetti western.

Iain Robert Smith

Man Called Blade

Mannaja

Studio:
Devon Film

Director:
Sergio Martino

Producer:
Luciano Martino

Screenwriters:
Sauro Scavolini
Sergio Martino

Cinematographer:
Federico Zanni

Synopsis

In the American Old West, an axe-wielding mercenary known only as 'Blade' chases and apprehends a wanted outlaw named Burt Craven. Blade attempts to collect his bounty from Suttonville, a lawless mining town dominated by the wheelchair-bound owner of the mine and his sadistic henchman. After winning $5,000 from Voller in a card game, Blade frees Craven and offers his services to McGowan, promising to help defend his assets for a wage. McGowan is not interested, however, and Voller's mob try to run Blade out of town, beating him up then triggering a rockslide that crushes him as he rides through a canyon. Left to die in the rubble, Blade is found by the members of a passing burlesque troupe and is nursed back to health by one of the dancing girls, whom he befriends. Hiding with the troupe, Blade returns to Suttonville to confront the treacherous Voller, who unbeknownst to McGowan has secretly been looting silver from the mine and has even kidnapped McGowan's daughter to claim ransom money from him. Blade sets out to rescue the girl but, as the bodies pile up and the ensuing war with Voller speeds towards its bloody climax, a more deep-rooted and personal quest for vengeance against McGowan emerges…

Composers:
Guido and Maurizio De Angelis

Editor:
Eugenio Alabiso

Duration:
92 minutes

Genre:
Western

Cast:
Maurizio Merli
John Steiner
Sonja Jeannine
Donald O'Brien

Year:
1977

Critique

Released in 1977, well after the popularity of the Italian western had begun to dwindle, *Mannaja* nonetheless represents a rare creative apex for the cycle, borne largely from the constant commercial pressure to identify, exploit and repackage successful filmic formulae that shaped Italy's *filone* cycles. The result is a glorious cinematic mishmash that draws from a number of commercially-successful *filoni* in an attempt to maximize its box-office returns. *Mannaja* teams one of the *giallo* thriller's most prolific directors (Sergio Martino) with one of the *poliziottesco* cop drama's key leading men (Maurizio Merli) and translates a fairly hackneyed western revenge plot into something far more interesting via a myriad of intertextual borrowings. Alongside the usual guns, girls and gringos, the film is peppered with horror-film motifs (eerie, fog-strewn swamps, devil dogs, severed limbs, gore and eye mutilation), chase sequences, a tree-hugging eco-western subplot and heavy religious allegory (the father and the son, resurrection from a cave, betrayal by a 'Judas'), all mixed in with a smattering of high camp (mud wrestling, burlesque dance sequences, an effete German villain). That all of this is flamboyantly accompanied by a soundtrack that veers unpredictably between Italian western ballads, contemporary pop songs, synth-led horror motifs and 1970s prog rock is no surprise, for *Mannaja* is truly the hybrid western *par excellence*.

Yet the film's real triumph is that it somehow manages to be more than the sum of its many disparate parts: Merli's *Dirty Harry*-esque tough cop transposes quite smoothly from the *poliziottesco* to the western and he fixates throughout, typically dominating the screen in tight facial close-up, his hirsute Mediterranean machismo perfectly offset by the sneering Teutonic camp of John Steiner's Voller. When, in one of the film's key scenes, the villain buries Blade up to his neck in sand, pins his eyelids open and leaves him gazing into the burning midday sun, the effect is profoundly disturbing. But this is just one of the many emotions that Martino's relentlessly playful film elicits; equally evocative is the mood of gallows humour that permeates, most notably in a central scene where a full-on burlesque song-and-dance sequence is intercut with a sequence depicting Voller's men cruelly butchering innocent civilians in a stagecoach. As the music from the dance troupe bleeds across both scenes, shots of bodies being riddled with bullets are accompanied by the whoops and cheers of the burlesque audience, with slow-motion shots of the massacre vying with fetishistic close-ups of dancing leather boots, frilly knickers and makeup-caked faces. Furthermore, as if such an alignment of extreme violence and entertainment – perhaps the two *modus operandi* of the *filone* – was not enough, by cutting together close-ups of boots and horses' hooves, red garter pom-poms and bloody bullet wounds from the two spaces, the film actively encourages its audience to identify links between the two. The lesson is clear: in the hands of the Italian directors, violence in the Old West is stripped of all the historical and ideo-

logical importance that lent it such symbolic force in the classical Hollywood western, replaced instead by the showy, burlesque brutality epitomized by scenes such as this. Though far from being an archetypal Italian western like the films of Leone, Corbucci and Sollima, *Mannaja*'s heady medley of violence, spectacle and genre makes it the perfect entry-point to a wider appreciation of the Italian *filone*.

Robbie Edmonstone

My Name is Trinity

Lo chiamavano Trinità…

Studio:
West Film

Director:
EB Clucher (Enzo Barboni)

Producers:
Joseph E Levine
Donald Taylor
Italo Zingarelli
Roberto Palaggi

Screenwriter:
EB Clucher (Enzo Barboni)

Cinematographer:
Aldo Giordani

Art Director:
Enzo Bulgarelli

Editor:
Giampiero Giunti

Composer:
Franco Micalizzi

Duration:
106 minutes

Genre:
Western

Synopsis

A handsome, but bedraggled, young man lazily journeys across the wilderness on a horse-drawn travois. Arriving at a stagecoach station he has a copious meal. His reputation as the fast-shooting Trinity, the 'Right Hand of the Devil', enables him to seize an injured Mexican prisoner from a couple of bounty hunters, whom he then nonchalantly kills without seeming to aim. He transports the Mexican to a small town where he observes the sheriff effortlessly killing three men single-handed in a gun fight. This huge, bad-tempered man is revealed to be Trinity's estranged brother Bambino, who is faking the position of lawman, while in fact he is a horse-thief on the run. Trinity and Bambino form an awkward, temporary alliance to defend some peace-loving Mormons from two menacing factions: a group of wild Mexicans led by Mezcal; and an acquisitive landowner Major Harriman, who covets their terrain.

Critique

The spaghetti western had reached its peak in terms of annual turnover in 1968, and an innovative approach was needed to refresh this *filone*. A waning genre will often try a new approach by parodying itself or by blending with other genres. In the case of *Lo chiamavano Trinità…*, the revitalized format was a mixture of slapstick comedy, spaghetti western violence and a traditional western theme of outsiders coming to the aid of a community, as found in *Shane* (George Stevens, 1953) and *The Magnificent Seven* (John Sturges, 1960). The building of the Mormon settlement and the fight with Harriman's men also have resonances with the barn-raising scene from *Seven Brides for Seven Brothers* (Stanley Donen, 1954). The contemptuous undermining of the moral authority of the powers of law enforcement, the cynical financial motivation of the heroes and the rich and powerful tyrant controlling the town are plot continuities from previous spaghetti westerns. However, *Lo chiamavano Trinità…* is seen as the start of a further sub-*filone*, using the formula of brawls and coarse visual humour. This category is sometimes called the *fagioli* (beans) western, and aspects of it were subsequently borrowed by Hollywood in *Blazing Saddles* (Mel Brooks, 1974).

Cast:
Terence Hill (Mario Girotti)
Bud Spencer (Carlo Pedersoli)
Steffen Zacharias
Dan Sturkie
Farley Granger

Year:
1970

The film was one of many to combine the comic forces of the blue-eyed, good-looking matinée idol Mario Girotti and the former swimming champion Carlo Pedersoli, in their Anglicized personas as Terence Hill and Bud Spencer. Here they are presented not as the ideal American heroes but as crude, lazy, unreliable, unwashed and unshaven antiheroes, with the saving grace of possessing kind hearts. The character of Trinity is a mixture of many elements. His footloose, roguish, deceitful nature as a womanizer and glutton resembles the protagonist of Charles de Coster's novel *The Legend of Thyl Ulenspiegel* (1867). His ultimately kind-hearted personality, with his propensity for helping the underdog, echoes Robin Hood, the Scarlet Pimpernel or Zorro. There is also a very strong influence from the *commedia dell'arte*, with Trinity in the role of Harlequin, the acrobatic scamp who was both childlike and amorous.

The largely visual humour includes scenes of eating in a gross style and extraordinary feats of fighting. Trinity demonstrates almost superhuman powers with the gun, while his 'baby' brother displays enough strength to defeat hordes of adversaries at once. However, the violence is more comic-book than realistic and as well as spectacular displays of shooting, there is a magnificent climactic fist-fight. The elaborate fight scenes were the result of the Italian stuntmen's years of experience with saloon fights in previous spaghetti westerns. The brothers recall Laurel and Hardy in *Way Out West* (James W Horne, 1937) or the Hollywood slapstick of the Mack Sennett era, and are contrasted in size and personality: one slim, attractive and carefree; the other fat, ugly and irritable.

Lo chiamavano Trinità... was the Italian film with the highest number of cinema viewers in Italy until 1986 and its comedic aspect became the profitable way forward for the spaghetti western. Hill and Spencer continued to be popular throughout the 1980s and 1990s, with films such as *Miami Supercops* (Bruno Corbucci, 1985) and *Botte di Natale/The Fight Before Christmas* (Terence Hill, 1994).

Eleanor Andrews

Ringo and His Golden Pistol

Johnny Oro

Studio/Distributor:
Sanson-Film

Director:
Sergio Corbucci

Synopsis

Johnny, a bounty hunter nicknamed Ringo, arrives at a small Mexican town where a forced wedding between Paco Perez and a local woman, Manuela, is taking place. In a showdown outside the church, Ringo kills the Perez brothers but spares the youngest, Juanito, who has no 'price on his head'. Ringo's passion for gold seems to be the motivating factor for all his actions. In Coldstone, a small town on the other side of the border, Sheriff Bill throws out of the saloon the rowdy Apache chief Sebastian. Juanito, determined to extract revenge, kills Manuela and forges an alliance with

Producer:
Joseph Fryd

Screenwriters:
Adriano Bolzoni
Franco Rossetti

Cinematographer:
Riccardo Pallotini

Art Director:
Carlo Simi

Editor:
Otello Colangeli

Composer:
Carlo Savina

Duration:
87 minutes

Genre:
Western

Cast:
Mark Damon, Valeria Fabrizi, Franco De Rosa, Etore Manni

Year:
1966

Sebastian's Apaches. Ringo, ambushed by members of the Perez gang, blows them up with a makeshift grenade but is sentenced to five days imprisonment by the over-scrupulous Bill. Juanito, now leading a formidable force of Mexican outlaws and Apaches, demands that Ringo is handed over to him or he will attack the town. This is rejected by Bill who places Ringo under his protection. The saloon owner Gilmore, who has traded in whisky and arms with the Apaches, fails to strike his own deal with Juanito and Sebastian. An exodus ensues leaving Bill, Matt (an old man who is a permanent resident of the jail), Jane, Stan and Ringo as the sole defenders of Coldstone.

Critique

Spaghetti westerns almost always involve a fine balance between mischievous playfulness and deadly seriousness. In that respect *Johnny Oro* offers clear insights into Corbucci's formative approach to the *filone*. In his third western, as the often anarchic directorial style becomes more assured, playfulness permeates not only the film's narrative but also its self reflexive employment of formal conventions. While capitalizing, at least with the English title, on international familiarity with a mythical western character (through 1950s films such as *Gunfight at the OK Corral*, John Sturges, 1957; the 1959–60 American television series *Johnny Ringo*; and Duccio Tessari's 1965 Italian western *Una pistola per Ringo/A Pistol for Ringo*), Corbucci's Ringo is a peculiar appropriation of that figure.

His real name, Johnny Artemidoro Jefferson Gonzales, sounds, as his jail mate Matt observes, 'half Mexican and half American' and it is this hybrid identity (typical of many of the spaghetti heroes) that makes the liminal space of the border his natural habitat. Despite his ceaseless mobility between cultures, Ringo is a perennial outsider, belonging nowhere and cropping up everywhere, an ambiguous centre of the profoundly relational narrative strands of the film. The rigid binary opposites of the traditional western become dynamic relationships in *Johnny Oro*: Mexico and the US; Gilmore and the Apaches; the Law and the outlaws; Bill and Jane who wants to move the family from Coldstone to civilized Boston Gilmore who lusts after Margie who loves Ringo. At the heart of all these fluid relationships, with uncertain boundaries and borders, lies, as in all westerns, the hero, or, to be precise, gold because Johnny is after all 'Oro'.

It is the values of the hero that in the traditional western reconcile the crucial ideological binaries and provide the film with its anxiously- and precariously-achieved coherence. But for Ringo the only value is gold; as the ballad of the Italian-language credits sequence explains: 'love has no importance to Johnny Oro; his only love is gold'. The dubbed English version of the song adds detail to the second part of the verse: 'His only love the power and glitter of gold.' This, I would suggest, holds the key to Corbucci's approach to the western *filone*. On the one hand Ringo, the ultimate spaghetti hero, is pure power, placing himself beyond

and above any form of social interaction in the same way that gold guarantees but also eludes any monetary transaction. In that respect Ringo is the hyperbolic and hyper-masculine version of all western heroes.

But such exaggerated and solitary devotion to power points to an equally hyperbolic underlying narcissism. The opening shot of the film, with Ringo dominating the frame in his immaculate black clothes, his perfect moustache and his golden pistol, strongly suggests that the real power of the character lies in the image, in his glittery golden looks. In fact 'looking good' becomes the ultimate value in Corbucci's formal system. The film uses camera movement, frame composition and shifts in focus to expressively articulate the fluid relationships that inform its narrative. A clear example is the opening shot where the camera juxtaposes the lush (and rather Mediterranean-looking) landscape from which Ringo emerges to the stark, dusty, empty streets of the Mexican town. A recurring visual motif in the film is placing Ringo in a shared frame with other characters (Gilmore, Matt, Juanito), constructing a hierarchical relationship through contrasts in lighting or by a focus pull. There are no ideological values informing those hierarchies but simply 'looks' – whatever and whoever looks good is good. As Ringo says about his golden pistol, 'the more I shoot it the prettier it gets.'

There is no moral centre in Corbucci's cinema and there is no rational justification of narrative development and resolution. Events are justified purely in terms of their value as audio-visual spectacle. The finale of *Johnny Oro* is the obvious case [**spoiler alert**]: The defence of Coldstone leads to its destruction but yields a reward for Ringo, who then returns it in order to rebuild the town. The narrative cycle is complete but also pointless and any logical explanation of the resolution is consumed by the pleasures of the pyrotechnics of destruction and the film appropriately ends with images of the raging flames. Corbucci's 'faith in the image' and commitment to good looks deprive him of a coherent system of ideological values, leading to criticisms of his work as 'disorderly', 'anarchic' and 'chaotic'. However, the lack of coherence is also creative liberation and *Johnny Oro* offers many instances of pure audio-visual joy and overall a celebration of playful cinematic inventiveness.

Dimitris Eleftheriotis

Sabata

Ehi amico… c'è Sabata, hai chiuso!

Studio:
Produzioni Europee Associati (PEA)

Director:
Frank Kramer (Gianfranco Parolini)

Producer:
Alberto Grimaldi

Screenwriters:
Renato Izzo
Gianfranco Parolini

Cinematographer:
Sandro Mancori

Composer:
Marcello Giombini

Editor:
Edmondo Lozzi

Art Director:
Carlo Simi

Duration:
106 minutes

Genre:
Western

Cast:
Lee Van Cleef
William Berger
Franco Ressel

Year:
1969

Synopsis

Daugherty City, Texas: a criminal gang steals $100,000 of army money from the bank, killing all the soldiers left on guard. Passing gunman Sabata tracks down and apprehends the thieves with relative ease, thanks to his sharp wits, superior marksmanship and formidable arsenal of weapons. He then discovers the heist was organized by local dignitaries, led by businessman Stengel, who are playing for much higher stakes. Backed up by the town drunk Carrincha and his mute Native American friend Alley Cat, Sabata engages in a war of nerves with Stengel, alternately helped and hindered by the enigmatic Banjo, a figure from his past.

Critique

Sabata is one of the best-known carnivalesque or 'circus' westerns, a sub-*filone* that highlights acrobatics, slapstick and gadget-based action rather than sustained tension, excitement or indeed narrative momentum. The film also foregrounds its clichéd narrative and visual devices, opening with dark deeds on a stormy night, just as a mysterious stranger rides into town, and finishing with stolen banknotes scattered in the breeze. The Italian title (which translates as 'Hey, amigo… it's Sabata, you're finished!') could be interpreted as a self-referential joke, reducing the Italian western to its basic components: the eponymous hero – or antihero – arrives and all resistance will fall in his wake. With the outcome a foregone conclusion, it seems the ride should be as enjoyable or playful as possible.

Sabata is not so much lightweight as deliberately inconsequential, its narrative and characters mere props in a gaudy sideshow. Carrincha's brief meditation on the value of warfare and military honours is no more than a throwaway aside as he scrounges for booze money. Sabata is pitted against crooked capitalists who stole army money to buy land through which the advancing railroad must pass; this is a clear lift from *C'era una volta il West/Once Upon a Time in the West* (Sergio Leone, 1968), released nine months earlier, which, in turn, draws directly from the Hollywood western *Johnny Guitar* (Nicholas Ray, 1954) and more generally from the genre's time-honoured ambivalence towards the coming of modern civilization and associated industrial and economic transformation.

Gianfranco Parolini's direction makes heavy use of obtrusive camera techniques such as the telephoto lens without exhibiting a distinctive signature. The most memorable sequence in visual terms is a hotel-lobby encounter between Sabata and Banjo, long-time associates whose precise relationship is undefined. The hand-held camera tilts repeatedly between Banjo's face and instrument, intercut with close-ups of Sabata's boots as he walks upstairs. Unsettling banjo music cranks up a rare moment of tension, yet this mini *tour de force* is an empty flourish, capped with a humorous payoff as Sabata shoots the banjo strings and quips: 'You were out

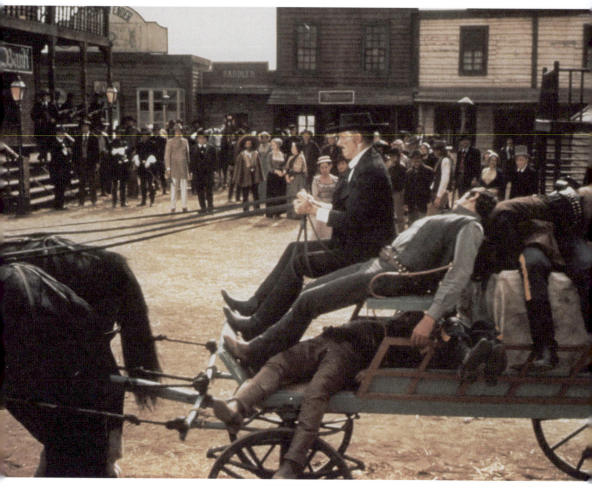

Sabata, P.E.A/Delphos.

of tempo.' Most of the action set-pieces rely on technology and ingenuity as much as skill or daring. Sabata's trick-firing Derringer pistol and Banjo's combination banjo/rifle may be inventive but the weapons function largely as ersatz James Bond gadgetry transposed to the Wild West.

Sabata is modelled superficially on Van Cleef's Colonel Mortimer in Per qualche dollaro in più/For a Few Dollars More (Sergio Leone, 1965), at least in terms of his wardrobe and collection of firearms. Unlike Mortimer, however, Sabata has no social or familial ties and his relentless pursuit of the main villain is motivated as much by profit as morality. Unlike most Italian-western protagonists he claims to operate within the law and appeals to a higher authority when Stengel threatens violence, a surprising lapse in masculine self-sufficiency and potency.

Stengel is a cultured dandy and a true son of the Old South; he cites as his inspiration the historical figure Thomas Dew, an

advocate of slavery who regarded inequality as intrinsic to the social order. Any racial or political subtexts associated with Stengel are, however, sidelined in favour of his perceived masculine deficiencies and lack of physical attractiveness. Unable to eliminate Sabata through hired guns, Stengel mistakes the latter's financial demands for mere blackmail, as opposed to a shrewd business offer. Their inevitable showdown emphasizes fairground-level marksmanship and the humiliation of an opponent, the predictable outcome staged in perfunctory fashion. While *Sabata* remains true to its circus formula, the lack of any underpinning – dramatic, thematic, narrative or visual – renders its set pieces free-floating frivolities devoid of resonance and thin on entertainment value.

Daniel O'Brien

Facts and dilemmas of public life, relating to the state, the civic community and, more generally, the exercise of power (and its abuses) have featured significantly in Italian cinema. The many political scandals and the widespread corruption of Italy's political class have inspired films such as Francesco Rosi's *Le mani sulla città/Hands Over the City* (1963) or Elio Petri's *Todo modo* (1976). The persistence of organized crime in the south and its effects on the lives of ordinary citizens have been the subject of countless films especially concerned with the Mafia and Camorra (its Neapolitan equivalent), for instance, Damiano Damiani's *Il giorno della civetta* (1968) and Matteo Garrone's *Gomorra/Gomorrah* (2008). Similarly, the radicalization of the political conflict between right and left and the rise of terrorism during the 1970s have been dramatized in film such as Marco Tullio Giordana's *La meglio gioventù/The Best of Youth* (2003) and Gianni Amelio's *Colpire al cuore* (1983).

What defines this tradition beyond simply its politically relevant subject matter is its distinctive ethics of civic engagement and social protest. A film such as *La classe operaia va in paradiso/The Working Class Goes to Heaven* (Elio Petri, 1971), for instance, does more than just illustrate the workers' struggles for more tolerable work conditions and the end of piece-work rates in a Milanese factory. The film renders visible the process by which the workers, and in particular the protagonist Lulù, become aware of their own exploitation. By showing the protagonist's gradual realization of his own enslavement to the logic of capitalist production, the film presents his transformation into leftist militant as an exemplary trajectory towards the achievement of class consciousness for its audience. Political films such as *La classe operaia va in paradiso* do not simply 'show' a particular social or political predicament but aim to render clear the logic that determines that predicament as well as its ramifications. Their political significance lies in their desire to 'denounce' whilst attempting to foster a political consciousness amongst audiences, through a filmic style which renders the alienating experience of capitalist society and a sense of social breakdown as much as through a thematic address to political issues.

The golden era of politically-oriented film-making in Italy occurred in the 1960s and 1970s. In an atmosphere of social unrest and ideological ferment, many Italian directors found the ideal conditions to challenge the status quo and question the authoritarian nature of traditional Italian institutions such as the patriarchal family – *Padre padrone* (Paolo and Vittorio Taviani, 1977); the army – *Marcia trionfale/Victory March* (Marco Bellocchio, 1976); or the church – *Nel nome del padre/In the Name of the Father* (Marco Bellocchio, 1972). Films of this period also complicated and expanded viewers' understanding of what the realm of the 'political' could be. Under the influence of 1968 and the sexual liberation movements of the 1970s, many films began to look at sexuality as an inherently political issue. *Ultimo tango a Parigi/Last Tango in Paris* (Bernardo Bertolucci, 1972), for instance, focuses on the erotic relation between a man and a woman in order to criticize typically bourgeois family values by demonstrating correspondences between personal experiences

Left: *Mimì metallurgico ferito nell'onore*, Euro International.

of repression and the more general restrictions to individuals' freedom imposed by the dominant capitalist order.

Regardless of their subject matter, Italian political films may be said to share a certain tendency to unveil a 'hidden truth'. For the neorealists, this 'truth' coincided with those collective experiences of hardship and marginalization that had been concealed by years of fascist obscurantism. Whilst the mimetic pretensions and naturalistic aesthetics of neorealism were subsequently contested by some of the politically-oriented directors of the 1960s and 1970s, most notably the Taviani brothers, Bernardo Bertolucci and Pier Paolo Pasolini, a distinctive tendency to bear witness to this truth remains an ongoing crucial preoccupation for the Italian political directors who came after neorealism. This tendency may be reflected in a desire to destroy the illusion of a harmonious social order and uncover instead a much darker reality. Francesco Rosi's *Il caso Mattei/The Mattei Affair* (1972), for instance, reconstructs the events that led to the mysterious death of the director of Italy's then state-owned oil company ENI, Enrico Mattei, in an airplane crash. Based on meticulous research into the life of this public figure, the film weaves connections between Mattei's work and its effects on particular economic and political interests of the time. The film does not demonstrate that Mattei was killed and does not give a clear reason for this death but exposes some of the power relations pervading Italy's economic and political life during the post-war period.

In the 1960s, in the light of Jean-Luc Godard's famous exhortation not to make political films but to make films politically and under the influence of the gruppo '63 neo-avant-garde, German dramatist Bertolt Brecht, and the critical debates of the French film journal *Cahiers du Cinéma*, the question of cinematic language became crucial to politically-oriented film-making. Debates over the political value of what came to be known as 'counter-cinema' concentrated on the idea that a film ought to aspire to be revolutionary not through content but primarily in its form. In its most militant output, political counter-cinema endorsed the idea that cinema was useful for deconstructing power relations between dominant and oppressed groups, and for foregrounding class struggle. This approach revolved around the need to disrupt the production of spectatorial pleasure inherent to mainstream cinema. It was a strategy that aspired to deny, in a Brechtian fashion, the audience's emotional involvement with the cinematic spectacle through a process of estrangement. By denying pleasurable identification with the cinematic spectacle, counter-cinema aimed to defamiliarize the view of the spectator and prompt them to consider the dialectics of a political situation with new eyes. Famous examples of this tendency were Valentino Orsini's *I dannati della terra* (1967) and the Tavianis' *Sotto il segno dello scorpione/Under the Sign of Scorpio* (1969). By using this approach, these films valorized the intellectual processes through which spectators make sense of cinema.

The so-called 'commercial political cinema' of the 1960s and 1970s – including some of the films of directors such as Elio Petri, Francesco Rosi, Lina Wertmüller and Damiano Damiani – used instead a different approach. These were film-makers who attempted to combine social and political denunciation with a preference for spectacle in more commercially viable forms. Often attacked by radical Marxist critics for its alleged capitulation to the demands of the market and its use of standardized expressive forms typical of mainstream cinema, this was a kind of political cinema that aimed to attract as many people as possible. *Indagine su un cittadino al di sopra di ogni sospetto/Investigation of a Citizen Above Suspicion* (Elio Petri, 1970) borrows some of the generic conventions of the detective film and utilizes a suspenseful soundtrack for its critique of the logic of the authoritarian state and its oppressive power. The film appealed to mass audiences whilst remaining a powerful denunciation of the oppressive workings and logic of the State and its police in a period of increasing repression against political dissent.

There remains a strong political current in contemporary Italian cinema. It is a political sentiment animated by a belief in the power of the cinematic medium to 'denounce' and

raise awareness especially in a time in which PM Berlusconi's media empire and his hold on state broadcaster RAI have limited the possibilities for criticizing political power on the main national TV channels. The films of Sabina Guzzanti, notoriously removed from RAI for her biting satires of Berlusconi's repeated abuses of power, are arguably among the most acclaimed examples of this new tendency. Her most recent film, *Draquila – L'Italia che trema/Draquila – Italy Trembles* (2010), denounces Berlusconi's shameless handling of the crisis following the L'Aquila earthquake of 2009 to boost his image after a number of sex scandals. A similar type of controversial, aggressive political documentary is also exemplified by Beppe Cremagnini and Enrico Deaglio's *Uccidete la democrazia* (2006), an investigation into the electoral fraud that led to the victory of the right-wing coalition at the 2006 general elections. Sexual politics also remain central thanks to films such as *All'improvviso l'inverno scorso/Suddenly Last Winter* (Luca Ragazzi and Gustav Hofer, 2008), a documentary concerned with the 2005 parliamentary debate on civil partnerships and gay marriage, and Lorella Zanardo's *Il corpo delle donne* (2009), a film essay on the shameless exploitation and sexualization of women's bodies on Italian TV.

Sergio Rigoletto

Allonsanfàn

Studio/Distributor:
Una Cooperativa Cinematografica and Artificial Eye

Directors:
Paolo and Vittorio Taviani

Producer:
Giuliano De Negri

Screenwriters:
Paolo and Vittorio Taviani

Cinematographer:
Giuseppe Ruzzolini

Art Director:
Giovanni Sbarra

Editor:
Roberto Perpignani

Duration:
111 minutes

Genre:
Historical drama

Cast:
Marcello Mastroianni
Lea Massari
Laura Betti
Bruno Cirino
Claudio Cassinelli

Year:
1974

Synopsis

Fulvio Imbriani is a Jacobin revolutionary of aristocratic origins and a member of the Sublime Brethren, a secret sect committed to armed insurrection. Fulvio has just been released from prison. After going back to his family, he becomes increasingly disillusioned about his political ideals and keen to take refuge in the warmth and comfort of his aristocratic life. After the death of Charlotte, Fulvio's lover, the Brethren appear at her funeral and persuade Fulvio to join them again for an expedition to the south, where poverty and a major cholera epidemic have created good opportunities for a popular insurrection. Fulvio first tries to disappear with his son but, after being drugged, eventually finds himself in the ship sailing to the south. After disembarking, Fulvio will commit an act of betrayal which will have serious effects on the outcome of the insurrection.

Critique

Set in 1816 during the period of restoration that followed the Congress of Vienna (1815), *Allonsanfàn* is a film in which the Tavianis reflect on the meanings and challenges of revolutionary action in a climate of political frustration and despair. The immediate historical referent is the network of secret societies that carried out subversive actions to liberate Italy from foreign rulers until its final unification (1861). However, being made in the wake of 1968, the film seems to look at the past as a way of commenting on Italy's present. Thus, the failure of the Brethren's revolutionary activities may be seen as an allegory for the sense of failure of the extra-parliamentary groups of the Left after the historical compromise: the move by which the Communist party formed a moderate coalition government with the ruling centre-right-wing Christian Democrats.

A central concern of the film is the difficult relation between the individual and the collective in political action. This is a problem that is explored through the protagonist, Fulvio, and his dilemmas as he tries to break free from the Brethren and the high demands of revolutionary political commitment. Fulvio's hesitations and his changing political consciousness are made explicit through a distinctive visual style. This is exemplified by the Tavianis' insistence on vertiginous movements of the hand-held camera in the opening scenes and the use of different colour filters to mark Fulvio's subjective views of his family and comrades and his remorseful visions. Despite portraying the protagonist's political disillusion and increasing individualism in negative terms, the film gives a vivid sense of the difficulties that any revolutionary faces in being dedicated to a life that may be full of frustrations and sacrifices. *Allonsanfàn* offers an alternative to the isolation and despair faced by Fulvio in the solidarity and collective efforts of the Brethren. Fulvio's comrades appear in the film as a unitary, compact collective body heroically fighting for a higher cause at the cost of sacrificing their lives. It is a sympathetic view which nevertheless does not

Allonsanfan, Cooperativa Cinematografica.

hide a critique of the naivety and blind faith of the members of the Brethren.

Despite this critical outlook, the film ends up being a joyful celebration of the utopianism embedded in any revolutionary project that aims at the creation of a fairer and more equal society. It is a utopian message that is conveyed through the character of Allonsanfan at the end of the film. Meeting Fulvio who has betrayed the Brethren by causing the massacre of many members, Allonsanfan constructs a fantasy in which he imagines his fellow revolutionaries and the Southern peasants embracing each other and dancing in communal solidarity. The Tavianis seem to invoke here the optimism of willpower as an antidote to a more cynical perspective on the possibility of creating a more just society.

Sergio Rigoletto

The Battle of Algiers

La battaglia di Algeri

Studio:
Igor Film
Casbah Film

Director:
Gillo Pontecorvo

Producer:
Saadi Yacef

Screenwriter:
Franco Solinas

Cinematographer:
Marcello Gatti

Art Director:
Sergio Canevari

Editor:
Mario Morra
Mario Serandrai

Duration:
121 minutes

Genre:
Drama/War

Cast:
Brahim Haggiag
Jean Martin
Saadi Yacef
Samia Kerbash

Year:
1966

Synopsis

Algiers, 1954. A petty criminal, Ali La Pointe, becomes radicalized whilst in prison and is subsequently recruited to the top level of the Algerian nationalist group Front de Libération Nationale (FLN) by its leader, El-Hadi Jaffar. The FLN begin a campaign of insurgency against French colonial rule with random shootings of policemen on the streets of the European Quarter. Violence escalates after a clandestine French paramilitary group places a devastating bomb in the Casbah. Shortly afterwards, three Algerian women smuggle bombs past police checkpoints and place them in crowded public places in the European Quarter. The French government deploys a paratrooper regiment to crack down on the insurgency. Under the command of Colonel Mathieu, the paras gather intelligence on the organization's pyramid structure through the interrogation and torture of key suspects and eventually close in on the FLN leadership, who are all either captured or killed by the end of 1957. Nevertheless, two years later a spontaneous mass uprising breaks out on the streets of the city and by 1962, Algerian independence is declared.

Critique

Few political films of the post-neorealist Italian cinema have gained the notoriety and international influence of *La battaglia di Algeri*. Made with the backing of the recently-formed Algerian state, the film reconstructs key events in the Algerian War of Independence, concentrating on the intense period of armed urban struggle in 1956–7 from which the film takes its name. Pontecorvo has claimed Sergei Eisenstein and Roberto Rossellini as major influences, and the film can be seen to hitch the hard-edged political commitment of the former to the realist outlook and humanist ethics of the latter. The film's neorealist inheritance is clearly visible in its hand-held camerawork and high-contrast black-and-white cinematography, which knowingly replicated the effect of newsreel footage; foreign prints routinely carried a disclaimer that 'not one foot of newsreel or documentary film' had been included in the picture. Indeed, the film's apparent realism has lent it the status of a historical document – it has famously been used as a training manual for revolutionaries *and* counter-insurgents, closely studied by both the Black Panthers and the Pentagon, for example. While its unflinching portrayal of torture ensured that it was banned in France until 1971, it also drew criticism for being insufficiently committed to the cause of national liberation that it depicted. However, its objectivity and even-handedness can now surely be seen as one of its assets, and it is to Pontecorvo's credit that the film never becomes straightforward agitprop. While it is never in doubt on which side the film-makers' sympathies lie – and by extension, those expected of the audience – Pontecorvo et al are careful not to caricature the French. In particular, Colonel Mathieu is presented as a compelling and complex figure, and we are reminded, for example, that many of the paratroopers fought against fascism in the Resistance.

The Battle Of Algiers/La battaglia di Algeri, Casbah/Igor.

However, its reception as a political work and discussion of its verisimilitude to real historical events have often overshadowed the film's considerable artistic achievements. Indeed, Pontecorvo's documentary approach is so effective that it is easy to forget that each crowd scene is a tightly-controlled and masterfully-orchestrated reconstruction. Perhaps the most powerful of all the bravura set pieces is a sequence in which three women 'westernize' themselves in order to smuggle explosive devices out of the Casbah and place them in crowded cafés and bars in the European Quarter. Expertly paced and edited, it compels us to identify with these women – we hold our breath as they wait at the checkpoints, bombs concealed in their handbags – before unsettling this with a chilling moment in which the camera pans around a room of unsuspecting victims just moments before the explosion. The film's documentary style is also persistently complicated by strikingly-composed close-ups of the human face, many of them belonging to non-professional actors drawn from the real participants of the events depicted. The film-makers' use of sound and music is also exemplary, from the

Algerian drumming that underpins the aforementioned bombing sequence to the haunting sounds of women ululating that echoes across the city throughout the film. Ennio Morricone's superb score is central to the film's ethical balance: the same affecting strings are played over scenes of destruction and bloodshed both in the Casbah and in the European Quarter, drawing our attention to the human tragedy on both sides.

This is also a film in which the real locations of Algiers play a central role, with almost every scene taking advantage of the city's distinctive social and physical characteristics. Pontecorvo's film is alive to how urban space can become an instrument of power, exclusion and containment, a territory divided and controlled by surveillance, borders and checkpoints, and it suggests how, in the right circumstances, that space might be reclaimed and its properties turned against the occupying forces. Indeed, if the film has lost little of its power in the decades since its release, this may be because its central concerns – for example, how traditional military tactics become outmoded in the context of guerrilla warfare, or the moral bankruptcy and ultimate futility of torture – arguably remain as relevant today as ever.

Lawrence Webb

The Conformist

Il conformista

Studio/Distributor:
Mars Film/Paramount

Director:
Bernardo Bertolucci

Producer:
Giovanni Bertolucci

Screenwriter:
Bernardo Bertolucci (from the novel by Alberto Moravia)

Cinematographer:
Vittorio Storaro

Art Director:
Ferdinando Scarfiotti

Music:
Georges Delerue

Editor:
Franco Arcalli

Synopsis

Beginning in Paris in the mid-1930s, the life of Marcello Clerici, an Italian intellectual and secret service agent, is told through a series of flashbacks. Following an adolescent homosexual liaison with a young chauffeur that culminates in the chauffeur's apparent murder, Clerici attempts to hide what he perceives as the aberrant elements of his personality behind a mask of bourgeois conformity: marriage to the frivolous Giulia and acquiescence to the burgeoning Fascist state. This leads him, ultimately, to undertake a mission to intercept his former mentor, Professor Quadri, now living as a dissident with his wife, Anna, in Paris. Falling for Anna, the sham of Clerici's existence is revealed to him, but not before the disastrous consequences of his actions are set in train.

Critique

Viewed alongside Fellini's *Amarcord* (1973) and Pasolini's *Saló* (1975), Bertolucci's *Il conformista* (1970) can be seen as part of a trend of 1970s films to explore the psycho-sexual underpinnings of Italian Fascism. Protagonist Marcello Clerici, played by French actor Jean-Louis Tringtignant, aspires to be a model citizen of the Fascist state, hiding earlier transgressions behind a façade of normality that leads him to become an agent for the state. Clerici's youthful – and apparently murderous – infatuation with Lino, a young chauffeur who seems to have strayed from one of Caravaggio's more lubricious paintings, comes to embody everything that he

Duration:
111 minutes

Genre:
Drama

Cast:
Jean-Louis Trintignant, Stefania Sandrelli, Enzo Tarascio, Dominique Sanda

Year:
1970

seeks to repress in his adult existence. In contrasting Clerici's early sexual non-conformity with his later, doomed, attempt at bourgeois respectability, the film evokes both the oppressive nature of Fascism, and the perversions to which it seems, inevitably, to give rise. This is a film whose characters are haunted by their pasts – be it Marcello himself, Manganiello, his secret service handler, plagued by memories of past atrocities in Abyssinia, or even Giulia, Marcello's apparently carefree young wife, with her recollection of past sexual abuse – but who are moving towards a far greater catastrophe that they are powerless to prevent.

The film is notable for its highly complex interwoven flashback structure, with Clerici's character revealed gradually to the audience as he travels from Paris on the journey that will become the defining event of his life, and for its extremely elaborate production design, with Vittorio Storaro's camerawork discovering startling chiaroscuro effects amongst the fascist kitsch of Ferdinando Scarfiotti's designs. This visual opulence suggests a departure for Bertolucci, away from the twin influences on his early films of Italian neorealism – his first job had been as an assistant to Pasolini on his neorealist-inspired *Accattone* (1961) – and the French New Wave, and towards the high style that would come to define his mature work. However, the genius of this film stems precisely from the tensions with its patriarchal influences, most significantly that of Jean-Luc Godard, whose debut feature, *À bout de souffle/Breathless* (1959), first inspired Bertolucci to become a film-maker.

The Conformist/Il conformista, Mars/Marianne/Maran.

As Bertolucci himself has noted, Clerici's former mentor Professor Quadri is given the Parisian address of Jean-Luc Godard at the time, and it is possible to view *Il conformista* as an extended dialogue with Godard's 1963 film *Le Mépris*, both being adapted from works by the Italian novelist Alberto Moravia, only one amidst a range of intertextual references between the two films. Godard, however, somewhat loftily dismissed his source as a good book for a train journey, and proceeded to strip most of the psychological nuance from Moravia's tale of a screenwriter's estrangement from his wife, replacing it with a characteristically modernist reflection on the interconnections between cinema, sex, and commerce. Bertolucci, by contrast, reinforces the psychological complexity of his central character, using a flashback structure not present in the novel as a way of emphasizing the development of Clerici's psyche. Although dressed in a manner reminiscent of one of Godard's louche antiheros and engaging in the same unconvincing gunplay, Trintignant imbues Clerici with an altogether more tragic demeanour. The cool flatness of Godard's images – created with his key collaborator of the New Wave period, cinematographer Raoul Coutard – is in similarly marked contrast to the depth of Storaro's work here, suggestive of Bertolucci's attempt to forge a fresh mode of psychological realism in a post-New Wave cinema. In this endeavour, one is reminded rather of Gilles Deleuze's characterization of the painter Francis Bacon's attempt to discover a new type of representational art in a world that had been changed forever by abstraction.

Corin Depper

Fists in the Pocket

I pugni in tasca

Studio/Distributor:
Doria

Director:
Marco Bellocchio

Producer:
Enzo Doria

Screenwriter:
Marco Bellocchio

Cinematographer:
Alberto Marrama

Synopsis

In a claustrophobic household in the Northern Italian countryside, a mother lives with her children, Augusto, Giulia, Alessandro and Leone. The mother is blind, and most of the children are stricken with illnesses and are strikingly immature; only Alessandro is healthy, and attempts to use his job and girlfriend to escape the violent conflicts and implications of incest which take place in the home. Alessandro lies to Augusto, informing him that he has passed a driving test, which then allows him more freedom: he drives away with most of the family, apparently in a failed attempt to kill them all, himself included. Shortly after, he tries again, one by one, first driving his mother to a ravine and pushing her off, killing her immediately. Alessandro then murders his younger, mentally-unstable brother Leone in the bath and then attempts to smother Giulia in her sleep. In the film's final crescendo, Alessandro's joy at his appropriated power fades into a dramatic epileptic fit and he dies crying out his sister's name as she ignores him from the room next door.

Art Director:
Gisella Longo

Editor:
Silvano Agosti
Anita Cacciolati

Duration:
105 minutes

Genre:
Drama

Cast:
Lou Castel
Paola Pitagora
Marino Masé
Liliana Gerace

Year:
1965

Critique

When it was first released in 1965, the reactions to Marco Bellocchio's debut feature fell into two extremes: international critics and journalists lauded the film, and Christian Democrat politicians in Italy attempted to have it banned for its negative image of the family. And it certainly is bleak: Bellocchio's critique of the bourgeois family bars no holds and paints a very unfavourable picture of each character. The mother of the family is blind, thus unable to see the family's misbehaviour at the table, nor the cat tucking in to her food, nor indeed can she pick up on Alessandro's veiled threats as he feigns reading the newspaper to her. The two younger sons, Leone and Alessandro, are prone to epileptic fits; the former is mentally unstable and the latter has incestuous feelings for Giulia. The daughter is emotionally very immature and narcissistic, and is childishly jealous of Augusto's fiancée. This oldest son is the 'strongest' child, with real future prospects and thus capable of continuing the family, and yet seems as utterly self-involved as the other children. Alessandro, really the film's antiheroic protagonist, is acutely aware of his brother's role and, moreover, of the obstacle presented by the weak family, and he takes it upon himself to rid his brother of this problem.

While Bellocchio's use of allegory in his *oeuvre* is rarely straightforward, the sickness which plagues the family can be read as a simple yet powerful metaphor for a sick society. The political core of the film remains complex, though, not to mention a portent of times soon to come: it engages with the past and present through the parent/child dialectic, and very clearly forebshadows May 1968 with its key theme of adolescent rebellion. The failure of the (single) mother's leadership is highlighted through Alessandro's improvised news item that the king of England is dead; the mother seeks reassurance that the queen reigns alone but the son simply responds, 'punto, a capo' – 'back to square one'. Certainly the sightless mother is symbolic of what Bellocchio viewed as an amaurotic Chrisitan Democrat government, and he moreover affords blame to the 'parents' for creating narcissistic 'children'. Relying on Freudian psychoanalysis, the film's fatherless children have evidently struggled in their sexual development, the oedipal stage, thus their extreme narcissism and inability to relate outside of the family can be explained by dangerously under-developed super-egos. This stunted development seems, moreover, to incorporate the problematic, dated gender identities performed by the younger generation of the family.

The upheaval of the traditional, hierarchical family structure which accompanied 1968 is presaged by Alessandro's murder of his mother and, with Giulia, his ceremonial destruction of her belongings. The widespread disillusionment with the government and the wider capitalist framework – again pre-empting the political movements of 1968 – emerges from Alessandro's absurd enforcement of social Darwinism. The survival of the fittest, of Augusto, literally leaves no space for the 'weak', such as Leone or the mother, irrespective of Augusto's own moral code. And the

older brother's behaviour is perhaps the most shocking, purely due to his complete disregard of Alessandro's actions: rather than intervening, he stoically overlooks everything, doubtlessly realizing that the eradication of the family would allow him to achieve his ambitions. The melodramatic, Verdian aria which accompanies the final scene, the death of Alessandro, is an ironic funeral march to the antihero who perfectly embodies a fundamental and present danger within capitalistic society; and yet it is the consciously-blind eyes of Augusto and Giulia, their sanctioning of this danger, which is the film's most frightening legacy.

Dom Holdaway

Investigation of a Citizen Above Suspicion

Indagine su un cittadino al di sopra di ogni sospetto

Studio/Distributor:
Vera Films
Euro International Film
Medusa Home Entertainment

Director:
Elio Petri

Producers:
Marina Cicogna
Daniele Senatore

Screenwriters:
Elio Petri
Ugo Pirro

Cinematographer:
Luigi Kuveiller

Art Director:
Carlo Egidi

Editor:
Ruggero Mastroianni

Duration:
112 minutes

Genre:
Drama

Synopsis

On the very day that he is promoted from the murder unit to leading the political unit of the police force, Il dottore murders Augusta, his mistress, in a frenzied act while they make love. He proceeds to meticulously interact with the scene of the murder leaving strong and deliberate, self-condemning evidence. Alongside flashbacks of his relationship with Augusta, the murder investigation develops as the dottore schizophrenically and repeatedly changes his mind, at times incriminating himself, at others destroying the evidence. In an apparent attempt to push the limits of power, Il dottore finally leaves a confession and returns home to await his fate. A group of Italy's most powerful men arrive at the scene but they simply scold the dottore, despite his frenzied confessions. Moments later he awakens in his bed, but the imminent arrival of the men once again demonstrates that his dream was a premonition, the scene will repeat itself, and he is above all suspicion.

Critique

Released in the most unhappy period in Italy's contemporary history – the 'years of lead', with the government's 'strategy of tension' and several tragic terrorist attacks – Elio Petri's film simultaneously reflects contemporary despair towards political power and issues an utterly damning critique of it. The film united many of Petri's favoured collaborators, including actor Gian Maria Volontè, perhaps the most familiar face of Italian *cinema politico*, scriptwriter Ugo Pirro and composer Ennio Morricone, and it was awarded both an Oscar and the Grand Prize at Cannes. Petri would repeat the bleak sentiment of *Indagine…* in later years (with similar collaborations) in *La classe operaia va in paradiso/The Working Class Goes to Heaven* (1971), *La proprietà non è più un furto/Property Is No Longer A Theft* (1973) and *Todo Modo* (1976), cementing his reputation as one of Italy's most important political directors.

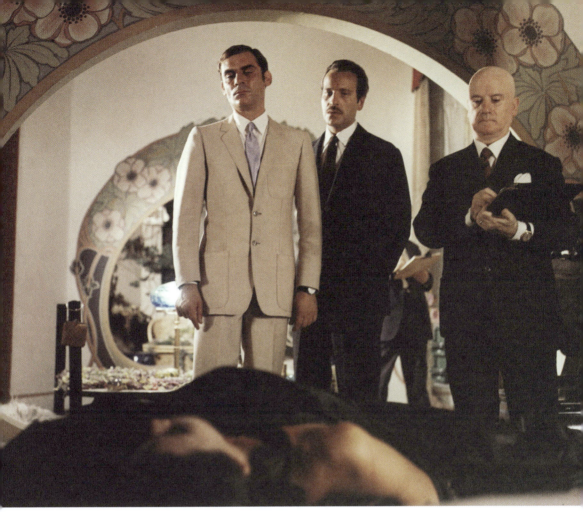

Investigation of a Citizen above Suspicion/Indagine su un cittadino al di sopra di ogni sospetto, Vera Film.

Cast:
Gian Maria Volontè
Florinda Bolkan
Gianni Santuccio
Orazio Orlando

Year:
1970

As Bertolucci does in *Il conformista/The Conformist* (1970), Petri creates a dialogue between the protagonist's sex life and his violent politics. Rather than a question of cause or consequence as in the other film, Petri here asks us to view the dottore's sexual acts as an extension of his political conscience. Indeed the flashbacks to his relationship with Augusta define the very dynamic of power of which, through the brutal behaviour of both parties, Petri is highly critical. The dominant attitude of the dottore towards Augusta's submission – she asks him to tie her up, kidnap and violate her – is explicitly mapped over a typecast parent-child relationship, allowing us to perceive a wider rotten patriarchy at the core of Italian society. This dynamic certainly accentuates the scathing tone of the film: while the scene in which a Duce-like dottore's motto, 'repression is civility', triggers cheers and an oration from his colleagues is frightening enough, it is, rather, his ability to seduce and eventually murder Augusta, just to see if he can get away with it, which is surely most shocking of all.

Indagine… is not entirely bleak, though: its sharp, striking cinematography and repeated, plunky trademark score complement the dark humour at the core of the film. As with some of the director's other films, such as *La decima vittima/The Tenth Victim* (1965) and *Todo Modo*, humour emerges from the sheer absurdity of the situation: almost unbelievably deranged men in positions of inconceivable power. Nonetheless the line is carefully trod between the completely absurd and the begrudgingly plausible, indeed there are pivotal scenes and moments in the film(s) which deliberately bring the reality home to the spectator. Nowhere is this more explicit than the metaphoric dream sequence at the conclusion of *Indagine…*, where Petri consciously terms the absurd situation as oneiric (that such a man is above suspicion can surely be only a nightmare). And yet the overt mapping of the fictional onto the real, as the dottore awakens, can surely be little more than an invitation to consider the film's Kafkaesque message in our own realities.

Certainly the combination of a biting political message with a dark humour, the mix of a serious subject matter with entertainment, is both a sign of Petri's skill as a director and a legacy to political film in Italy; it is a tragedy that since his untimely death in 1982 he has been so critically underappreciated.

Dom Holdaway

The Mattei Affair

Il caso Mattei

Studio:
Verona Produzione, Vides Cinematografica

Director:
Francesco Rosi

Producer:
Franco Cristaldi

Screenwriter:
Tonino Guerra

Cinematographer:
Pasqualino De Santis

Art Director:
Andrea Crisanti

Synopsis

An investigation into the suspicious circumstances surrounding the death of the Italian industrialist Enrico Mattei in a plane crash at Bascape, near Milan, 1962. Mattei was the mercurial CEO of the Italian oil and gas monopoly Ente Nazionale Idrocarburi (ENI), an organization he transformed during the late 1940s and 1950s into a state-owned business empire with interests ranging from rubber and plastics to a chain of restaurants and its own daily newspaper. The principal narrative strand of the film is composed of a series of flashbacks that follow Mattei's career and the development of ENI from the discovery of natural gas reserves in the Po Valley in the late 1940s to its emergence as a powerful player on the world stage in the 1950s. This is intercut with a mix of reconstruction and documentary footage that details the investigation and public inquest following Mattei's death and the director's own research into the Mattei affair in the early 1970s.

Critique

Il caso Mattei is one of a series of hard-hitting political films by Francesco Rosi, who has often been called the 'civic conscience' of the Italian cinema. The film shared the Palme d'Or at Cannes with Elio Petri's *La classe operaia va in paradiso/The Working Class Goes to Heaven* in 1972, a year which might now be seen as the

Editor:
Ruggero Mastroianni

Duration:
116 minutes

Genre:
Biopic
Thriller

Cast:
Gian Maria Volonté
Peter Baldwin
Franco Graziosi
Edda Ferronao

Year:
1972

high-water mark of the Italian political cinema both in terms of artistic ambition and international influence. Perhaps more than any other Italian film of its time, it draws links between Italy's postwar 'economic miracle' and the geopolitical realities of the Cold War; with hindsight, its release was timely, coming shortly before the OPEC crisis pushed the politics of oil production to the top of the global agenda.

An innovative hybrid of fiction and documentary, *Il caso Mattei* develops Rosi's notion of the *cine-inchieste* or 'film investigation' and the film's complex, flashback structure draws on the influence of *Citizen Kane* (Orson Welles, 1941) as well as Rosi's own *Salvatore Giuliano* (1962). It might be described as a postmodernist biopic: while Rosi retains a neorealist preference for location shooting and non-professional actors, he complicates this approach by presenting a heterogeneous patchwork of evidence, from dramatic reconstruction and interviews to expert testimony and documentary footage. The film suggests that by brokering deals with the non-aligned nations of the Third World and publicly railing against the power of the 'Seven Sisters' – a now commonplace term Mattei coined for the major oil companies who dominate the world market – Mattei may have made enough enemies to warrant his assassination, and, while Rosi presents enough information to cast reasonable doubt on the official verdict, he pulls back just far enough from fleshing out a conspiracy theory. The film is also interspersed with footage of the director on the trail of his friend and collaborator, the journalist Mauro de Mauro, who mysteriously disappeared while carrying out research for the film and whose case has likewise never been solved. This lends the film a sense of immediacy and suggests that, at the time of its release, the Mattei affair was still a pressing concern in Italy. Leaving its central mystery unresolved, the film is infused with an implicit scepticism about the final availability of historical truth and the possibility of its narrative representation.

The film discards most of the conventional trappings of the biopic genre. However, while steering commendably clear of cliché, the film's unflinchingly objective style allows the audience limited emotional identification with the characters. Ultimately, it is driven forward by a commanding performance from Gian Maria Volonté, a pivotal figure in the politically-committed cinema of the 1960s and 1970s. Whereas in *Salvatore Giuliano* the infamous Sicilian bandit remained an almost invisible presence at the centre of the film, *Il caso Mattei* indulges in the myth of Mattei, and there remains some question as to whether Rosi maintains enough critical distance from the protagonist's mythmaking and self-aggrandizement. While the film's complexity reflects the labyrinthine nature of Italian politics during the 1970s, many references will doubtless seem obscure to a contemporary international audience. The exposition-laden dialogue can feel forced, even wooden, and the film occasionally veers into the territory of television drama. However, *Il caso Mattei* affirms Rosi's reputation as an accomplished visual stylist, containing impressive location work in a range of settings, from the rural landscapes of the Po Valley and Sicily, to oil fields in Iran

and Algeria. In particular, Rosi and cinematographer Pasqualino de Santis take advantage of the sleek geometry and reflective surfaces of the ENI offices in Rome and Milan. The film also makes limited but extremely effective use of Piero Piccioni's electronic score to amplify the mounting sensation of paranoia.

Lawrence Webb

Novecento
1900

Studio/Distributor:
Produzioni Europee Associati/
Paramount Pictures

Director:
Bernardo Bertolucci

Producer:
Alberto Grimaldi

Screenwriters:
Franco Arcalli
Bernardo Bertolucci
Giuseppe Bertolucci

Cinematographer:
Vittorio Storaro

Art Director:
Ezio Frigerio

Editor:
Franco Arcalli

Duration:
311 minutes (uncut)

Genre:
Historical drama

Cast:
Robert De Niro
Gerard Départdieu
Dominique Sanda
Donald Sutherland

Year:
1976

Synopsis

Olmo Dalcò and Alfredo Berlinghieri are born just metres apart on the same day in 1901, Olmo to a peasant family working on the estate of Alfredo's grandfather. As boys they become close friends; meanwhile the grandfathers of the two men die: Alfredo Berlinghieri hangs himself whereas Leo Dalcò dies peacefully. Later Olmo goes to fight in the First World War and, when he returns, he becomes involved in worker unions fighting against the oppression of Alfredo's father and his brutish farm manager Attila Mellanchini. Olmo marries a communist teacher, and Alfredo meets and later marries Ida, a whimsical, liberated woman. Alfredo's cousin, Regina, jealous of Ida, marries Attila, by then a Fascist leader in the town. In a frenzy, Attila and Regina murder a child, and the Fascists' attempt to blame Olmo, socially outcast by many for his communist allegiances. After publicly humiliating Attila, Olmo is forced to flee for his safety and Ida, in love with him, follows; in an act of revenge Attila and his thugs murder several of the peasants. The resistance and liberation occur, Attila is killed and the land is finally shared by all of the peasants, who publicly try Alfredo.

Critique

When Bertolucci created and released his historical epic *Novecento* in 1976, he was a well-established director at the height of his game. Having started out as assistant director to Pasolini on *Accattone* (1961), then directing his first feature from Pasolini's script for *La commare secca/The Grim Reaper* (1962), he was seen from the start as a 'political' director. *Prima della rivoluzione/Before the Revolution* (1964), *Il conformista/The Conformist* (1970) and *La strategia del ragno/The Spider's Stratagem* (1970) cemented this reputation, and the 1972 *Ultimo tango a Parigi/Last Tango in Paris* brought him widespread international fame that culminated with the Oscar-winning success of *L'ultimo imperatore/The Last Emperor* (1987). At the time, the success of *Ultimo tango* allowed Bertolucci to gain PEA and Paramount Pictures' support for *Novecento*, and to attract mainstream stars: De Niro, Départdieu, Sutherland and Sanda (who had already starred in Bertolucci's 1970 film *Il conformista*), as well as Laura Betti and Burt Lancaster. The director's aim was reportedly to create a left-wing, Italian equivalent to *Gone with the Wind* (Victor Fleming, 1939), and epic it was, with the original cut lasting five and a half hours and covering 50 years of Italian history.

The political contexts of the film are many. Bertolucci begins at the turn of the century with a critique of the *padroni* (a word meaning both 'land owners' and 'bosses'), overlapping thematically with Visconti's *Il gattopardo/The Leopard* (1963). Italy at the beginning of the twentieth century still relied very heavily on agriculture, and feudal-like conditions were rife. This is the scene into which Alfredo and Olmo are born, on the same day but to very different fathers – one a peasant, the other a *padrone*. The grandfathers begin a polarization of class which recurs throughout the film, consistently painting the proletariat in a positive if not heroic manner, where the Berlinghieri friends and family are, at best, morally ambiguous. Nevertheless the two men grow up in a constantly changing society and are exposed to contrasting political contexts: Olmo becomes involved in the early socialist movements which then evolve into the Italian Communist Party. Alfredo's aristocratic family are explicitly conservative, and then become embroiled with Fascism as it takes root in the country, through the evil, child-murdering character of Attila. A simplistic division of the two sides of the political spectrum is matched with a naive prioritization of the left throughout, which does little to conceal Bertolucci's own political stance.

Bertolucci's epic ends with Alfredo and Olmo as old men, still bickering, still politically contrasted. Yet the background of their old age is implied to be a successful socialist agenda: a land-share, which emerges at the liberation of Italy after the Second World War. This 'happy end', while most certainly a far cry from the reality of 1970s Italy, perhaps demonstrates the director's adherence to a Marxist approach to art advocated by György Lukács. For a film to positively influence the spectator, the critic wrote, it must offer them a different reality, yet one which is accurate and comprehensive: an effectual 'type' which represents the 'totality' of social relations. Whether or not the spectator sees this epic film as successful in its political agenda, it is quite clear that Bertolucci did not simply want to create a closed narrative, but wanted to offer an alternative – and crucially, an achievable – reality to that of 1970s Italy.

Dom Holdaway

The Seduction of Mimì

Mimì metallurgico ferito nell'onore

Studio/Distributor:
Euro International Film
New Line Cinema
Saguenay Film

Synopsis

Mimì, a Sicilian miner, loses his job after refusing to vote for a Mafia-backed candidate at the local elections. He moves to Turin in search of better work opportunities, leaving his wife in Sicily. In Turin, he finds a job as a metalworker, a political passion (communism) and a woman he loves (Fiore) with whom he has a child. On his return to Sicily, Mimì starts leading a double life, with Fiore and their child on the one hand and his wife on the other. He gradually repudiates his communist ideals and turns away from the struggles of his co-workers. In the final part of the film, Mimì becomes obsessed with defending his masculine honour after he finds out that his wife has betrayed him with another man.

Director:
Lina Wertmüller

Producers:
Romano Cardarelli
Daniele Senatore

Screenwriter:
Lina Wertmüller

Cinematographer:
Dario Di Palma

Art Director:
Amedeo Fago

Editor:
Franco Fraticelli

Duration:
123 minutes

Genre:
Comedy

Cast:
Giancarlo Giannini
Mariangela Melato
Turi Ferro
Elena Fiore

Year:
1972

Critique

Mimì metallurgico ferito nell'onore is a cautionary tale about the difficult negotiation between political ideals and personal conduct. The film exemplifies Wertmüller's ambition at this stage of her career to shed light on political dilemmas and bring them into the open through self-critical laughter, rather than through a more serious approach. *Mimì metallurgico* makes fun of aspects of Sicilian folklore with echoes of Pietro Germi's *Divorzio all'italiana/Divorce: Italian Style* (1961) and *Sedotta e abbandonata/Seduced and Abandoned* (1964). It hints at the commercial concessions made by Germi's films through the satirical exposure of Sicilian codes of honour. The protagonist Mimì is a buffoonish caricature in the comic fashion of *commedia all'italiana*. His uptight behaviour as he tries to perform his Latin-lover tricks with Fiore plays out some of the mythologies of Sicilian masculinity whilst being repeatedly exposed as ludicrous. In the role of Mimì, Wertmüller's beloved actor Giancarlo Giannini gives a five-star performance. His exaggerated Sicilian accent and his caricatured impersonation of the typical Sicilian Latin lover create a laughable cartoon-like figure out of Mimì.

In the second part of the film, the comedy turns very bitter. The film exposes the protagonist's moral shortcomings and his abdication of political responsibility as acts which allow a critical response from the spectator. The film stresses that Mimì's retreat from politics and his pursuit of individualistic interests are dictated by cowardice and self-centredness. This is signalled by moments that depart from the prevailingly-comic development of the story in which the audience is invited to reflect on the difficulties of living their everyday lives 'politically'. The film also features a hyperbolic visual style that was to become the signature of Wertmüller's films of the 1970s. Very dramatic high/low camera angles and visual asymmetries in point-of-view serve the purpose of emphasizing the establishment of particular power relations between the protagonist and the corrupted political and criminal forces in favour of which he gives up his socialist ideals to pursue a life of self-centredness, political irresponsibility and individualism.

Sergio Rigoletto

The 100 Steps

I cento passi

Studio/Distributor:
Rai Cinemafiction
Istituto Luce

Director:
Marco Tullio Giordana

Synopsis

Born to a Sicilian family with very close links to the local mafia, the young Giuseppe 'Peppino' Impastato seems destined to join the criminal organization until a tragedy occurs in the family and the boy begins to question his surroundings. By the early 1970s, the adult Peppino is a far cry from the expectation: having become involved with the local Communist party, he is boldly unafraid to take on any political opposition in his home town, Cinisi, even if this leads to his imprisonment. With a group of friends, he violently

Producer:
Fabrizio Mosca
Guido Simonetti (Line Producer)

Screenwriters:
Claudio Fava
Marco Tullio Giordana
Monica Zapelli

Cinematographer:
Roberto Forza

Art Director:
Franco Ceraolo

Editor:
Roberto Missiroli

Duration:
114 minutes

Genre:
Drama/Biography

Cast:
Luigi Lo Cascio
Luigi Maria Burruano
Lucia Sardo
Tony Sperandeo

Year:
2000

denounces the local mafia and its boss, Tano Badalamenti, through street manifestations, the press and the group's radio station. Peppino's outspoken behaviour causes frictions in the home and his father – Luigi Impastato, one of Badalamenti's cronies – forces his son out of the family home. This does little to slow Peppino's political zeal, however, and after the mysterious death of Luigi, and despite repeated warnings from friends and family of the danger of Badalamenti, Peppino offers his candidacy for the Proletarian Democracy Party, with ultimately tragic consequences.

Critique

Though not his first feature, having created films of varying success over the previous two decades, *I cento passi* brought widespread recognition to director Marco Tullio Giordana and marked a style of film-making which has since become his signature: that which might be labelled 'the popular-political film'. In *I cento passi*, as with the television series-cum-international feature *La meglio gioventù/The Best of Youth* (2003) and feature films *Quando sei nato non poui più nasconderti/Once You're Born You Can No Longer Hide* (2005) and *Sanguepazzo/Wild Blood* (2008), Giordana constructs the film through engagement with contemporary social and political issues matched with a fast pace, colourful *mise-en-scène* and popular cultural references. With an excellent script (later published by Feltrinelli, with surprising success), fine performances from the lead actors and a confident, if conventional, cinematography, it is of little surprise that the film was critically acclaimed, took decent box-office takings and had success in several European film festivals. What is particularly striking, though, is Giordana's ability to straddle several themes and approaches, combining countless genre conventions from gangster film, to western, to family drama. It moreover cites both popular Hollywood and artistic Italian representations of the mafia, both glorified (such as *The Godfather*, Francis Ford Coppola, 1972, explicitly referenced in the costume and *mise-en-scène*) and antagonistic, whereby the mafia is a dangerous plague to society (see also *La scorta/The Bodyguards*, Ricky Tognazzi, 1993, or *Gomorra/Gomorrah*, Matteo Garrone, 2008).

What makes Peppino's denunciation of the mafia outstanding is his familial link: the implication is that, were it not for the explosive murder of his uncle, mafia *capo* Cesare Manzella, Peppino would have inherited the family business. Yet this rupture point in the boy's life turns him towards the local representative of the Communist Party, who then, by implication through a well-timed flashforward, strongly influences the boy's political formation. From here, the film's narrative and stylistics create a binary split between two political ideologies: the mafia hegemony and the 'cultural communists'. The rejection of his own family leads Peppino to search for alternative support, eventually locating it in the 'Circolo musica e cultura' and radio station established by Peppino and his comrades. The costume, *mise-en-scène* and lighting prioritize the younger generation throughout, contrasting bright colours and a

vocal activism to a latent violence, passivity and typically monochrome sets and costumes of Badalamenti and his mafiosi.

The soundtrack to the lives of Peppino and his friends features several well-known artists and songs, from Leonard Cohen to the Animals and a striking repetition of 'Whiter Shade of Pale'; these are almost stereotypical songs which aim to capture a feeling of youthful political revolt. In fact, throughout the film, Giordana relies on a series of complex artistic references which replace more explicit political engagement in the film. In terms of poetry alone, a nod to the Soviet poet Vladimir Mayakovsky marks the flash-forward to Peppino's adulthood, merely *implying* a Communist formation; Peppino's melodramatic adaptation of Dante's *Divine Comedy* maps the poet's severe criticism of fourteenth-century Florence over Peppino's powerful denunciation of twentieth-century Sicily; Pier Paolo Pasolini, too, is explicitly cited, bearing the weight of his infamous, unyielding criticism of 1970s society and anticipating Peppino's untimely death. Most poignant, though, is the citation of Francesco Rosi's 1964 film *Le mani sulla città/Hands Over the City*, with Peppino's accompanying statement that 'a work of art should re-invent reality, and…recharge it with new meaning': the self-reflexivity here can surely be little less than Giordana's manifesto for a new form of *cinema politico*.

Dom Holdaway

Theorem

Teorema

Studio/Distributor:
Aetos Produzioni
Cinematografiche
Euro International Film

Director:
Pier Paolo Pasolini

Producers:
Manolo Bolognini
Franco Rossellini

Screenwriter:
Pier Paolo Pasolini

Cinematographer:
Giuseppe Ruzzolini

Art Director:
Luciano Puccini

Synopsis

Paolo is a wealthy Milanese factory owner and father to a typical bourgeois family, living peacefully with his wife Lucia, children Pietro and Odetta, and the family's maid, Emilia. Unannounced, a mysterious visitor arrives, staying with the family indefinitely and, though extraordinarily passive and understated, the visitor appears to methodically seduce the maid, the son, the mother, the daughter and finally the father. Then, just as suddenly, he announces his departure and they all – excluding the maid – come to a sudden self-awareness. Once he has disappeared, their lives undergo drastic changes: Odetta wonders around the empty house, then declines into a suspended, unmoving state; Pietro becomes an extremely abstract and at times scatological artist; Lucia drives around the periphery of Milan picking up and seducing young men; and Paolo strips himself naked at a railway station and walks away, eventually finishing on the slopes of a volcano. Emilia returns to her village, where she undergoes a religious epiphany, heals the sick, levitates, and finally buries herself in the ground.

Critique

Pasolini's *Teorema* opens with a dislocated sequence shot outside a factory which a bourgeois businessman has just donated to its workers. A pushy journalist presses the workers for responses while

Editor:
Nino Baragli

Duration:
105 minutes

Genre:
Drama

Cast:
Laura Betti
Silvana Mangano
Massimo Girotti
Terence Stamp
Ninetto Davoli

Year:
1968

the handheld camera cuts impulsively from point-of-view perspectives, immediately aligning us with the interrogated. 'Is this action a way to empower the working classes? Does it destroy the chance of a class revolution? When the bourgeoisie evolves to new situations, do we not have to question them in new, different ways?' These questions bear the full weight of the contemporary political context: the film was released in late 1968, a time when the very moral code of society was being challenged. When the workers remain mute, the journalist pushes them (us) repeatedly: 'Can you respond to these questions?' Rather than allowing an answer, though, Pasolini intervenes by suddenly cutting to the opening credits of his film: the response is to be sought in the film.

The film is logically structured, with essentially two acts: the posing of Pasolini's *theorem* (what would happen to a family if a sexual liberation suddenly disrupts their bourgeois lifestyle?) and then the theorized consequences of this act (the absolute disintegration of the family). Between the two acts is a key turning point,

Theorem/Teorema, Aetos.

at which each member of the family discusses with the visitor their personal realization of having conformed to bourgeois values, for which Pasolini brutally punishes them in the second act. The children interrupt their middle-class formation, whereby Pietro's individuality becomes symbolized by his extremely abstract, abhorrent art and Odetta's recognition of a suppressed sexuality leads her to view her life as pointless, and she falls into a vegetative state. The lives of the parents are massively inverted, whereby Lucia suddenly views her life as a chaste and loyal wife as futile, attempting repeatedly to recreate her affair with the visitor; and Paolo, aware of the emptiness of property, literally sheds himself of everything and absconds from Milan. It cannot be coincidental that Emilia, the character who represents the working class, does not talk personally to the visitor, only symbolically sharing the burden of his departure and then also leaving. Yet unlike the family members, Emilia's reaction to the visitor is not negative, indeed her religious epiphany demonstrates a fundamental hope for the proletariat. The determined actions of Emilia and the 'tears of renewal' which she sheds at the end must ultimately contradict the unresponsive factory workers at the film's beginning, suggesting that the maid's departure is a necessary allegorical evolution of the working class alongside the bourgeoisie, specifically at a time of massive social change.

The absolute absence of pity or redemption for the bourgeois family is typical of Pasolini's cinema. Each of Pasolini's films shares a similar political awareness matched with anger towards social injustice, echoing the sentiments in the director's novels and poetry. And yet, unlike many of his other works, *Teorema* for the most part lacks Pasolini's ironic humour in this regard, instead foreshadowing the extreme bleakness of *Salò o le 120 giorni di Sodoma/Salò, or the 120 Days of Sodom* (1975), the last film released before his brutal murder. His bitter irony is not entirely absent, though, when he vocalizes his essential message from the film's prologue, as the journalist asks: 'a member of the bourgeoisie, even if he shares his factory, no matter what he does, is wrong. Isn't it thus?'

Dom Holdaway

We All Loved Each Other So Much

C'eravamo tanto amati

Studio/Distributor:
La Deantir
Delta Film
Dean Film

Synopsis

Three young men become friends while fighting in the Resistance but after the war their paths diverge and their hopes, dreams and ideals are repeatedly dashed. Would-be intellectual Nicola abandons his wife, child and life in the provinces after a heated debate following a screening of *Ladri di biciclette/Bicycle Thieves* (Vittorio De Sica, 1948) costs him his job; instead he attempts to forge a career as a film critic in Rome. Gianni renounces his socialist ideals and his one true love in order to marry the daughter of a rich and corrupt industrialist and assure himself a successful and financially

Director:
Ettore Scola

Producers:
Pio Angeletti
Adriano De Micheli

Screenwriters:
Age (Agenore Incrocci)
Furio Scarpelli
Ettore Scola

Cinematographer:
Claudio Cirillo

Art Director:
Luciano Ricceri

Editor:
Raimondo Crociani

Duration:
121 minutes

Genre:
Comedy

Cast:
Nino Manfredi
Vittorio Gassman
Stefania Sandrelli
Stefano Satta Flores

Year:
1974

lucrative career as a lawyer. And Antonio, who works as a hospital porter, falls in love with an aspiring actress, Luciana, only for her to abandon him in favour of Gianni. As the years pass and their paths repeatedly cross, the friends are able to see reflected in one another the changes that life has wrought on their youthful selves.

Critique

C'eravamo tanto amati is a bitter-sweet meditation on the failings of post-war Italian society, the role of cinema, and how one comes to terms with life's refusal to match our aspirations. It is a quintessential example of the *commedia all'italiana* and a key title in the filmography of Ettore Scola. Typically for the genre, the main characters are constructed as social types and the vicissitudes that befall them are intended to reflect broader moods and events in Italian history. Thus the film traces a familiar path from the hopes and ideals of the Resistance, through a process of 'selling out' during the Economic Boom to an image of a corrupt and compromised present. Those unsympathetic to this idea of cinema as social history could certainly find much to object to in Scola's film. Its sense of nostalgia for an idealized past and pessimism about the present are arguably counterproductive to the political commentary underpinning the narrative with which Age and Scarpelli clearly wish to imbue the film. Similarly, the way in which the film encourages (Italian) viewers to identify with its protagonists arguably results in an apology for their vices and failings. Seen in this light, it is hard not to recognize the central polemic of Scola's film in the fictional film with which Nanni Moretti satirizes contemporary Italian cinema in *Caro diario*/*Dear Diary* (1993). Nanni's response to the film's insistence that we've all compromised and become shadows of our former selves – turning the 'we' into a 'you' and affirming that the film does not speak for him – constitutes an open challenge to this kind of cinema.

However, Moretti's parody concerns the Italian cinema of the late 1980s and perfectly captures the schematic plotting and aesthetic poverty that characterize many of the films made during this period. Scola's film, on the other hand, is a beautifully-made example of the *commedia all'italiana* that dates from the final years of its golden age. Even if the characters are constructed as social types, they are rarely schematic and the performances of genre stalwarts Gassman, Manfredi and Sandrelli are all perfectly judged. Stylistically the film is relatively audacious, too. From the opening scene's freeze-frame during Gianni's dive into his private pool (and the accompanying voice-over announcing that the dive will only be completed at the end of the film) to the film's unexpected transition from monochrome to colour mid-way through, Scola consistently utilizes the stylistic possibilities of the medium to liven up his tale. There are some wonderful stylistic flourishes, most notably the characters' habit of stepping out of the diegesis to reveal their inner feelings to the audience – a conceit borrowed from the Eugene O'Neill play that Luciana drags the uncomprehending Antonio to and which Scola manages to utilize in a variety of surprising and often delightful ways.

This attention to cinema aesthetics feeds back into a broader discourse about cinema and its role within Italian society. Thus it is neorealism – and *Ladri di biciclette* in particular – that changes the course of Nicola's life, and it is during the filming of Anita Ekberg's dip in the Trevi Fountain in *La dolce vita* (Federico Fellini, 1960) that Antonio bumps into Luciana once more. (Federico Fellini, Marcello Mastroianni, Mike Buongiorno and many others all have cameos in the film, while Vittorio De Sica appears in archive footage.) Thus the film's narrative of compromise and social change is linked to a discourse about Italian cinema that seems to articulate a decline from neorealism into the kind of film Moretti parodies. It is fitting, then, that the film is dedicated to De Sica, whose directorial career perfectly embodied the ideals of the post-war moment only to founder under the harsh demands of life and the industry in the decades that followed.

Alex Marlow-Mann

Videocracy

Videocracy – basta apparire

Studio/Distributor:
Atmo Media Network
Sveriges Television
Zentropa Entertainment

Director:
Erik Gandini

Producer:
Mikael Olsen

Screenwriter:
Erik Gandini

Cinematographers:
Manuel Alberto Claro
Lukas Eisenhauer

Art Director:
Martin Hultman

Editor:
Johan Söderberg

Duration:
85 minutes

Genre:
Documentary

Synopsis

This documentary traces the origins of today's populist Italian television by linking the increasing centrality of the medium to the deterioration of the cultural and political life of the country. It begins with archival footage of late-night TV shows featuring housewives who would take off their clothes when contestants answered questions correctly. These shows were broadcast 40 years ago on the first commercial Italian TV channel owned by Italy's current PM Silvio Berlusconi. Gandini focuses on the effects of those early experiments in commercial entertainment by offering a collection of clips from contemporary Italian TV programmes where half-naked women continuously smile and dance for the camera. Constantly referring to Berlusconi as 'il presidente', the film investigates the implications around his double role as PM and owner of Italy's TV empire Mediaset.

Critique

Videocracy sets up for itself the very ambitious task of exploring the significance of Italy's TV culture and its role in relation to Berlusconi's hold on power. The title introduces the thesis that the documentary will develop: through his media empire and his control over Italy's main TV channels, Berlusconi has created a modern form of cultural hegemony. His political dominance is, according to Gandini, bound up with the rule of the televisual image. In a country in which TV and political power are the same thing, we are told, we should not find it hard to understand why Italians continue to vote for Berlusconi.

Videocracy stresses the prominent role that the shameless sexualization of female bodies has on Italian TV by suggesting a direct relation between this phenomenon and the current state of Italian

Cast:
Silvio Berlusconi
Fabrizio Corona
Lele Mora
Rick Canelli

Year:
2009

politics. This is perhaps the least convincing part of the documentary. In mentioning that one of these barely-dressed showgirls has become the Equal Opportunities Minister in Berlusconi's government, the documentary seems simply to offer shocking anecdotes about the current state of Italy's democracy for international audiences to laugh at. One of the most disturbing and yet amusing sections of the film features seedy TV agent and close friend of Berlusconi, Lele Mora, posing in front of the camera as he shares with us his 'pearls of wisdom' about the opportunities for fame and wealth in the Italian TV world. It is perhaps ironic that, after showing the persistent exploitation of women's bodies in the Italian media, the documentary should feature one of its most powerful figures and wheeler-dealers in his Sardinian villa surrounded by his harem of muscular tanned young men walking around half-naked.

The subtitle of the film – *Basta apparire* (all you have to do is to appear) – highlights Gandini's conviction that the power of the image in Berlusconi's Italy is directly dependent on the dreamlike world of Italian TV and its appeal to ordinary Italians. The interview with Ricky, a factory worker aspiring to be part of the gilded world of TV celebrities, is an insightful encounter with one of these people. The interview with Ricky is particularly successful in achieving one of the main objectives of the documentary, to stress the populist nature of Italian television and the illusory nature of the success and happiness it projects to its viewers. The interview with ex-paparazzo-turned-celebrity Fabrizio Corona may at first appear slightly disconnected from the rest of the documentary and its main argument. Yet Corona's megalomaniac rhetoric slowly reveals itself to be one of the many disturbing faces of Berlusconi's world of illusions. From self-proclaimed Robin Hood, Corona finally emerges as Berlusconi's alter ego, a cynical and money-obsessed individual incarnating the vacuity and moral shallowness of the media world that has made him famous.

Sergio Rigoletto

We Want Roses Too

Vogliamo anche le rose

Studio/Distributor:
Mir Cinematografica

Director:
Alina Marazzi

Producer:
Gaia Giani

Synopsis

Marazzi's 2007 documentary opens on a typical 1960s housewife gazing into a crystal ball to see her future, only to reel in shock at a sexually-liberated, naked woman dancing in a field (a clip which we too will see later in the film). Constructed thus, of animations of old clips and photos from 1960s–1970s media spliced together with a modern voice-over, the film then investigates a history of women's rights in Italy. With a vaguely-chronological order, the documentary investigates the progression of feminisms through subtly-linked themes, beginning with marriage, birth, sexual education and church oppression. The film reaches 1968, and the themes converge in intimate descriptions from diary entries (read by the women who wrote them), pushing for and responding to equal

Screenwriter:
Alina Marazzi

Art Director:
Cristina Diana Seresini (animation)

Editor:
Ilaria Fraioli

Duration:
85 minutes

Genre:
Documentary

Cast:
Anita Caprioli
Teresa Saponangelo
Valentina Carnelutti (voices)

Year:
2007

working rights, divorce, abortion, contraception and sexual liberation. The film concludes with a list of laws which have affected gender rights in the period covered by the film until the present day.

Critique

In the early 1960s, Pietro Germi's *Divorzio all'italiana/Divorce: Italian Style* (1961) painted a bleak picture of women's rights in Italy at the time. Marcello Mastroianni's character Fefé plots to frame his wife for adultery and then murder her: divorce was illegal, and 'crimes of honour' by cuckolded men were given greatly reduced prison sentences. Alina Marazzi's documentary, *Vogliamo anche le rose* – the title a nod to the 1912 Lawrence Textile Strike – picks up where Germi left off, and with a similarly scathing portrayal of conservative, patriarchal laws. And yet the film reveals much more, tracing the emergence of feminism within an oppressive society.

The beauty of the film lies precisely in its very intimate nature. The diaries of Anita, Teresa and Valentina each depict vividly not only the society in which they live but also, through the intelligent and well-paced editing of the film, the different levels of interaction of each woman with that society. Valentina, for instance, not only illustrates the life of a militant feminist but, moreover, describes the consequent difficulties in finding love; the diary of Anita delicately details a shy teenager who is intimidated by overtly sexualized images, but also condemns her oppressive Catholic education for her inhibitions. While the diary entries signal various themes, which also overlap vaguely with chronological progressions in women's rights through the 1960s and 1970s, Marazzi includes more than the subjective narrations. Clips from a variety of contemporary television programmes and films show the audience a wider perspective on the issues, and allow women and men of all backgrounds to offer their opinion gives the film a claim to objectivity. The documentary nonetheless has a very explicit political intention, and the awful, misogynistic arguments are satisfyingly dated and small (perhaps the lyrics of the feminist punk band at the end best summarize this feeling, 'Horror! Horror! You make me sick! I feel awful when I'm near you').

Vogliamo anche le rose, as implied by the above lyrics, has a darkly humorous undercurrent running throughout, emerging at times from the dramatic irony implicit in our modern viewpoint, at others from the simple ridiculing of misogyny through editing, animation and the non-diegetic soundtrack. And yet this humour coincides with some very poignant scenes – such as Teresa's candid narration of her brutal abortion. The overlay of emotional scenes designed to manipulate and associate the spectator with the film's central issue is a process familiar in several documentaries contemporary to *Vogliamo anche le rose*. Films such as *Quando c'era Silvio* (Beppe Cremagnani and Enrico Deaglio, 2005), *Camicie verdi: bruciare il tricolore* (Claudio Lazzaro, 2006), *Improvvisamente l'inverno scorso/Suddenly, Last Winter* (Gustav Hofer and Luca Ragazzi, 2007) and *Nazirock* (Claudio Lazzaro, 2008) similarly engage

with events in twentieth-century Italian history, presenting a serious issue in an almost tragicomic manner and highlighting the ongoing and topical relevance of the issue at hand. Nowhere is this more evident in Marazzi's film than in the final few minutes: rather than simply including the legal *advancements* which promote gender equality, the list also includes a number of attempts to retract antecedent laws. The final item, marking only the *beginning* of debates on rights for *de facto* couples – debates since then halted by the Berlusconi government – demonstrates that this fundamental issue remains powerfully present.

Dom Holdaway

CONTEMPORARY CINEMA

Italian cinema in recent decades is often discussed in relation to its recovery from the supposed crisis of the 1980s, when cinema was thought, by many critics, to have lost its social or civic function, particularly as an instrument of *impegno*, or political commitment. Although it is fair to say that in Italy cinema is thought to be in a more-or-less-permanent state of crisis, since the 1980s critics have argued for a rebirth of the national cinema: the 'neo-neorealism' of the late 1980s and 1990s, represented in this volume by Gianni Amelio's 1992 film *Il ladro di bambini/The Stolen Children*, is a good case in point. The film's clear debt to neorealism through its use of non-professional actors and natural landscapes, combined with a hard-hitting social message, places it in the tradition of that most beloved of Italian cinematic institutions, post-war neorealism, a tradition also keyed into by *Gomorra/Gomorrah*, Matteo Garrone's 2008 international success.

The Italian cinema industry's love affair with a certain kind of (often state-subsidized) 'quality cinema' has seen the predominance of certain exportable auteurs, like Amelio, Garrone, as well as Gabriele Salvatores, and, recently, Paolo Sorrentino. In addition, one of Italian cinema's most beloved directorial figures, Nanni Moretti, achieved cultural visibility with his early comically-inflected films of the 1980s, and turned his gaze on the Berlusconi governments with *Aprile/April* (1994) and *Il caimano/The Caiman* (2006), as well as achieving international success for his melancholy chamber piece *La stanza del figlio/The Son's Room* (2000).

In the last ten years one of the key areas on which politically-committed Italian cinema has concentrated its attention is the portrayal of the traumatic experiences of the nation during the 1970s and early 1980s, the so-called *anni di piombo*, or 'years of lead', which were marked by popular unrest and extra-parliamentary violence. The representation of Italy's traumatic past has seen works investigating the repercussions of terrorism by directors such as Gianni Amelio (*Colpire al cuore/Blow to the Heart*, 1983), Mimmo Calopresti (*La seconda volta/The Second Time*, 1995), Renato De Maria (*La prima linea/The Front Line*, 2009), Marco Bellocchio (*Buongiorno, notte/Good Morning, Night*, 2003) and many others, a key event being the kidnapping and murder by the Red Brigades of Christian Democrat leader Aldo Moro in 1978, the subject of Bellocchio's film and many others. However, it is fair to say that in Italy auteur or arthouse cinema came rather late to the representation of terrorism: it was the much-maligned (if now critically re-evaluated) popular genre of the *poliziesco*, or cop movie that was the first to address these contested events in the 1970s. In recent years Italy has witnessed the flowering of a middlebrow cinema of *impegno*, or social commitment: unlike the realist, often formally 'difficult' films by auteurs that had composed Italian *cinema d'impegno*, these are films that work with star casts, melodramatic or sentimental plots and an address to a mainstream viewer to construct narratives that thematize political commitment, often in a homosocial key. In such films, events like the Moro affair or the bombing of Bologna train station in 1980 have been woven into melodramatic plots centred on family life or homosocial/fraternal bonds: successful examples

Left: *Gomorra*, Fandango.

of this type of film include *Romanzo criminale/Crime Novel* (Placido, 2005), *La meglio gioventù/The Best of Youth* (Marco Tullio Giordana, 2003), *I cento passi/The 100 Steps* (Giordana, 2000), *Il grande sogno/The Big Dream* (Placido, 2009) and *Mio fratello è figlio unico/My Brother is an Only Child* (Daniele Luchetti, 2007). These films are anchored by impressive central performances by a group of charismatic male actors who now dominate current Italian cinema: Riccardo Scamarcio, Elio Germano, Pierfrancesco Favino, Claudio Santamaria, Luigi Lo Cascio. In fact, it is fair to generalize that this is a golden age of masculine stardom in Italian cinema, with female performers being rather sidelined, or relegated to the traditional, passive role of wife or girlfriend.

Quality Italian cinema has also turned its gaze on the phenomenon of migration to Italy, generally favouring fairly bleak narratives in a realist style that document the difficulty of integration into the Italian nation for the foreign migrant, whether s/he be African or Eastern European. In more recent years, however, these rather simplistic narratives of the 'good' migrant arriving in Italy have been complicated by more subtle, varied, and questioning narratives that reflect the different relations that immigrants now have with the Italian host nation. Roberta Torre's *Sud Side Stori/South Side Story* (2000), for example, restaged *Romeo and Juliet* as a grotesque and comic romance between a Nigerian prostitute and a Palermitan wide boy. Many of the recent films on migration continue the homosocial thematic that is so key to current Italian cinema, by representing troubled and troubling bonds of affection, complicity and antagonism between male migrants and Italians, as exemplified in *Cover boy: L'ultima rivoluzione/Cover Boy: The Last Revolution* (Carmine Amoroso, 2007).

The popular has long been ignored in studies of Italian cinema, which, as noted above, derives so much of its international prestige from its exporting of arthouse auteurs. Only recently have attempts been made to rehabilitate Italy's so-called 'unexportable' cinematic products, notably its comedies, which have formed the backbone of the domestic box-office take since the war. The 'cinepanettone' or 'Christmas comedy' *filone*, represented in this volume by *Natale sul Nilo/Christmas on the Nile* (Neri Parenti, 2002), has been critically reviled since its emergence in the 1980s, and it is only now that scholars are starting to ask questions about the immense popularity of these films, their ritual function, and their status as Italy's true 'national cinema'. Another popular genre that has performed extremely well at the Italian box-office in the last decade is the teen comedy. Often derived from the best-selling work of author Federico Moccia, these films have drawn a young audience generally presumed to be female (though little work has been done to ascertain the gender breakdown of box-office figures). Their use of current international pop songs, product placement and commercial-style fast-paced editing has attracted young audiences to the cinema, and created a kind of participatory fandom that is interesting to examine. The films made a star of heartthrob Riccardo Scamarcio (now one of Italy's most prolific and respected stars), and gave visibility to a new generation of male performers such as Silvio Muccino and Nicolas Vaporidis and female stars such as Laura Chiatti and Cristiana Capotondi.

Most of these actors emerged from the world of TV, as did Luca Argentero, star of *Saturno contro/Saturn in Opposition* (Ferzan Özpetek, 2007), and *Il grande sogno*, who was first 'discovered' on Italian *Big Brother*. The synergies between TV and film extend beyond stardom, with TV production companies such as RAI Fiction and Taodue now playing an important role in 'quality' domestic film production. One of the most interesting examples of the cross-over between film and TV is the TV adaptation of hit film *Romanzo criminale* as a series produced by Sky Italia and Cattleya, and screened on Sky. The critical and commercial success of the series, which began its second series in late 2010, falls hot on the heels of the TV adaptation of *Quo vadis, baby?* (Gabriele Salvatores, 2005), directed by Guido Chiesa for Sky Italia in 2008, and demonstrates very effectively some of the ways in which the panorama of Italian film production is evolving.

Catherine O'Rawe

April

Aprile

Studio:
Sacher Film
Bac Films
Rai Uno
Canal Plus

Director:
Nanni Moretti

Producers:
Angelo Barbagallo
Nanni Moretti

Screenwriter:
Nanni Moretti

Cinematographer:
Giuseppe Lanci

Art Director:
Marta Maffucci

Editor:
Angelo Nicolini

Duration:
78 minutes

Genre:
Documentary/Comedy

Cast:
Nanni Moretti
Silvio Orlando
Silvia Nono
Pietro Moretti

Year:
1998

Synopsis

The famous left-wing director Nanni Moretti is going to make an odd film, whose production he has already attempted to begin many times in the past: a musical concerning the life of a Trotskyist pâtissier in the narrow-minded Italy of the 1950s. As soon as the first day of shooting finally comes, Moretti is overwhelmed by doubts and stops the film's production. Then he plans to undertake a documentary about the upcoming 1996 general election, in which the centre-right coalition – led by the former prime minister Silvio Berlusconi – will face a new centre-left alliance – coordinated by Romano Prodi. Although the Italian Left wins the election for the first time in history, allowing him to film a lot of documentation, Moretti seems to be interested neither in politics nor in cinema: he is only concerned with his private life, since Silvia, his wife, is giving birth to Pietro, their first child.

Critique

Released in 1998, *Aprile* appears as a strange hybrid, taking a pivotal place in Nanni Moretti's career. Neither staged nor documentary, *Aprile* instead mixes the two forms. Hence, for chronological and narrative reasons, the film stands between two successful, both Cannes-awarded, productions: the allegedly more personal and episodic *Caro diario/Dear Diary* (1993), and *La stanza del figlio/The Son's Room* (2001), Moretti's return to making a full-length narrative feature film.

The transitional character of *Aprile* is also attested, as well as by its intrinsic nature as a cinematic 'notebook', by some textual features, such as its unusual length (only 78 minutes), and the aspect ratio, the almost obsolete, TV-like 1,66:1.

These traits seem useful in order to connect *Aprile* to its explicit reference point: Iranian cinema of the early 1990s, namely *Salaam Cinema/Hello Cinema* (Mohsen Makhmalbaf, 1994) and *Nema-ye Nazdik/Close-Up* (Abbas Kiarostami, 1990), which Moretti also supported during those years through his activity as a cinema owner. The phenomenological gaze and the loose dramatic tension of the Iranian models, which had informed *Caro diario*, are also at work here in a slightly different way.

Moretti has usually been celebrated for the scathing brevity of his dialogues, which often became political catchphrases, rather than for the visual stylishness of his images. This film too provided Italian political debate with some long-lasting slogans ('D'Alema, say something left-wing!'). Nevertheless, *Aprile* alternates the visually very flat, dialogue-heavy, real-life sequences, with the colorful takes of the –fantasized – film within the film, thus introducing a dreamy, uneven mood into Moretti's cinema, which will be developed in a totally different direction some years later in *Il caimano/The Caiman* (2006).

Though Moretti, predictably enough, acts both as a witness and a prophet with regard to the frustrated feelings of Italian

progressive, middle-class culture, the whole film is in fact filled with a sense of doubleness, which apparently represents the director's human, as well as artistic, transition.

Two very rare and shocking events, the birth of Moretti's son Pietro and the victory of the Left, make possible its balance between opposing impulses: documentary and musical, *impegno* (or ideological commitment) and escapism, idiosyncrasy and enthusiasm, (supposedly masculine) political commitment and (supposedly feminine) familial care. The later films of the Roman director suggest how precarious that balance was.

Paolo Noto

The Best of Youth

La meglio gioventù

Studio/Distributor:
RAI Cinema/Bibi

Director:
Marco Tullio Giordana

Producers:
Angelo Barbagallo
Franco Barbagallo

Screenwriters:
Sandro Petraglia
Stefano Rulli

Cinematographer:
Roberto Forza

Art Director:
Jörg Baumgarten

Editor:
Roberto Missiroli

Duration:
383 minutes

Genre:
Drama/Melodrama

Synopsis

The film tracks the lives of two brothers from Turin, Matteo and Nicola Carati, from 1966 to 2003, as their lives intersect with significant events in Italian history. The brothers first encounter a young woman with learning difficulties, Giorgia, and attempt to help her, first by freeing her from a mental institution, and running away with her, and then through the work of Nicola, as a psychiatrist interested in the reform of Italy's mental asylums, who finds her a place in an assisted living facility. The brothers' lives play out against the historical landscape of 1970s and 1980s Italian terrorism and mafia violence: they choose opposing political ideologies, as Nicola joins left-wing student protests, while Matteo becomes a police officer more interested in the repression of disorder (and of his own emotions). Nicola meets Giulia, a talented pianist, and although they have a daughter, Sara, their relationship crumbles when Giulia chooses the path of terrorism over peaceful protest and goes on the run. Matteo meets Mirella, a Sicilian photographer who tries to pursue a relationship with him, but who is thwarted by his inability to connect with others emotionally.

Critique

Originally shown over two nights on Italian public television in 2003, *La meglio gioventù* then attained theatrical success in Italy and internationally, with its sweeping story of two brothers, Matteo and Nicola, whose lives intersect with the most significant events of recent Italian history. As such, the film fits firmly into Italian cinema's tendency to revisit the 1970s and 1980s, particularly the terrorism that marked the so-called *anni di piombo*, or 'years of lead', a period that continues to be addressed in recent films such as *Mio fratello è figlio unico/My Brother is an Only Child* (Daniele Luchetti, 2007), *Buongiorno, notte/Good Morning, Night* (Marco Bellocchio, 2004), *La prima linea/The Front Line* (Renato De Maria, 2009), *Romanzo criminale/Crime Novel* (Michele Placido, 2005), and *Il grande sogno/The Big Dream* (Placido, 2009), several of

Cast:
Alessio Boni
Luigi Lo Cascio
Adriana Asti
Maya Sansa

Year:
2003

which were also scripted by the powerhouse screenwriting team of Stefano Rulli and Sandro Petraglia.

Intended as a portrait of a generation, the generation of middle-class, left-wing Italians who came of age during the political turmoil of 1968, the film includes many direct references to key moments of recent Italian history, often by including archive footage: so we see the 1966 flood of Florence, the shooting of Pope John Paul II, the murder of anti-mafia magistrate Giovanni Falcone (the boys' sister is a judge involved in the case), and of course the *anni di piombo*, evoked principally through the figure of Nicola's wife Giulia, the passionate pianist-turned-Red Brigade terrorist, who chooses violent action over her husband and, significantly, her daughter. As an extreme figure, Giulia is aligned with the mysterious Matteo, who seeks out authoritarian policing as a way of giving some security and certainty to his life, but keeps his family and lovers at bay. The tragic fate of Matteo is one of the film's enigmas, and allows for a rather soap-operatic romantic triangle to develop.

The Best Of Youth/La meglio gioventu, Rai/Bibifilm. Photographer Angelo Turetta.

The film's use of the conventions of the soap opera and the melodrama, in addition to its use of real footage, shows it to be reworking the tradition of politically-engaged or *impegnato* Italian film-making in a middlebrow key: this middlebrow *impegno* is also on display in Giordana's anti-mafia drama *I cento passi/The 100 Steps* (2000) and his family melodrama dealing with immigration *Quando sei nato non puoi più nasconderti/Once You're Born You Can No Longer Hide* (2005). In addition, Giordana's use of the trope of two brothers whose affective bond is compromised by opposing choices keys into a rich tradition of narratives of fraternal rivalry in Italian cinema, from Visconti's *Rocco e i suoi fratelli/Rocco and his Brothers* (1960), to Bertolucci's *Novecento/1900* (1976) and Rosi's *Tre fratelli/Three Brothers* (1980). Giordana's interweaving of the familial and the political eventually gives way to an apolitical and somewhat utopian climax, as Nicola becomes involved with Mirella, Matteo's ex-girlfriend, and the hopes of the Italian generation of '68 live on in the child of Matteo and Mirella. The film's ending, on a note of sublime, ahistorical beauty, appears to try and erase the contestation that marked the earlier parts, and to bring together 'both sides' of the troubled recent decades in consensual engagement with an imagined future.

Catherine O'Rawe

Christmas on the Nile

Natale sul Nilo

Studio:
Filmauro

Director:
Neri Parenti

Producer:
Aurelio De Larentiis

Screenwriters:
Fausto Brizzi
Lorenzo De Luca
Andrea Margiotta
Marco Martani
Neri Parenti

Cinematographer:
Gianlorenzo battaglia

Art Director:
Maria Stilde Ambruzzi

Synopsis

Desperate to distract his 15-year-old daughter from her dream of becoming a scantily-clad dancer on television (a 'letterina') and so bag a footballer husband, widower and Carabiniere General Enrico Ombrone takes her to spend Christmas in Egypt, accompanied by his Neapolitan adjutant, who hopes instead to persuade the General to marry his ugly sister. Inevitably, a troupe of four 'letterine' share the General's cruise ship, led by their coarse Roman impresario. At the same time, the Roman lawyer and inveterate philanderer Fabio Ciulla has followed his wife to Egypt in the attempt to save their marriage following his 740 adulterous conquests. She is traveling with their son (with whom Ciulla has a fractious relationship) and his new girlfriend (who unfortunately has seduced Ciulla before they realize each other's identity). Also on board is a pair of childish brothers who find two magical rings in the Great Pyramid, one of which brings extraordinary luck while the other brings great misfortune. Hilarious antics ensue as the three groups work through their own situations and (to some extent) interact with each other and a perplexed local population.

Critique

Natale sul Nilo is one of an ongoing series of ensemble comedies colloquially known as 'cinepanettoni' ('film-Christmas-cakes') produced since 1983. These critically despised but hugely popular films have become part of the annual festive rituals for huge numbers

Editor:
Luca Montanari

Duration:
110 minutes

Genre:
Farcical comedy

Cast:
Massimo Boldi
Christian De Sica
Enrico Salvi
Biagio Izzo

Year:
2002

of Italians, and have spawned offshoots as star actors defect to produce copycat films. Given its strong similarity to other films in the series (certainly the more recent ones directed by Neri Parenti) the choice to review *Natale sul Nilo* is an arbitrary one. However, this entry is reckoned in some sources to have been the highest-grossing of the series thus far and features the classic oppositional pairing (now defunct) of the handsome Christian De Sica (son of director and actor Vittorio) and the rotund Massimo Boldi. In several respects it is a clumsy film: the editing is merely functional and the intersection of the three narrative strands is perfunctory, while minor characters and extras seem barely to have been directed at all.

The best bits are found in the comic duets between the grotesque Ciulla/De Sica, a monster of vitality and selfishness (the character's name is derived from a versatile and vulgar slang verb meaning 'shag'), and the hapless Ombrone/Boldi, whose ugly but loveably infantile face one always feels an urge to caress. These duets are, of course, examples of consummate professionals engaged in a well-honed craft, even if the dialogue rarely sparkles and (a familiar criticism this) too often relies on expletives to generate laughter. Better examples of the screenwriter's craft are those moments, appropriately staged in a confined space, when the De Sica persona comes to be trapped by his scheming and infidelities, and can no longer evade the disclosure of his deceptions. In another film of the series he actually appeals to the spectator for help; in this one, confronted with his wife, his son, and the son's girlfriend's simultaneous revelation of his treachery, he pauses as if on a television quiz show and asks how much time he has to respond. This moment is as refined a pleasure as the film allows, but films such as this should not be dismissed for a coarseness that is perfectly deliberate, and carefully graded for a variegated audience. If the cheesecake is on show for the daddies and lads in the theatre, then the antics of the two brothers (the comedy duo known as the 'Fichi d'india', the 'prickly pears') are geared towards the youngest in the room. The content is, of course, offensive. The frank sexism would be better disguised in other film cultures, though the *mise-en-abîme* of female objectification in the 'letterine' plot points to a capacity for irony. There are no substantial roles for women (other films in the series feature stronger female presences, like that of the current blonde starlet Michelle Hunziker), and females are here nothing more than tokens to be exchanged in the homosocial game of patriarchy.

More shocking, because more surprising, is the film's philistine Orientalism and racist attitude to the Egyptians, all male and explicitly described as sexually predatory. This aspect of the film has to be read in the context of anti-immigration hysteria in Italy itself. But still – the scene where General Ombrone uses the swaddling bandages from the only intact mummy in the Great Pyramid to clean himself after a bout of diarrhoea, and so reduces the treasure to dust, will cheer anyone who has ever been browbeaten into a museum. This is a film no better or worse than you or I, and with no wish to improve either of us.

Alan O'Leary

Cover Boy: The Last Revolution

Cover boy: L'ultima rivoluzione

Studio/Distributor:
Paco cinematografico

Director:
Carmine Amoroso

Producer:
Augusto Allegra

Screenwriters:
Carmine Amoroso
Filipo Ascione

Cinematographer:
Paolo Ferrari

Art Director:
Biagio Fersini

Editor:
Luca Manes

Duration:
93 minutes

Genre:
Drama

Cast:
Eduard Gabia
Luca Lionello
Chiara Caselli
Luciana Littizzetto

Year:
2007

Synopsis

Set in the last days of Ceaușescu's Romania, *Cover boy* focuses on the family of the young Ioan and particularly the very tender relationship he has with his father. His father is, however, shot and killed and the film cuts to a desolate present-day Romania where an adult Ioan decides to try his luck emigrating to Italy with a friend. His friend is stopped as they cross the border and Ioan finds himself homeless on the streets of Rome. He finally meets Michele who is working as a cleaner in the toilets at Termini station. He moves into Michele's flat and finds a job at a scrap yard, resisting the opportunity of earning a living through gay prostitution. While Ioan's fortunes slowly improve, Michele struggles to keep his job. After he is discovered in the street by Laura, a professional photographer, Ioan moves to Milan to start a career as a professional model. Michele, meanwhile, is made unemployed and is reduced to begging from tourists in St Peter's. Ioan leaves Laura after he sees that she has superimposed his naked image onto shots of 1980s Bucharest for a fashion spread. He goes back to Rome to collect Michele with the aim of setting up a restaurant together on the Danube delta.

Critique

Over the last 20 years Italian cinema has dealt increasingly with the phenomenon of migration to Italy. Mostly, these films fall into the category of middlebrow drama and treat migration as a serious political issue. Cinema has largely been seen as a liberal counter to the more xenophobic accounts of migration to Italy found in other media. Until recently though, this body of work tended to focus on issues relating to arrival and settlement, and the very real threat of deportation was a common plot device. One of the most striking features of films such as Francesco Munzi's *Saimir* (2004) is the extent to which foreign migrants and Italians lead very separate lives. Migrants are usually seen in squalid peripheral locations and contact with Italians is only ever realized on a short-term basis through a doomed heterosexual romance, or through encounters with the authorities. *Cover boy: L'ultima rivoluzione* is part of a growing number of recent productions that bring Italians and migrants into close proximity. These films use the figure of the migrant to reflect on the often-beleaguered situation of Italians themselves.

Michele represents all those finding it difficult to survive on short-term work contracts. He struggles to pay the rent on a neglected apartment next to a railway line, and the deterioration of his living conditions contrasts with Ioan's social mobility. In a number of the most recent films about migration, the migrant is no longer at the bottom of the pile. Indeed, it is the migrant who has the resources to leapfrog over a hapless Italian underclass. To some degree, Ioan fits the stereotype of the hard-working migrant who often appears in this type of cinema yet, unlike many, he does succeed. A curious feature of Italian films about migration is that they have tended to make the migrant body an object of spectacle. Laura

obsessively photographs Ioan, yet her determination to possess his body through the camera's lens had already been anticipated by the way in which Michele appears not to be able to keep his eyes off his friend. Point-of-view shots suggest a homoerotic interest on Michele's part, yet Amoroso resists any clear definition of their relationship, which recalls the intense homosocial bonding that has become a staple of contemporary Italian cinema.

The lack of an explicit sense of causality characterizes this low-budget, digitally-shot feature. There is no real indication of the plot's temporal span, and the flashbacks to Ioan's childhood and the shooting of his father suggest the influence of history on the present in ways which again are never clarified. The long concluding sequence where Ioan and Michele drive off together can be inferred as the staging of a wish-fulfilment that can never take place. The inclusion of counterfactual elements links *Cover boy* as much to more overtly-political, or historically-situated films such as *Romanzo criminale/Crime Novel* (Michele Placido, 2005) or *Il divo* (Paolo Sorrentino, 2008) whose inclusion of such elements encourages the spectator to speculate on how the past might have turned out differently. In *Cover boy*, however, Amoroso is interested in the future as well as the past. **[Spoiler alert: the following sentences reveal a major plot development]** The film's closing expression of a rosy homosocial interethnic future as Michele and Ioan drive off into the sunset belies the fact that in the previous scene the spectator is led to believe that Michele has killed himself. In addition, Ioan's return to Romania echoes what has become a familiar plot device in films about migration where the migrant is either killed or repatriated; in either case he is expelled from the national territory. *Cover boy* is a particularly interesting example of Italy's exploration of its new multicultural reality. Its complex organization of time and historical memory, and the allusive nature of Ioan's relationships with the Italians he meets indicate a move away from the middlebrow realist aesthetic that has formed the dominant framing of migrants in Italian cinema.

Derek Duncan

Crime Novel

Romanzo criminale

Studio/Distributor:
Cattleya
Babe
Warner Bros

Director:
Michele Placido

Synopsis

The film traces the rise and fall of the real-life 1970s Roman criminal gang, the 'Banda della Magliana', as they wipe out their enemies to dominate the drug market in Rome, form connections with the Sicilian mafia, and even become involved in two of the most shocking terrorist-related events of the 1970s in Italy: the kidnapping of Christian Democrat leader Aldo Moro in 1978 and the bombing of Bologna train station in 1980. The detective leading the investigation into their activities, Scialoja, becomes romantically involved with the prostitute girlfriend of Dandi, one of the gang. The relationship between another member, Il Freddo, and his demure new girlfriend creates tensions within the group,

Producers:
Riccardo Tozzi
Giovanni Stabilini
Marco Chimenz

Screenwriters:
Sandro Petraglia
Stefano Rulli

Cinematographer:
Luca Bigazzi

Art Director:
Paola Comencini

Editor:
Esmeralda Calabria

Duration:
154 minutes

Genre:
Crime drama

Cast:
Stefano Accorsi
Pierfrancesco Favino
Claudio Santamaria
Kim Rossi Stewart
Riccardo Scamarcio

Year:
2005

tensions fatally exacerbated by their new-found wealth and decadent lifestyles.

Critique

Adapted from the successful 2002 novel by Giancarlo De Cataldo of the same title, *Romanzo criminale*, the story of the real-life Banda della Magliana in 1970s Rome, is a distinctive generic hybrid, bringing together influences of the Italian-American gangster films of Scorsese and Coppola with those of the *poliziesco* (the Italian 1970s crime thriller 'B' movie). For non-Italian audiences, the film's references to the kidnapping of Christian Democrat leader Aldo Moro, and the Bologna train station bombing may be perplexing, and the film deliberately never makes entirely clear the connection between these events and the gang's activities. However, it is this rooting of the film in the Italian political landscape of the period that makes it so distinctive: the film's retro visual appeal involves stylish costumes and production design, as well as a soundtrack of Italian and American pop music, occasionally used in a disorienting, 'Tarantino-esque' fashion, such as when Labelle's 'Lady Marmalade' is juxtaposed with archive footage of Moro being held by the Red Brigades.

Another interesting feature of the film is its casting: it brings together an ensemble cast of Italy's leading male actors of the time. The creepy detective, Scialoja, is played by Stefano Accorsi, then Italian cinema's main heartthrob, and he is reunited on screen with Piefrancesco Favino (Lebanese) and Claudio Santamaria

Crime Novel/Romanzo criminale, Cattleya/Aquarius Films/Babe.
Photographer Philippe Antonello.

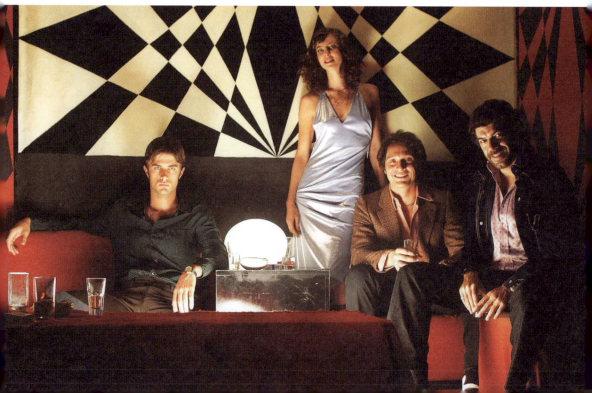

(Dandi), who had appeared together in the 2001 hit romantic drama *L'ultimo bacio/The Last Kiss* (Gabriele Muccino). Although Favino garnered most praise from critics for his muscular performance, it was Riccardo Scamarcio as Il Nero who went on to greatest success, and in retrospect this can be seen as a key role in Scamarcio's move from lightweight romantic hero to serious protagonist of middlebrow political drama. Kim Rossi Stuart as Il Freddo rounds out the male cast, and it is his romantic plotline that undermines the film's homosocial dynamic. As is typical of the genre (whether the Hollywood gangster picture or the Italian *poliziesco*), women feature only marginally, and as either virginal heroines or whores. This homosocial dynamic is familiar in the work of screenwriters Stefano Rulli and Sandro Petraglia, writers of much contemporary middlebrow Italian drama.

Placido's montage-driven, fast-paced style secured the film international distribution, and the film's success spawned an equally popular TV series in Italy, produced by Sky Italia, of which a second series began in late 2010.

Catherine O'Rawe

Golden Door

Nuovomondo

Studio/Distributor:
Miramax Films

Director:
Emanuele Crialese

Producers:
Alexandre Mallet-Guy
Fabrizio Mosca

Screenwriter:
Emanuele Crialese

Cinematographer:
Agnès Godard

Art Directors:
Laurent Ott
Filippo Pecoraino
Monica Sallustio

Editor:
Maryline Monthieux

Duration:
112 minutes

Synopsis

Set in 1913 in the Sicilian countryside, *Nuovomondo* begins with the protagonist, Salvatore Mancuso, spitting blood while he climbs an arid mountain barefooted. After seeing photo-manipulated postcards that portray America as a land of abundance, the widower Salvatore decides to gather his two sons, Angelo and deaf-mute Pietro, as well as his elderly mother Fortunata, and sell all their possessions in order to try his luck in the new world. While waiting to board amidst other peasants, the family encounters Lucy, a mysterious and refined British woman, who, knowing that only married women can be granted entrance to America, asks Salvatore to marry her. The dangerous voyage aboard an ocean liner is presented as only one of the many challenges faced by the migrant family. Once in New York, the family is put in confinement on Ellis Island where they succumb to numerous examinations and imposed transformations such as change of name and marital status until they are told whether or not the members of the family meet the requirements to enter the new world.

Critique

At the turn of the twentieth century, numerous Italian immigrants risked their lives by embarking on a journey across the Atlantic Ocean in search of a better life. Whilst Hollywood films from Wallace McCutcheon's *The Black Hand: True Story of a Recent Occurrence in the Italian Quarter of New York* (1906) to *The Godfather* (Francis Ford Coppola, 1972) have largely explored the theme and constructed the image of the Italian immigrant usually

Genre:
Drama

Cast:
Charlotte Gainsbourg
Vincenzo Amato
Aurora Quattrocchi

Year:
2006

as the stereotypical 'mafioso', mainstream Italian cinema has rarely engaged with the stories of suffering and loss amongst Italian migrants. A notable exception is Emanuele Crialese's *Nuovomondo* which offers a critical revaluation of this neglected past, by deconstructing some dominant representations of the migrant. Vincenzo Amato, featuring in his third film by Crialese (Amato also stars in *Respiro*, 2002, and *Once We Were Strangers*, 1997) delivers a remarkable performance as the naive and desperate Salvatore Mancuso, who envisages a prosperous life in the new world after looking at photo-manipulated postcards containing images of giant vegetables and money trees supposedly found in America. The film masterfully expresses how those images shape Salvatore's imagination and offers a critique of the manipulative power of images in activating desires that are unattainable. The narrative juxtaposes harsh reality with surrealistic sequences where characters swim in rivers of milk, holding oversized vegetables.

The original title, *Nuovomondo*, which literally translated means 'new world', implies the binary between old and new which is represented in the film by two contrasting female figures, Salvatore's mother, Fortunata, who is reluctant to leave Sicily, and the mysterious English lady, Lucy, who marries Salvatore in order to gain entrance to America. The stunning cinematography contributes to the film's distinctive approach to the archetypal passage from old to new. Geographical displacement is evoked by the powerful sequence where the ocean liner pulls out of the harbour whereas the movement towards cultural transformation is suggested by the language shift from strict Sicilian dialect to English-spoken dialogues. The experience of crossing the Atlantic Ocean is presented as dangerous and chaotic and Ellis Island, one of the furthermost transit stations in migration history, is depicted as an unkind place of transformation and separation where the immigrants are either granted entrance to the new world or sent back. The English title 'Golden Door' refers precisely to the geographical and metaphorical borders represented by Ellis Island as well as to the 1883 poem by Emma Lazarus engraved on the Statue of Liberty

Rather than relying on the traditional nostalgic tone employed by the majority of films that deal with migration in the twentieth century, Crialese makes striking use of parody as well as subverting the official and mainstream versions of this historic event. In one of the most memorable sequences of the film, where the characters are posing for a family photo, they are asked to place their heads behind the cutouts in order to hide the fact they are dressed in rags. This imparts a tragi-comic tone to the narrative and it is precisely this deconstruction of conventional images of Italian migration that makes the film unique. In capturing the characters' feelings of expectation and loss involved in the process of displacement, *Nuovomondo* strips away the iconography of the successful and powerful Sicilian immigrant. If in *Godfather: Part II* (Francis Ford Coppola, 1974) the spectator knows what the future holds for the young Vito Corleone during his experience in Ellis Island, the narrative of *Nuovomondo* ends in confinement, undermining Salvatore's American dream. The film creates perhaps the most touching

cinematic account of the traumatic experience of Ellis Island (also known as the 'Island of tears') since Robert Bober's documentary *Ellis Island Tales* (1980).

Natalia Pinazza

Gomorrah
Gomorra

Studio:
Fandango
Rai Cinema

Director:
Matteo Garrone

Producer:
Domenico Procacci

Screenwriters:
Maurizio Braucci
Ugo Chiti
Gianni Di Gregorio
Matteo Garrone
Massimo Gaudioso
Roberto Saviano

Cinematographer:
Marco Onorato

Art Director:
Paolo Bonfini

Editor:
Marco Spoletini

Duration:
129 minutes

Genre:
Drama/Crime

Cast:
Toni Servillo
Gianfelice Imparato
Maria Nazionale
Salvatore Cantalupo

Year:
2008

Synopsis

Four interwoven stories set in contemporary, Camorra-dominated Naples, and inspired by Roberto Saviano's international best-seller. Pasquale is a talented tailor who creates garments for renowned fashion labels. Exploited by his boss, Pasquale agrees to give lessons in dressmaking to Chinese irregular workers. The deprived area of Scampìa is torn apart by the war between the declining Di Lauro clan and the so-called Scissionisti ('Secessionists'). Don Ciro is in charge of delivering monthly payments to the relatives of imprisoned and fugitive Camorra members, the 13-year-old Totò is trained as a merciless criminal, and their friend Maria pays for her son's betrayal. Two teenagers, Ciro and Marco, try to emulate their cinematic model: Brian De Palma's *Scarface* (1983). Their awkward attempts to find a place in criminal society are soon halted. Franco is an expert businessman involved in illicit toxic waste management. Roberto, his assistant, witnesses the human, as well as material, devastation of his homeland.

Critique

Perhaps more anxiously than any other Italian film in the last decade, *Gomorra* was awaited as a huge sensation even before it was released. This was due to an array of different reasons: soon after the publication of the book upon which the film is based, in 2006, the 27-year-old author Roberto Saviano became an influential personality in the Italian socio-cultural landscape. However, because of the popularity gained by *Gomorra*, which for the first time brought the *camorra* to the attention of a mass readership, he was also forced to live under police protection after receiving death threats from the Camorra. The director Matteo Garrone had achieved box-office and – especially – critical success, thanks to his two previous films, *L'imbalsamatore/The Embalmer* (2002), and *Primo amore/First Love* (2004), both of which shaped morbid love affairs into gloomy forms which, according to many critics, resembled genre films, mainly American *film noir*.

Gomorra the film, then, even before it was actually released, seemed to respond to a recurring need in Italian cinematic culture for a prestige adaptation that might also convey an important message to a large audience. Nevertheless it would be unfair to reduce the impact of *Gomorra* to its alleged social function, since Garrone's film treats the questions it addresses in a very specific way.

First of all, unlike the majority of the films exploring the criminal underworld, *Gomorra* offers the viewer no completely positive

example and no redemptive hypothesis. Apart from in the final sequence there is no character that average viewers might easily identify with. Furthermore, the significance of those textual features, such as real-life settings, hand-held camera shots, and non-professional actors, which have been underlined by many reviewers, should not be overestimated. Rather than evidence of a presumptive neorealist heritage, these elements seem to display the plurivocal quality of a style that has been defined the 'New Italian Epic': in this style, Carlo Lucarelli's Italian TV reports on real-life crime, and memories of Martin Scorsese's deglamorized gangsters are mixed with *The Sopranos*' depiction of daily life.

The world of *Gomorra*, therefore, is not constructed as the worlds of documentary or realistic cinema are, that is, in a way that can satisfy the curiosity and the hunger for knowledge of both the camera and the viewer. *Gomorra*'s actions, rather, appear as the creepy re-staging of something that has been already staged elsewhere: the episode of young Marco and Ciro is telling from this point of view. As the singer Raffaello, in the song running over the opening title, declares: 'Our romance seems to be written by a TV cartoon'.

Furthermore, like stock characters, or carnival participants, the people of *Gomorra* bear upon their bodies the evidence of their role: they pursue and show off scars, tattoos, piercings, tans, and manicured hands as signs which allow those who wear them to play that game. Additionally, and like carnival fools, the main characters maintain an ambiguous attitude towards the Camorra, both as observing outsiders and inner operators of the upside-down world they are involved in. In the last sequence we see Roberto simply walking down a country road, having quit his job. This shot would be pointless if we had not been watching, for more than two hours, people walking underground, a swimming pool lying on the roof of a building, kids driving trucks, and people travelling in car trunks.

Paolo Noto

Good Morning, Night

Buongiorno, notte

Studio/Distributor:
Filmalbatros
Rai Cinemafiction/01 Distribuzione.

Director:
Marco Bellocchio

Synopsis

Rome, 1978. Having rented an apartment and built a secret cell in it, a group of Red Brigade terrorists kidnap Aldo Moro, the president of the Christian Democrats (the party that for more than thirty years has governed Italy), and keep him imprisoned for almost two months. Among the jailors is a woman, Chiara, the only one who is allowed to maintain contact with the outside world and have a regular job. In his cell Moro undergoes a 'proletarian trial', where he has to account for the accusations that the leader Mariano presents to him about the alleged abuses his party has always perpetrated against the workers. In the apartment, the group's clandestine life is split between this interrogation, watching TV news and household chores. Listening to people's comments and reading Moro's

Producers:
Marco Bellocchio
Sergio Pelone

Screenwriters:
Marco Bellocchio
Daniela Ceselli
Anna Laura Braghetti
Paola Tavella

Cinematographer:
Pasquale Mari

Art Director:
Marco Dentici

Editor:
Francesca Calvelli

Duration:
105 minutes

Genre:
Drama

Cast:
Maya Sansa
Roberto Herlitzka
Luigi Lo Cascio
Paolo Briguglia

Year:
2003

letters to his wife, Chiara starts having doubts about the necessity of killing the prisoner. Working as a librarian, she meets the young Enzo, who turns out to be the author of the script the group found in Moro's briefcase, *Good Morning, Night*. Talking to her about the story he is writing, Enzo indirectly contributes to the development of Chiara's resistance to Moro's killing.

Critique

Throughout his multifaceted career, Marco Bellocchio has gained a national and international reputation as one of the few Italian *auteurs* who has constantly criticized the oppressive influence that institutions such as the Catholic Church and the family exert over Italian society. In the same way, in *Buongiorno, notte*, Bellocchio challenges official historiography by tackling what is unanimously considered the crucial event in Italian contemporary history, namely the 1978 kidnapping and murder of the Christian Democrat president Aldo Moro by the left-wing revolutionary group the Red Brigades. For its political significance, and above all for its unprecedented non-stop coverage by the media, this affair is still discussed and remembered in Italy as the first and unequalled case of collective trauma, which has been revisited by an inexhaustible production of literature, theatrical and filmic texts in an attempt to overcome the silences and unanswered questions that followed.

Contrary to films such as *Il caso Moro/The Moro Affair* (Giuseppe Ferrara, 1986) and *Piazza delle Cinque Lune/Five Moons Plaza* (Renzo Martinelli, 2003), *Buongiorno, notte* avoids attempting uncertain realistic reconstructions or suggesting theories of international plots, as its main aim is to look at how we shape memory. The fact that the film declares itself to be 'freely inspired' by the memoir *The Prisoner* (2004), by Anna Laura Braghetti, the female member of the kidnapping team that lived with Moro in the apartment where he was held prisoner, challenges the viewer's expectation of a realist version with a definitive stand on the story. In Braghetti's literary work, more-or-less-known facts are interwoven with details of a more personal nature concerning the daily life and the atmosphere in the apartment. Bellocchio lingers on some of them to build up the fictionalization of the event, which, whilst intended to be symbolic, contributes above all to questioning the way representational means, first of all visual ones, are produced and organized to construct the memory of past events. This happens through the use of clips interspersed from other films – such as *Paisà/Paisan* (Roberto Rossellini, 1946), and Dziga Vertov's *Tri pesni o Lenine/Three Songs About Lenin* (1936) – and TV footage, and the narrative addition of a paradoxical character, Enzo, who appears as the writer of *Buongiorno, notte*'s script. With its more-or-less-scandalous fictional references (the title itself is a line from Emily Dickinson) and inventions, among which its very disputed ending, *Buongiorno, notte* can 'put the real in parenthesis' precisely because Bellocchio can count on the audience's knowledge of the facts. Instead of contributing to any conflict-ridden debate by commenting on the silences of the Moro affair, the director

chooses to follow an alternative path: that is, he reconstructs history as a means of challenging the view that it is territory for ideological opposition, common in post-war Italy, and rather to suggest the idea of history as a critical tool.

Above all, the reference to the memoir allows Bellocchio to concentrate on the human aspects of the terrorists' characters – it is precisely this humanization that has attracted most criticism – not only as ordinary lower-middle-class individuals with their daily paranoia and dependence on the television, but also as people with an inner maturity. In fact, Chiara, the fictional character embodying Braghetti's point of view, comes to question the darkness of the Red Brigades' ideology, reaching a 'humanist enlightenment' that makes her consider the possibility of changing the course of events. This is a pathway towards the 'redemption' of the past, which liberates new responsibilities to be taken in the present: with the failure of political power, it becomes an individual and civil responsibility to liberate Moro.

Emanuele D'Onofrio

Nasty Love

L'amore molesto

Studio:
Lucky Red

Director:
Mario Martone

Producers:
Angelo Curti
Andrea Occhipinti
Kermit Smith

Screenwriters:
Mario Martone
Elena Ferrante

Cinematographer:
Luca Bigazzi

Art Director:
Giancarlo Muselli

Editor:
Jacopo Quadri

Duration:
104 minutes

Synopsis

Delia, a professionally successful but solitary middle-aged woman awaits a visit at her home in Bologna by her more gregarious elderly Neapolitan mother Amalia. Her mother never shows but Delia receives a series of bizarre and chilling late-night phone calls, apparently from her mother, who, as she cackles wildly down the line, appears to be either in the throes of madness or some sort of drug-induced stupor. In amongst this feral laughter, Delia's mother also appears to be wickedly teasing her, repeating the phrases 'he wants me to take it in the mouth,' and 'he'll kill you too' which seriously unnerves the reserved Delia.

Soon after, Delia receives word that her mother's nearly-naked body has been found washed up ashore on the Neapolitan coastline. This prompts Delia to head south in order to organize the funeral and put her late mother's matters in order. Upon her arrival, she attempts to establish the truth behind her mother's mysterious and sudden demise. From here on in, Delia's investigation forces her to confront uncomfortable truths about her mother's sexuality, suppressed, traumatic memories originating from her own childhood, and the consequences of the momentary white lies that people can tell.

Critique

L'amore molesto is an artfully-crafted thriller based on the successful novel of the same name by Elena Ferrante. It uses a woman's personal inquest into the curious death of her mother to unpack a range of contemporary ideas relating to Italian inter-generational conflict, gender roles and construction, sexuality, language and

Nasty Love/L'amore molesto, Lucky Red/Teatri Uniti.

Genre:
Mystery Thriller

Cast:
Anna Bonaiuto
Angela Luce
Giovanni Viglietti

Year:
1995

Italian geography. To tell this sophisticated story, director Mario Martone demonstrates a limpid approach to using cinematic structures and languages. The death of Delia's mother and her journey from the terse palettes of liberal, pseudo-intellectual Bologna (with all its socio-cultural contexts) over the Mezzogiorno to the more unruly, vivid chromatic system of Naples, unleashes a sort of convection current through which ideas of identity are explored. This physical journey and self-examination enables Delia to open up her own sexuality, explore the truth of her relationship with her separated parents and interrogate her own choices over the course of her life.

Using a clear, divided *mise-en-scène* strategy for the two principal locations, the director aims to emphasize the cultural and social differences between the 'undeveloped' south and the more 'sophisticated' north represented by Bologna, which Delia, born in the Neapolitan area, has now adopted as her home. Naples, when the story arrives there, is immediately and noticeably more chaotic than the ordered, structured existence that Delia leads in Bologna.

The framing is offset and systematically jumbled, and the Naples sound signature incorporates a clamorous, shrieking mix of car horns and traffic whirr. This disorientating cloud finds its verbal twin in the more visually-expressive and freewheeling dialect spoken by Delia's mother and uncle in stark contrast to her own clear and contemporary Italian and conservative body language.

The viewer also discerns a clear arc of development in Delia's sexuality and gendered identity. When we first meet Delia she is dressed predominantly in more masculine codes of colour and shape, her hair 'unfeminine' in its short length and her body language communicating a more masculine gender construction. This is made most visually explicit when Delia, unusually for Italy, is one of the four bearers of her mother's coffin down the steps of the church. However, with that convection current of identity change, a temperature rise is also palpable: Delia in Naples is dressed in the revealing red dress that belonged to her mother but fits Delia like a glove. For Delia the dress becomes a means to liberate her own sexuality by transposing herself into the very symbol of her mother's (imagined) sexual adventures during her twilight years. At the same time, she succeeds in bringing herself closer to the mother she had forever defined herself as being intrinsically different from. Delia's gradual acceptance of her own sexuality and that of her mother results in a key, if deeply strange exchange in a Turkish bath with a burly, now-balding male friend from childhood who, appropriately, is the son of Caserta.

As the film's denouement and purposeful twist takes hold, we are reminded of Delia's profession, only briefly alluded to at the outset, as that of a graphic novel writer or comic strip producer. Delia is, we discover, adept at both inventing narratives and compartmentalizing memories according to her whims.

Matthew Pink

The Second Time

La seconda volta

Studio:
Banfilm

Director:
Mimmo Calopresti

Producer:
Nanni Moretti

Synopsis

Professor Alberto Sajevo, a lecturer in business and economics at Turin University and ex-senior manager at Fiat, has lived under a pseudonym and reconstructed identity for the best part of twelve years following a terrorist attack upon his life. Single, and close to his sister, there is also a suggestion that he has had problematic homosexual relationships. Since the attack he has lived with a bullet embedded within his skull which is liable to give him serious migraines and potentially worse.

One day at lunch, he sees by chance a woman whom he recognizes as one of his attackers: Lisa Venturi. However, Venturi does not reciprocate the recognition and introduces herself as Adele. Sajevo resolves to follow Venturi, bemused and angry as to why she is apparently now walking free. During the day, Venturi works as an administrative assistant in a city centre office but, at night,

Screenwriters:
Mimmo Calopresti
Franceco Bruni
Heidrun Schleef

Cinematographer:
Alessandro Pesci

Art Director:
Giuseppe M. Gaudino

Editor:
Claudio Cormio

Duration:
80 minutes

Genre:
Drama

Cast:
Valeria Bruni Tedeschi
Nanni Moretti

Year:
1995

she must return to the prison on the city's outskirts from where she is on day release as part of her ongoing process of social reintegration. After Sajevo has confronted Venturi with his real identity, a psychological game of cat and mouse ensues, with Venturi refusing to engage any further with Sajevo, and with him demanding an answer and some sort of closure for his trauma.

Critique

Dealing with the thorny issue of Italy's recent history of political terrorism is a problem which refuses to subside for Italy's governments. In the mid- to late 1990s, when this film was produced, the Italian judiciary were in the process of formulating laws granting an 'indulto' to terrorists convicted of 'lesser' crimes committed up until 1989, and who had been duly imprisoned as a result. An 'indulto' was a particular form of official pardon (by no means complete) which sought to reduce the remaining terms of the sentence.

However, the recriminations of passing any such law provoked a stormy debate, led for the larger part by the families and victims of terrorist activities dating from the late 1960s and 1970s. In 1997, President Scalfari issued a surprising pardon to six incarcerated terrorists (who had not been convicted of murder), lighting another fire underneath the fierce debate.

Mimmo Calopresti's film does not so much grasp this thorn as examine and query it from a calm, detached perspective. He presents it simply and through deliberately non-pyrotechnical, humanist means.

Sajevo's bullet-embedded brain serves as the perfect metaphor for the parameters that the wider Italian society finds itself operating within. The terrorists, past and present, were contributing members of Italian society, just as their victims were. Their violent actions and their consequences live on in many, now-middle-aged Italians, and continue to infect their memories with the trauma of conflicting emotions. Sajevo's migraines and the persistent threat to his own mortality encompass the fragile nature of this social malaise. William Faulkner looms large here, perhaps: 'The past is never dead. It's not even past.'

Calopresti creates an ambiance of stasis. Nanni Moretti as Sajevo, surrounded by blue, is first framed rowing inside on a machine, taking him precisely nowhere. Notably, he lacks the conviction to step back into the real thing and course down the Po. Turin is wintry and discontented. Soft rains force heads down and collars up, encouraging insular living and pared-down communication. Savejo's office is found in the grey and grubby Palazzo Nuovo of Turin University, the Mole Antonelliana next door visible only through dank mists and charcoal skies.

Sajevo himself is anglicized (he chooses roast beef, drinks tea often and from a pot) in the way that Mediterraneans sometimes view the English – as emotionally cold and (sexually) repressed. Sajevo, like the city of Turin, is obviously automated by the mechanical rhythms of manufacture, of the Fiat factory (of which a long take is featured as a means to introduce the tempo of the film). The city's public transport network and commuter spaces –

mensa-type bars and cafes, park benches, offices – operating as they do in Turin, on a tightly-knit extended grid, offer the means for Sajevo and Venturi to conduct their mechanized daily business.

Calopresti takes considerable time to subtly build empathetic portraits of two of the sides of this argument – how to come to terms with the legacy of terrorism – and to his great credit, provides no simple solution. Sajevo's character has his bullet in the head, Venturi has her institutionalization and her refracted memory. She also unwittingly carries a signifier of her past every day in the form of a scarlet coat.

There are, for Calopresti, no easy forms of compromise or resolution. Indeed, reconciliation may well even be impossible. This is captured in the final images of Sajevo, as he begins to write Venturi a letter saying that their meetings have helped him in some way. But as his train to Germany rattles past open, vague landscapes, he throws his letter from the train and into oblivion.

Matthew Pink

Sorry If I Love You

Scusa ma ti chiamo amore

Studio:
Medusa

Director:
Federico Moccia

Producers:
Vittorio Cecchi Gori
Rita Rusic

Screenwriters:
Chiara Barzini
Luca Infascelli

Cinematographer:
Marcello Montarsi

Art Director:
Federico Ciommo

Editor:
Patrizio Marone

Duration:
113 minutes

Genre:
Teen/Romantic comedy

Synopsis

Fun-loving 17-year-old Niki and her group of female friends are in the last year of high school, but they enjoy life, love, fashion, and sport, mostly leaving serious study to their male counterparts. Thirty-seven-year-old workaholic creative director in advertising, Alex, by contrast, finds himself abandoned by his girlfriend of many years just after he has proposed, and he is left in the company of some rather washed-up men in midlife crisis who constitute his depressing friendship group. When Niki's path crosses Alex's, as he distractedly bumps his 4 x 4 into her scooter, an unlikely love story unfolds from their hostile clash. Initially distant, Alex is pursued by this rambunctious, energetic schoolgirl. She breaks down his defences, inspires him to find new creativity in his work, to recover a joyous spontaneity in living, and to take bold decisions about his lifestyle. At the same time the tender relationship between the two of them is exposed to the mockery of friends, parental disapproval, Alex's own desires to conform, and the return of his former girlfriend, apparently repentant. In a world of romantic misadventures, can the two lovers ever really bridge the decades that divide them?

Critique

Recent years have witnessed unprecedented recognition of mass female film audiences' desires in Hollywood: from the *Sex and the City* films to the *Twilight* saga. That recognition has been accompanied by debate about the quality of these films, debate that rages far less powerfully around the mass products created for male or mixed audience tastes. These films have created shockwaves in Italy too. However, there has been a similar scenario unfolding with Italy's home-grown cinema, as the recent case of films based on

Cast:
Raoul Bova
Michela Quattrociocche

Year:
2008

the bestselling teen books by Federico Moccia demonstrates. It is equally likely that what occasions the outpourings of critical scorn on Moccia's products might be a general disregard for any kind of collaboration with female audiences' supposed desires, although Moccia's fanbase is not necessarily only female.

Scusa ma ti chiamo amore saw Moccia return to film-making after a long break and pick up on the success of the previous film adaptations of his work by others and their broad teenage fan base (*Tre metri sopra il cielo/Three Steps Over Heaven*, Luca Lucini, 2004; *Ho voglia di te/I Want You*, Luis Prieto, 2007). With takings of 12.6 million euros, the film came eighth in the Italian 2008 box office overall, beating *Gomorra/Gomorrah* (Matteo Garrone), and fourth out of all Italian films made that year. Initially it seems that the typically Italian cross-generic appeal of the film accounted for its success, as its clearly multiple address combined the male midlife crisis narrative of *L'ultimo bacio/The Last Kiss* (Gabriele Muccino, 2001) and many other films of the last decade with earlier Moccia narratives of teen romantic suffering. Inspired by the classic formula of films like *I dolci inganni/Sweet Deceptions* (Alberto Lattuada, 1960), the film taps into a popular history of the cross-generational romance (in a certain gendered configuration). The film's weaker follow-up *Scusa ma ti voglio sposare/Sorry, But I Want to Marry You* (2010) achieved a still-respectable box-office ranking of 26th in the 2009/10 season (over 6.6 million euros). Amongst many criticisms, *Scusa ma ti chiamo amore* provoked accusations of a suspect predilection for turning the camera on attractive young girls, whilst the film a prolific Moccia made between the *Scusa* products, *Amore 14* (2009), which examines the sexual curiosity of a group of 14-year-olds (in fact played by 19-year-olds), was subject to even sterner treatment.

However, in the light of recent theoretical work, it is possible to read the films as typically postfeminist products (Negra, 2009), in which feminism is re-packaged as commodity, but not without retaining a trace of its original substance. These films can promote, through their protagonists, a saccharine image of 'acqua e sapone' femininity, which has in turn produced an understandable vein of 'anti-Moccia' sentiment amongst certain Italian teen audiences. The films do also, nonetheless, create a mainstream space for the exploration of female friendship, anxieties about early sexual experience and female commitment, and articulate female protagonists who take initiative, albeit within a strictly delimited personal sphere. In the criticism of the films' commercial appeal, it is easy to forget that these protagonists' concerns, by contrast with the earlier largely male-focused tradition, now address in part the female audiences of *Twilight*, who seek pleasure in their film-going: a pleasure that may express itself in complex and sometimes critically-unpalatable ways. If sexuality is the key mode through which manifestations of feminism are now filtering into the popular, we should engage with representations of that sexuality in more depth. Much more needs to be done to understand what female audiences really want, but Moccia's *oeuvre* to date has demonstrated that caring even a little bit can be very lucrative.

Danielle Hipkins

Southside Story

Sud Side Stori

Studio:
Gam Film

Director:
Roberta Torre

Producers:
Leos Kamsteeg
Gherardo Pagliei
Donatella Palermo
Elisabetta Riga

Screenwriters:
Franco Maresco
Francesco Suriano
Roberta Torre

Cinematographer:
Daniele Cipri

Art Director:
Filippo Pecoraino

Editor:
Giogiò Franchini

Duration:
87 minutes

Genre:
Musical Drama

Cast:
Forstine Ehobor
Roberto Rondelli
Little Tony

Year:
1997

Synopsis

The Capo slums in Palermo: Toni Giulietto is a vulnerable street singer and Little Tony-impersonator (who is himself an Italian Elvis-impersonator) who is constantly deceived and hoodwinked by almost everyone he knows. Romea is an attractive Nigerian immigrant who sells sex on the streets of Palermo to pay off her huge fee to the man who smuggled her in to the country. Toni and Romea meet and fall in love when they move into the same apartment building, but their love is severely frowned upon by their different friend and familial groups. They even face disapproval from the local Catholic priest. Toni lives with three interfering and irksome aunts who dominate his every decision. Romea's community is that of the rest of the Nigerian immigrant population in this part of Sicily; her closest friends Mercutia and Baldassarra strongly disapprove. Both sides consult witchdoctor types to find potential magic potions which will help put an end to Toni and Romea's blossoming but socially-taboo relationship. Various characters plot against each other and the plots, which draw in people from all the different social strata, spiral out of control as the tug-of-war between these different factions of Sicilian society is fought to the last.

Critique

Roberta Torre's second feature-length fictional picture is a wild, untamed film operating almost entirely sui generis (and is all the more successful for it). Its starting points are of course the most famous Shakespearean tale of them all, the narrative structures and tropes provided by the American musical (of which *West Side Story* provides the obvious titular inspiration) but also the very contemporary flux of Sicilian society which here acts as a microcosmic example of the more globalized patterns of migration and boundary shifts which define the world as we know it today.

Having no truck with conventional dramatic representation, *Sud Side Stori* is a gaudy, heady and rambunctious mix of interracial conflict and resolution, cross-cultural insemination, anthropological detail, song, dance, drama and cinema where the only logic is that internal to the film itself. Palermo, and in particular its more jagged edges, the harbour-side area and the slums of the Capo area, are drawn as both rough and impoverished but also phantasmagorical, where both brutal physical reality and magical possibilities come into contact (in a very similar vein to the way the French author Daniel Pennac paints his home of Belleville in his series of Malaussène novels).

There is a deliberate ploy on the part of Torre to subvert, reverse and open up formally rigid generic constructs: ideas of matriarchy and patriarchy, gender politics, racial prejudices and Sicilian (and Italian) traditions and beliefs. The film continues to mix the high-

with the low-brow and trades pieces of cultural production from all over the globe with each other. Inevitably, given the story and location, it places a particular emphasis on pitching the Italian pop song against the African folk equivalent while drawing on bits and pieces of American culture and Shakespeare to build the direction of the tale.

In relation to cinematic genre, the film moves nimbly and without recourse across the melodrama, the musical, the romantic comedy and even moves purposefully into documentary at times. In moving across genre so confidently the film succeeds in teasing out the real network which underpins ideas of genre whilst artfully pastiching the traits we know so well. Through this method the film builds commonality across the differing social, political and cultural contexts and shows how, through processes of adaption, translation and interface, the transnational movements of the immigrant and emigrant populations are replicated. As a result of this hybridized approach to film genre and dramatic structure, commonly held ideas of 'otherness' and 'the foreign' are exposed for their inherent superficiality.

Matthew Pink

The Stolen Children

Il ladro di bambini

Studio:
Erre Produzioni
Alia Film in association with RAIDUE

Distributor:
SACIS

Director:
Gianni Amelio

Producer:
Angelo Rizzoli

Screenwriters:
Gianni Amelio
Sandro Petraglia
Stefano Rulli

Cinematographers:
Tonino Nardi
Renato Tafuri

Synopsis

In a dilapidated suburb of Milan, a Sicilian woman is arrested for the serial prostitution of her 11-year-old daughter. Following the woman's arrest and incarceration (and in the absence of other family members), the child, Rosetta, and her younger brother Luciano are entrusted to the State and escorted to a Catholic children's home in Civitavecchia, by a young paramilitary police officer (Antonio), also of Southern origin. A missing medical certificate means, however, that the siblings are turned away, and a second journey, this time to an orphanage in Sicily (the children's birthplace), ensues. During this road trip of sorts, and in light of Antonio's increasingly compassionate engagement with the children's plight, an affective bond gradually builds between them, culminating in a much-celebrated beach episode in the picturesque seaside town of Marina di Ragusa. The carefree, holiday atmosphere of this and a subsequent holiday sequence in Noto is however, short-lived. Having been accidentally brought into contact with his superiors following the apprehension of a camera thief, Antonio is accused of kidnapping the children and molesting Rosetta.

Critique

Released in the wake of the success of the Oscar-nominated *Porte aperte/Open Doors* (Gianni Amelio, 1990), *Il ladro di bambini* confirmed Gianni Amelio's status as a film-maker of international

Art Director:
Andrea Crisanti

Editor:
Simona Paggi

Duration:
114 minutes

Genre:
Drama

Cast:
Valentina Scalici
Giuseppe Ieracitano
Enrico Lo Verso
Vitalba Andrea

Year:
1992

repute. Drawing on the themes and concerns scattered elsewhere in Amelio's sprawling oeuvre (the autobiographically-inspired absence of biological fathers, the shortcomings of the State, internal migration, and the meshing of the private and political spheres), the film, which appeared theatrically in the spring of 1992, took the Italian box-office by storm and won a raft of coveted awards including the Special Jury Prize at the Cannes Film Festival.

Since its release, Il ladro di bambini, widely regarded as one of the key Italian films of the 1990s, has also enjoyed largely continuous scholarly attention. This vigorous response was and continues to be energized both by the neorealist-inspired 'spirit of spontaneity' in which it was made (improvised scripts, eschewal of the studio and use of some non-professional actors), and by the film's glaring titular and inter-textual references to some of the great Italian cinematic accomplishments of the early post-war period. These include, most conspicuously, Vittorio De Sica's much-lauded male child-oriented dyad, Bicycle Thieves/Ladri di biciclette (1948) and its wartime precursor I bambini ci guardano/The Children Are Watching Us (1944), as well as works by Roberto Rossellini, Michelangelo Antonioni and Luchino Visconti. The charge that Il ladro di bambini bears all the hallmarks of Amelio's indebtedness to first- and second-wave neorealism resonates widely within dominant discourse surrounding the film's perceived significance within the landscape of contemporary Italian cinema.

However, amongst the numerous intertextual presences and at times more codified re-workings of neorealist concerns and film-making practices, perhaps the overarching quality which allows critics repeatedly to set Il ladro di bambini in dialogue with its neorealist forebears is its determined engagement with the social dynamics of a contemporary Italy. Appearing at a time when the so-called 'First' Republic and its Christian Democrat hegemony was being dealt what would soon turn out to be deathly blows by high-profile mafia killings and well-publicized corruption scandals, Amelio's film constitutes a timely dramatization of the human consequences of widespread social and political malaise for those occupying Italian society's margins in the final decade of the last century.

Yet in spite of a palpable reticence among critics, whose attention has largely and quite legitimately been directed towards excavating the film's fidelities to and departures from neorealist film-making, its opening sequence, which captures the moments leading up to the forced sexual encounter between Rosetta, the film's 11-year-old co-protagonist, and a paedophile businessman, reminds us as spectators that Il ladro di bambini is a work which not only takes the Italian cinematographic tradition as its theme but also the sexual abuse of a female child. Whilst childhood sexual abuse should not be understood either as historically embedded or geographically specific, as a phenomenon it was, by the early 1990s, gaining considerable visibility within the

Western press and broadcast media realm. Amelio's determined aim to de-sensationalize such abuse, to negate the voyeuristic gaze of an Italian media realm saturated with so-called *TV verità* and, in so doing, restore dignity to its victim, become just as important within the film's narrative economy, then, as Amelio's damning indictment of the insufficiencies of a myriad of social and political institutions.

Roger Pitt

RECOMMENDED READING

Aprà, Adriano & Claudio Carabba (1976) *Neorealismo d'appendice: Per un dibattito sul cinema popolare, il caso Matarazzo*, Rimini: Guaraldi

Bazin, André (2011) *André Bazin and Italian Neorealism* (edited by Bert Cardullo), London: Continuum.

Ben-Ghiat, Ruth (2005) 'Unmaking the Fascist Man: Film, Masculinity, and the Transition from Dictatorship' *Journal of Modern Italian Studies*, vol. 10, no.3 (fall 2005): 336–65.

Bondanella, Peter (2001) *Italian Cinema From Neorealism to the Present – Third Edition*, New York and London: Continuum.

Brunetta, Gian Piero (2009) *The History of Italian Cinema* (trans. Jeremy Parzan), Princeton and Oxford: Princeton University Press.

Burke, Frank (1996) *Fellini's Films: From Postwar to Postmodern*, New York: MacMillan/Twayne.

Caldiron, Orio (2004) *Le fortune del melodramma*, Rome: Bulzoni.

Cannella, Mario (1973/74) 'Ideology and Aesthetic Hypotheses in the Criticism of Neo-Realism', *Screen*, Winter 1973/74, Volume 14 Number 4, pp. 5–60.

Canova, Gianni (2009) 'Commedia e identità nazionale', in LL Cavalli Sforza (ed) *La cultura italiana*, Vol. IX, *Musica, spettacolo, fotografia, design*, Turin: UTET, pp. 458–75.

Celli, Carlo & Margo Cottino-Jones (2007) *A New Guide to Italian Cinema*, Basingstoke: Palgrave MacMillan.

Creed, Barbara (1993) *The Monstrous-Feminine: Film, Feminism*, Psychoanalysis, London and New York: Routledge

Dalle Vacche, Angela (1992) *The Body in the Mirror*, Princeton: Princeton University Press.

Dalle Vacche, Angela (2008) *Diva: Passion and Defiance in Early Italian Cinema*, Austin: University of Texas Press.

Della Casa, Stefano (2001) 'L'horror', in Giorgio De Vincenti (ed) *Storia del cinema italiano vol. 10: 1960–1964*, Venice and Rome: Marsilio/Edizioni di Bianco & Nero, pp. 319–30.

Fanchi, Mariagrazia (2007) 'Un genere di storia. Alcune considerazioni su storia di genere and storiografia del cinema' in G Alonge & R West (eds) *Cinema e Gender Studies, 'La valle dell'Eden'*, 2007, 19, pp. 183–93.

Ferrero, Adelio (1999) 'La «coscienza di sé»: ideologie e verità del neorealismo', in Lino Micciché (ed) Il neorealismo cinematografico italiano, Venice: Marsilio.

Giovannini, Memmo, Enrico Magrelli & Mario Sesti (1986) *Nanni Moretti*, Napoli: Edizioni Scientifiche Italiane.

Gieri, Manuela (1995) *Contemporary Italian Film-making: Strategies of Subversion – Pirandello, Fellini, Scola, and the Directors of the New Generation*, Toronto, Buffalo, London: University of Toronto Press.

Girelli, Elisabetta (2007) 'Transnational Orientalism: Ferzan Özpetek's Turkish Dream in *Hamam*', *New Cinemas*, (2007, 5:1) pp.23–38.

Günsberg, Maggie (2004) *Italian Cinema: Gender and Genre*, Basingstoke and New York: Palgrave Macmillan.

Hipkins, Danielle (2008) 'Why Italian Film Studies Need a Second Take on Gender', *Special issue of Italian Studies*, 'Thinking Italian Film', vol. 63, no. 2, 2008, pp.213–34.

Jenks, Carol (1992) 'The Other Face of Death: Barbara Steele and *La maschera del demonio*', in Richard Dyer & Ginette Vincendeau (eds) *Popular European Cinema*, New York and London: Routledge, pp. 149–62.

Koven, Mikel (2006) *La Dolce Morte: Vernacular Cinema and the Italian Giallo Film*, Lanham/Toronto/Oxford: Scarecrow Press.

Landy, Marcia (2004) 'Diverting clichés: femininity, masculinity, melodrama, and neorealism in *Open City*' in Sidney Gottlieb (ed) *Roberto Rossellini's Rome Open City*, Cambridge: Cambridge University Press, pp.85–106.

Landy, Marcia (2000) *Italian Film*, Cambridge: Cambridge University Press.

Liehm, Mira (1984) *Passion and Defiance: Film in Italy from 1942 to the Present*, Berkeley, Los Angeles and London: University of California Press.

McDonagh, M (1991) *Broken Mirrors, Broken Minds: The Dark Dreams of Dario Argento*, London: Sun Tavern Fields.

Marcus, Millicent (2002) *After Fellini: National Cinema in the Postmodern Age*, Baltimore: Johns Hopkins University Press.

Marcus, Millicent (1986) *Italian Film in the Light of Neorealism*, Princeton: Princeton University Press.

Mazierska, Ewa & Rascaroli, Laura (2004) *The Cinema of Nanni Moretti: Dreams and Diaries*, London: Wallflower Press.

Mercer, John & Martin Shingler (2004) *Melodrama: Genre, Style, Sensibility*, London: Wallflower Press.

Mychalczyk, J (1986) *The Italian Political Film-makers*, London: Associated University Press.

Negra, Diane (2009) *What a Girl Wants?: Fantasizing the Reclamation of the Self in Postfeminism*, London: Routledge.

Nowell-Smith, Geoffrey (ed) (1996) *The Companion to Italian Cinema*, London: BFI.

O'Healy, Aine (2009) '"[Non] è una somala": Deconstructing African femininity in Italian film', *The Italianist*, Vol. 29, No. 2., pp. 175–98.

O'Leary, Alan (2009) *Tragedia all'italiana: Italian Cinema and Italian Terrorisms, 1970-2008*, Oxford: Peter Lang.

O'Leary, Alan (2007) 'Marco Tullio Giordana, or the Persistence of "impegno"', in Angela Barwig & Thomas Stauder (eds) *Intellettuali italiani del secondo Novecento*, Oldenbourg: Verlag für deutsch-italienische Studien, pp. 481–502.

O'Rawe, Catherine (2011) 'Brothers in Arms: Middebrow *Impegno* and Homosocial Relations in the Cinema of Petraglia and Rulli' in Danielle Hipkins & Luciano Parisi (eds) *Intellectual Communities and Partnerships: Studies in Honour of Mark Davie*, Oxford: Peter Lang.

O'Rawe, Catherine (2008) '"I padri e i maestri": Genre, Auteurs, and Absences in Italian Film Studies', *Italian Studies*, 63: 2, Autumn 2008, pp. 173–94.

Overbey, David (ed.) (1978) *Springtime in Italy: A Reader in Italian Neorealism*, London: Talisman Books.

Sitney, P. Adams (1995) *Vital Crises in Italian Cinema: Iconography, Stylistics, Politics*, Austin: University of Texas Press.

Sorlin, Pierre (2009) *Gli italiani al cinema: immaginario e identita sociale di una nazione*, Mantua: Tre lune.

Sprio, Margherita (2008) 'Migrant Translations – Matarazzo Remembered', in Helen Chambers (ed) *Europe and the Province; The Poetics of the Margins*, Bern: Peter Lang Publications.

Viganò, Aldo (1998) *Storia del Cinema: Commedia italiana in cento film*, Genova: Le Mani.

Wagstaff, C (1992) 'A Forkful of Westerns: Industry, Audiences and the Italian Western', in R Dyer & G Vincendeau (eds) *Popular European Cinema*, New York/London: Routledge, pp. 245–61.

Wood, Mary (2004) '"Pink Neorealism" and the Rehearsal of Gender Roles in Italy, 1946–1955' in Phil Powrie, Ann Davies & Bruce Babington (eds): *The Trouble with Men: Masculinities in European and Hollywood Cinema*, Brighton: Wallflower Press, pp.134–44.

Wood, Mary (2005) *Italian Cinema*, Oxford: Berg.

Wood, Mary (2010) 'Chiaroscuro: The half-glimpsed femme fatale of Italian film noir' in Catherine O'Rawe & Helen Hanson (eds): *The Femme Fatale: Images, Histories, Contexts*, Basingstoke: Palgrave MacMillan.

Italian Cinema Online

Cinecittà Luce
http://www.cinecitta.com/wp/index.php
Italian language website of Cinecittà Luce, the principal organization promoting Italian cinema. Includes details of organizations, press releases, archived, and other activities linked to the promotion of film production in Italy.

Cinemaitaliano.info
www.cinemaitaliano.info/
Italian language website detailing film festivals in Italy, new Italian films and all new releases in the country.

Il cinema italiano
web.ccsu.edu/italian/il_cinema_italiano.htm
Italian language website which collects together a wide range of links to websites featuring film news, criticism, promotional material, listings and further information.

Cinematografo.it
http://www.cinematografo.it/cinematografo_new/s2magazine/index1.jsp?idPagina=12145
Italian language resource detailing reviews, trailers, festivals and other activities related to Italian cinema.

Film Studies For Free
http://filmstudiesforfree.blogspot.com/
English language website not dedicated solely to Italian cinema, but which collects academic film studies material available online.

Giallo Fever
http://giallo-fever.blogspot.com/
English language website dedicated to the *giallo* film.

In Italy Online
http://www.initaly.com/itathome/movies.htm
English language website which lists Italian movies by setting and also details foreign films set in Italy.

Italica
www.italica.rai.it/eng/cinema/index.htm
English language website listing prominent Italian film directors, genres, and films, fully illustrated with bibliographical suggestions.

The Mondo Research Laboratory
http://tmrl.baywords.com/
English language website devoted to the world of the Mondo documentary, the trash Italian films popularized in the 1960s

The Wild Eye
http://www.thewildeye.co.uk/blog/
English language website dedicated to discussion of European cinema.

Spaghetti Western Database
http://www.spaghetti-western.net/
English language website which archives information about the Spaghetti Western genre.

Zeroland
http://www.zeroland.co.nz/italian_film.html
English language website which offers links to other websites with information on Italian film.

TEST YOUR KNOWLEDGE

Questions

1. Italian cinema of the 1930s is often remembered as being most interested in the lives of the wealthy, but which status symbol of the time gave its name to a whole cycle of films?
2. What makes young Bruno Ricci burst into tears in *Ladri di biciclette*?
3. Which neorealist film's bleak vision of Italy was singled out by MP Giulio Andreotti as a disservice to the nation?
4. Which tragic heroine's fate is sealed with the line '*tu non esisti*' (you don't exist)?
5. What occurs 'the four times' in the film of the same name?
6. Which future international star played her first major starring role as Aïda after changing her name from Sofia Scicolone?
7. To which political figure does Nanni Moretti in *Aprile* implore, 'say something left wing!', adopted as a slogan on the Italian left nationally?
8. Which composer was asked in 1917 to write a symphonic score for *Rapsodia satanica*?
9. Which symbolist poet wrote the intertitles in 1916 for *Cabiria*?
10. What was the name of renowned stage actor Eleonora Duse's one foray into film, a commercial failure in 1916?
11. Which newspaper did Raf Vallone work for when he was recruited for a starring role in *Riso amaro*?
12. Which actor, who said 'I have played every screen part, except that of the baddie', successfully progressed from uniformed star of Fascist cinema to principal male lead of melodramatic 'popular neorealism' after the war?
13. Which director, reputed to cry when shooting his own films, paired the above actor with Yvonne Sanson to make the most commercially-successful screen couple of the post-war years?
14. A dance scene from which post-war melodrama is briefly glimpsed by the lead character in Nanni Moretti's *Caro diario/Dear Diary* (1993)?
15. What filling does Nando Moriconi, aka Alberto Sordi as *Un americano a Roma*, put in his sandwich in a vain attempt at an American-style snack?
16. Which 1966 spaghetti western featured an ear-slicing incident which was both inspiration for a similar scene in Quentin Tarantino's *Reservoir Dogs* (1992) and responsible for its being banned in the UK until after the Tarantino film was released?

17. Which actor became an international star after moving from American television shows into spaghetti westerns?
18. Who directed the following spaghetti westerns: *Navajo Joe* (1966), *I crudeli/The Hellbenders* (1967) and *Il grande Silenzio/The Great Silence* (1968)?
19. Which popular silent film character was revived as one of the major *peplum* heroes?
20. Which 1954 Kirk Douglas film is regarded as a forerunner to the *peplum* genre?
21. In *Romolo e Remo*, Romulus is played by *peplum* icon Steve Reeves. Who plays his twin brother Remus?
22. Which American company distributed Mario Bava's *La maschera del demonio* (1960) as *Black Sunday* and later released his anthology feature *I tre volti della paura* (1963) as *Black Sabbath* to cash in on the former's success?
23. How many Italian gothic horror films starred genre icon Barbara Steele?
24. Which traditional Italian Christmas cake has lent its name to a contemporary form of popular Italian comedy?
25. Which epic account of recent Italian history was initially screened over two nights on television, before receiving a theatrical release?
26. Which film is based on a book whose author was forced to live in hiding due to its uncompromising account of the organized criminal activities of the Neapolitan Camorra?
27. What British actor worked with Both Dario Argento and Michelangelo Antonioni?
28. What father and son duo both worked in the *giallo* genre?
29. What is the essential fashion accoutrement for most *giallo* murderers?
30. Apart from directing films, what was Fellini's other creative talent?
31. Which Marxist epic is intended as an Italian equivalent to *Gone With the Wind* (Victor Fleming, 1939)?
32. Whose reputation as one of Italy's foremost directors of political cinema has been eclipsed since his untimely death in 1982?
33. The political exploitation of which natural disaster forms the basis for Sabina Guazzanti's documentary *Draquila – L'Italia che trema/Draquila – Italy Trembles* (2010)?

Answers
1. White telephone (*telefoni bianchi*)
2. His father slapping him, or Vittorio De Sica falsely accusing the child actor Enzo Stajola on set of cheating, depending on whether you are watching *Ladri* or the discussion of it in *C'eravamo tanto amati/We All Loved Each Other So Much*!
3. *Umberto D*
4. Emma Recchi, played by Tilda Swinton, in *Io sono l'amore/I Am Love*
5. Death
6. Sophia Loren
7. Massimo D'Alema
8. Pietro Mascagni
9. Gabriele D'Annunzio
10. *Cenere*
11. Comunist daily *L'unità*
12. Amedeo Nazzari
13. Raffaello Matarazzo
14. *Anna* (1951)
15. Jam, yoghurt, mustard and milk, which he soon rejects.
16. *Django*
17. Clint Eastwood
18. Sergio Corbucci
19. Maciste
20. *Ulisse/Ulysses*
21. Gordon Scott
22. AIP (American International Pictures)
23. Nine
24. Panettone, to *cinepanettone*
25. *La meglio gioventù/The Best of Youth* (Marco Tullio Giordana, 2003)
26. Roberto Saviano
27. David Hemmings
28. Mario and Lamberto Bava
29. Black gloves
30. Drawing and illustration
31. *Novecento/1900* (Bernardo Bertolucci, 1976)
32. Elio Petri
33. The 2009 earthquake that devastated the town of L'Aquila

NOTES ON CONTRIBUTORS

Eleanor Andrews is Senior Lecturer in Italian and Course Leader for Film Studies at the University of Wolverhampton, UK. She teaches European Cinema, in particular French Cinema from the Golden Age of the 1930s to the present. Her interest in Italian Cinema includes neorealism, the Spaghetti Western and the work of the director Nanni Moretti. She has published chapters on Moretti and family life and Moretti and authorship. Her PhD thesis examines Moretti's use of space in his ten major feature films to date. She has recently started working on the Holocaust in film.

Louis Bayman lectures film studies, and his research specialisms are Italian cinema, melodrama, and popular culture (having completed a PhD on post-war Italian melodrama). He is currently co-editing volumes on *Popular Italian Cinema* and *Directory of World Cinema: Brazil*.

Adam Bingham has a PhD in Japanese cinema and teaches film studies at Edge Hill University in Lancashire. He writes regularly for *CineAction*, *Cineaste* and *Asian Cinema* among other publications.

Maria Buratti is a PhD student in Communication and New Technologies at Iulm University (Milano), where she has worked in the Cinema Department (teaching History of Cinema and History of Italian Cinema Courses) since 2003. She teaches History of Cinematographic Language at Cisa – Conservatorio Internazionale di Scienze Audiovisive (Lugano). She has written an article for *La cultura italiana* (ed. by Luca Cavalli Sforza, Utet Torino 2010) on the cinematographic representation of landscape.

Frank Burke teaches in the Film and Media Department of Queen's University (Canada). His research has focused on Italian, American, and Italian-American cinema, specializing in the work of Federico Fellini. He has published three books on Fellini in English and contributed to two Italian volumes on the director. He provided the audio commentary, along with the late Peter Brunette for the Criterion 2006 DVD release of Fellini's *Amarcord*. His detailed analysis of Fellini's commercials appeared in the 2010 film issue of *The Italianist*. He is currently preparing *The Blackwell Companion to Italian Cinema*, as well as a book-length study of the peplum for Edinburgh University Press.

Corin Depper teaches Film Studies in the School of Performance and Screen Studies at Kingston University.

Emanuele D'Onofrio completed a PhD (funded by the AHRC) entitled 'Film Music, National and Narrative Identity: Italian Contemporary Cinema Revisits the 1970s'. His current research areas cover the work of new composers in contemporary Italian cinema, and the influence of the Roman Catholic Church on Italian cinema across the twentieth century. His research has produced publications on directors such as Guido Chiesa, Renato De Maria, Marco Tullio Giordana and Marco Bellocchio. Currently he works as a TV writer in Italy.

Derek Duncan is Professor of Italian Cultural Studies at the University of Bristol. He has published extensively on gender and sexuality in Italian literature and film. He is the author of *Reading and Writing Italian Homosexuality: a case of possible difference* (2006), and has co-edited three volumes on colonial and postcolonial Italy. He is Senior Editor of the Cultural Studies issue of the long-established journal Italian Studies.

Richard Dyer teaches film studies at King's College London. He is the author of *Stars*, *White*, *Pastiche* and *Nino Rota*.

Robbie Edmonstone is a corporate video designer, musician and freelance writer based in Glasgow. In 2008 he graduated from the University of Glasgow with a PhD exploring violence and spectacle in popular Italian genre cinema, with specific emphasis on the Italian western, *polizieschi*, *giallo* and horror cycles. He is currently contributing to a number of academic and non-academic cult cinema-related projects, including liner notes for the recent BFI Centre of Information DVD entitled *'Stop! Look! Listen!'*

Dimitris Eleftheriotis teaches film at the University of Glasgow. A member of the Advisory Editorial Board of Screen he has published extensively on various aspects of film theory, history and aesthetics. He has just published the monograph *Cinematic Journeys: Film and Movement*. Other books include *Asian Cinemas: A Reader and Guide* and *Popular Cinemas of Europe: Studies of Texts, Contexts and Frameworks*. He is currently working on a series of articles on the work of Jules Dassin.

Luisella Farinotti teaches History and Aesthetics of Cinema at Iulm Univerity in Milano. She has written essays on cinema from Lombardy, on the idea of the author in modern cinema, on Italian cinema in the 1960s and the 1970s, and on the relationship between cinema and memory. She has written on cultural industry and independent cinema (*La cultura del margine*, 2001), history and theory of genres (*Territori di confine*, 2002, together with R Eugeni) and Home movies (*Il metodo e la passione. Cinema amatoriale e film di famiglia in Italia*, 2005, together with E Mosconi). She published a monograph on Edgar Reitz's cinema (*Il futuro dietro le spalle. Tempo e storia nel cinema di E Reitz*, 2005).

Austin Fisher is a lecturer in Film Studies and the author of *Radical Frontiers in the Spaghetti Western: Politics, Violence and Popular Italian Cinema* (2011). His main area of expertise concerns popular Italian cinema's engagement with the countercultural movements of the 1960s and 1970s, and his research in this

field has appeared in *The Italianist* and *Scope: an Online Journal of Film and TV Studies*. Austin is currently working on a project about *polizieschi*.

Barry Forshaw's books include *British Crime Writing: An Encyclopedia* and *The Rough Guide to Crime Fiction*, along with books on Italian Cinema, Film Noir and a biography of Stieg Larsson, *The Man Who Left Too Soon*. He has written for *The Independent*, *The Express*, *The Times* and *Movie Mail*. He edits *Crime Time* and is a talking head for the ITV Crime Thriller author profiles and BBC TV documentaries. He has been Vice Chair of the Crime Writers' Association.

Christopher Frayling was until recently Rector of the Royal College of Art and Chair of Arts Council England. An historian, critic and award-winning broadcaster, he has published eighteen books on popular culture, art and design and film, including *Spaghetti Westerns, Sergio Leone – something to do with death*, and *Once Upon a Time in Italy*. In 2004, he guest-curated a major exhibition on Leone's Westerns at the Museum of Western Heritage in Los Angeles. He is currently Professor Emeritus of Cultural History at the Royal College of Art and a Fellow of Churchill College Cambridge.

Natalie Fullwood is currently completing a PhD on *commedia all'italiana* in the Department of Italian at the University of Cambridge. Her research interests include Italian film and popular culture, cinematic space, and representations of gender and sexuality.

Mimmo Gianneri is a PhD student in Communication and New Technologies at Iulm University (Milano), where he works with the Cinema Department (for the Languages of Cinema and Television Course). He has written essays on Contemporary Italian Cinema and on Italian musical comedies of the 1960s. He organizes courses of audiovisual education for high school students.

Elena Gipponi obtained her Degree in History of Italian Cinema and is a PhD student in Communication and New Technologies at Iulm University in Milano. Her key research areas are Contempory Italian Cinema and genres of comedy. She worked in a research unit on 1970s' Italian Culture for the exhibition annisettanta at La Triennale di Milano (2007).

Phil Hardcastle has an MA from Auckland University where he majored in Hispanic Literature and completed a thesis on seventeenth-century Spanish drama. He is a life-long fan of Italian westerns and is a staff member and editor of the Spaghetti Western Database website to which he has contributed numerous reviews, articles and interviews. He also runs the 'Son of Django' blog site where he regularly posts his film reviews. Phil has currently seen some 300 European westerns and is still hunting down more elusive titles.

Danielle Hipkins is Senior Lecturer in Italian at the University of Exeter. She has published on postwar Italian women's writing, cinema and gender, and is currently working on *Beyond the Bordello: Gender and Prostitution in Postwar Italian Cinema* (forthcoming, 2011). She is also working on audience studies relating to cinema of the 1940s and 1950s, and to contemporary cinema in the context of postfeminism.

Dom Holdaway is currently completing a doctoral research project on *cinema d'impegno* at the University of Warwick, specializing in political representations of mafia and organized criminal activity from its earliest (post-war) embodiments through to the present day.

Ella Ide completed her PhD at the University of Cambridge on representations of masculinity in contemporary Italian cinema in 2009, after an MA in European Languages and Culture. She now works as a journalist with the Agence France Press in Rome

Edward Lamberti is a PhD candidate in the Film Studies department at King's College London. His thesis is on Levinasian ethics, film style and spectatorship in relation to the work of the Dardenne brothers, Barbet Schroeder and Paul Schrader.

Irene Lottini has a PhD in Comparative Studies from the University of Siena. She is currently teaching Italian language and Italian cinema at the University of Iowa. She published articles and presented papers on silent cinema, Italian cinema, Italian literature, and the relationship between literature and cinema.

Alex Marlow-Mann has a PhD on Italian cinema from the University of Reading. He has worked for the BFI and taught Italian cinema at the Universities of Reading, Cardiff and Leeds and is currently Research Co-ordinator at the Centre for Film Studies at the University of St Andrews. He has published numerous articles on Italian cinema, both in the UK and Italy, on such diverse subjects as musicals, historical epics of the silent era and the distribution of Italian cinema in the UK. His book *The New Neapolitan Cinema* was published by Edinburgh University Press in March 2011.

Rocco Moccagatta is a critic and expert in cinema, in particular B-movies, and Hollywood Blockbusters. He is currently working for the Department of Art, Culture and Literature at Iulm University in Milan, and for the Department of Communication Sciences at Università Cattolica del Sacro Cuore, in Milan. He has published essays for *La cultura italiana* (edited by Luca Cavalli Sforza, Utet Torino 2010), and journals including *Comunicazioni Sociali*, *Link*, *Comunicazione Politica*. He also works on the movie magazine *Duellanti* and is a media researcher and consultant for TV channels and networks.

Katharine Mitchell is Sutasoma Research Fellow at Lucy Cavendish College, Cambridge. She has published on nineteenth-century Italian women's historiography, women in the public sphere (as actors, singers, artists, novelists, journalists, essayists) and Italian opera, and is currently working on a monograph on domestic fiction and journalism by women writers in early post-unification Italy. From January 2011 onwards she is a Lecturer in Italian at the University of Strathclyde, Glasgow.

Paolo Noto completed a PhD at Bologna on Italian genre cinema in the 1950s and currently holds a research grant from the same University. Intertextuality and film, genre theory and the history of post-war Italian cinema are his main research topics. His first book is *Il cinema neorealista, a reader on Italian neorealism* co-edited with Francesco Pitassio (2010).

Daniel O'Brien is a writer and occasional teacher who has contributed to encyclopedias, dictionaries and other reference works, and written books on such subjects as Clint Eastwood, Frank Sinatra, British science fiction, Hong Kong horror movies, the Hannibal Lecter books and films, Paul Newman and Daniel Craig. He is currently completing a PhD on the *peplum* genre.

Áine O'Healy is Professor of Italian at Loyola Marymount University in Los Angeles. Her book on contemporary Italian film, *National Cinema in a Transnational Landscape*, is forthcoming.

Alan O'Leary is Senior Lecturer in Italian at Leeds and has published a monograph, an edited volume and several articles on the representation of terrorism in Italian cinema. He is now working on a short book on the broad comedies known as the 'cinepanettone' (see the project blog <http://holidaypictures.tumblr.com/><http://holidaypictures.tumblr.com/>). He works closely with Catherine O'Rawe (Bristol) on the 'Thinking Italian Film' project, which aims to put the study of Italian cinema on a firmer institutional and theoretical footing in the academy. He is the co-editor (with Millicent Marcus, Yale) of the annual film issue of the journal *The Italianist*.

Catherine O'Rawe is Senior Lecturer in Italian at the University of Bristol. She is currently working on a monograph on Italian neorealism and Hollywood, and has articles published and in press on Romanzo criminale, Angela, and masculinity in contemporary Italian cinema. She is co-editor with Alan O'Leary of the special issue of the journal *Italian Studies* on 'Thinking Italian Film' (2008); she is also co-editor, with Helen Hanson, of the volume *The Femme Fatale: Images, Histories, Contexts* (2010).

Natalia Pinazza graduated in Languages and Literature (Italian and Portuguese) from the Universidade de Sao Paulo, Brazil, and joined the University of Bath in 2007 to do a MA in European Cinema. She is currently working towards her PhD in the impacts of globalization on contemporary Argentina and Brazilian cinemas.

Matthew Pink is a copy editor and writer based in Cambridge, UK, specializing in film sound and music. He has BA (Joint Hons) in French and Italian from the University of Leeds and an MA with Distinction in Cinema Studies from the University of Bristol.

Roger Pitt is an AHRC-funded doctoral candidate in Italian at the University of Exeter, where he has also taught undergraduate modules in Italian language, literature and film. The focus of Roger's postgraduate research is Italian cinema of the last two decades with particular emphasis on the figure of the missing child.

Sergio Rigoletto is Teaching Fellow in Italian at the University of Reading, UK, where he was awarded his PhD in 2010 with a dissertation that examined the politics of masculinity in Italian cinema of the 1970s. He has published articles on Ferzan Özpetek, Pier Paolo Pasolini and the Italian comedy of the economic miracle, and is co-editor of a book entitled *Popular Italian Cinema*.

Jonathan Romney is film critic of the Independent on Sunday, and a contributing editor to *Sight and Sound*. He is the author of *Short Orders* – a book of collected criticism – and a monograph on Atom Egoyan in the BFI World Directors series

Iain Robert Smith is a Lecturer in Film Studies at Roehampton University, London. He is the editor of *Cultural Borrowings: Appropriation, Reworking, Transformation* (2009) and author of the forthcoming *The Hollywood Meme: Transnational Appropriation of US Film and Television*. He has published articles in a range of international journals including *Velvet Light Trap* and *Portal: Journal of Multidisciplinary International Studies*.

Lawrence Webb recently completed his PhD thesis at King's College London on international cinema and urban space in the 1970s. He has taught film studies at King's College London and Royal Holloway, University of London. His research interests include the relationships between cinema, urbanism and architecture, geographies of film production, cinematic sound, and the cultural representation of economic crisis.

FILMOGR

The 100 Steps/I cento passi (2000)	244
1900/Novecento (1976)	242
A Bay of Blood/Reazione a catena/Ecology of a Crime/Bloodbath/Twitch of the Death Nerve/Ecologia del delitto (1971)	135
A Bullet for the General/El chuncho, quien sabe? (1966)	204
A Fistful of Dollars/Per un pugno di dollari (1964)	214
A Lizard in a Woman's Skin/Una lucertola nella pelle di una donna (1971)	145
Accattone (1961)	58
Allonsanfàn (1974)	230
Along the Ridge/Anche libero va bene (2006)	85
An American in Rome/Un americano a Roma (1954)	112
Anna (1951)	86
April/Aprile (1998)	257
The Arcane Sorcerer/L'arcano incantatore/The Mysterious Enchanter (1996)	157
Ashes/Cenere (1916)	36
Assunta Spina (1915)	37
The Bandit/Il bandito (1946)	59
The Battle of Algiers/La battaglia di Algeri (1966)	232
The Beach/La spiaggia (1954)	113
The Best of Youth/La meglio gioventù (2003)	258
Bicycle Thieves/Ladri di biciclette (1948)	61
Big Deal on Madonna Street/I soliti ignoti (1958)	115
The Big Gundown/La resa dei conti (1967)	203
The Bird with the Crystal Plumage/L'uccello dalle piume di cristallo (1970)	136
Bitter Rice/Riso amaro (1948)	63
Black Sabbath/I tre volti della paura (1963)	158
Black Sunday/La maschera del demonio (1960)	159
Blood and Black Lace/Sei donne per l'assassino (1964)	138
Bread, Love and Fantasy/Pane, amore e fantasia (1953)	116
Cabiria (1914)	39
The Capture of Rome. 20th September, 1870/La presa di Roma (1905)	41
The Case of the Scorpion's Tail/La coda dello scorpione (1970)	140
Castle of Blood/Danza macabra (1964)	161
Chains/Catene (1949)	89
Christmas on the Nile/Natale sul Nilo (2002)	260
The Colossus of Rhodes/Il colosso di Rodi (1961)	179
The Conformist/Il Conformista (1970)	234
Cover Boy: The Last Revolution/Cover boy: l'ultima rivoluzione (2007)	262
Crime Novel/Romanzo criminale (2005)	263
Crypt of Horror/La cripta e l'incubo (1964)	163

Dante's Inferno/Inferno (1911)	42
Day of Anger/I giorni dell'ira (1967)	207
Deep Red/Profondo rosso (1975)	141
Divorce: Italian Style/Divorzio all'italiana (1961)	118
Django (1966)	208
Django, Kill! (If You Live, Shoot!)/Se sei vivo, spara! (1967)	210
Duel of the Titans/Romolo e Remo (1961)	181
The Earth Trembles/La terra trema: Episodio del mare (1948)	64
The Easy Life/Il sorpasso (1962)	119
Face to Face/Faccia a faccia (1967)	212
The Fall of the Rebel Angels/La caduta degli angeli ribelli (1981)	92
Fists in the Pocket/I pugni in tasca (1965)	236
The Giant of Marathon/La battaglia di Maratona (1959)	183
Golden Door/Nuovomondo (2006)	265
Gomorrah/Gomorra (2008)	267
Good Morning, Night/Buongiorno, notte (2003)	268
The Great War/La grande guerra (1959)	121
Hamam – The Turkish Bath/Hamam (1997)	94
Hercules/Le fatiche di Ercole/The Labors of Hercules (1958)	185
Hercules Conquers Atlantis/Ercole alla conquista di Atlantide/Hercules and the Captive Women (1961)	187
Hercules in the Centre of the Earth/Ercole al centro della terra/Hercules in the Haunted World (1961)	188
Hercules Unchained/Ercole e la regina di Lidia (1959)	189
The Horrible Dr Hichcock/L'orribile segreto del Dr Hichcock/The Terror of Dr. Hichcock (1962)	164
The House With the Laughing Windows/La casa delle finestre che ridono (1976)	143
In the Name of the Law/In nome della legge (1949)	67
Inferno (1980)	166
Investigation of a Citizen Above Suspicion/Indagine su un cittadino al di sopra di ogni sospetto (1970)	238
Keoma (1976)	216
The Killer Must Kill Again/L'assassino è costretto a uccidere ancora (1975)	146
La signora di tutti (1934)	100
The Last Days of Pompeii/Gli ultimi giorni di Pompei (1913)	44
The Last Days of Pompeii/Gli ultimi giorni di Pompei (1959)	193
Le confessioni di una donna (1928)	90
Le quattro volte (2010)	14
Life Begins Anew/La vita ricomincia (1945)	95

Title	Page
Io sono l'amore/I Am Love (2009)	10
Love Everlasting/Ma l'amor mio non muore! (1913)	45
The Loves of Hercules/Gli amori di Ercole/Hercules vs the Hydra (1960)	191
Lust of the Vampire/I vampiri/The Devil's Commandment (1956)	167
Man Called Blade/Mannaja (1977)	217
The Mattei Affair/Il caso Mattei (1972)	240
Mediterraneo (1991)	123
Miracle in Milan/Miracolo a Milano (1951)	68
My Name is Trinity/Lo chiamavano Trinità... (1970)	219
Mill of the Stone Women/Il mulino delle donne di pietra/Drops of Blood (1960)	169
Nasty Love/L'amore molesto (1995)	270
Nightmare Castle/Amanti d'oltretomba/Night of the Doomed (1965)	171
Ossessione (1943)	71
The Other Side/L'aldilà – e tu vivrai nel terrore (1981)	172
Paisan/Paisà (1946)	72
Pinocchio (1911)	47
The Private Secretary/La segretaria privata (1931)	126
Quo vadis? (1913)	48
The Railroad Man/Il ferroviere (1956)	74
Ringo and his Golden Pistol/Johnny Oro (1966)	220
Rocco and His Brothers/Rocco e i suoi fratelli (1960)	97
Rome, Open City/Roma città aperta (1945)	76
Sabata/Ehi amico... c'è Sabata, hai chiuso! (1969)	223
Satan's Rhapsody/Rapsodia Satanica (1917)	50
The Scorpion with Two Tails/Assassinio all'cimitero etrusco/Murder in the Etruscan Cemetery (1982)	148
The Second Time/La seconda volta (1995)	272
The Seduction of Mimì/Mimì metallurgico ferito nell'onore (1972)	243
Senso (1954)	99
The Sign of Venus/Il segno di Venere (1955)	124
Son of Spartacus/Il figlio di Spartacus/The Slave (1962)	195
Sons of Thunder/Arrivano i Titani/My Son, the Hero (1962)	196
Sorry If I Love You/Scusa ma ti chiamo amore (2008)	274
Stromboli/Stromboli, terra di Dio (1950)	77
Southside Story/Sud Side Stori (2000)	276
The Stolen Children/Il ladro di bambini (1992)	277
The Strange Vice of Mrs Wardh/Lo strano vizio della Signora Wardh (1971)	149
Suspiria (1977)	174
Tenebrae/Tenebre (1982)	150
The Tree of Wooden Clogs/L'albero degli zoccoli (1978)	80
Theorem/Teorema (1968)	246
Tontolini is Sad/Tontolini è triste (1910)	51
Too Beautiful!/Cretinetti che bello! (1909)	52
Torso/The Bodies Present Traces of Carnal Violence/I corpi presentano tracce di violenza carnale (1973)	152
Totò, Peppino and the Hussy/Totò, Peppino e la malafemmena (1956)	127
The Unfaithfuls/Le infedeli (1953)	102
The Unknown Woman/La sconosciuta (2006)	104
Videocracy/Videocracy – basta apparire (2009)	250
The Visitor/La visita (1963)	130
Volcano/Vulcano (1950)	105
We All Loved Each Other So Much/C'eravamo tanto amati (1974)	248
We Want Roses Too/Vogliamo anche le rose (2007)	251
What Rascals Men Are!/Gli uomini, che mascalzoni... (1933)	129
The Witch's Curse/Maciste all'inferno (1962)	198